Marc Fennell is an award-winning film critic and media mischief-maker who likes to pull high-brow culture down off its high horse and give it a solid spanking. He is known to triple j and ABC Local Radio listeners around Australia as 'That Movie Guy'. He was a presenter on the ABC's genre-defying *Hungry Beast* and each week you can catch him dishing out quirky film reviews for Network Ten's Logie-winning talk show *The Circle*.

Marc began his torrid love affair with movies back in high school when he was a winner in the Australian Film Institute's inaugural (and final) Young Film Critics competition. The prize was a free ticket to a terrible Australian film. This was a sign of things to come.

Marc then spent four years as the resident film critic for Sydney radio station FBi. There he reviewed hundreds of movies, interviewed countless filmmakers and actors, and produced stories on everything from punk cinema to porn flicks.

In 2004, Marc was selected from hundreds of applicants to join SBS's revamped *The Movie Show*, where he was tasked with digging up cult DVDs and grinning widely while talking about them.

Since then he has explored cinema and popular culture for the likes of MySpace, magazines *Yen* and *Dazed and Confused*, the Movie Network, ABC News 24, Sky News, Showtime and the *Canberra Times*. He even performed a live comedy show at the 2009 Melbourne International Comedy Festival.

Actor Brendan Fraser once threw a newspaper at Marc but, hey, we all suffer for our art.

THAT
MOVIE
BOOK

MF

MARC FENNELL

The following book contains coarse
language, adult themes, overwrought
analogies, unnecessary similes, redundant
metaphors and some repetition. Readers are
advised that parental guidance is irritating
at the best of times but even more so when
you're trying to watch a movie.

THAT MOVIE BOOK

AWESOME, WEIRD AND WONDERFUL MOVIES FOR EVERY WEEKEND OF THE YEAR

MARC FENNELL

ABC
Books

The ABC 'Wave' device is a trademark of the Australian Broadcasting Corporation and is used under licence by HarperCollins*Publishers* Australia.

First published in Australia in 2011
by HarperCollins*Publishers* Australia Pty Limited
ABN 36 009 913 517
harpercollins.com.au

HarperCollins*Publishers*
Level 13, 201 Elizabeth Street, Sydney NSW 2000, Australia
31 View Road, Glenfield, Auckland 0627, New Zealand
1–A Hamilton House, Connaught Place, New Delhi — 110 001, India
77–85 Fulham Palace Road, London W6 8JB, United Kingdom
2 Bloor Street East, 20th floor, Toronto, Ontario M4W 1A8, Canada
10 East 53rd Street, New York NY 10022, USA

National Library of Australia Cataloguing-in-Publication data:

Fennell, Marc.
 That movie book: awesome, weird and wonderful movies for
 every weekend of the year / Marc Fennell.
 ISBN: 978 0 7333 2789 6 (pbk.)
 Includes index.
 Motion pictures.
 Australian Broadcasting Corporation.
791.43

Cover and internal design by Matt Stanton, HarperCollins Design Studio
Cover and author photographs by Stuart Scott
Cover models: Darth Vader, Blake McIntyre; Snow White, Jasmine Edwards
Typeset in 10.5/15pt Bembo by Kirby Jones
Printed and bound in Australia by Griffin Press
70gsm Classic used by HarperCollins*Publishers* is a natural, recyclable product made from wood grown in sustainable forests. The manufacturing processes conform to the environmental regulations in the country of origin, Finland.

5 4 3 2 1 11 12 13 14

For Maddy
You are my best friend, my coach, my teacher
and my audience. Except it's generally considered
unacceptable to sleep with all of those people,
so you beat them all :)

CONTENTS

So, um, what is this all about? (aka the introduction) 1

Memory loss? Memory gained!: a guide to
 cinematic amnesia 3

We're gonna need a bigger sequel: a beginner's
 guide to shark movies 10

Movies based on true stories (that aren't really true) 17

Don't come Monday: the evilest workplaces ever
 committed to film 25

A weekend with Walt Disney's most racist characters 33

Taking aim at Luc Besson 40

You are cordially invited to the wedding
 weekend of the year 47

Movie schools you should be grateful you don't go to 54

Friends, Romans, countrymen: a crash course in
 politics, movie-style 60

Teachers who can (and will) kick your arse 67

For the love of God, why are we doing this?!:
 why messing with DNA is a bad idea 72

The delicate delicacies in the delicatessen of
 Jean-Pierre Jeunet 79

Smash and grab: how to plan a movie heist 86

Wizard Death-match 93

Stuck in a room 100

Babysitters who simply should not to be trusted 107

Chris Nolan: mastermind 114

Some of my best friends are black: a beginner's guide
to interracial clashes 121

Male? Female? Other?: a weekend of gender-bending 128

Mother's Day: movie mums you should be glad
you don't have 135

Walking and talking with Aaron Sorkin 142

It's not a weekend, it's a wrinkle in time: how to
time travel (according to films) 146

Nicolas Cage: loser at large 153

How to be royal (according to the movies) 159

Play it again, Sam: remakes that are better than
the original 166

How to get rid of a dead body (according to movies) 173

An EOFY guide to cinema's best accountants 180

Thuglife: International Gangster Death-match 187

Serving up a platter of foodie movies 194

Nazis are evil (just in case you forgot) 200

Inside the magical world of Hayao Miyazaki 207

Why your comfortable life in the suburbs sucks and
you should be ashamed of it 214

All critics are wankers 221

Getting into a clustercuss with Wes Anderson 228

Interfacing with cyborgs 235

Father's Day flicks 243

The silent punchline 249

Movie kids who will put you off procreating 256

Curling up on the couch to feel guilty about the homeless 263

Is your reality real? 270

Documentaries about obsessives (that make you feel
better about being normal) 278

They will come from above!: when movie aliens attack 285

In case of emergency: the filmic fear of flying 292

How not to make a movie, according to movies 299

Just the headlines: journalists on film 306

All-night benders 313

Why all tourists must die 319

Love at first bite: what's the big deal about zombie flicks? 326

Puppets are evil, seditious, amoral and creepy. So there. 333

Recut: movies that have had their endings changed 340

The many disturbing faces of Santa Claus 347

Going out with a bang, a whimper and a fight:
your guide to the apocalypse 354

Fin. 361

Thanks 363

Index of reviews 365

SO, UM, WHAT IS THIS ALL ABOUT?
(AKA THE INTRODUCTION)

Who hasn't walked into a video store on a rainy weekend and thought to themselves: 'Why am I here? I haven't the faintest clue what to rent … and now the children are screaming for sugared goods! Oh dear God, where's my Valium? Get me out of here!'

It's a commonplace dilemma, and one that's usually followed by a lightheaded spell and a quick trip to the emergency room, thus placing an unacceptable burden on our public health system.

Never again will you be afflicted with this scourge of indecision. You will walk into the video store with an Anthony Robbins-esque purpose that will shock, awe and frighten those around you. *That Movie Book* is a weekend-by-weekend guide that will take you on a journey through time and space, and by 'time and space' I mean film genres, trends, filmmakers and themes. It is a toolkit for your very own couch-based film festival. You'll find yourself with enough DVDs to effectively slaughter each weekend of the year, relieving you of all that pointless sunlight and exercise.

Like any good cultish exercise, each weekend will be structured by a theme, actor, director or genre. The Friday night film is the easy introduction movie. If you enjoy that, then the Saturday flicks go deeper into that world. And then, of course, there are the Sunday movies — those are for freaks. Or people under house arrest.

So whether you're bored, housebound or infirm, your level of commitment is catered for, no obligation. Just like Scientology, only we're quite upfront about the aliens (see the 'They will come from above!: when movie aliens attack' chapter).

I can't promise that you will love every film in this book. I can, however, promise that I've tried to trawl through a wide mix of available DVDs, some highbrow, some lowbrow, some certifiably deranged. You're about to travel from India to Indianapolis, covering almost a hundred years of moviemaking. Keep an eye out for special themes at special times of the year (Christmas, Mother's Day, The Autumnal Sacrificing of a Virgin, et cetera).

My chief hope is that this book will give you something to talk about. To me, cinema comes alive when people can debate, share and ravish it together. My dream is that you emerge from each weekend awash with not only a lot of enjoyment, emotion and strong opinions but also a crippling vitamin D deficiency.

Have fun.

MEMORY LOSS? MEMORY GAINED!
A GUIDE TO CINEMATIC AMNESIA

What? Where am I? Who am I?

If you're reading this book correctly, then today is New Year's Day and you, by rights, should have a soul-crushing hangover and absolutely no memory of last night. This will be very unhelpful when it comes to explaining why you woke up wearing only a pair of denim cut-offs and your dog smells like gin.

For decades, cinema has made some good gravy out of the *ye olde memory-loss plot*™.

In *Memento* it was an unfortunate hindrance to finding a murdered lover. Memory loss led Drew Barrymore to fall in love with Adam Sandler again and again in *50 First Dates* (memory loss so bad that she even forgot she made *The Wedding Singer* with him). The *Men in Black* even had a hand-held gadget that could inflict memory loss on unsuspecting hillbillies, removing cumbersome recollections of alien encounters. Even worse is poor Gregory Peck. He plays a doctor in Hitchcock's *Spellbound* who has suppressed the memory of a crime. Each attempt to summon it up leaves him looking like a constipated child. Not pretty.

While amnesia movies are often stupid (to say nothing of wildly inaccurate), the good ones expose all manner of insights into our consciousness, giving us some genuine insights into the business of being a human.

FRIDAY NIGHT FILM

The Bourne Identity (USA) (2002)
Director: Doug Liman
Stars: Matt Damon, Franka Potente, Chris Cooper

The opening minutes of *The Bourne Identity* find Matt Damon
sinking in the middle of the Mediterranean before he is rescued
and nursed back to health by the crew of a passing fishing boat.
Somewhat annoyingly, he can't remember his name, his background
nor how he came to be floating shark bait with two bullet wounds
and a handgun stuffed down his pants. Nor can we ascertain why
he can speak multiple languages fluently and has a device implanted
in his hip that projects a laser image of an account number at a
high-security Swiss bank.

He adopts the name 'Jason Bourne' from one of his many
passports and goes on the lam across Europe accompanied by
a peppy German lass named Marie (Franka Potente, best known
for *Run, Lola, Run*). Together, Bourne and his new gal pal attempt
to work out the details of his forgotten life while a bunch of
Eurotrashy assassins keep shooting at them. But hey, it's still better
than a Contiki tour.

This movie has almost nothing in common with the Robert
Ludlum novel it's supposedly based on. If you can separate yourself
from that fact then *The Bourne Identity* is a rather good, tense, quasi-
realistic spy thriller.

Notoriously difficult-to-work-with director Doug Liman keeps
the suspense high, and his camerawork is kinetic.

Damon's understated way of handling the constant crises his
character faces is perfect for Liman's indie spin on the spy genre. As
for his co-star, there's an easy, unforced attraction between this duo

that leaps out from the screen. There's a particularly touching hair-colouring scene where no words are spoken, but the sexual tension is palpable.

SATURDAY FLICKS

A Scanner Darkly (USA) (2006)
Director: Richard Linklater
Stars: Keanu Reeves, Winona Ryder, Robert Downey Jr

In the not-so-distant future (read: unsubtle allegory for present-day problem), twenty per cent of the population is using a fancy-arse new drug called Substance D. Its original name 'Death' was considered to be something of a downer. D is, in fact, a highly addictive drug that destroys memories, reshapes your psyche and slowly obliterates the mind. A militaristic police state has emerged to keep a close eye on all citizens and wipe out the Substance D menace.

Keanu Reeves plays an undercover narcotics agent named Fred whose goal is to pursue a dealer named Bob Arctor. Here's the problem: Fred and Arctor are the same person. You see, Substance D has split his brain into two personalities. As Fred/Arctor continues to load up on D, what precious little is left of his mind begins to crumble.

A Scanner Darkly sits halfway between a live-action flick and an animation film. The movie utilises a rare technique called 'interpolated rotoscoping', where Linklater actually filmed actors on a set but then drew over the footage to create an animation that is filled with all these actor-ly inflections, a method he experimented with in his trippy 2001 stream-of-consciousness flick, *Waking Life*. But with *A Scanner Darkly* he seriously upped the level of detail: it

took 500 hours to create a single minute of footage, and the entire rotoscoping process took eighteen months to complete. The result is a destabilising form of reality that places you in the altered mental state of Linklater's junkies.

The story itself is based on a 1977 novel by science-fiction legend Philip K Dick. *Darkly* came after he produced an amphetamine-fuelled torrent of novels, short stories and essays in the fifties and sixties. By the seventies, Dick had cleaned himself up and slowed down his output to a more sustainable trickle, so *A Scanner Darkly* was far less sci-fi and much more personal than his other work. It's a view of drug abuse from someone who has been there and done that and is both critical of and sympathetic to all sides of the debate: the government, the dealers and the users.

Total Recall (USA) (1990)
Director: Paul Verhoeven
Stars: Arnold Schwarzenegger, Sharon Stone, Michael Ironside

Arnold Schwarzenegger is Douglas Quaid: just your ordinary, garden variety, 'roided up construction worker. He resides in the future where Earth appears to be made entirely out of concrete and Mars is caught up in a civil war. Quaid is dissatisfied with his life and perhaps also his wife, played by a spandex-draped Sharon Stone (doing her best impression of a plank of wood), so Beefy McDude wanders down the way to get himself a virtual holiday to Mars, where they implant the memory of a holiday instead of actually having one. But then things turn into a bright shade of 'fucked up'. The Governator wakes up believing that he is a secret agent/death-machine bred by deranged scientists to liberate Mars from its totalitarian dictator and eviscerate any plate glass that gets in his way. Is he really who he thinks he is? Was he really who he used to think he was but might not be? And … ow, my head hurts.

Science-fiction fans owe a lot to writer Philip K Dick (yes, twice in one weekend). He was the master of crafting tales that questioned the nature of both reality and identity, the building blocks that shape our existence. Director Paul Verhoeven and writers Ronald Shusett and Dan O'Bannon expanded Dick's story into an intricate, well-crafted thriller. It's not without holes, but the whole thing moves so fast you don't really notice. *Total Recall* has held up surprisingly well over the years, and the debate over what to make of its 'dream versus reality' premise is still entertaining. As is Arnold's acting, which is a gleefully stupid pleasure every time.

From a structural standpoint the plot is ingenious: Verhoeven, Shusett and O'Bannon set up story twists quite early on that pay off to great effect as the film plays out. Expect a lot of strategic red herrings and subtle foreshadowing. The storytelling causes you to question almost everything about Quaid's reality. Verhoeven seems to relish in messing with you — just as any good Philip K Dick yarn should.

THE SUNDAY MOVIES

Eternal Sunshine of the Spotless Mind (USA) (2004)
Director: Michel Gondry
Stars: Jim Carrey, Kate Winslet, Tom Wilkinson

What if you could have a person erased from your memory? Imagine having that horrible breakup, abusive teacher or awkward, fumbling one-night stand permanently eradicated from your brain. Wouldn't that be grand? Just picture it: you go to sleep one night and, bit by bit, your memories are gradually deleted by a group of unkempt technicians huddled over your bed. This is the story of Joel (played by Jim Carrey, in one of his best roles) and Clementine (played by

Kate Winslet, in one of her most ridiculous haircuts). Or perhaps it would be more apt to say that this is the story of Joel without Clementine. Carrey plays a down-and-out guy who decides to have his last girlfriend removed from his memory by a ragtag team of brain specialists. The only problem is that Joel remains conscious inside his mind, reliving his memories as they're deleted.

Eternal Sunshine of the Spotless Mind has to be one of the most warm, whimsical, magical, insane, funny and insightful entries in the often lazy genre of romantic comedies. Charlie Kaufman's script is bursting with wry dialogue, surprising characters and sharp insights into modern relationships. Jim Carrey and Kate Winslet both give delicately nuanced performances with sparks of spontaneity that bring the film alive.

Director Michel Gondry uses physical effects, on-set trickery and a lo-fi aesthetic to create a playful dream world of *Eternal Sunshine*. Particularly good is the sequence where Carrey is transformed into a toddler version of himself in a scaled-up version of a 1960s kitchen. There are so few filmmakers who could make this idea work. Kaufman and Gondry were just the nutters to pull it off.

The Machinist (Spain) (2004)
Director: Brad Anderson
Stars: Christian Bale, Jennifer Jason Leigh,
Aitana Sánchez-Gijón

Trevor Reznick is a machine-shop worker by day but he claims not to have slept in a year. Instead, each night he sits up and reads fat Russian novels (no wonder he's depressed). In the early hours of the morning he bleaches clean the grout between the bathroom floor tiles … with a toothbrush. At his day job he has sinister conversations with a creepy welder whom none of his colleagues

can see, and he keeps stumbling across cryptic notes in the form of hangman games. As Reznick mentally unspools, we slowly discover the reason for his nut-bar behaviour, and let's just say that the more he learns, the less he wants to know.

Christian Bale is a big man; the dude is almost two metres tall. He dropped 28 kilograms for his role as Trevor Reznick, which brought him down to an anorexic 50 kilos. He looks like something halfway between an ice addict and Skeletor.

Director Brad Anderson, in only his second film, proves to be an expert at creating an atmosphere of dread. He wrings an enormous amount of suspense from every scene, whether it's Reznick's shop floor (where all those mechanical behemoths look particularly evil) or the angry, brooding skies that bear down from the outside.

Anderson has crafted a haunting examination of how guilt can eat you alive, so your enjoyment of the movie will probably be proportional to your outlook on the world. In other words, the more nihilistic you are, the more reassuring you should find the outlook of this film. Make of that what you will.

WE'RE GONNA NEED A BIGGER SEQUEL

A BEGINNER'S GUIDE TO SHARK MOVIES

Hollywood owes a lot to the common shark. After all, it was a shark that gave birth to the modern blockbuster in the form of Steven Spielberg's *Jaws*. And in return, the movie industry has given back to sharks ... well, very little to be proud of. If I were a shark's lawyer I would be suing Hollywood for defamation. I would also be concerned about how a shark was going to pay my fee. For decades, filmmakers of varying levels of talent have been offering up wildly inaccurate and borderline slanderous shark portrayals. For starters, take basic shark anatomy: a *movie* shark is always massive. You never hear the local coastguard scream, 'Help! A regular-sized shark is dismembering a small child!' It's time that Hollywood let sharks know that it's not size that matters but how many obese tourists they can eat in one go.

And then there's the insulting portrayal of the shark's personality. The standard movie shark has a severe anger management problem. In the first and second *Jaws* movies a shark held a grudge against an entire township; by the fourth instalment, *Jaws: The Revenge*, a shark targets a single *family* and follows them clear across the country to exact his vengeance.

The strangest personality quirk of the movie shark is that they really hate helicopters. It might not seem an obvious foe, but movie sharks have taken out more helicopters than Rambo … as you'll discover this weekend. All this said, sharks are also often depicted as the Rhodes scholars of the sea; the average movie shark is freakishly smart and possesses an innate understanding of structural engineering in order to impale a submarine or eat a 747 jet.

And yet in spite of — but mostly because of — these libellous inaccuracies, sharks are great cinema meat. Be prepared to witness shark movies from the suspenseful to the sinister to the sublimely stupid.

FRIDAY NIGHT FILM

Jaws (USA) (1975)
Director: Steven Spielberg
Stars: Roy Scheider, Robert Shaw, Richard Dreyfuss

Laidback holiday destination Amity Island is getting set for the tourist influx that comes every year with the Fourth of July weekend. Amity's new police chief, New Yorker Martin Brodie (Roy Scheider), has the yawn-worthy job of overseeing the safety of the crowd. This gig becomes considerably harder when masticated chunks of a college student start washing ashore. The coroner is clear: she was killed by a shark. This is where the local mayor waddles in and argues that closing the beaches will impact on the tourist dollar. And suddenly the coroner is clear again: she was killed in a 'boating accident'. Most residents in the town buy this (for Amitians are a stupid people). Well, that is until the attacks start. The town soon turns to the one man who can save them, a

salty shark hunter named Quint (Robert Shaw). They all set out on the good ship *Orca* to go bring back some shark meat.

Hollywood changed forever on 20 June 1975, the day this teensy flick about a peckish shark premiered on 409 screens around America. Seventy-eight days later, *Jaws* was the top-grossing film of all time, surpassing the $85 million earned by *The Godfather*. It later became the first film to break the $100 million mark — and that was all just in the USA. *Jaws* saw the birth of a new breed of movie: the summer blockbuster.

By all accounts *Jaws* was a bloody nightmare to make. Multiple mechanical sharks were intended to bring the actual 'Jaws' to life but in the end one main shark (or 'The Great White Turd', as Spielberg used to call it) was mounted, along with all the hydraulic bits and pieces on a large barge-like device. When it arrived on the location it abruptly sank to the bottom of the ocean. In the end Spielberg had to significantly change the story on the fly. For example, he switched many of the planned mechanical shark shots to 'shark's eye view' and in doing so created some of the most iconic images of the film. By keeping the shark out of sight for most of the film, Spielberg lets us use our own imaginations to create an image of it — and our deepest, darkest fears take over.

Jaws is greater than the sum of its parts. The story, acting and editing are all decent but not mind-blowing, but combining them together you have a truly stunning piece of drama that still makes you writhe around the couch in fear. It also allowed Spielberg to really define his now-famous shtick: implausible plots that defy at least three laws of science but are delivered with so much gusto it's impossible not to get caught up in them.

SATURDAY FLICKS

Deep Blue Sea (Australia/USA) (1999)
Director: Renny Harlin
Stars: Thomas Jane, Saffron Burrows, Samuel L Jackson

Giant genetically engineered man-eating sharks, huge explosions and Samuel L Jackson — what more could you people possibly want? It's the unapologetic ludicrousness of *Deep Blue Sea* that makes it a classic. We begin with Carter Blake (Thomas Jane). He works at Aquatica, a submarine refuelling station that has been retrofitted into a floating research facility. Aquatica is experimenting on sharks to see if they can produce a protein that could cure Alzheimer's disease. As a result, the sharks have become smarter while the humans have somehow become proportionally stupider. Cut a long story short: the sharks escape and learn how to use door handles, meaning we're all fucked.

There are several things that separate *Deep Blue Sea* from its grandpappy, *Jaws*. Firstly, you *see* a lot more of the sharks. Unlike Spielberg's frustrating rubber monsters, these sharks are rendered on screen using a combination of animatronics, computer-generated imagery and real-life footage. (While it's hard to distinguish the difference between the robot sharks and the real ones, the CG sharks are pretty obvious.) Secondly, the gore is front and centre … and awesome. In a way, the lack of subtlety and suspense makes this a far more fun film. Any pretensions of realism happily fall by the wayside as you start taking bets on which of the annoying characters will get eaten first. The dialogue is inane, the narrative borders on the absurd, the film's disregard of basic physics is flagrant and Samuel L Jackson looks like he agreed to do this movie because he heard the catering was decent. But the whole retarded exercise is

13

executed with such panache that it ultimately proves to be a lot of fun. I won't lie, though — it helps if you're drunk.

Open Water (USA) (2003)
Director: Chris Kentis
Stars: Blanchard Ryan, Daniel Travis, Saul Stein

While we're still in the middle of the Australian summer, there's a reasonable chance that you are reading this on some kind of holiday. If this is the case and you are planning on going anywhere near the sea, please do not watch *Open Water*, the story of a husband and wife who find themselves stranded by their scuba diving boat in the middle of shark feeding season.

The most succinct description of this film I could offer is that it is *Jaws* meets *The Blair Witch Project*. It's not an altogether inventive story (like *Blair Witch*) but because the film is shot entirely on video, with real sharks, and is based on a real-life story, there is a frightening realism to the film. *Open Water* uses its low budget to enhance a sense of immediacy and the final result is a very well executed thriller.

It's a slow burner. The first half hour is too understated but once it gets going, it *really* gets going. This film relishes in ratcheting up the stakes and needling your fears of abandonment, drowning and being eaten alive. My feet still have cramps from all that toe-curling terror *Open Water* created. *Open Water* also has the somewhat dubious honour of being one of the few films to make me literally squeal with fear (in a manner not dissimilar to a small pig). But then the tension will break, often with small bursts of humour. I particularly love the Doctor Phil-style argument that rages between the bickering married couple while they're being chomped on by the fishies.

THE SUNDAY MOVIES

Mega Shark Versus Giant Octopus (USA) (2009)
Director: Jack Perez
Stars: Lorenzo Lamas, Deborah Gibson, Vic Chao

Two giant monsters are mystically defrosted from within a prehistoric iceberg. They have been trapped (alive? really?) since ancient times and are now preparing to open a twenty-first century can of whoopass. If you don't think that is a scientifically watertight set-up for a film then you have no business reading this chapter. You might also struggle with the notion of eighties pop star(let) Debbie Gibson as a marine biologist (or in any role requiring tertiary education). And yet it will come down to her and Lorenzo Lamas to save the world from 18-million-year-old animals intent on fucking shit up.

Perhaps the best way of reviewing this movie is to simply name-check the sort of plot turns you can expect to witness in this film: prepare to see an octopus dismember a Japanese oil rig, a shark leaping from the water to bite a 747 out of the sky, and (my favourite) the octopus chomping on the Golden Gate Bridge. This is a thing of beauty.

Mega Shark Versus Giant Octopus is bizarre, stilted and in fact utterly shit. It's gloriously stupid, amateurish and vapid. The writing is staggeringly bad, and the direction is roughly on par with a high-school production. However, if you watch it in the right headspace (ahem: drunk, again), it's also fall-off-your-chair-laughing fun. I also heartily encourage you to play the mega shark drinking game, which involves knocking one back when you see any of the following:

- scenes with bystanders screaming
- people making declarations like 'They don't rest, they just kill' (not kidding, that one's for real)

- superimposed text explaining the plot, because the characters have given up
- dodgy science

Suffice it to say that I'd advise against playing this game with hard spirits.

Mega Shark Versus Crocosaurus (USA) (2010)
Director: Christopher Ray
Stars: Gary Stretch, Jaleel White, Sarah Lieving

And just when you thought it was safe to get off the couch and back into the water, they're back … with another amazing, straight-to-DVD film. This time around both Debbie Gibson and the octopus have been replaced by a giant crocodile.

The DVD cover implies that there is a plot. Something about an illegal diamond-mining operation in the Democratic Republic of Congo … y'know what? Fuck it … it doesn't matter.

You now need to add a few more rules:
- drink every time you see Urkel (yes, Jaleel White, the actor who played uber-nerd Steve Urkel from *Family Matters*, is in this film)
- drink every time you hear a dodgy foreign accent
- drink every time you hear dodgy science that sounds like a sex act. For example, 'I need to put my hydroponic spear in the water'
- drink every time you see Megashark rape the laws of physics

Just drink.

MOVIES BASED ON TRUE STORIES
(THAT AREN'T REALLY TRUE)

Filmmakers have been basing feature films on real life since the dawn of cinema with films like *The General* (1926) and *Napoleon* (1927). If you trace the lines of cinema history you'll notice that filmmakers have always used claims of truthiness to make and sell their flicks. In the last decade alone, the cinema industry made over 211 films with the promise of being 'based on a true story'. It makes sense, particularly if your 'true story' was a big news event that acts as pre-buzz marketing for your film.

No one honestly expects 100 per cent accuracy from movies that claim to be based on a true story. Truth is slippery, subjective, often implausible, inconvenient but, most of all, usually quite dull. Watching the Von Trapps don their lederhosen and climb a mountain to freedom in the climax to *The Sound of Music* is markedly more inspiring than stuffing them onto a crowded train to Italy (i.e., what really happened). Given the chance I suspect we would all replace our boringly believable lives with more charismatic characters, clearly defined goodies and baddies, better-looking friends, the odd superpower and infinitely more competent sex. However, dear filmmakers, if you *are* going to tag a film with 'true story', could you aim for at least, geez, I dunno, ten per cent truth?

FRIDAY NIGHT FILM

A Beautiful Mind (USA) (2001)

Director: Ron Howard
Stars: Russell Crowe, Ed Harris, Jennifer Connelly

A Beautiful Mind is pure, unmitigated Oscar-bait. It was precisely crafted to be showered in slightly-heavier-than-you-expect-them-to-be statuettes, prestige and a portentous sense of event. And yet, almost by accident, it also ends up being rather good.

It presents the 'true' tale of John Nash, a Nobel prize-winning mathematician, following him through his education at Princeton University and his career working for a shady government agency. However, we soon discover that things may or may not be what they seem, and that Nash is ever-so-slightly crazy.

Ron Howard imbues the story, particularly the first half, with a subtle sense of mystery. The soundtrack is especially good, albeit in a vaguely Disney kind of way, capturing both the wonder with which Nash sees the world but also his fragile mental state. The performances from Russell Crowe as Nash and his long-suffering wife Alicia (Jennifer Connelly) live up to the meaty, melodramatic script they were handed. But it's the structure of the script that really makes it work — particularly if you don't know much about Nash. While there are certain elements of Nash's experience that may not be entirely real, by witnessing this world entirely from his point of view you are in effect *inside* the disease with him and are given no reason to believe things are otherwise. All in all, *A Beautiful Mind* is a big, slick, 'important' movie that pulls plenty of heartstrings.

Also … it's bullshit.

In reality, John and his wife divorced in 1963, around six years after getting hitched. They remarried in 2001. As for all of

the imaginary friends that John Nash saw, well, he didn't. His hallucinations were completely auditory so he only heard voices. But, hey, this is a visual medium, people.

And it wasn't just imaginary friends. According to biographer Sylvia Nasar, Nash also believed that he was the emperor of Antarctica, the Messiah, a Japanese shogun and that he was being hunted by the Jews (perhaps he should have been played by Mel Gibson).

The film also implies that he gradually learned to take his meds and manage his hallucinations until he gives an impassioned, heartfelt tribute to his wife as he accepts his Nobel prize in the film's beautiful climax. Sadly, no. Nash reportedly stopped taking the pills in 1970 and he wasn't allowed to make a Nobel acceptance speech in 1994 on the off-chance that he started spouting about how the Jews stole Christmas.

SATURDAY FLICKS

The Last King of Scotland (UK) (2006)
Director: Kevin Macdonald
Stars: James McAvoy, Forest Whitaker, Gillian Anderson

They're the original odd couple: a ruthless, psychotic Ugandan dictator and his plucky, daring Scottish doctor (with a thing for married women). Such is the 'true' story of *The Last King of Scotland*. James McAvoy plays Nicholas Garrigan, an intrepid Scottish missionary man of medicine in search of adventure. Instead he falls in with the charismatic African despot Idi Amin played by Forest Whitaker (with his lazy eye that I firmly believe can shoot lasers). Garrigan soon goes from being a trusted advisor to plotting to assassinate Amin.

Amazing story. Incredibly well plotted, and directed with tonnes of energy … So what's wrong with it?

Well, for starters: there is no Nick Garrigan.

In fact the character is based on a guy called 'Major' Bob Astles, reputed to be the second-most hated man in Ugandan history. Known as the 'White Rat', Astles was an advisor under the pre-Amin Ugandan government. When Amin took over, Astles was jailed and tortured for seventeen weeks. Then Amin gave him a job — making frathouse hazing rituals seem like an entirely legitimate method of welcoming someone into the fold. Okay, but surely the rest is true … surely? Please tell me that he banged Amin's wife and plotted his overthrow, I hear you say.

'Fraid not. The romantic subplot of *The Last King of Scotland* is based on someone else entirely. Mbalu Mukasa was an African doctor and his extramarital relationship with Amin's wife was abruptly halted when she died during a botched abortion. Mukasa committed suicide shortly after. What was Astles doing throughout all of this? Well, he definitely wasn't plotting some kind of elaborate coup. Astles remained with the Amin regime until it was overthrown in 1979 when he was promptly thrown into jail.

Did I mention that Astles wasn't Scottish, or a doctor?

I give up.

Fargo (USA/UK) (1996)
Director: Joel Coen, Ethan Coen
Stars: William H Macy, Frances McDormand, Steve Buscemi

'THIS IS A TRUE STORY. The events depicted in this film took place in Minnesota in 1987. At the request of the survivors, the names have been changed. Out of respect for the dead, the rest has been told exactly as it occurred.'

These are the words that open Joel and Ethan Coen's most famous film. These are great opening lines … and there's not an ounce of truth in any of them.

Set in an icy Minneapolis winter or, as the Coen's describe it, 'Siberia with family restaurants', *Fargo* is the account of loser/car salesman Jerry Lundegaard (William H Macy). Deep in debt, he devises a borderline insane plan to have his own wife 'kidnapped' by hired heavies so he can swindle his moneyed father-in-law out of the ransom. Predictably, the whole thing goes horrifically wrong and before you know it there's a body being loaded into a woodchipper. Meanwhile, heavily pregnant local sheriff Marge Gunderson (Frances McDormand, who won a best actress Oscar for the role) is on the case, trying to track down the two staggeringly incompetent kidnappers.

Is it any good? Yes. Hilariously, blackly so. *Fargo* is one of the Coens most quotable and entertaining movies. And yet, it's almost entirely untrue. On the *Fargo* special edition DVD trivia track you'll discover that the main source of inspiration for the movie was the 1986 Connecticut murder of Helle Crafts. She was killed at the hands of her husband, Richard, who then disposed of her frozen and dismembered body through a woodchipper. But almost all of the rest of the plot is fiction. The Coens regard their opening lines as a part of the fiction, designed to heighten the 'I can't believe that this really happened' factor. The thinking being that if an audience believes that something is based on a real event it gives the filmmakers permission to show plot twists that the audience might otherwise not accept.

While most audience members eventually gleaned that the story was untrue (perhaps because it closes on the words 'all characters are fictional'), a 28-year-old Japanese girl named Takako Konishi apparently held the faith. In 2001, she travelled to North Dakota. The local police believe that she did so in search of the missing treasure that was never recovered in the film. When officers interviewed the confused Tokyo office worker, she showed them a crude map showing her desired location. The cops surmised that she

was after the fictitious money. Perhaps it was the language barrier (she spoke no English and people in Dakota have funny accents that render them impossible to take seriously) but she refused to accept that it was a fictional movie and that any such treasure was equally fictional. In an ending that is as sad as it is oddly fitting, a hunter later found her body in woodland somewhere near Fargo.

THE SUNDAY MOVIES

The Texas Chainsaw Massacre (USA) (1974)
Director: Tobe Hooper
Stars: Marilyn Burns, Edwin Neal, Allen Danziger

This seminal horror classic has, at various points, been claimed to be based on a 'true story', a 'true incident' and at least one over-eager video-cassette designer was content to simply say 'it happened!!'.

Except it didn't happen in Texas, it didn't involve chainsaws, and there was no massacre.

So, yeah, there's that.

The Texas Chainsaw Massacre was a groundbreaking work of tension with its gruelling account of young hippies who fall prey to three homicidal brothers and their cannibal grandparents. Made during the height of the 1973 energy crisis (when running out of gas in the middle of rural America was a real possibility) the film still has a sense of heavy foreboding. Filmmaker Tobe Hooper wanted the film to exude the dread of a generation that had just returned from Vietnam, fresh with the images of what horrors humans could exact on each other. The film needled the massive distrust that existed between America's permissive young hippies and conservative rural values. It was crafted to be a nightmare for a new generation and it succeeded. *The Texas Chainsaw Massacre* is

now regarded as one of the most successful and iconic horror films of its time.

So where did this enormously influential and successful horror tale come from? Was there really an event where a cannibalistic farmer lured virile young teenagers into his house made of human remains and hacked at them with power tools?

Umm, no. Although the idea for the chainsaw bit came from a real shopping mall. Back in the early seventies recent film school graduate Tobe Hooper was trapped in an overcrowded hardware department. Speculating as to what might be the fastest way of getting out of the building, his eyes settled on the chainsaws. Mercifully, Hooper banked the idea in his head rather than acting on it; many Texan hardware lovers were spared that day.

If the bad guy, 'Leatherface', was based on anyone, it was most likely a Wisconsin farmer named Ed Gein who mostly robbed graves as a part-time hobby. He even robbed the grave of his own mother back in the 1950s. Infamous for disembowelling, decapitating and occasionally doing the wild thing with his corpses, when police finally captured Gein they discovered the remains of fifteen different mutilated female bodies. Some had been fashioned into drums, bowls, masks, bracelets, purses, chairs, lampshades, shirts and, most disturbingly, leggings. Curiously, Gein also inspired the villains from *Psycho* and *Silence of the Lambs*. Busy boy.

Good Morning, Vietnam (USA) (1987)
Director: Barry Levinson
Stars: Robin Williams, Forest Whitaker, Tung Thanh Tran

The Vietnam War was not fun. Or so I am told. Just the mere thought of all that shooting, sweltering heat, loud southern drill sergeants and offers to 'love you long time' — it's enough to make you angrily pluck 'All Along the Watchtower'.

In fact, according to *Good Morning, Vietnam*, the only way to get through this nightmare was to tune in to the manic broadcast stylings of Robin Williams. He plays 'real-life' radio presenter Adrian Cronauer, a staunch anti-war liberal working for Armed Forces Radio during the height of the war. Cronauer openly criticises the army establishment (well, their uniforms, mostly), befriends the locals, chases girls and irritates his superiors to the point that they come up with all kinds of extralegal punishments, like sending him into Vietcong territory in the hopes that he might be killed, or at the very least poached by another network.

Good Morning, Vietnam came out of that pre-family-friendly period of Robin Williams' career (otherwise known as the cocaine years) and he is a sight to behold. Williams' performance is a powder keg of manic energy. It's remarkably funny … and yet … also bullshit. Almost every element of the real-life plot was retooled into something that would fit Williams' not inconsiderable skills. The real Cronauer, for example, is a lifelong card-carrying right-wing Republican. He was the vice-chairman for the 2004 Bush/Cheney re-election campaign, for Christ's sake! Though the real Cronauer wasn't terribly bothered by the gross historical inaccuracies; he originally pitched the *Good Morning, Vietnam* idea as a TV sitcom. The studio executives, having apparently not heard of *M*A*S*H*, decided that comedy and war were never going to work together. It wasn't really until Williams' manager came across the idea that Cronauer's film started to develop.

And the real Cronauer? He ended up working in veterans' affairs in the Bush administration, helping families of missing soldiers locate their remains. A noble task, but not quite what you'd imagine Williams' character doing well into his eighties.

DON'T COME MONDAY
THE EVILEST WORKPLACES
EVER COMMITTED TO FILM

Corporations, at least in fiction, are the perfect monster of the modern age. A machine that lives for profit, you would be hard-pressed to find a positive representation of any major corporation in movies or television. Whether it's Mr Burns blocking out the sun in *The Simpsons*, 'The Energy Corporation' from *Rollerball* demonstrating the futility of individuality through their violent death sports — hell, even hula hoops become a tool of wickedness when constructed by heartless Hudsucker Industries cronies in the Coen brothers' *The Hudsucker Proxy*. It was the RDA Corporation that raped and pillaged the enchanted planet of Pandora in *Avatar*, while Buy-n-Large in *WALL-E* rendered Earth completely uninhabitable. My personal favourite is the Engulf & Devour conglomerate from Mel Brooks' comedy *Silent Movie* with its tagline 'Our fingers are in everything'. Curiously, the Engulf & Devour Corporation was a thinly veiled reference to the Gulf and Western Corporation's takeover of Paramount Pictures some years prior.

While you sit back on the couch and witness these companies inflict their unspeakable acts on poor workers, be grateful. As you dread all the things you need to do at the office on Monday, sigh with relief: at least you don't work for these guys.

FRIDAY NIGHT FILM

Office Space (USA) (1999)
Director: Mike Judge
Stars: Ron Livingston, Jennifer Aniston, David Herman

Every day that Peter Gibbons (Ron Livingston) has been working at Texan software company Initech has been worse than the last. Beige walls, cubicles like jail cells and more middle management than actual workers. This is the Initech way. Forget to put a cover sheet on your TPS reports and you can expect a visit from a handful of overpaid, underskilled Porsche-driving arsehat bosses. So, in a last-ditch attempt at regaining some sanity, Peter pays a visit to a morbidly obese hypnotherapist. Suddenly Peter Gibbons is now the most chilled human this side of *The Big Lebowski*. It's only a matter of time before he hooks up with Jennifer Aniston, starts embezzling cash and nabs a promotion.

Oh *Office Space*, how awesome you are, let me count the ways. *Office Space* was the live-action feature-film debut of Mike Judge, who achieved fame and not inconsiderable fortune by creating the MTV cult hit *Beavis and Butt-Head* and later *King of the Hill*. *Office Space*'s plot was extrapolated from Judge's animated 'Milton' short films, which he put together for *Saturday Night Live* in 1993.

By all accounts, the making of this movie was not pleasant. Inspired by his time as an engineer in the Silicon Valley back in the eighties, Judge resisted early suggestions to make *Office Space* a glamorous vision of the corporate world (á la the first hour of *Wall Street*) or even a glamorously bizarre vision of corporate culture (á la *Brazil*). Studio executives were less than thrilled with the wry, subtle humour that Judge turned in with *Office Space*. And yet, after a modest result at the box office (read: fail), everyone involved

assumed that the film would be swept into the past. It wasn't until the movie was played something upwards of thirty-three times on US cable channel Comedy Central did *Office Space* truly find its audience.

This is a movie made up of 'moments' — quotable, charming, infectiously rebellious and sometimes even infuriating moments. In the bland world of Initech, tiny personality traits — like the way someone answers the phone — become magnified until they are exasperatingly annoying and very funny. When you repeat the banal enough times it becomes absurdly hilarious. And that's where the film finds its best jokes.

SATURDAY FLICKS

Alien (USA) (1979)
Director: Ridley Scott
Stars: Sigourney Weaver, Tom Skerritt, John Hurt

Okay, so you didn't get that pay rise that you deserve, and the workplace sexual harassment is so virulent that just sitting at your seat is to risk a communicable disease. But hey, look on the bright side: at least your employer didn't send you to be human-sized bait for a genetically perfect killing machine from another planet. This is the Weyland-Yutani corporation, a merciless profiteering company of A-grade douchebags. And that is precisely what they do to the crew of the *Nostromo*, a dilapidated long-haul space carrier. On the way home from a mission, the cryogenically frozen crew are awakened by an automated distress beacon. They trace the signal to an abandoned planet. Soon, a new life form is brought on board and begins picking off the crew one by one.

Alien is the movie that refuses to date; it's just as terrifying and cunning today as it ever was. It maintains a very deliberate pace — not slow, but precisely controlled. Ridley Scott, in only his second feature film, is in total command of every frame, every emotional beat, bracing you for what may be around the corner. He deftly cultivates the sense that no one is safe as he picks off all of the characters you expect to save the day.

The art direction of *Alien* is still one of the most distinct and effective elements of the movie. The alien herself is fascinatingly sexual in her design — equal parts phallic and vaginal, mechanical and organic. She was created by infamous Swiss illustrator/ hermit/nut bar HR Giger, author of the world's most fucked up picture book, *Necronomicon*. Giger revelled in creating nightmarish illustrations of mechanised, satanic and erotic figures, which he would turn into ink drawings, paintings and even sculptures. 'The Alien' remains his most popular, lasting work.

Ultimately the biggest achievement of *Alien* is in how it brings together such a wide collection of genres (science fiction, horror, thriller) and yet is beholden to none of them. It's a unique pioneering and petrifying film that may or may not result in you soiling yourself.

WALL-E (USA) (2008)
Director: Andrew Stanton
Stars: Ben Burtt, Elissa Knight, Jeff Garlin

The Buy-n-Large corporation put forward a perky, clean and glossy image that is instantly recognisable to any person who's ever walked into a shopping mall. It's also the all-consuming, wasteful organisation that has turned Earth into a rubbish dump while humanity has given up on the planet and gone to live in space. And who have they left to clean up the mess? A little trash-compacting

robot named WALL-E, and he is adorable. He has spent 700 years doing what he was *built* to do in life — taking out the garbage. When another robot arrives on planet Earth, however, he'll discover what he is truly *meant* to do in life.

Consider yourself forewarned: you will finish this film with the overwhelming desire to hug a rubbish bin. Mentally prepare now for the awkward stares your family will give you when it happens. Animation giants Pixar have imbued this little bucket of bolts with so much personality and humanity that he bounds out of the screen, and if the wizened, hate-filled knob of coal that used to be my heart can be warmed by this guy, so can yours.

The craft and artistry of this movie blow my mind every single time. The first two-thirds of *WALL-E* are essentially a silent film — he doesn't talk. But Pixar, those crazy geniuses, use his body language to somehow impart his hopes, fears, dreams and desires. The plot rollicks along fast and you're so intrigued by every move he makes that you simply don't have time to stop and think, 'Hey, that dude can't speak!'

Ultimately, *WALL-E* is something of a paradox. It's a smart bit of science fiction doing what sci-fi loves to do: comment on a contemporary social issue. But it's also an unashamedly sentimental Pixar flick from Andrew Stanton (the same guy who made you cry over your daddy issues in *Finding Nemo*). The film makes no bones about how humanity is becoming wasteful and slovenly at the hands of corporate behemoths, and that's the sort of none-too-subtle message that has every potential to seem condescending. Yet somehow, in the hands of the Pixar team, the argument is rendered meaningful precisely because it's *not* a film 'about the message'. The ideological argument about wastefulness finds its meaning in the plight of WALL-E against a race of stupid fat humans. Watch it. You'll love it, and you'll probably recycle more too.

THE SUNDAY MOVIES

RoboCop (USA) (1987)
Director: Paul Verhoeven
Stars: Peter Weller, Nancy Allen, Dan O'Herlihy

In the not-too-distant (read: allegorical) future, 'Old Detroit' is a wasteland. Drug barons and warlords rule the streets with military-grade weaponry, white powder and maniacal laughs. The government has outsourced police control to the amusingly vague Omni Consumer Products corporation. Omni have a plan to restore order in the city: a giant metal chicken. Okay, not quite; it's more of a giant metal robot droid called the ED-209. It walks like a chicken, barks like a dog (not kidding) and is armed like a tank. The ED-209 looks set to be the saviour of both the company and the city; its rollout will restore faith to this once proud hub of American industry. Except for one small hitch. In a boardroom demonstration for the executives of OCP, the ED-209 accidentally riddles some middle management flunkie with bullets. Sure, it's a win for proponents of flattened management structures. OCP, however, clearly needs another solution before it loses its government contract.

The answer is Officer Alex J Murphy, a good, honest, salt-of-the-earth cop who has recently been viciously murdered by a drug lord <*insert maniacal laugh here*>. OCP takes Murphy's body and revives him with cybernetic devices, turning him into the first half-human, half-machine, crime-fighting cyborg: RoboCop.

Dutch director Paul Verhoeven has a strange gift for making incredibly subversive movies about fascism that look like tacky action flicks. It's quite apt, really, given most action flicks have a slightly fascist bent to them anyway. RoboCop is exceedingly

gruesome and violent. It looks and feels like a big glossy blockbuster so you expect to see the camera cut away when someone has their arm blown off by street thugs with shotguns. But that's not how it works in a Verhoeven movie: he makes you watch it. He also pushes the film into the realm of black comedy, breaking up the spatters of gore with regular newscasts showing disconcertingly perky newscasters with plastic smiles delivering images of war-torn cities and human atrocities.

Many filmmakers have set out to make you feel guilty for the violence we enjoy on screen, but Verhoeven actually succeeds. It's as though he is saying, 'You wanna watch a fun shoot-'em-up movie? Here it is. In its entirety.'

Syriana (USA) (2005)
Director: Stephen Gaghan
Stars: George Clooney, Matt Damon, Amanda Peet

Terrorism. Laws. Economics. Royal succession. Intelligence organisations. And the single most influential, addictive substance known to man: oil. In *Syriana*, they're all connected by one company: the Connex-Killeen Oil Group.

Syriana is a dense, intricate movie, possibly a little too complex for its own good. But then again, it's dealing with geo-political petroleum intrigue — to be anything less than convoluted would be underselling the subject matter. Very, very loosely based on the memoir of former CIA case worker Robert Baer, *See No Evil*, the film explores the oil industry and how its tendrils reach into every corner of our lives. We see this tapestry through the eyes of all the players, including a weathered CIA operative (George Clooney), an energy analyst and grieving father (Matt Damon), a reserved Washington attorney (Jeffrey Wright) and an unemployed Pakistani worker (Mazhar Munir) living in an Arab nation.

Syriana is the directorial debut of screenwriter Stephen Gaghan, who also wrote the multi-threaded drug epic *Traffic*. In many ways *Syriana* is a sequel to that film, utilising the same interlocking narrative to explore the West's oil dependency. Gaghan manages to instil a palpable undercurrent of urgency to each plotline but, whilst the individual stories are often compelling, *Syriana* struggles to keep you emotionally connected to the screen. Where *Traffic* brought the full devastating effects of drug addiction home to roost, *Syriana* struggles to make it personal. Instead he finds himself occasionally bogged in the vagaries of geopolitics. Still, by and large *Syriana* paints its picture very well. It is easily the best fictional film exploring the very real, very scary effects of our oil dependency. And above all you have to respect a movie that assumes your intelligence and ability to follow a difficult issue.

A WEEKEND WITH WALT DISNEY'S MOST RACIST CHARACTERS

As long as there's been a House of Mouse, Walt Disney has been accused of racism. And Nazism. And being a government spy. And being cryogenically frozen underneath the Epcot centre, only to rise again at the coming of the equinox. Are any of these allegations true? For legal reasons I'm obliged to say 'Who knows?' Though, for the record, I've got money riding on the equinox resurrection.

Walt Disney did indeed have a chequered and complex history. The man was well known for his hatred of unions and he testified against people he thought were communists in those somewhat ropey McCarthy senate hearings. His moustache also made him look like one of his own villains. That said, he also revolutionised not just the way the world animates but the very way we imagine our childhoods. He rewrote centuries-old fairytales and he gave us quintessential Americana in its purest form. Mice with big ears and ducks with speech impediments are now the symbol of all things good and clean in the world.

Perhaps what's most interesting about Walt Disney Studios is how much these classic movies are an indicator of changing

American values. Disney is nothing if not a populist company and, in their rush to stay on the pulse, these films depict how Americans see the world at certain moments of history. What we've ended up with is an ever-changing image of America itself, through the dreams and fairytales they've fed their children, and the world's children. So, let us now take a trip around the Wonderful World of Disney ... or rather, the Wonderful World as Disney Sees It.

FRIDAY NIGHT FILM

Aladdin (USA) (1992)
Directors: Ron Clements, John Musker
Stars: Scott Weinger, Robin Williams, Linda Larkin

Aladdin was the completely inauspiciously numbered thirty-first animated feature film from Walt Disney, but it *was* notable in being one of the first animated films to make use of a big-name celebrity voice in the form of Robin Williams, and it paid off in dividends. His largely improvised role went a long way to making *Aladdin* the most successful film of 1992, earning over $217 million in revenue in the United States, and over $504 million worldwide. Not only did Williams play the genie, he also plays the narrator who originally opened the film with these lines:

> *Oh I come from a land, from a faraway place*
> *Where the caravan camels roam,*
> *Where they cut off your ear*
> *If they don't like your face,*
> *It's barbaric, but hey, it's home.*

It's hard to believe that people of Arabian extraction would object to this sweeping simplification of the local laws and customs … To Disney's credit, they have since dubbed Robin Williams' third and fourth lines with the far less provocative 'Where it's flat and immense and the heat is intense'. The more important question is this: where did Aladdin get his decidedly southern Californian accent from? But note the somewhat more, um, ethnic-looking villain, Jafar. Curiously, Aladdin's look appears to be based on a combination of Michael J Fox, Tom Cruise and a series of Calvin Klein models who have all had a bad run-in with a spray-tan machine.

And yet *Aladdin* is still a great movie, sweeping in scope and filled with beautiful details. Williams' performance is surprising and hilarious. The musical sequences in particular are marvellously written, elaborately staged and a wonder to behold. All in all, it's brilliantly crafted entertainment … just a little bit racist, too.

SATURDAY FLICKS

Peter Pan (USA) (1953)
Directors: Clyde Geronimi, Wilfred Jackson, Hamilton Luske
Stars: Bobby Driscoll, Kathryn Beaumont, Hans Conried

He was the boy who would not grow up and instead chose to live on an island plagued by crocodiles, camp pirate villains and those stuck-up Darling kids. Ah, the things you'll put up with if you want to fly.

This version of *Peter Pan* is quite the loose interpretation of JM Barrie's original book. Disney had been trying to buy the film rights to Barrie's play since 1935. It took four years to come to an arrangement with Great Ormond Street Hospital in London, to

whom Barrie had bequeathed the rights to the play. Disney opened up the narrative and lightened it and, for the most part, it works. *Peter Pan* is a little gem from a golden era of animation.

And, also, a little racist.

Take, for example, the Native American 'injuns'. Not only are they a bit dumb-looking but they are also painted as being broadly misogynistic, though the kicker is a little song about what gives the Native Americans their distinctive colouring. The lyrics say that many moons ago, a Native American blushed red when he kissed a girl, and it's been part of their race's genetic make-up since. So, in other words, there needed to be some catalyst to change their skin from the normal, human colour of 'white'. Hmm. Smells like scientific.

Dumbo (USA) (1941)
Directors: Samuel Armstrong, Norman Ferguson
Stars: Sterling Holloway, Edward Brophy, James Baskett

Dumbo was designed as a cheap movie to help pull in some cash for the Disney studio after the financial failures of both *Pinocchio* and *Fantasia* in 1940. And you know what? It really is an incredibly charming film that still stands up to this day. It immediately transports you into the headspace of a child — and thank Christ for that, because if you retained your senses you'd know just how offensive this film really was to a whole bunch of people.

Firstly, unionists. Disney was in the middle of a large-scale strike with animators demanding better pay and conditions. You can see that reflected and caricatured within the film itself when the clowns go on strike for more money. But it's black people who cop it most, and not just the faceless, featureless 'roustabout' workers who build the circus while they sing about how good it is that they 'n'ver learned to read or write'. In fairness, real roustabouts

probably *couldn't* read or write. No, the most racist part of *Dumbo* is the infamous crows, the ones who 'ain't never seen an elephant fly'.

You know the scene. Dumbo, the circus-bound elephant, runs into a band of jive-talking black crows. It's one of those iconic Disney moments. If you ask me, the crows are shown to be lazy, stupid and judgmental. If that ain't a classic minstrel show, I don't know what is.

The irony is that this was all progressive for the era. *Dumbo* was released just a few years after Congress blocked a bill to outlaw lynching. If nothing else, *Dumbo* is a symbol of how far we've come.

THE SUNDAY MOVIES

The Rescuers Down Under (USA) (1990)
Director: Hendel Butoy, Mike Gabriel
Stars: Bob Newhart, Eva Gabor, John Candy

This very belated sequel to the 1977 film *The Rescuers* (featuring a genteel Eurotrash rodent SWAT team) has a lot of things going for it. For starters, there's the stunning visuals. It was only the second animated film to incorporate computer effects and we all saw how that went. The film is lush and brims with excitement; in fact, it was one of the augurs of Disney's renaissance, the period in the nineties when the House of Mouse produced enormously successful films such as *Aladdin*, *Beauty and the Beast* and *The Lion King*.

Deep within Australia's vast collection of natural tourist attractions, a young boy named Cody (who presumably *is* Australian in spite of his American accent) befriends a rare golden eagle called Marahute, who shows him her nest and eggs. Later the boy is captured in an animal trap set by wanted local poacher Percival C McLeach. A message is sent to the Rescue Aid Society

headquarters, and Bernard and Bianca (Bob Newhart and Eva Gabor), the RAS's elite field agents, are assigned to the mission. What ensues is a beautiful, lush, big-hearted adventure in a postcard version of Australia. Just remember to tie the kangaroo down lest it starts talking with an accent so unrecognisable it might as well be a South African who's had its tongue hacked with a meat cleaver.

I'm ignoring the fact that you have the Australian lead Cody voiced by a Norwegian American kid actor. I'm also ignoring that the Australian angle is reduced to a few silhouettes of Uluru and a smattering of 'g'days'. Tokenism I can handle. But why does the villain McLeach (George C Scott) have to be darker-skinned compared to all of the other characters? You could argue that it's an accident, or that he's seen in shadows, but the reality is when you're making movies for kids, there's a coded message that you send with every frame. Light equals good, brown equals bad: accident or not, that's negative racial stereotyping.

Song of the South (USA) (1946)
Directors: Harve Foster, Wilfred Jackson
Stars: Ruth Warrick, Bobby Driscoll, James Baskett

This was the first feature film that truly combined live action and animation together. It was a milestone in animation at the time, but Disney has refused to release it on video or DVD in its home country. Why? Well, it has to do with the plot …

The film is set in the Deep South after the Civil War. It's about a rich young white boy living on a plantation who, like all well-to-do pre-teen emo bitches, decides to run away from home. Upon doing so, he comes across a big burly black man, who starts to tell him the animated stories of Brer Rabbit.

The film came out at a time when white segregationists were pretty much running the country, and basically the film

depicts African Americans as subservient slaves — and lovin' it. Unsurprisingly, the African American community are not fans of this film, but *Song of the South* is not without its redeeming features. Even if it is profoundly racist and naïve, *Song of the South* exudes charm and whimsy. Disney have since refused to re-release it in its homeland. Some argue that people should be allowed to watch it and make up their own mind. Ordinarily that would be a no-brainer; there are plenty of films depicting racism and slavery. The problem here is that you have a film for kids, and children take fiction quite literally. *Song of the South* is frequently stocked in video stores in Australia and easily watched online.

One last anecdote: when the movie had its world premiere in 1946 in Atlanta, then a racially segregated city, James Baskett, the actor who played Uncle Remus, could not attend as he would not have been allowed to join in any of the planned events. Sing it with me now, 'Zip-a-dee-doo-dah ...'

TAKING AIM AT LUC BESSON

In 1977, an eighteen-year-old Luc Besson trundled into the La Fémis (France's national film school, home of all things avant-garde and any genre beginning with the word 'neo'). Luc was asked in his entrance interview which filmmakers he most admired. Before he could finish the sentence 'Spielberg, Scorsese and —' the administrator cut him off, saying, 'That's enough, I don't think you belong here.'

Such is the complicated relationship between France and its most commercially successful director. For better or for worse, Luc Besson has dragged French moviemaking out of the art house, riddled it with bullet holes and then put it up for display in the multiplex. Ham-fisted mixed metaphors aside, Besson's movies like *Nikita*, *Leon: The Professional* and *The Fifth Element* have opened up the door for the French blockbusters like *Amélie* and *Brotherhood of the Wolf*.

These days, Besson is mostly a movie producer and writer responsible for various action movies like *The Transporter* and *Taxi* franchises. Back in his heyday as a director, though, Besson married slick, inventive action with a distinctive European quirk. He introduced the world to Natalie Portman and Milla Jovovich (I assume Revlon are still paying him royalties for the latter). All this from a man who never owned a TV or went to the cinema as a child.

Besson was dubbed the leading light of a movement known as *cinéma du look* — which was for all intents and purposes a backhanded compliment that meant 'your stuff looks better than it actually is'. And yet, when his films are good (and no, not all of them are) they are unique, fun and seductive.

FRIDAY NIGHT FILM

The Fifth Element (France) (1997)
Director: Luc Besson
Stars: Bruce Willis, Milla Jovovich, Gary Oldman

The Fifth Element is the feather boa constrictor of Hollywood blockbusters — it's almost more catwalk and gallery than it is filmmaking. Incorporating design work from iconic French fashion designer Jean Paul Gaultier, it is a vision of the future that is not simply mind-blowing but also fabulous.

The year is ... 'the future'. In other words, imagine New York with flying cars. Korben Dallas (Bruce Willis) is a taxi driver, which is a pretty piss-poor career progression from his previous gig as an elite army commando. Perhaps they kicked him out because of his unfortunate bleached blond hair? Peroxide mishap or no, Willis is in luck. A gargantuan flaming spaceball of intergalactic hate is coming to consume the Earth and feed on the tears of puppies, or something, and Earth's space fleet can do nothing to stop it (at least I think that's who those dudes with the berets were. 'Cos God help us if they're just a crack team of interstellar mime performers). It turns out, though, that we humans have a secret weapon — a fifth element. You see, when earth, wind, fire and water aren't enough to repel interstellar attacks, there is also a *human* element to protect

us. And she has orange hair. Somehow Willis is roped back into military service to protect this fifth element (Milla Jovovich), blow some stuff up, collect some very important looking stones, blow some stuff up, survive an insufferable radio host, blow some stuff up and then if/when Earth is saved there shall be a celebratory blowing up of some stuff.

Upon its release *The Fifth Element* was hailed as something of a *Star Wars* for the nineties. More to the point, this movie is *nuts*. The Earth-destroying genre is one that is often lacking in comedy but this movie delivers a fantastic sense of humour. Some characters are wildly over the top, others are completely wry. Certain scenes are lavish and indulgent while the performances are sly. Besson mixes so many different styles it almost feels as though this is the carnival at the end of the universe. And yet, to Besson's credit, he makes this world mesh in a way that many other directors wouldn't even be game to try let alone succeed at.

SATURDAY FLICKS

The Extraordinary Adventures of
Adèle Blanc-Sec (France) (2010)
Director: Luc Besson
Stars: Louise Bourgoin, Mathieu Amalric, Gilles Lellouche

The year is 1911. Intrepid young French reporter Adèle Blanc-Sec will go to any lengths to get her story, including embarking on a trip to Egypt to uncover the secrets of the legendary mummy of Patmosis. Meanwhile, back in Paris, a 136-million-year-old pterodactyl egg on a shelf in the Jardin des Plantes at the Natural History Museum has mysteriously hatched and the offspring is raining terror on Parisian skies. Related? Hmm, I wonder ...

Adapted from the comic books *Les Aventures Extraordinaires d'Adèle Blanc-Sec* by Jacques Tardi, the film is a bundle of energy as it mixes ye olde Indiana Jones–style adventure with villains, mummies and a flying dinosaur.

Surprisingly, the best bit of the film is Louise Bourgoin as Adèle. Bourgoin made her way into acting via modelling and television presenting, but her charisma propels this whole flick … well, that and her array of elaborate hats, dresses and wonderfully stupid disguises.

Luc Besson directs with that patented quirky sense of style and humour. He seems to enjoy chucking in the odd showy camera angle and tacky dissolve transition just to keep it fun. *The Extraordinary Adventures of Adèle Blanc-Sec* is an eccentric little movie and a light and fun watch.

Léon: The Professional (France) (1994)
Director: Luc Besson
Stars: Jean Reno, Gary Oldman, Natalie Portman

You can't stop what you can't see coming: that's the MO that Léon (Jean Reno) works off. He's a French hit man on a retainer for a certain New York mob. Armed with a beige trench coat, perfectly round sunglasses, a pot plant, a small mobile armoury and zero interpersonal skills, Léon is extremely good at what he does. Then, of course, a bunch of DEA agents massacre his next-door neighbours leaving only their twelve-year-old daughter Mathilda (Natalie Portman) alive. Against his better judgment, Léon lets the girl into his life and the rest is your typical boy meets girl, boy teaches girl how to kill, girl establishes an Elektra complex and instigates a bloodbath scenario.

Y'know, that old chestnut.

Léon extrudes a lot of dramatic tension from Léon and Mathilda's relationship, mostly because it's not entirely healthy for either of

them. Their interactions veer hazardously close to romantic territory in one scene and then to parental in the next. It often feels icky, but that's why it's engaging — because you don't know where it's going next. It's also somewhat mitigated by the fact that Léon is the emotional equivalent of a child and Mathilda possesses a freakish maturity. Portman carries off the role with a raw energy and wisdom that far exceeds her years; it's pretty easy to see why she would later become a star. Besson also reflects this dichotomy between 'child' and 'adult' within the tone of the film, which jumps wildly like a small kid who's had too much *Dora the Explorer*, from stylised carnage in slow motion in one shot to whimsical makeshift family-bonding in the next. Of course, I'd be remiss not to mention our overstimulated psychopathic villain, Gary Oldman. He plays a cop gone rogue — and by rogue I mean he likes to blow up houses for no clear reason.

Léon is violent, camp, insightful and complex.

THE SUNDAY MOVIES

Nikita (France) (1990)
Director: Luc Bresson
Stars: Anne Parillaud, Marc Duret, Patrick Fontana

Before Luc Besson gave us a contract killer with a kid in *Léon* and thrust us into a flamboyant future with *The Fifth Element*, he came to popular attention with *Nikita*, a gritty thriller about a drug addict transformed into a super-assassin.

The story follows a savage and sadistic street crim who finds herself in serious legal trouble when she's blamed for a robbery gone gruesomely wrong. In something of a twist, she then wakes up in a white room and is given a choice by the cruel Bob (Tcheky Karyo) — she can die, or she can be trained as a government agent.

Nikita is widely regarded as the most influential European action film of the 1990s. It set the tone for a number of films in the same genre (John Badham's 1993 *Point of No Return* starring Bridget Fonda, for example). This film has also spun off not one but two TV series to date, and it's easy to understand why. Anne Parillaud is remarkable as Nikita — her evolution from sadistic junkie to suave assassin is terrifying. There's no doubt that she's a sociopath, but somehow Parillaud makes that seem vulnerable, even sympathetic. And remember, we're talking about someone who can aerate your skull with a handgun, impale your hand with a pencil and headbutt you if she doesn't like your legal advice. Parillaud brings an intense physicality to the role. Every little tic, every sideways glance gives you a peek into her inner torment.

The ending of the film, to me, is still a little jarring but, unlike many films of the nineties, *Nikita* largely holds up surprisingly well more than twenty years later.

Subway (France) (1985)
Director: Luc Bresson
Stars: Christopher Lambert, Isabelle Adjani, Richard Bohringer

Behold a man in a dinner suit with bleached blond hair and a fistful of stolen documents. Fred (played by Christopher 'There Can Be Only One Highlander!' Lambert) is the anti-007. His ideal refuge from the thugs that want the documents back is the underground world of the Paris Métro. As the mob henchmen chase him through the underground tunnels, Fred develops a romance with a gangster boss's wife, Héléna (Isabelle Adjani). Then, for no immediately obvious reason, Fred decides to form a band and perform in the subway. Can the gangster's men find him in the labyrinthine underground world?

Fun? This movie definitely is. Realistic? It most definitely is not. This is an urban fantasy, one in which those who live in the subway

enjoy a safe and clean life, play fancy music and dance at night in the brightly lit station with no evidence of a rodent invasion. And yet *Subway* is still an enjoyable and energetic flick. Besson goes to town with his dramatic wide shots, tracks and Steadicam work. *Subway* may not always click, but on the whole it's still smart, imaginative and a good deal of fun.

YOU ARE CORDIALLY INVITED TO THE WEDDING WEEKEND OF THE YEAR

Marriage is an ancient and profound institution, the union of two hearts in holy matrimony in the eyes of God and the somewhat less creepy eyes of the state. It's a tradition envied by homosexuals who (for reasons known only to God himself) are not allowed to partake in this activity. The Bible clearly states that the legalisation of gay marriage will result in cataclysmic disasters, plagues, pestilence and a sequel to *Mamma Mia*.

Marriage is a mega-industry, a multibillion-dollar matrimony-industrial complex preying on the Disney-fied fantasies of countless young girls, each believing in their divine right to be princess for a day. And how is this myth propagated? That's right, through *movies*. The film industry has presented the most beautiful and financially unattainable weddings in the world.

And yet in spite of all of the above, movies and weddings are indeed a perfect union. Weddings are all about high emotion, high romance, high drama and occasionally high catering staff. The opulence of some weddings makes them instantly cinematic. So put on your five-thousand-dollar dress that you will wear once and somehow think that's okay. You are cordially invited to five of the weddings of the year.

FRIDAY NIGHT FILM

Muriel's Wedding (Australia) (1994)
Director: PJ Hogan
Stars: Toni Collette, Rachel Griffiths, Bill Hunter

Muriel (Toni Collette) hails from the boganest town in Australia, Porpoise Spit. She is a twenty-something chubby misfit who still lives with her dysfunctional, fashion-retardant family. No one has any respect for Muriel. Her father, a corrupt local politician, thinks she is useless. The 'pretty' girls she hangs around with treat her like shit. No wonder Muriel gets hooked on ABBA tunes. She dreams of escaping this life through marriage (hopefully she doesn't end up like her depressed mother, who is ignored and lied to by everyone). Muriel secretly appropriates some money from her dad and buggers off to Bali for a holiday. There she meets up with the free-spirited Rhonda (Rachel Griffiths). They make the move to Sydney where Muriel reinvents herself and even gets a shot at fulfilling her wildest wedding fantasies.

It's big, it's broad, it's bitchy and it's as Australian as sledging. *Muriel's Wedding* is an exuberant watch whilst maintaining a sharp condemnation of parochial suburban Australia. It also proved to be quite the career launcher. *Muriel's Wedding* was written and directed by PJ Hogan, who went on to direct *My Best Friend's Wedding* (well, at least he remained on-brand). Toni Collette, in her breakout role, infuses Muriel with kind-hearted optimism that's charming and infuriating, in equal parts. Initially her Muriel seems impervious to the onslaught of insults, but Collette deftly allows the pain and hurt to seep out in small doses, making it all the more affecting. Rachel Griffiths cuts a swathe of personality through the movie as best friend Rhonda, particularly in the second half of the film.

In many ways *Muriel's Wedding* is a critique of wedding culture and marriage as a status symbol but doesn't become cynical or hard-hearted along the way — and that's a hard balance to strike.

SATURDAY FLICKS

The Princess Bride (USA) (1987)
Director: Rob Reiner
Stars: Cary Elwes, Mandy Patinkin, Robin Wright

Young Buttercup (Robin Wright) is the most beautiful girl in the mystical land of Florin. Just as well, because I think you'll agree she has a dreadfully stupid name. Buttercup is something of a bitch to a local farm boy, Westley (Cary Elwes). She loves bullying him, which covers her long-held crush on him. When Westley sets out to find his fortune he is killed by pirates. Buttercup realises that she will never love again and so she gets engaged to the unfortunately named Prince Humperdinck (Chris Sarandon), heir to the throne of Florin. Alas, before the wedding she is kidnapped by a gang of outlaws. Their goal is to kill the princess and blame the neighbouring realm of Guilder, thus triggering a war. Ahhh, intrigue. But the kidnappers are blindsided when Buttercup is kidnapped from *them* by a mysterious masked stranger. Together they launch into an adventure of fencing, fighting, prancing, revenge, prancing, monsters, even more prancing, miracles and really, really, really obvious secret identities.

This late-eighties Rob Reiner fantasy tale is a lot of fun. It's witty, warm and, most importantly, incredibly quotable — the snappy dialogue flies thick and fast. Full credit to writer William Goldman for taking the admirable and uncommon position that the audience is smart and wishes to be treated accordingly. Goldman

delicately balances satire and earnestness, a rarity in fantasy films. In fact, the film is as much a piss-take of fantasy movies as it is one itself. Robin Wright is perfectly cast as Princess Buttercup. She is, obviously, very beautiful, even after misadventures in the Fire Swamp and with the odd shrieking eel. Sit back and prepare to learn lines that you will repeat endlessly when drunk in public ...

The Wedding Banquet (Taiwan/USA) (1993)
Director: Ang Lee
Stars: Winston Chao, May Chin, Ya-lei Kuei

Long before Ang Lee was matchmaking cowboys on Brokeback Mountain or giving us hulking superheroes in need of intense psychotherapy, he tackled the modern Chinese wedding. Wai-Tung (Winston Chao) has a big problem. He lives in New York, has a highly paid job, a nice home, and a great partner (Mitchell Lichtenstein) — everything is swell, except ...

His parents back in China don't know that he is gay and are getting tetchy about why Wai-Tung hasn't found a nice girl to settle down with. They simply refuse to die until they've been to their son's wedding. There's no way that Wai-Tung can come out to them so he hatches an alternative plan: Wei-Wei (May Chin). A tenant in a building owned by Wai-Tung, Wei-Wei needs citizenship or she'll be deported. Welcome to Solutionsville, which is about four kilometres east of Sham-Marriageton. A marriage of convenience is the perfect plan, until Wai-Tung's parents fly in from China to organise the wedding banquet.

At first *The Wedding Banquet* seems like a simple romantic comedy of misunderstandings, but it's actually a perceptive look at cultural, sexual and generational differences. The wedding banquet — itself steeped in cultural significance — becomes a focal point around which all of these different threads of the characters' lives

become intertwined. In spite of *The Wedding Banquet*'s light and playful mood, there is a very dramatic and serious subtext at play. Chinese-American writer/director/producer Ang Lee displays a remarkable knack for giving you an array of views about modern marriage while avoiding the clichés and stereotypes. The result is a poignant, lively mosaic of how marriage fits into and around who we are.

THE SUNDAY MOVIES

Monsoon Wedding (India/USA) (2001)
Director: Mira Nair
Stars: Naseeruddin Shah, Lillete Dubey, Shefali Shetty

Panicky Indian dad Lalit Verma (Naseeruddin Shah) walks into his front garden four days before his only daughter's colossal wedding and it dawns on him that he's actually entered a disaster zone: nothing is ready. Lalit makes the first of many irritated calls to 'PK' Dubey (Vijay Raaz), the woefully inadequate 'event manager' in charge of proceedings. It's a mammoth task, with oversized tents, flower arrangements ... oh, and did I mention the full marching band? While Dubey attempts to bring order to the wedding chaos he is also falling madly in love with the household servant, Alice (Tillotama Shome). As the extended family pours in to the house, the tension mounts. The twist? Bride Aditi (Vasundhara Das) has a serious case of cold feet about her quasi-arranged marriage. And there's an impending monsoon ...

It's hard to describe the story of *Monsoon Wedding* without making it sound like a wacky comedy, perhaps starring Steve Martin. I suspect that director Mira Nair will probably make you laugh with this film, but the movie also offers so much more. Nair

skilfully binds three couples' subplots together. The parents show us a hard-won love, while the bride and groom view love with both trepidation and potential, neither partner knowing exactly what they've just signed up for. And the love story between the wedding coordinator, Dubey, and Alice is a pure and passionate fairytale.

This structure has the potential to make the film seem a bit disconnected, shifting from slapstick comedy to romance to the odd accusation of inappropriate kiddy-fiddling. But Mira Nair sticks it together in an organic way that embraces the complexity and subtlety of the characters every time. The film is shot in a fast-paced documentary style, which gives a frenetic sense of urgency to the wedding preparations.

The resulting tapestry offers not just a picture of a family but an image of modern India.

Rachel Getting Married (USA) (2008)
Director: Jonathan Demme
Stars: Anne Hathaway, Rosemarie DeWitt, Debra Winger

Rachel (Rosemarie DeWitt) is getting married to Sidney (Tunde Adebimpe, lead singer of TV on the Radio) which is pretty rad, 'cos they seem like just about the coolest people in the world. It shall be a bohemian extravagance at her family's upscale Connecticut house.

One problem: Rachel's sister, Kym (Anne Hathaway), has been released from rehab to attend the wedding. Their father (Bill Irwin) is struggling to keep the peace. Their mother (Debra Winger) is trying to stay away from the whole thing. And while Kym attempts to stay sober, her own devils rear their ugly heads.

Director Jonathan Demme is a filmmaker who likes to dabble in a lot of different genres. He's best known for making Hannibal Lecter's most memorable big-screen outing, *The Silence of the*

Lambs, and also one of mainstream Hollywood's earliest attempts at covering AIDS in *Philadelphia*. Since then he's made some great films and some other movies so bad they could blind you. This is one of Demme's better films.

That said, I've heard a lot of complaint hurled at *Rachel Getting Married*, specifically that it's depressing. There *are* a lot of dark, raw moments amongst the family strife, but there is also a great deal of love and joy and laughter — none of which is depressing.

For Hathaway it's an exercise in emotional striptease. She plays a character who has done some awful things and buried the surrounding emotions under as many layers as she can. Hathaway spends the film gradually peeling them off, one by one.

At the end of the day, I think Jonathan Demme is at his best when he gets to explore what makes us human beings tick. He shows a genuine empathy for people and humanises all of his characters, no matter how comprehensively fucked up they may be, from mafia wives to Hannibal Lecter. The same goes for Kym in *Rachel Getting Married*: she is still triangulating her place in life, and Demme brings you into that most intimate of journeys.

MOVIE SCHOOLS YOU SHOULD BE GRATEFUL YOU DON'T GO TO

There's only one subset of society that hates school more than actual school students: filmmakers. Strolling the aisles of a video store is like flicking through a giant yearbook of bitter, traumatic adolescent memories, and practically no part of the education process gets off clean. Teachers either end up as soulless automatons (Bueller? Bueller??) or aliens bent on outright human destruction (*The Faculty*). Sure, there are a few exceptions, like lovable prat Robin Williams in *Dead Poets Society*. But even those few seemingly supportive movie school environs have their dark side. Take Harry Potter's Hogwarts, for example: great goblins in heaven, would you trust a school that was frequented by something called 'dementors'? Besides, what's with all the flying phoenixes and walk-through walls? Hogwarts is an OH&S disaster. Or there's the X-Men's Xavier School for Gifted Youngsters: I'm not sure how I'd feel about sending a child to school at a place where jet planes take off from the basketball court and graduation involves handing students a spandex unitard and dispatching them to fight. Worst of all is the vaguely named East High from Disney's *High School Musical*, a place so insidious it has the capacity to turn the entire student population into a demographically perfect chorus of all-singing, all-dancing Stepford teens. Still ... at least you didn't go to these schools.

FRIDAY NIGHT FILM

Heathers (USA) (1988)
Director: Michael Lehmann
Stars: Winona Ryder, Christian Slater, Shannen Doherty

'Are we going to prom or to hell?'

Welcome to Westerburg High School, where the parents are vague, the teachers stupid, and suicide is the cool new thing.

Veronica (Winona Ryder) is in with the popular girls at Westerberg. Though, as she puts it, 'They're, like, people I work with, and our job is being popular.' But she still feels empty. JD (Christian Slater), a boy with a gift for anarchy and a passing resemblance to Jack Nicholson, enters and their whirlwind romance takes on an ever-so-slightly murderous flavour as he tricks her into knocking off the most popular kids on campus and faking their suicide notes.

In 1988 *Heathers* created a fair bit of controversy, perhaps unsurprisingly for a movie that portrayed faux-homosexuality, drinking Drano, and teenage suicide as reasonable responses to a bored privileged adolescence.

Still, it's brilliant.

This is one of those rare movies with dialogue so quotable, a plot so twisted and hair so voluminous that it earns cult status within about three minutes of starting. See this movie once and I all but guarantee that its lines will form part of your phraseology. Though be careful of where you drop 'fuck me gently with a chainsaw!' into conversation.

Perhaps the film's greatest achievement is that it's not simply *about* high school, but rather it's a movie about how we *look* at high school, its power structures and its psychology.

SATURDAY FLICKS

Battle Royale (Japan) (2000)
Director: Kinji Fukasaku
Stars: Tatsuya Fujiwara, Aki Maeda, Tarô Yamamoto

In the not-too-distant future, Japan has passed the Millennium Educational Reform Act where each year a high-school class is abandoned on a remote island. Everyone receives a weapon (some more useful than others). After their mandatory ten minutes of uncontrollable sobbing, it's game on: the last kid standing is the only person who gets to go home to mummy and daddy.

After this wafer-thin pretext you are dumped in an absurdly violent world where teenagers discover who amongst them is a natural born killer and who is about to — *thwap* — have a knife sticking out of their forehead. *Battle Royale* is fast, hilarious and horrific. It's a giddy cross between a slasher movie and *Dawson's Creek*. The movie jumps from campy and gratuitous violence to *Home and Away*-grade sentimentality to incisive satire about teen delinquency, but the important point is this: once *Battle Royale* starts, it's almost impossible to look away.

Although the film is based on a novel and manga by Koushun Takami, director Kinji Fukasaku found inspiration for this movie in his childhood. At the age of fifteen Fukasaku and his class were drafted to work in a munitions factory. When the factory was attacked with artillery fire there was no escape, and classmates had to hide underneath each other to survive. The ones that did were tasked with the job of disposing of their friends' bodies. The horrific experience instilled a deep sense of distrust and hatred for adults within Fukasaku, a sensation that reverberates throughout the film.

It's a bloody good watch. Literally.

Brick (USA) (2005)

Director: Rian Johnson

Stars: Joseph Gordon-Levitt, Lukas Haas, Emilie de Ravin

If high school were written by hard-boiled detective writer Dashiell Hammett, then *Brick* is what he would've turned in at the end of class. Imagine a normal, everyday, unnamed Californian high school populated with gangsters, gumshoes, femme fatales, warring factions and damsels who should know better.

Brendan's (Joseph Gordon-Levitt) ex has gone missing. The local drug dealer might be involved. The pieces aren't clear and the ranks have closed in.

Brick leaps out of the screen. The script is smart, inventive and sometimes impenetrable, but it always gives you just enough of a sense of what's going on. It's not a parody of old-time detective movies of the forties but rather a sophisticated homage. *Brick* brings the energy, weight, oppressive paranoia and subterranean sexuality of that genre to bear on a high-school setting. Not to mention the highly stylised language.

In a way this stylistic conceit says more about being a teenager than the plot itself. By placing all the events of high school into the high-drama genre of murder mysteries, the film is implicitly saying what we all know to be true: when you're a teenager, all drama is magnified. In high school, the slightest event seems like a massively big deal: breakups are the end of life as we know it, teachers are always deliberately out to get us. Not only is *Brick* a very well-made high-school film, it's also a well made comment on the psychology of high school.

THE SUNDAY MOVIES

Carrie (USA) (1976)
Director: Brian De Palma
Stars: Sissy Spacek, Piper Laurie, Amy Irving

Important life lesson: before you pick on the school weirdo, make sure they have not been blessed with freaky powers of telekinesis. 'Cos that shit can go really badly.

A very young Sissy Spacek stars as Carrie White, a socially inadequate teenager at Bates High School with an overbearing and evangelical mother. When Carrie gets her first period in gym class she is teased mercilessly. In fairness, one or two students grant her some kindness, but when a prom-night prank goes wrong, Carrie's latent psychic gifts bring on a menstrual flow of murderous proportions.

There are a lot of horror movies where you can sense the construction, those movies where you are constantly aware that the director or producer has desperately wanted to whack in a terrifying set piece at the end. All you can feel in those films is how they've contrived characters and the plot so they can justify their bravura moment — it's the tail wagging the dog. The best horror flicks are the exact opposite, where the horrific scenes boil out of the characters, heavy with inevitability. That's what *Carrie* does so well. The film is essentially of frustrated sexual awakening, starting with the discovery of Carrie's late-breaking period and the boy who she falls in love with. Everything within the movie is designed to accentuate that adolescent sensuality, from Sissy Spacek's wide eyes of a child to the rich chamber music soundtrack. And when she cracks, when the rug is pulled out from underneath her, bloody hell, you truly feel it with her.

Not only did *Carrie* give Sissy Spacek her biggest role, this film put director Brian De Palma and a little-known writer named Stephen King on the map to scare generations.

If ... (UK) (1968)
Director: Lindsay Anderson
Stars: Malcolm McDowell, David Wood, Richard Warwick

If ... is set in an unnamed British boarding school ruled mercilessly by the 'whips', older students, in a crushing caste system. What follows is a violent, absurd and groundbreaking insurrection led by Mick Travis (a very young Malcolm McDowell). The film's most famous moment — even more shocking now than it was at the time — sees Travis and his team in sniper positions on the roof, picking off people below. The film grows darker and darker until there is no good side to root for.

Director Lindsay Anderson had come from the theatre, so he decided upon casting struggling actors from in and around London to fill the roles. Although the cast is an ensemble, you'll fixate on Malcolm McDowell more than everyone else. At first you might think it's because he's the most famous alum of the production, but no. There is just something eye-catching about his presence whenever he's on screen; it became McDowell's audition for his most iconic role in *A Clockwork Orange* (Stanley Kubrick has admitted to watching *If ...* on repeat).

The film oscillates from colour to black and white for budgetary reasons, but the technique contributes to the movie's overall sense of burgeoning chaos. *If ...* was a celebration of anarchy and, appropriately, it's still as shocking, uncomfortable and exhilarating today as it was when it first appeared.

FRIENDS, ROMANS, COUNTRYMEN

A CRASH COURSE IN POLITICS, MOVIE-STYLE

People decide to do stupid things on weekends. Perhaps it's that warm, fuzzy feeling left in the absence of workplace responsibility. Just imagine how many clueless people spend their Saturdays wandering through hardware stores looking for wood, a few cutting implements and one of those hammery things, and all because they saw a lovely water feature in some smug weekend newspaper insert. Still, it's not the worst thing you could do on a weekend. You could be convinced to embark on the most stupid venture there is — running for public office. Think about it: if the lift-outs can inspire thousands of ill-advised home improvements, can you imagine what the influence of a front page might be with its travails of Gillard, Obama and the gang?

If you *are* one of those people who has decided to run for politics, let me say, on behalf of your friends, family and others who may rely upon your income: you are an idiot. Consider your private life, your financial life, the lives of your kids, your crack habit — all of these are about to become open slather.

If you do still insist on thrusting yourself neck-first into the world of politics, the least you can do is prepare yourself with some flicks. Politics is perfect cinematic fodder: charismatic leads, stark ideological differences, big rousing speeches, dirty

behind-the-scenes skulduggery, high stakes and — most of all — clear winners and losers (provided you don't run in Florida). So here's a weekend crash course in how to survive in politics (according to movies).

FRIDAY NIGHT FILM

Election (USA) (1999)
Director: Alexander Payne
Stars: Matthew Broderick, Reese Witherspoon, Chris Klein

This is the movie that put Reese Witherspoon on the map, and once you've seen it you'll know why. She plays the over-achieving, uptight, hyper-competitive, presumptive class president Tracy Flick. We've all met a girl like Tracy. She's the know-it-all, the one with her hand perpetually hoisted above her head in class while the teacher desperately looks for someone else to call on. Behind her wardrobe of perfectly pressed blue tunics, geometrically exact hair and sensible shoes sits a sense of entitlement that cannot be shaken.

Tracy has a small secret: she just banged her maths teacher (Mark Harelik). When all is revealed he loses his job and marriage. You might argue that he had this coming. Mr McAllister disagrees. Jim McAllister (Matthew Broderick) is a dowdy, well-meaning educator and friend of the sexpesty maths teacher. He looks like a man who's been so emasculated by his job that he may only possess one testicle. However, not even lopsided genitalia are enough to prevent him from his new mission: to stop Tracy Flick from becoming class president. McAllister enlists some competition for Flick — a docile but friendly jock (Chris Klein) who looks a lot like someone who started the day with a fistful of horse tranquillisers.

Election is sacrilegiously good fun. At its core, it is an incredibly black comedy comprised almost entirely of well-meaning characters. It's also a brilliant example of how those in positions of power can rationalise horrific, manipulative and sometimes felonious acts in the name of the 'greater good'. *Election* is a microcosm for real-world politics. Broderick seems to have a ball (zing!) inverting his iconic Ferris Bueller character: where he was once the symbol of teenage rebellion he now appears as an empty husk. Still, this *is* Witherspoon's film. By this point she had already built up a solid résumé in movies like *Fear* and *Freeway*, but Witherspoon wasn't getting the roles she wanted. *Election* was her career shift, showing her not inconsiderable comedic chops. Unfortunately she spent the next year struggling to get work because everyone thought that she *was* Tracy Flick. Eventually, though, Witherspoon made *Legally Blonde*, giving her enough money to wipe her arse with gold bullion (impractical and ineffective, though it may well be). *Election*, however, will always be her cult film for me.

SATURDAY FLICKS

Wag the Dog (USA) (1997)
Director: Barry Levinson
Stars: Dustin Hoffman, Robert De Niro, Anne Heche

Today, the art of the political cover-up. No one is perfect. It's ludicrous to assume that our politicians are somehow morally pure. For that matter, I don't even understand why we would want them to be. For example, surely a bit of drug experience actually makes you more qualified to construct drug legislation? What next? Priests dictating our sex lives? Anyways, the point is that politicians make mistakes, so in order to survive you're going to need to learn how

to cover them up. And no film features a political cover-up quite as brazen as *Wag the Dog*.

The US president (unnamed, but let's call him Cill Blinton) has been fondling girl scouts — as you do. Luckily, when the story breaks the president is in China, far from the burning accusatory eyes of CNN and Fox News (because those guys are extremely unlikely to send a reporter to cover the leader of the free world visiting one of the globe's largest economies). How can the administration distract the American public away from this shocking act of impropriety and even more shocking taste in women? Enter political advisor Conrad Brean (Robert De Niro wearing a fishing hat that makes him look alarmingly like the next-door neighbour from TV sitcom *Home Improvement*). The plan? They'll start a war. A big, patriotic, dramatic, bulletin-filling *war*! But with who? Hmm. How about Romania? Or Albania, maybe?

Given that most Americans believe that Australia is where they set *The Sound of Music*, Brean might just get away with it. He decides to fake the war in a Hollywood studio with the help of orange-tinted producer Stanley Motss (Dustin Hoffman).

A large part of why *Wag the Dog* has become such a cult film has a lot to do with how eerily similar it is to that cruel joke they call 'The Bush Administration'. You'll be gobsmacked at how reminiscent Motss's manufactured invasion of Eastern Europe is of Bush's real-life Middle Eastern campaigns. *Wag the Dog* demonstrates just how much showbiz and politics have in common.

Primary Colors (USA) (1998)
Director: Mike Nichols
Stars: John Travolta, Emma Thompson, Kathy Bates

Charisma: there is almost no end to what people will forgive if you possess this magical quality. That's the questionable moral of this

brilliant, thinly veiled exposé on Bill Clinton's rise to power. And when I say 'thinly veiled', I mean they might as well have wrapped it in cling wrap. John Travolta's turn as presidential candidate Jack Stanton is so loaded with Clinton-esque mannerisms that you keep expecting him to whip out a saxophone. However, behind Stanton's effortless, salt-of-the-earth charm resides a cold, calculating manipulator. Those two sides of his character both complement and strain each other, and that's what powers the film's best scenes. Actually, the film isn't really centred on Stanton at all but rather his aides (Maura Tierney, Kathy Bates and Adrian Lester). Together they come to form Stanton's moral rudder — well, his incredibly rusty moral rudders who dig dirt on competitors for Stanton.

There's an interesting bit of back-story behind this film. The 1996 book that it's based on came with a rarely used by-line: Anonymous. For months there was so much speculation about the author's identity that the only way you knew that you were a 'player' in Washington was if you'd been accused of writing *Primary Colors*. Suspicion eventually settled on Joe Klein, a journalist who has worked for *Time*, *Newsweek* and CBS. After some very public cajoling he finally admitted to writing it.

One of the strongest elements of this film is that it recognises the value of Stanton/Clinton's charisma. His desire to be both loved and liked is, in part, what makes him such a skilled politician. His libido, his ego and his drive — they're all integral parts of his personality woven together. Stanton's flaws define and propel him. It's startling how much insight *Primary Colors* gives you into the mentality and psychology of a politician — well, the charming horny ones, anyway.

THE SUNDAY MOVIES

Power (USA) (1986)
Director: Sidney Lumet
Stars: Richard Gere, Julie Christie, Gene Hackman

When there's something strange in your congressional district, who ya gonna call? Richard Gere. Because it doesn't matter where you are or how strange your event may be, Richard Gere's character, Pete St John, can help you. Pete is the go-to guy for getting people elected, a roving campaign manager who flies from city to city helping congressmen, senators and mayors find their way into office. As he says, 'Once you're in there, you can do what you want.' But you gotta get in first.

As Gere juggles a handful of clients it becomes increasingly apparent that something is not right. Information begins to go missing. His offices have been tapped. But which of Gere's candidate clients is all this related to, and why?

Power is worth it almost purely to see Richard Gere with an extremely ill-advised moustache and Gene Hackman's performance as a charming political operator who gradually turns into a white-hot ball of 'don't fuck with me'.

While *Power* doesn't have the great one-liners of *Election* or the immediately identifiable topical references of *Wag the Dog* or *Primary Colors*, it cuts straight to the esoteric idea that drives all of these movies: power. It's probably a touch too slow, but the climax is fascinating as it exposes how petty their world is. It's nihilistic to the point of almost feeling like a non-ending, but hey — I did warn you that it was a fruitless career. Honestly, I reckon you're better off trying to build that water feature.

In the Loop (UK) (2009)

Director: Armando Iannucci

Stars: Peter Capaldi, James Gandolfini

In the Loop is about the real people who manage our country: public servants.

Yes, hate-filled and staggeringly incompetent public servants. In this thinly veiled parody of the US invasion of Iraq, the US President and UK Prime Minister are keen on a war in the Middle East. *In the Loop* follows the inept aides and advisors on both sides of the Atlantic as they tussle for control of the situation. Cutting through them all is the Prime Minister's chief spin-doctor and the world's angriest Scotsman, Malcolm Tucker (Peter Capaldi).

In the Loop is a spin-off of British TV series *The Thick of It*, which explored the inglorious behind-the-scenes shenanigans of a low-ranking government department. Luckily, the film and TV series are only loosely linked so you won't need to watch one to understand the other.

Shot in a semi-documentary style and filled with long, furious exchanges of dialogue *In the Loop* is a political farce that is both funny and scarily plausible. At its heart, *In the Loop* is a comedy about failure, a film that wallows in hilarious schadenfreude for its characters. So frequent are the administrative screw-ups, you can't help but sit back on the couch and just think, 'Why are they screwing this up so badly????' Mind you, you are probably going to be thinking this amidst uncontrollable fits of laughter.

In the Loop isn't just cruel to its characters; it can be a little cruel to its audience too. The action and political jargon darts by at a furious speed. You often find yourself laughing straight through important plot points. You may need to rewatch it to recall the entire plot, but you'll also *want* to rewatch it for all the hilarious dialogue.

In the Loop is political satire at its best, leaving you chuckling at the gags yet feeling total misery about the political process.

TEACHERS WHO CAN (AND WILL) KICK YOUR ARSE

The idea of a teacher who could, pardon the pun, school you old-school is terrifying. The image of a teacher giving one a roadhouse kick to the groin makes me very grateful for the endless 'he could achieve better if he stopped talking in class' report cards I received as a child. Cinema, on the other hand, *loves* a teacher who can lay the smackdown with extreme prejudice. Teachers make for some of the best mentors, surrogate parents and, of course, villains in movies. In fact, in the best cases, all these roles merge. Whether it's Morgan Freeman cutting a swathe of fury through underperforming students (and teachers) in *Lean on Me*, or Master Yoda eviscerating both the Sith and conventional grammar with equal fury in *Star Wars: Attack of the Clones*, there is much to be learned from these fonts of wisdom.

FRIDAY NIGHT FILM

The Karate Kid (USA) (1984)
Director: John G Avildsen
Stars: Ralph Macchio, Pat Morita, Elisabeth Shue

After moving clear across the country from New Jersey to California, Daniel Larusso (Ralph Macchio) is hating his new school. Not

only does he suck at dealing with the opposite sex, but Daniel has also drawn the ire of the local bullies. After one particularly brutal beating, Daniel turns to local handyman and karate master Mr Miyagi (Pat Morita) to help him learn the art of combat so that he might rip his tormentors a new arsehole in a forthcoming karate tournament. Mr Miyagi treats his new student's desperation as an opportunity for some low-impact child labour as he assigns Daniel some repetitive household chores. But soon, these techniques come in handy and many cans of whoopass are prised open.

Ralph Macchio has a disarmingly endearing screen presence and captures the spirit of an underdog flawlessly in his performance. He's far more complex than you expect, nailing the role with panache and authenticity. Makes you wonder why Macchio never went on to become a megastar.

But, unsurprisingly, it's Pat Morita who steals the film. He and Macchio share a sincere chemistry, but what makes Morita unique is the conviction and subtle intimacy that he brings to the character.

The Karate Kid is a ripper. The only thing you need to enjoy this is a big heart. It's charming, rousing and adorable, all setting up for one of the most involving climaxes in the history of eighties martial arts flicks.

SATURDAY FLICKS

X-Men (USA) (2000)
Director: Bryan Singer
Stars: Patrick Stewart, Hugh Jackman, Ian McKellen

This may look like a superhero movie, it may smell like a superhero movie, it may in fact even *be* a superhero movie — but to my mind *X-Men* is really a movie about bigotry.

In the not-too-distant future, mankind is beginning its next stage of evolution in the form of mutant beings with special and extraordinary powers. The existence of these mutants has sent waves of moral panic through normal humans. Soon mutants are indivertibly put into conflict with the rest of humanity. Battle lines are drawn, with the militant wing of oppressed mutants being led by Magneto (Ian McKellen). Having witnessed his parents murdered by the Nazis during World War II, Magneto sees history repeating itself. On the other side is Professor Charles Xavier (Patrick Stewart) and his team of benevolent peace-loving mutants: the X-Men. It's Professor Xavier who takes the cake for best teacher, a gentle but firm force. Patrick Stewart, always a commanding presence, brings a reassuring even-keel balance to everything he does as the professor. He has faith in his students and always looks them in the eye, whether they're a child with a forked tongue or Hugh Jackman coming to terms with his overactive facial hair, metal claws and proclivity to attack randoms. And yet, when push comes to shove, Professor Xavier has the mental capacity to telepathically destroy your mind and school you six ways from Sunday.

The X-Men comics were always at their best when they demonstrated that being different is both a wondrous thing, but also painful and difficult. Director Bryan Singer knows this. This tale of genetic mutants is a beautifully wrought allegory that will ring true for those on the sharp end of homophobia, racism and more.

The Untouchables (USA) (1987)
Director: Brian De Palma
Stars: Kevin Costner, Sean Connery, Robert De Niro

It's 1930 and prohibition has turned Chicago into a city at war. Mob gangs compete for the city's billion-dollar empire of illegal alcohol and the nights are alive with the sound of Tommy guns. Al Capone

(Robert De Niro) is the de facto ruler of the city — his influence extends from the skankiest speak-easies to the highest offices of the Windy City. Enter Eliot Ness (Kevin Costner), a Treasury agent fresh off the apple cart. Ness and his band of 'Untouchables' set about the dangerous business of toppling Capone's empire.

Brian De Palma's film version of the classic television series featured Costner in one of his earliest lead performances and Sean Connery in one of his first 'mentor to the young kid' roles. The film is big, bloody and full of sharp one-liners. It moves at a rocketing pace, never really letting you catch your breath.

It should probably be said that *The Untouchables* is about as historically accurate as *Dora the Explorer*. According to the various DVD extras, it was never intended to be so: De Palma was interested in exploring the myth, not the history.

The real star of *The Untouchables* is Sean Connery in his Oscar-winning role as world-weary cop Jimmy Malone, who teaches Costner 'the Chicago way'. Connery takes every line from David Mamet's screenplay and makes it sing with his wry charm, determination and good old-fashioned star power.

THE SUNDAY MOVIES

Kill Bill (volumes 1 and 2) (USA) (2003 and 2004)
Director: Quentin Tarantino
Stars: Uma Thurman, David Carradine, Daryl Hannah

Coma.

Rape.

Pussy Wagon.

Uma.

Now that I have your attention …

I'm assigning both volumes of this movie for today, even though it's really the second volume that features my favourite diabolical teacher. What can you do? Sequels rarely work without their originals.

This omnibus version of *Kill Bill* is essentially a four-hour-long revenge flick — divided into two volumes — involving samurai swords, yellow latex and blood. It comes from legendary director Quentin Tarantino, known for his sharp dialogue, unrelenting violence and gigantic forehead.

The Bride (Uma Thurman) was once part of Gangster Bill's death squad. She fled, and was promptly shot for her insolence. She lived in a coma for years until one day she wakes up and makes herself a list. One by one she begins killing the remaining members of her death squad: O-Ren Ishii, aka Coppermouth (Lucy Liu); Vernita Green, aka Copperhead (Vivica A Fox); Budd, aka Sidewinder (Michael Madsen); Elle Driver, aka California Mountain Snake (Daryl Hannah) and Bill, aka Snake Charmer (David Carradine). They will pay.

Ah, but where did The Bride acquire these skills to kill, maim and destroy? From Pai Mei (Gordon Liu), easily one of the most hilarious and disagreeable arsehole teachers ever to grace a cinema screen. The Bride is an American Caucasian woman — three things that Mei cannot abide. He tortures her without mercy.

Kill Bill is what I like to call 'Tarantino Concentrate'. It is one movie made from all of his reconstituted cinematic influences (kung-fu, Japanese sword-fighting chambara films, westerns, and so on). And in spite of this homage-apalooza, he still creates thrilling suspense, nuanced characters and a totally unique form of storytelling.

FOR THE LOVE OF GOD, WHY ARE WE DOING THIS?!

WHY MESSING WITH DNA IS A BAD IDEA

Scientists. What dicks.

When they're not turning harmless atoms into city-levelling bombs or scaring away the opposite sex with their own woeful lack of personal skills, they're busy performing crimes against nature ... or so say the movies. And whilst it seems patently obvious to you and I that no good can come of combining a monkey and a jellyfish, genetic engineering is a popular pastime amongst the scientician set. When will they learn? So, fetch some supplies, gird thy genetic material and prepare to be terrified.

FRIDAY NIGHT FILM

Jurassic Park (US) (1993)
Director: Steven Spielberg
Stars: Sam Neill, Laura Dern, Jeff Goldblum

Dinosaurs made from hermaphrodite frogs?! That is the idea behind this nineties mega-blockbuster that made every ten-year-old boy want a Tyrannosaurus Rex-themed birthday party to go with their Velociraptor-themed nightmares.

Sam Neill plays a surly palaeontologist with an unfeasibly attractive girlfriend in the form of Laura Dern. They are both invited to the island hideaway of an eccentric millionaire. This turns out to be <*music swells*> a giant theme park filled with genetically reborn dinosaurs crafted from the DNA (care of ancient mummified vampire mosquitoes and topped up with the genetic juices of a few West African tranny frogs). Along for the ride is a charismatic mathematician (contradiction in terms?) Dr Ian Malcolm (Jeff Goldblum). Dr Malcolm's repeatedly brushed off suggestions that dinosaurs might not take well to being in captivity prove to be well founded. The dinosaurs rebel as only dinosaurs can: by eating tourists and demanding a profit-sharing deal on the back end of any movie spin-offs or sequels. But mostly by eating people. And some lawyers.

To director Steven Spielberg's credit, this is some of the most marvellously assembled, brilliantly entertaining popcorn cinema ever made. In spite of decades-old effects, it's still thoroughly convincing. In some ways, the combination of animatronics and computer trickery is MORE realistic than the complete CGI universes we see these days — there's a certain weight and physics that is hard to fake. But *Jurassic Park* also offers a witty script delivered by talented actors with just the right amount of cinematic awe. And if that's not enough, it's all delivered with a ham-fisted cautionary message about respecting nature. What more could you possibly ask from a nineties blockbuster?

The only downside to *Jurassic Park* is that the huge advances in computer imagery featured in the film were also the inspiration George Lucas finally needed to make his Star Wars prequels.

On second thoughts, fuck you, *Jurassic Park*.

SATURDAY FLICKS

Splice (US) (2009)
Director: Vincenzo Natali
Stars: Adrien Brody, Sarah Polley, Delphine Chanéac

I don't know about you, but I love a happy accident. Like finding fifty bucks in your pocket, or a rogue icy pole in the back of the freezer, or that time I accidentally cloned a sexy human–mouse hybrid with an Oedipus complex. Man, that was weird ...

Welcome to grossly underrated horror/sci-fi flick *Splice*, from equally underrated Canadian director Vincenzo Natali. Clive (Adrien Brody) and Elsa (Sarah Polley) are lovers and geneticists working on the holy grail of world food problems: homegrown meat. Imagine if you could grow meat humanely in a lab — what would be the implications for farming? Consumer prices? The environmental impact of not having all those farms? And, of course, how amazing would the look of confusion be on the face of all the animal liberationists?

Clive and Elsa are trying to lovingly raise what appears to be a sentient rump steak and it just keeps dying. So they try something new — using a mixture of Elsa's and animal DNA. The result is Dren. Initially Dren is kind of like a genetic turducken, with elements of mouse, scorpion, shark and, of course, human. She grows from a large mouse until she looks like a toddler with warped developmental issues. She then rapidly ages into a tempestuous, sexy chimera.

Once you get past this movie's slight preoccupation with lame CSI-style science montages, this Canadian French co-production is one of the more fascinating explorations of genetics. Sarah Polley and Adrien Brody have fantastic onscreen chemistry and make for a believable couple, while the existence of Dren places a series of

very complex obstacles in the way of their relationship. The most suspenseful, icky and thrilling moments in *Splice* come from seeing how the sacred temple of human flesh has been perverted. It's a deeply sexual film, reminding us that the most profound act of genetic creation is indeed sex and all of the messy, fun and painful bits that come with that act. But, more than anything, it is an awesomely messed-up, skin-crawling flick.

Gattaca (US) (1997)
Director: Andrew Niccol
Stars: Ethan Hawke, Uma Thurman, Jude Law

As we continue our weekend of horrifying genetic mutations, now prepare to be terrified by … um … very well-groomed genetically engineered astronauts.

Gattaca is set in a not-too-distant future where everyone has collectively decided to dress as though it's the 1940s. In this world, all of your potential medical 'defects' — heart problems, inadequate height, left-handedness — can be screened out before you are born. This process will render you 'valid'. Valids get the best jobs, the best partners and the best Brylcreem for your 1940s hairdo.

Vincent Freeman (Ethan Hawke) dreams of being an astronaut. He is capable, fit and smart, but he is also born naturally, or 'invalid' as his class is derisively termed. So Vincent hatches a plan to buy a valid's genetic identity. Enter Jerome Morrow (Jude Law), a world-class athlete. At least, he was, until he broke both his legs. Jerome is in need of cash and the sizeable chip on his shoulder isn't helping. Hawke begins the job of transforming himself into Jerome by borrowing samples of blood, skin and hair that he can use for genetic screening. But will he pull it off?

New Zealand-born director Andrew Niccol is known for making thoughtful, creative and beautiful Hollywood movies (*The*

Truman Show, Lord of War), but this film still stands out as one of his best. He's created a genteel world where discrimination is implied and accepted. The retro stylings of *Gattaca* inspire comparisons to racial segregation of the not-so-distant past. Many critics have complained that the film is lacking in emotion but to me *Gattaca* feels classy and cool. Hawke has a steely intensity about him. With every step he takes his fragile world could topple — if just one stray hair or a random fleck of skin gets through the system, his plans will fall apart. Alan Arkin effortlessly wisecracks his way through the film as an ageing detective on the hunt for the missing invalid. But the film belongs to Jude Law, playing a man who was born with every opportunity laid in front of him then had them all cruelly taken away. He's the character your heart ends up bleeding for as he spirals down a path of self-loathing and self-destruction.

THE SUNDAY MOVIES

Black Sheep (New Zealand) (2006)
Director: Jonathan King
Stars: Oliver Driver, Nathan Meister, Tammy Davis

They say that New Zealand has more sheep than people. What would happen if they wanted to take over? This is the terrifyingly funny prospect posed by *Black Sheep*.

Meet Henry (Nathan Meister). Henry does not like sheep because of a cruel joke his sadistic brother pulled with a bloody sheepskin in their childhood. Things are so bad, in fact, that he became sheep-phobic and had to move away from the family farm. When Henry returns years later to sell off his share of the farm he discovers that his brother has become an even more sadistic prick

and is genetically altering his flock, turning them into murderous, flesh-eating monsters. Clearly, when there's no more room in hell, the dead shall graze in New Zealand.

Black Sheep is a very gory black comedy that is at its best when it's being as weird as possible. New Zealand's answer to something like *Shaun of the Dead* (though not quite as clever), this similarly mixes slapstick, blood-splatterin' gore with some cute political undertones. The effects are decidedly lo-fi, with plenty of latex guts and corn-syrup blood. It works, though, and a movie like this should be a bit rough and tumble.

The film owes a lot to Peter '*Lord of the Rings*' Jackson, whose earlier movies (like *Braindead*) were classic splatter-fests. *Black Sheep* also cleverly messes with our perception of Kiwis as folksy inbreds who say 'bro' a lot. (What? Don't look at me like that, they do!) The dialogue and acting can be a little hokey, but hey, it's a movie about killer sheep.

The Fly (USA) (1986)
Director: David Cronenberg
Stars: Jeff Goldblum, Geena Davis, John Getz

And finally, be terrified by an overly talkative Jewish guy who may also be a large insect. With a mullet.

Jeff Goldblum is back again this weekend as Seth Brundle, the geeky inventor of the world's first teleporter. After accidentally locking himself into his invention with a housefly, Goldblum begins to evolve into a human–fly hybrid from the inside out. It also stars Geena Davis (with a decidedly aerated hairdo) as Goldblum's lover, who may be impregnated with his infected seed.

A good horror movie should scare you, but a great one will show you what's scary about real life. Those are the sorts of movies that Canadian director David Cronenberg makes: horror movies

with brains, wit and heart. The more invasive, the more penetrative, the more aggressive his horror is, the better the movies are.

The Fly is one of my favourite Cronenberg movies. Yes, it's terrifying, but it's also sexy and smart, with some of the best-written monologues of all time. The very concept of this movie sounds absurd and, in fact, if you see the campy original 1950s version of this story you'll see it is very stupid indeed. But Cronenberg's unique treatment turns it into a visceral assault that hooks into one of our greatest vulnerabilities: disease. *The Fly* cuts deep into that terrible fear of being attacked from within by something you can't fight, reason with or even see.

THE DELICATE DELICACIES IN THE DELICATESSEN OF JEAN-PIERRE JEUNET

According to visionary French director Jean-Pierre Jeunet, there are two kinds of beauty in this world. The first is the Greek statue kind of beauty: anatomically perfect, rippled bodies with somewhat shrivelled phalluses. The other form of beauty is the African statue kind: think stylised angles and elegant lines, a warped impression that may be less 'accurate' but in fact gives a far greater essence of the being. This 'African statue' is the kind of beauty that Jean-Pierre loves. He savours it like a small kid in the throes of a red-cordial-fuelled crafternoon. The French director and his long-time collaborator Marc Caro have made nightmarish visions of oil-rig laboratories, taken us into a beastly cannibal butcher's lair and led us through a whimsy-drenched Parisian fairytale. Demented? Yes. But always beautiful. His films are playful, fantastic, paranoid, bizarre and wondrous. He imbues these vivid worlds with a generous humanity. Full hearts and wonky eyes: such is the world of Jean-Pierre Jeunet.

FRIDAY NIGHT FILM

Amélie (France) (2001)
Director: Jean-Pierre Jeunet
Stars: Audrey Tautou, Mathieu Kassovitz, Rufus

Amélie is Jean-Pierre's most personal, popular and positive film. It is a fairytale about a beautiful waif of a waitress. Amélie (Audrey Tatou) hails from Montmartre and possesses a distinct paucity of social skills which she makes up for with an abundance of imagination. Her goal is to surreptitiously change the lives of those around her with a little loving manipulation. Along the way, Amélie also finds herself embarking on a tentative romance with a boy who possesses the people skills of a steamed turnip.

Jeunet says that he sees filmmaking as 'a box of tools': cinematography, special effects, music, and so on are all utensils he employs to create something beautiful. If nothing else, *Amélie* is a fine example of that. The film is a giddy mix of small vignettes and strange asides, covering things like how many orgasms are being had in Paris at any one time (fifteen).

Some of the more hard-nosed might find *Amélie* to be too much of a sugar rush but for me there are more than enough mysterious flecks in it. Jeunet's vision of Paris is intentionally childlike. His primary goal is to make you see life as Amélie Poulain does — as Jeunet does, channelling his own sense of wonder through his main character. Her experience of Paris is so detailed; she fixates on garden gnomes, abandoned photographs and long-lost toys. Sure, it's a bit like spending two hours with mild Asperger's syndrome — but only in the best possible way.

SATURDAY FLICKS

Micmacs (France) (2009)
Director: Jean-Pierre Jeunet
Stars: Dany Boon, André Dussollier, Nicolas Marié

The term 'micmacs' is code for shenanigans, and that is precisely what you're in for this weekend. The film tells the mischievous tale of a video-store clerk Bazil (Dany Boon) whose father is killed by an errant landmine. To make matters worse, the clerk himself is left with a stray bullet lodged in his cranium when a drive-by shooting goes awry.

There's nothing like a bit of hot metal stuck in your cerebrum to affect basic decision-making skills, which might explain why our video clerk falls in with a strange group of misfits who live in a pile of garbage. They are, however, a very talented team of odd bods: an African actor, a contortionist and a Guinness world-record human cannonball. Their garbage home isn't quite what it seems, either; it's actually a hollowed-out pile of rubbish converted into a cleverly disguised flat. It's here that Bazil gets an idea: he will destroy the arms manufacturers responsible for the weapons that killed his father and left his brain with a new piece of internal jewellery.

Micmacs was designed to be a metaphor for Jeunet's favourite aspect of moviemaking: teamwork. A team endeavour by its nature, filmmaking relies on an interlocking group of individuals each with their own unique talents. Jeunet delights in recreating that same collective creative buzz with this team, and some of the movie's biggest delights come from the team's bickering group dynamics.

However, it's Jeunet's love of mechanics that really push this movie over the edge as he clearly relishes detailing how the shenanigans are constructed and pulled off. Jeunet is a magician

with the brain of an engineer who delights in roping you into the plans. Combine that with the playfulness of his characters and this particular revenge becomes a unique experience.

A Very Long Engagement (France/USA) (2004)
Director: Jean-Pierre Jeunet
Stars: Audrey Tautou, Gaspard Ulliel, Jodie Foster

This film came immediately off the back of Jean-Pierre's megahit *Amélie*, and I suspect many audiences were expecting a similarly upbeat, tourism-friendly montage. What they got, however, was quite different.

Mathilde (Audrey Tautou) and Manech (Gaspard Ulliel) are engaged at the height of World War I. He is sent to the front line while she is stuck in provincial France with a munted leg. Time passes. Every account suggests Manech died on the front line, but Mathilde simply refuses to believe that he is dead: if he were, she would feel it. And so she begins to search for him. It's a chase that takes her into the lives and history of countless other soldiers that Manech might have known. It's also a journey into the horrible atrocities committed by both German and French sides, exposing scandals, tragedies and more. But will it ever unearth Manech himself?

A Very Long Engagement was a very big ask, a French film funded by Warner Brothers for a sizeable $30 million. But hey, that's what the success of *Amélie* will buy you. At its heart this is a great detective story, and Tautou brings an unflinching strength to the screen that belies her waify exterior. Meanwhile Jeunet brings all of his considerable toolbox of visual skills to bear on the story. The war scenes are harrowing and tense, but also choreographed in such a way that they also take on a blackly comic dimension.

There is a tangible sense of yearning throughout *A Very Long Engagement*. It's a sadness not just for the missing Manech but also

for a generation. Millions of French men, women and children were traumatised by the Great War, and an entire generation was left without fathers and brothers. It clearly cut a swathe across the country. *A Very Long Engagement* is an uncommonly beautiful vehicle to examine the damage that war inflicts.

THE SUNDAY MOVIES

Delicatessen (France) (1991)
Directors: Jean-Pierre Jeunet, Marc Caro
Stars: Marie-Laure Dougnac, Dominique Pinon, Pascal Benezech

Across all of these movies so far, you've probably noticed at least one recurring face. He's the guy with the bulbous forehead, receding hairline and the ever-present impression that he either *is* a carnie or — at the very least — he is the result of an unholy union between two carnie cousins. This man's name is Dominique Pinon; he is often regarded as Jeunet's favourite actor and this film is where their extensive screen relationship began.

Both movies on your platter today are actually co-directions. You see, in the early part of his career Jeunet was a double act: Jeunet and Caro. Marc Caro, that is, an artist, graphic designer and production designer. The two met at an animation festival in their youth and progressed into making short films and commercials together. Eventually they made their first feature film. And what a unique movie this was.

Delicatessen was made at a time when French cinema was best known for its angry, serious kitchen-sink dramas about unfaithful men, their long-suffering wives and the make-up sex that binds them together. *Delicatessen* was a breath of fresh air. In a post-

apocalyptic French future where meat is scarce, we meet a butcher who lives underneath a block of apartments. With animal meat so hard to come by, he cannibalises one of the lodgers. Enter Louison (Dominique Pinon), the building's new tasty man … sorry, I mean handy man.

Delicatessen offers unique oddball tenants, vivid visuals and a mixture of comedy and horror — all held together with industrial-grade meat glue. It's filled with so many amusingly perverted scenes, but best of all is when the beat of the butcher's love-making on a squeaky bed sparks a building-wide musical sequence. Gold.

The City of Lost Children (France/Germany) (1995)
Directors: Jean-Pierre Jeunet, Marc Caro
Stars: Ron Perlman, Daniel Emilfork, Judith Vittet

The City of Lost Children was Caro and Jeunet's second (and last, to date) feature film together before they realised that their interests were pulling them in different directions. It was also their darkest film.

We're in another post-apocalyptic wasteland, this one on the seaside. Abandoned children roam the streets and a spate of child kidnappings has begun. Children are being taken to an offshore oil rig where each is having their dreams harvested to feed an emaciated, hateful scientist who is no longer capable of creating his own. This lack of night-time reverie makes him cranky, and no matter what his three-foot midget mother, six identical brothers or personal advisor (a detached floating brain) do or say, he's just not happy.

Filled with dark shadows, distorted lenses and actors with faces that have been beaten with the ugly stick, this is a journey to a very dark and strange zone. Jeunet and Caro delight in contrasting the inherently innocent faces of the kids against this surreal world.

And although the movie is choreographed with the same camp, comedic aesthetic as their other films, the result is completely different. Instead of whimsical or fun, the comedy in this comes off like a sickly sweet childhood memory gone wrong. *The City of Lost Children* is best watched late at night. Trust me.

SMASH AND GRAB
HOW TO PLAN A MOVIE HEIST

I don't endorse crime. Well, not publicly, anyway. Let's just say that *if* you were going to undertake a major sting on a casino/bank/federal mint/ex's house then please, do it safely. And if it's a reliable and trustworthy source of safety information you require, there's no better place to turn than movies.

The first key to an effective heist is casting. You must get the right crew. Movie and television history has clearly indicated that criminals are, by and large, towering intellectual giants that make Socrates look like a Kardashian sister. You must find yourself these criminal masterminds. Then there's the tricky business of picking your target. Are we talking jewels, priceless art or simply pictures of an errant politician having sex with a goat? Each option presents its own unique challenges. Then comes the planning stage. Studies (of DVDs) show that this is best delivered in a montage of some kind. And finally one must execute the sting itself (preferably with limited collateral damage).

Luckily moviedom has given us many lessons over the years to address all of these issues. This weekend we give you the do's, don'ts and dear-God-what-were-you-thinkings of movie heists.

FRIDAY NIGHT FILM

Out of Sight (USA) (1998)
Director: Steven Soderbergh
Stars: George Clooney, Jennifer Lopez, Ving Rhames

Lesson number 1: Hire George Clooney. The man has the Midas touch for heists. Not only did he nab an implausibly happy ending from the excellent Gulf War heist flick *Three Kings*, he also headlined the charmingly smooth *Ocean's Eleven*. However, my pick of his kleptomaniac collection is *Out of Sight*. Clooney plays a career bank robber named Jack Foley. Whilst escaping from prison, Foley and his partner, Buddy Bragg (Ving Rhames), accidentally kidnap federal agent Karen Sisco (Jennifer Lopez). After being locked in the back of a car for half an hour talking about movies and life, it is suddenly very clear that Jack and Karen are hooked on each other. After she escapes, Clooney goes about committing one last job. Meanwhile Lopez joins the investigation to capture him. But, is she trying to jail him or just get close enough to hook up with him?

If you had to sum up *Out of Sight* in a single word it would be 'flirtatious'; director Steven Soderbergh relishes watching the suggestive googly eyes people give each other. It's sly, sexy and very funny.

This movie proved to be a big turning point for a lot of people. Soderbergh had only really been known for art house and indie films at this point, and *Out of Sight* was his attempt to build a bridge into mainstream moviemaking without necessarily making an outright blockbuster. As for Clooney, after years of appearing on television megahit *ER* it had taken some time to shake the impression that he was a small-screen pretty boy who had no place in movie theatres. After the disaster that was *Batman and Robin*, *Out*

of Sight was one of the first movies to demonstrate that Clooney had a unique movie-star quality. And Lopez? Well, *Out of Sight* is one of the precious few of her films that doesn't completely suck. So there's that.

SATURDAY FLICKS

Heat (USA) (1995)
Director: Michael Mann
Stars: Al Pacino, Robert De Niro, Val Kilmer

Lesson number 2: Smart criminals do *not* hire Robert De Niro. It's not that he's a bad actor, far from it. It just seems that any heist movie he appears in (like *Ronin* or *The Score*) seems to get very, very messy. This is great if you are a viewer; not so great if you're the one pulling the heist.

In a gothic, cool and industrial Los Angeles, Neil McCauley (Robert De Niro) is a career bank robber who leads a crack team of sociopathic kleptomaniacs stealing valuable bearer bonds. Aside from his career, McCauley is starting to feel a bit empty. He's also being tracked by Lieutenant Vincent Hanna (Al Pacino). He too is feeling an existential void. Hanna's slavish commitment to tracking criminals has left his marriage in tatters and his daughter inflicting self-harm. As a cat-and-mouse game ensues between the two, it soon becomes evident that they have far more in common than they have that separates them. Their relationship eventually forms the backbone of a much larger portrait of Los Angeles, a toxic environment crawling with criminals, cops and businesspeople that ultimately draws out the worst in people. As more heists follow, we witness revenge killings, police stake-outs, a romance, perilous dinner parties, two failing marriages, adultery and an extremely cathartic ending.

Michael Mann was the brilliant director who first put Hannibal Lecter on the big screen in *Manhunter* (1986). *Heat* is a film he'd wanted to make for decades, at one point virtually giving up on it ever making it into movie theatres and instead constructing a stripped back version for TV called *LA Takedown*, but it was nothing compared to this operatic masterpiece.

Bonnie and Clyde (USA) (1967)
Director: Arthur Penn
Stars: Warren Beatty, Faye Dunaway, Michael J Pollard

Lesson number 3: Criminals must always manage their image. The best way to operate as a robber is to frame yourself as a Robin Hood of sorts, stealing from the rich and giving to the poor (that is, yourself).

Set during the Depression, *Bonnie and Clyde* is the story of two self-mythologising folk heroes, Bonnie Parker (a doe-eyed Faye Dunaway) and Clyde Barrow (a snag-y Warren Beatty in a waistcoat). As the tagline says, 'They're young, they're in love, *and they kill people.*' As bank robbers, the pair became known for their taste in brutal violence and a very fashionable anti-establishment vibe. The movie follows them from their first meeting, through their posse recruitment process and right to the top of their blood-soaked career.

Bonnie and Clyde is as much a film about fame and mythmaking as it is about bank robbers. There's a sexual energy to everything in the film, from the comedic scenes through to the killings, drawing stimulating parallels between crime and sex. For example, when Clyde brandishes his manhood ... I mean, gun, Bonnie suggestively strokes it in what can only be described as a tug-job. *Bonnie and Clyde* was heavily influenced by the new wave French films of the 1960s. There are sudden shifts in the movie's tone and plenty of

choppy editing, all intentional, bringing a raw brand of energy. It also showed audiences a far more gruesome vision of crime than they were used to. Even today, Clyde's first murder packs a considerable punch. It's not that it's terribly realistic but remarkably unexpected. Of course, it's nothing compared to the final scene of the movie, which is both horrific and amazing in its ability to make a myth of the two characters.

THE SUNDAY MOVIES

Rififi (France) (1955)
Director: Jules Dassin
Stars: Jean Servais, Carl Möhner, Robrt Manuel

Lesson number 4: Always have a backup plan. *Rififi* is set in 1955 Paris where one Tony le Stéphanois (Jean Servais) has just been released from jail after a five-year sentence for jewel robbery. After a little bit of coercion he agrees to help in another jewel sting with two old mates. As they start to recruit the team, Tony then has a brainwave: 'Why aim so small?' he wonders. Instead the team go for the big one: a Paris jewellery store's safe. But is 250 million francs worth the retribution that will follow?

There is a scene in *Rififi* that, once seen, will never, ever leave you. It's a breathtaking half-hour heist sequence where the team carefully break into the jewellery store, pry open the safe, and make their getaway. Not a single word is spoken throughout — all you can hear is the men breathing and their tools. It's gripping.

Director Jules Dassin was actually an American filmmaker who had been blacklisted in the States. When he was offered the chance to make a movie version of the novel *Du Rififi Chez les Hommes* he very nearly said no, mostly because he couldn't understand the

book's colloquialised French dialect. His agent translated it for him and even then, Dassin wasn't thrilled with the story. But he needed the cash and agreed to take the job. The result was one of the biggest hits of French cinema in 1955, nabbing Dassin a best director award at the Cannes Film Festival later that year. Far more importantly, though, it gave birth to the modern heist flick, with its clipped personalities and cold, mechanical focus on the criminal act itself. It was also thought to be so accurate that the French authorities tried to have the movie banned due to it providing real criminals with tips on how to perform the perfect heist.

Dog Day Afternoon (USA) (1975)
Director: Sidney Lumet
Stars: Al Pacino, John Cazale, Charles Durning

Finally, and most importantly: Be prepared for a glorious ending. *Dog Day Afternoon* is one of the most memorable heist-gone-wrong flicks of all time.

Al Pacino is a Vietnam veteran named Sonny. He and his buddy Sal attempt to rob a Brooklyn bank and, well, let's just say that anything that *can* go wrong, does … with a vengeance. There is barely $1000 to actually steal in the bank itself, the hostages aren't scared of them plus Sonny and Sal are staggeringly bad at being criminals. A crime that was meant to take ten minutes soon becomes a protracted hostage stand-off.

The script for *Dog Day Afternoon* was based on New York City's first true hostage situation, a botched bank robbery in 1972 by John Wojtowicz and eighteen-year old Sal Naturile. The day-long siege was the talk of the Big Apple for some time.

Dog Day Afternoon revels in confounding your expectations of this kind of movie. Director Sidney Lumet shows all of the characters to be far more complex and endearing than you initially

imagine them, and overall it's a very hard movie to fault. Pacino, in particular, is at the height of his talent. It's a perfectly structured, perfectly acted hostage flick. It also has brilliant moments of black humour and genuine charm. By rights, *Dog Day Afternoon* should've walked away with a barrow of Oscars but the year was ridiculously jam-packed with excellent movies like *One Flew Over the Cuckoo's Nest* and *Jaws*. The stiff competition meant *Afternoon* only took out best original screenplay.

WIZARD DEATH-MATCH

Every family has a 'crazy'. You know, that uncle or parent who has a few roos loose in the top paddock. The relative who's so socially awkward that you question not only their grasp on reality but on this very astral plane. I think the great appeal of wizards in film is that their existence, albeit fictional, assures us that the world may indeed have a place for all of our crazy family members. It's as though the cosmos has given nut cases everywhere at least one vocation enshrined for them and them alone: wizard. Here's to you, Uncle Gary — may your wand remain unsplintered.

The history of sorcerers is a long one. Roman poet Virgil (not to be confused with the Thunderbird of the same name) was amongst the earliest to write about Siberian shamans, however similar wizards were said to exist in South American, Indian and Celtic lore as well. Naturally, movie history has no shortage of bearded sooths too. So, steady thy wand, stroke your pendulous beard and affix your gaze deeply upon thy freshly buffed crystal ball. This weekend we're launching into the Wizard Death-match: five wizards — one wand to rule them all. Who will win?

FRIDAY NIGHT FILM

Monty Python and the Holy Grail (UK) (1975)

Directors: Terry Gilliam, Terry Jones
Stars: Graham Chapman, John Cleese, Eric Idle

I'm not going to lie to you: I was just looking for an excuse to squeeze *The Holy Grail* into this book.

After their 1971 sketch-based feature, *And Now for Something Completely Different*, this was Monty Python's first 'proper' movie (their words, not mine). It saw Graham Chapman, John Cleese, Terry Gilliam, Eric Idle, Terry Jones and Michael Palin taking on that perennial favourite tale, King Arthur and his search for the Holy Grail. Directed by both Terry Jones and Terry Gilliam between the third and fourth series of their iconic BBC show *Monty Python's Flying Circus*, this is a landmark bit of utter silliness. And chief amongst these fine laughs is your first wizard of the weekend: we will call him The Enchanter, but there are those who also call him 'Tim'.

He may only have seven minutes of screen time, but Tim is no ordinary enchanter. For one, Tim possesses the amazing ability to blow stuff up; all his lines of dialogue are interspersed by him casually igniting a tree or incinerating a boulder. He speaks with a semi-Scottish brogue and has a hat made of rams' horns that's pretty ace. Tim may not be the most helpful wizard, but woe betide those who do not heed his warning about the evil beast with nasty teeth that guards the Cave of Caerbannog.

If you've never seen *The Holy Grail* before, you're in for a treat. Amongst the most quotable, absurd and brilliantly stupid bits of British comedy, it's also one of the most enduring and innovative works of visual humour (Trojan bunny, anyone?).

SATURDAY FLICKS

Harry Potter (USA/UK) (2001–2011)
Directors: Chris Columbus, Alfonso Cuarón, Mike Newell,
David Yates,
Stars: Daniel Radcliffe, Emma Watson, Rupert Grint

Well, I couldn't *not* include this now, could I? I'd have JK Rowling
fans throwing Quidditch balls at my windows and covering me
in Butterbeer at the pub. Which, whilst being tasty, would leave
terrible stains on my new Hogwarts-branded Snuggie.

Yes, I am a fan of the Harry Potter movies (I'll leave it to you
to pick which Potter film you want to start with). Although the
sprawling franchise undoubtedly has its qualitative ups and downs,
I still believe that JK Rowling and her cavalcade of movie directors
have succeeded at creating a rich and exciting world. Truly great
sci-fi and fantasy should offer you a universe that feels complete
with culture, history, rules and trends that induce complete
immersion. There's an art to this. The 'world' must be sufficiently
complex for your mind to get lost in it, but simple and familiar
enough that you can emotionally engage. Harry Potter, by and
large, does this with aplomb.

Within this framework we encounter an image of wizardry
that is still filled with a sense of wonder and invention, but also a
lot of heart. Dumbledore, the headmaster of Hogwarts School of
Witchcraft and Wizardry, is the parental unit that Harry has always
lacked. Richard Harris and later Micheal Gambon imbued the
character with depth and detail. But he could also clean the floor
with most wizards, so he knocks out *Holy Grail*'s contender Tim the
Enchanter pretty roundly. Mind you, the Harry Potter films often
suffer from their book origins and lack basic structural elements,

with the endings sometimes struggling to satisfy. Or you can think of it as always left wanting more and eager to return with each new movie. Each new film is a treat where you get to revisit the mini-wizards and see how their acting skills have improved. I think of it as a family reunion — except you don't have to drink to be around these people.

Excalibur (USA/UK) (1981)
Director: John Boorman
Stars: Nicol Williamson, Helen Mirren, Patrick Stewart

When Merlin (Nicol Williamson) waddles over the horizon and stumbles into the middle of a bloody battle, I imagine director John Boorman was intending a sense of wonder and fear. For Christ's sake, Boorman even liberally sampled the overblown music of Wagner in the background. Between that and the sharp clang of swords and lashings of blood, the viewer should gasp, 'Who is that man?' Instead all you can think is, 'What is that shiny thing on his head?'

The correct answer is 'a skullcap', a mystical wizard skullcap. Precisely what its purpose is remains unclear.

Long-time British stage actor Nicol Williamson features alongside a host of soon-to-be stars, including Patrick Stewart, Helen Mirren and Liam Neeson. Williamson's unique performance makes his one of the truly standout portrayals of the Merlin character, mostly because he truly *is* the crazy uncle of wizards. Sure, the whole film is pretentious and camp, but Williamson kicks it all up several notches. Speaking in a staccato patter so unpredictable it almost rivals William Shatner's, Williamson somehow anchors the movie. He provides us a character to hook onto in this sprawling two-hour-and-seventeen-minute journey. Keep an eye out for Williamson playing opposite Helen Mirren. Apparently they hated

each other, which might explain why all their scenes play out with the intensity of vigorous breakup sex.

The movie itself has dated a fair bit. From the moment the metallic Freudian phallus that is the sword Excalibur rises from the misty waters of Avalon, you know there will be a few inadvertent giggles throughout. But luckily it all moves along very fast, packing in a lot of details from the definitive Arthurian text *Le Morte d'Arthur*. The film also goes out of its way to depict knights as what they probably were: rugby league players with axes, not the poncy honour-bound snags that usually pop up in movies. Well, except for Lancelot, who is played by a Ken doll.

THE SUNDAY MOVIES

Lord of the Rings (New Zealand/USA) (2001–2003)
Director: Peter Jackson
Stars: Elijah Wood, Ian McKellen, Viggo Mortensen

The film adaptation of JRR Tolkien's *Lord of the Rings* trilogy was an unprecedented production, with 150 locations and 2730 special-effect shots on six million feet of film. All this for a book that many, including a few of JRR Tolkien's children, regarded as unfilmable.

And yet the result is stunning. These films, along with Harry Potter, reinvigorated big-screen fantasy filmmaking. In this world trolls, wizards, elves and men cohabit in a world known as Middle-earth. Within this realm a ring exists that allows its wearer to command and conquer; men become addicted to it and cannot be trusted to withstand its power. The evil lord Sauron, once a towering warrior in black, has now been relegated to the non-corporeal form of a giant, flaming, hate-filled vagina sitting atop a black pedestal while his ghouls do his unthinkable bidding. Oh, and he wants his

ring back. So the wise wizard Gandalf (Ian McKellen) entrusts the ring to a child, Frodo (Elijah Wood). Frodo must take the ring and throw it into the lava of the aptly named Mount Doom, for it is only in those flames that the ring will be destroyed.

Tolkien purists still argue endlessly about these films and their interpretation of the books. But few would say that the films are anything short of masterpieces, balancing amazing production design, breathtaking plots, magnificent acting and enthralling action. And driving so much of it is Ian McKellen as Gandalf the Grey. A towering figure with a flowing beard, crooked staff and a wise, gruff exterior, he is the classic image of wizard brought to dramatic life. Gandalf radiates warmth, humour and, occasionally, rage. McKellen injects Gandalf with the wonderful idiosyncrasies of a man who's been alive a millennia; our history is his memory. His urgency has weight and credibility that propels the trilogy forward.

Find the biggest screen you can, turn the volume right up and remember — at the end of the first film, everyone must get up and yell 'YOU SHALL NOT PASS' in unison. Only then, will your nerd-dom be complete.

Big Trouble in Little China (USA) (1986)
Director: John Carpenter
Stars: Kurt Russell, Kim Catrall, Dennis Dun

Oh, but who could beat Gandalf? I hear you cry. Which bearded master might possibly defeat the undisputed magical powerhouse of Middle-earth? Well, that would be pan-Asian wizard Lo Pan, the most batshit-crazy wizard of the weekend appearing in one of the most wonderfully insane movies of the eighties.

There are strange goings-on in San Francisco's Chinatown (okay, fine, it's a studio back lot made to look like Chinatown) and there's only one mullet-toting redneck truck driver who can solve

it, Jack Burton (played by Kurt 'business-at-the-front, party-out-the-back' Russell). While he is drawn into an ancient feud between warring martial arts warriors, the immortal evil emperor Lo Pan is scouring the Earth for a woman with green eyes to make his wife thus breaking some unnecessarily complex Chinese curse. And if Russell can't save us, then an army of mildly racist Asian stereotypes will envelop the world with the dodgiest of special effects.

There's 'trashy' and then there's 'John Carpenter trashy'. When veteran genre filmmaker Carpenter directs a movie, he has a way of putting his tongue so firmly in his cheek I'm amazed he hasn't choked on it yet. *Big Trouble in Little China* is camp, it's crazy and it has Kim Catrall (*Sex and the City*) back when she had full control of her facial muscles.

The script for this movie was at various points called 'unfilmable', 'unreadable' and a 'disaster', and somehow the mixture of cheesy dialogue and eighties hair helps it attain a nirvana of cult wonderment. And then there's the Wizard Lo Pan himself. Played by veteran character actor James Hong, Lo Pan is the most amazing parody of orientalism. With monstrously long fingernails and a Fu Manchu moustache he is a wonder to behold, but it's the laser beams that shoot from his eyes and mouth that get me.

The key to this movie is to watch it with lots of people and *with* the subtitles. Sometimes dialogue is so clunky that you need visual aids just to reinforce how truly ludicrous it is.

STUCK IN A ROOM

Movies are an expensive business. There're writers, directors, set decorators, 'associate producers'*, caterers, special-effects designers, actors, actors' drug dealers … And all these people, frustratingly, insist on being paid. So how do you keep costs down? Well, if you're a particularly smart filmmaker you can do away with one of those major costs quite easily. Dump all the extraneous locations and instead set most — if not all — of your film in one place. Basing an entire film in one space does present its own obstacles. How do you make the same four walls an exciting backdrop, for example?

Let's find out, shall we? Lock the doors, bar the windows, pop a vitamin D tablet and try to focus on something other than your crippling claustrophobia by fixing your gaze on that glowing screen in the corner. You're about to spend the weekend locked in a room …

* Usually lead actors suffering from relevance-deprivation syndrome.

FRIDAY NIGHT FILM

Buried (Spain/USA) (2010)
Director: Rodrigo Cortés
Stars: Ryan Reynolds, José Luis García Pérez, Robert Paterson

A man in a box. For 93 minutes.

That's not a movie. That's a war crime.

Actually, in the case of the excellent 2010 film *Buried* you get both. Ryan Reynolds plays Paul Conroy, a man who wakes up to discover that he is in a coffin buried underground: where? Dunno. Why? I got nothing. After some hyperventilating and deduction we realise that he was a truck driver in Iraq. He's been buried here with only a lighter, a phone and a knife to help him get out.

Buried is a movie that should be awful. At no point do you ever leave the box for the entire running time of the film — and yet somehow they pull it off. The cleverly structured script by Chris Sparling moves in waves. To wit, Paul will discover clues in the box or via the phone, he'll follow that path, the stress will build and build and build and then ... deeeeep breath ... that pattern repeats. However, Sparling folds new plot twists into each wave so it doesn't feel repetitive.

Whether you like him or not, Ryan Reynolds is an actor with wonderful comic timing. It's a natural instinct that really sharpens the drama of *Buried*. Reynolds' character gives you plenty of exasperated laughs to gild the growing tension.

For a film that takes place within a three-metre stage, *Buried* is remarkably beautiful to watch. Director Rodrigo Cortés gets right into every corner of the coffin, accentuating the claustrophobia with the sporadic lighting either from the clinical blue light of the

phone or the flickering flame of the lighter. He uses them both to control the mood and tension.

Buried isn't quite perfect; there are a couple of plot turns that stick out like a sore thumb. Ultimately though, it's an unexpected, clever, well acted and beautifully shot film that somehow goes beyond being 'a story' and becomes an experience.

SATURDAY FLICKS

Devil (USA) (2010)
Director: John Erick Dowdle
Stars: Chris Messina, Caroline Dhavernas, Bokeem Woodbine

You're stuck in an elevator suspended metres in the air, too far to climb down. Inside this tiny metal coffin held up with cables are four people. And one of them is the devil in disguise.

Devil comes from the mind of one-time master filmmaker M Night Shyamalan, the guy who once gave us *The Sixth Sense*, *Unbreakable* and *Signs* before he devolved into making dreadful films like *Lady in the Water* and *The Last Airbender* (which both suck gigantic dogs' bollocks). *Devil* is the first in what he calls *The Night Chronicles*, a concept where, essentially, he comes up with the plot and then farms the directing off to someone still in possession of their talent. And it works. Director John Erick Dowdle has created a bloody scary, tight little flick.

Devil has a simple, clean, terrifying and entertaining basis. The plot moves fast as people in the lift start being brutally killed off, one by one. Each of the scares is matched by strategically placed moments of humour. It's a visually unnerving film, littered with creative swooping shots of the city bringing the whole building to demonic life.

The big cliché of M Night Shyamalan's flicks is that he loves to include a massive twist at the end. *Devil*, happily, is filled with lots of little twists throughout, roping you right into a constant mind game. 'Aww, she looks evil … oh hang on, surely *he's* Satan … no, wait, he's just a dick …'

The only thing that pulls *Devil* back is the ending — it's all just a bit too neat and preachy.

Rear Window (USA) (1954)
Director: Alfred Hitchcock
Stars: James Stewart, Grace Kelly, Wendell Corey

There's a heatwave in New York. Your leg is in a cast and you're stuck in a wheelchair. Outside your apartment window is nothing but nagging neighbours. What do you do?

Y'know … apart from buy a goddamn television?

Well, if you happen to be adventure photographer LB 'Jeff' Jeffries (James Stewart), you start spying on said neighbours. When Jeff witnesses what he thinks is a murder, he ropes in his socialite girlfriend (Grace Kelly) and salt-of-the-earth nurse (Thelma Ritter) to help him prove a potentially unprovable crime.

Alfred Hitchcock generally makes one of two kinds of movies: 1) the 'story movies', where he uses his considerable innovation and technical skill to tell an interesting story, or 2) the 'idea movies' where he has a cool technique he wants to try out and he finds a way to build a plot around it. Unlike most directors, Hitchcock usually has the talent to make either of these approaches work. *Rear Window* is one of the rare examples that borrows a bit from both categories, being at once a Hitchcock experiment and a nail-bitingly clever mystery. The script is erudite, witty and even sexy at times. But what is really striking about *Rear Window* is its point of view: you almost only ever see the world from Jeff's perspective

making you a co-conspirator in his tom-peeping/crime-solving. Hitchcock uses this whodunit to deliver a wholesale critique on urban American life, its callous infidelity, its social isolation and, of course, its lack of privacy.

THE SUNDAY MOVIES

Cube (USA) (1997)
Director: Vincenzo Natali
Stars: Nicole de Boer, Maurice Dean Wint, David Hewlett

Six people are trapped in a gigantic network of cubes. Every cube has six doors, each leading to … another cube. Oh, and some of them are booby-trapped. There's no obvious reason why these people have been chosen (although, each character is curiously named after a famous prison). They have no food, no water and no bathrooms, and things are getting a little crazy and homicidal. We're cheating a little with this one because technically it takes place in multiple rooms (or cubes), but since they're all identical, let's agree that it's the same room, mmmkay?

The cast of *Cube* is very strong, particularly David Hewlett as the person who knows the most about the cube but still can't get them out. But what's most amazing is how they managed to make this entire film with one and a half sets and a lot of clever lighting to flesh out the world of the cube.

Canadian director Vincenzo Natali (who also directed *Splice* from a few chapters back) is one of the most underrated genre directors working these days. He borrows heavily from high-concept works like *Twilight Zone*, which often featured plots that could be reduced to one line, but Natali goes further. He draws you into the detailed mechanics of how the characters are going to

survive. Soon you also realise that these cubes are an extension of the characters' personalities. Their isolation forces them into a kind of existential dilemma.

The Disappearance of Alice Creed (UK) (2009)
Director: J Blakeson
Stars: Gemma Arterton, Eddie Marsan, Martin Compston

When this movie opens the first thing you notice is just how methodical it is. *The Disappearance of Alice Creed* begins with a virtually silent montage of two men meticulously preparing an apartment with soundproofing and bolting down a bed. You can surmise what they have planned. It's almost satisfying to watch as the whole abduction goes off without a hitch. Or it's also possible that I'm a closet sociopath who enjoys that kinda thing. But I digress ...

It's only when the victim, Alice Creed (Gemma Arterton), is locked in the room that we sense that something horrible will happen. The leering manner in which the men look at her body in various states of undress implies that the movie will make a turn for the rape-y, but the actual twists are far more unpredictable. When conflicting goals, emotions and double-crosses come into play, it becomes impossible to calculate the end result.

Gemma Arterton has made a pretty decent living thus far out of playing haughty bitches in a lot of usually bad movies. She's happily collected paycheques from *Prince of Persia* and *Clash of the Titans* for essentially playing a hot girl with an accent. Perhaps it's because those movies were so poor that Arterton seems so impressive in this. She plays a rich girl who is smarter than she wants people to think she is. And yet she is still capable — as any of us are — of falling apart under pressure. All the performances are universally brilliant. Eddie Marsan as kidnapper Vic has a certain indefinable innocence

about him that is endearing. Martin Compston as Danny, however, is the one you find yourself drifting towards as the story advances. What do those clear, piercing eyes hold? Cold-blooded murder? Love? Heartbreak? Hard to tell, compelling to find out.

BABYSITTERS WHO SIMPLY SHOULD NOT TO BE TRUSTED

Mary Poppins, bless her uppity soul, is a rare breed: a movie babysitter that not only can be trusted to return your child in one piece but with their moral fibre and hymen largely intact. A round of applause, if you please.

The rest of the cinematic canon is littered with babysitters of the other ilk: the dangerous, the stupid, the hideous, the unfriendly, the lazy and (occasionally) the dead. Take Walt Disney's *Sleeping Beauty*. Sure, the tubby winged fairies Flora, Fauna and Merryweather take on the challenge of hiding baby Aurora in the woods so she can avoid the 'dead by your sixteenth birthday' curse. But *then* they argue pointlessly over her dress, thus attracting the attention of some evil raven scout and ultimately getting Aurora captured. Women, you had *one* job …

Or there's the bulbous John Candy in the 1989 family movie *Uncle Buck*. He smokes, drinks, bets on horses, and can't hold down a job or a girlfriend (sitting on them doesn't count). Sure he teaches the kids how to laugh, but *how* does he impart this lesson? By kidnapping the neighbours and threatening them with a screwdriver. Do you really want a babysitter bonding with your child over a secret love of clandestine abductions?

And let's not forget Alicia Silverstone in the protracted masturbatory fantasy that was *The Babysitter*, playing an

incompetent babysitter who missed her calling as a high-priced callgirl. She lets the kids watch whatever they want on TV till way past bedtime, takes a long, luxurious bubble bath instead of supervising them, and walks around the house in a bathrobe. Age appropriate, please, Alicia.

But these are simply the incompetent babysitters — there is a wide range of maladies your movie babysitter could inflict on your ill-gotten spawn, so here you have them: babysittters who can't be trusted with your child.

FRIDAY NIGHT FILM

Don't Tell Mom the Babysitter's Dead (USA) (1991)
Director: Stephen Herek
Stars: Christina Applegate, Joanna Cassidy, John Getz

When she first walks in, Mrs Sturak (Eda Reiss Merin) is a gentle, sweet-voiced old lady who calls everyone 'dear'. But the moment Sue Ellen's (Christina Applegate) mum leaves for the airport, Mrs Sturak pulls out a whistle and growls for the 'maggots' to get inside and observe her absurd and unattainable house rules. Merin is only on screen/alive for the first few minutes of *Don't Tell Mom the Babysitter's Dead*, but in that minuscule length of time she becomes one of the cruellest, strictest childcarers in movie history. She angrily flicks off the TV and assigns an eight-year-old an academic report. She sets women's liberation back decades when she forces a pre-teen tomboy to wear a chintzy pink nightmare of a dress. She draws up a labyrinthine chore chart. She even plasters name tags on all the kids, insisting they must be worn at all times. Basically, she's the evil bitch version of Mary Poppins. And when

she keels over and spontaneously dies and the kids wrap her in a bed sheet and leave her on a mortuary doorstep — honestly, it seems like a good call.

Look, there are irritating dumb flicks and then there are joyous dumb flicks and then there are joyous dumb flicks with an awesome retro appeal. This one ticks the last box. The plot is about as plausible as unicorns knocking on your door to ask for a cup of sugar, and yet it is still a pretty amusing and ingratiating li'l flick. After finding fame as selfish airhead Kelly Bundy on *Married with Children*, the hair-tizzied Christina Applegate actually plays the brains of this borderline-retarded clan in her first headlining feature-film role.

The biggest problem is that the movie wants to be both lowbrow (like when one of the kids blows up the china with a shotgun, proclaiming 'The dishes are done, man!') and a quasi-date movie. While the two approaches never quite mesh, each half is decent enough to win some giggles.

SATURDAY FLICKS

Raising Arizona (USA) (1987)
Directors: Joel Coen, Ethan Coen
Stars: Nicolas Cage, Holly Hunter, Trey Wilson

Criminal Herbert (Nicolas Cage) and policewoman Edwina (Holly Hunter) meet when she takes his mug shot before he's sent off to jail. With repeated visits, romance blossoms, and the two get married just as soon as Herbert can finish his time. They move into a desert caravan and live a happy life, with one problem: they want to have children, but Edwina is infertile. They can't adopt, thanks to Herbert's criminal record. Then the couple learns of the 'Arizona Quints', sons of famous furniture tycoon Nathan Arizona

(Trey Wilson). Herbert and Edwina set about to kidnap one of the five babies.

Enter Herbert's prison buddies, played by John Goodman and William Forsythe. They become babysitters for the young Arizona … so long as you are happy to define 'babysitters' as 'convicts on the run with a kidnapped infant'. They fall head over heels in love with him, and hatch a plan to make him part of their own clan. They even include the baby on their planned tri-state crime spate. Good intentions aside, it's hard not to question the parenting technique on display as these two guys leave their kid on top of their car and then drive off. Twice.

Raising Arizona is a unique comedy that is the product of the infamous Coen brothers. Parts of it are very witty (I particularly love the first scene with Nathan Arizona and his wife) while other elements are possibly too subtle on a first watch. The characters are brought to life by a great cast who know exactly how to play their bizarre characters. *Raising Arizona* moves at lightning speed, and the Coen brothers have an enormous amount of fun toying with a number of odd point-of-view shots (anything from canines to hand grenades).

Halloween (USA) (1978)
Director: John Carpenter
Stars: Donald Pleasence, Jamie Lee Curtis, Tony Moran

As a babysitter, Laurie Strode (Jamie Lee Curtis) is pretty much perfect. She's the surrogate big-sister type who treats her charges with respect while doing all manner of arts and crafts. But there's just one problem: wherever Laurie goes, a crazy, knife-wielding murderer follows. *Halloween* is the film that turned Jamie Lee Curtis into a star and did untold damage to our understanding of mental illness. No, not *all* disturbed young boys turn into murdering

sociopaths when in the presence of a nubile babysitter and a few sharp objects. Just. No.

At the risk of sounding like the back of the DVD, director John Carpenter truly did change the face of horror forever with his release of *Halloween* three decades ago. More than fifteen years after Hitchcock gave birth to slasher movies with *Psycho*, John Carpenter pushed the genre into a new direction with his white-masked killer.

Halloween offers us one of the purest demonstrations of 'the bogeyman' as evil personified. Carpenter then unleashes this unreasonable darkness upon an archetypical American town. It's a powerful and terrifying spectre. Plenty of filmmakers make violence on the screen, but Carpenter is particularly skilled. The performances, the tension, the production, the music … it's all perfect for this kind of film. It's particularly interesting to see how Carpenter creates his victims. They're all ordinary people — there's no big star — so it's everyday people like you and me who could be hacked to death at any moment. Watching *Halloween* isn't like watching a movie: it's like having a movie *inflicted* upon you.

THE SUNDAY MOVIES

The Hand that Rocks the Cradle (USA) (1992)
Director: Curtis Hanson
Stars: Annabella Sciorra, Rebecca De Mornay, Matt McCoy

Peyton Flanders (Rebecca De Mornay) has had a rough trot. She's a nanny who was once married to an obstetrician with a habit of giving dangerously 'vigorous' examinations to his patients. One day he suddenly commits suicide, and she is left unable to have kids. She takes her vengeance out on the universe by moving to a decidedly

Stepfordian part of town and ingratiating herself into the life of Claire Bartel (Annabella Sciorra), a happy wife and mother ... oh, and the woman who first blew the whistle on Peyton's husband.

The Hand that Rocks the Cradle trades on the most philistine images of women imaginable — they're all either Doris Day or homicidal maniacs. But if you put the poor gender politics aside, it is still pretty compelling stuff. The premise is so primal, engineered to capture the anxiety of new mums everywhere. As the traumatised central character, Rebecca De Mornay is a marvel to watch. Amidst her cookie-cutter daze of warmth you soon catch flashes of her true nature — it's just subtle enough that you still get a shock when she starts slipping the baby her own breast for feeding, like a dog marking its territory.

And if that doesn't get you, the movie also features a certain famous redhead being impaled by a greenhouse.

The Night of the Hunter (USA) (1955)
Director: Charles Laughton
Stars: Robert Mitchum, Shelley Winters, Lillian Gish

When Robert Mitchum's darkly charismatic preacher Harry Powell swoops in on a widow and her two children, he seems to be a blessing, someone who can cleanse the memory of her criminal ex-husband and give her family a solid Christian upbringing. The townspeople are bowled over by the stranger's good manners and rigid decency. The mother (Shelley Winters) talks herself into believing that this intimidating man of God will bring stability to the household. But the kids aren't buying it, and behind closed doors Mitchum drops the façade too: he's after the stolen loot their father (his ex-cellmate) bequeathed to his children before getting shot down by police. Mitchum uses every coercive tactic he can to pry the information from them.

The Night of the Hunter is one of the most eerie, odd and dark films to come out of 1950s Hollywood. It is a living, breathing nightmare that features a career-changing performance by Robert Mitchum as the screen's most vile man of God imaginable, and that's saying a lot. These days it's considered by some to be one of the greatest American films of all time.

Director Charles Laughton crafted scenes to maximise the dread and menace, often using carefully shaped silhouettes, grassy hills and jagged shadows to create a looming sense of fear. But surely it's the leading man who is the standout. Mitchum had been arrested for possession of marijuana a few years before *The Night of the Hunter* was made and his time in prison clearly served him well. Fifty-five years later and Mitchum's Harry Powell is still one of the most powerful and disturbing villains ever to grace the silver screen.

CHRIS NOLAN
MASTERMIND

Perhaps it was because of Y2K (or that drugs briefly became very cheap in Hollywood) but roughly around the turn of the millennium, there were a lot of filmmakers intent on examining existential ideas about reality and perception. Arguably the most successful of these moviemakers were the Wachowski brothers with *The Matrix*. Not only did the original movie single-handedly make pleather trench coats cool, it brought a variety of metaphysical and philosophical questions to a very mainstream audience. (Questions that it stubbornly refused to answer in its two Cartesian clusterfuck sequels.) Then there was Aussie director Alex Proyas with *Dark City*, about a metropolis that undergoes supernatural reconstruction every night. Richard Kelly gave us *Donnie Darko*, which served up a dazed Jake Gyllenhaal, some Smiths songs and a completely inscrutable time-travel plot, thus becoming one of the defining cult movies for self-harming emos everywhere. And then, of course, there was Christopher Nolan, an English director who broke onto the scene with a quirky breakout hit called *Memento*.

Here's the thing: most of these filmmakers ended up sucking.

Yes, *The Matrix* made enough money to buy Larry Wachowski an impressive gender re-assignment surgery (he's now Lana Wachowski), but each of these filmmakers went on to make decreasingly watchable films.

That is, except for Nolan. Over Chris Nolan's relatively short recent career he has carved himself a niche as a filmmaker who can take cerebral, sometimes ephemeral ideas and give them depth, weight and excitement on a cinematic canvas. And he does so with enough dramatic heft to satisfy all of your popcorn-munching blockbuster desires.

FRIDAY NIGHT FILM

The Prestige (USA) (2006)
Director: Christopher Nolan
Stars: Christian Bale, Hugh Jackman, Scarlett Johansson

In dank and depressing Victorian England, two young magicians, Alfred (Christian Bale) and Robert (Hugh Jackman), are learning their trade. Where Jackman possesses enormous charisma, Bale is technical and gets lost in the detail of each trick's carefully crafted three-act structure: the pledge, the switch and the prestige. In time their friendship turns to a bitter rivalry that will see them both destroy that which they love most to get the better of each other. It all builds to a twist ending that is marvellously odd and totally devastating.

The roles are perfectly cast; Jackman has showmanship in his blood and Bale is a study in furrow-browed seriousness. Michael Caine as the associate who binds them ultimately proves to be the heart of the film, offering sometimes the only voice of sanity and decency.

The Prestige is a movie about obsession and the lengths one will go to to achieve fulfilment. Nolan pours so much energy into bringing us up close and personal with the men, demonstrating

their infectious passion for magic, that you find yourself with constantly shifting allegiances. Both are equally talented and flawed; it's like watching a neck and neck horserace. Nolan also very selectively reveals inside information about the magic tricks, giving us just enough detail to be amazed at the planning and dexterity required and yet still keeping us mostly in the dark to be astounded by the result. It's attention to detail like this that makes Nolan such a rare talent.

SATURDAY FLICKS

Batman Begins (USA/UK) (2005)
Director: Christopher Nolan
Stars: Christian Bale, Michael Caine, Ken Watanabe

Bruce Wayne (Christian Bale), a millionaire orphaned as a child, is angry and he's looking for something to fill the hole left by his parents' death. His search takes him to the ends of the Earth where he trains up in a secret martial arts school. Eventually he returns to his hometown of Gotham City to rid it of the corruption that killed his parents.

Many of Chris Nolan's films deal with characters in a fragile emotional state who are being pushed to the edge of their sanity. In that sense, Nolan was the perfect filmmaker for Batman. Unlike Superman or Spiderman, Bruce Wayne has no superpower. He's simply driven by a broken heart, a thirst for revenge, pig-headed idealism and a penchant for spelunking.

In the years preceding Nolan's reboot of the franchise, Batman movies had become a camp joke wrapped in skin-tight spandex and erect latex nipples. Nolan brought the character back to his psychological core, opting for a completely realistic approach to

Batman's origin story. Nolan takes the time to flesh out every step of Wayne's transformation, emotional and physical, and ensures it feels justified and imperative. The script is layered with intelligent dialogue and occasional moments of dry humour, the atmosphere is tense and the action in the film is just plain cool.

The actors are all spot-on too, Christian Bale displaying a dry wit and the steely intensity of an ideological zealot.

The Dark Knight (USA/UK) (2008)
Director: Christopher Nolan
Stars: Christian Bale, Heath Ledger, Aaron Eckhart

Well, you could pretty much sum up this movie with two letters: ER. As in biggER, darkER, scariER, cleverER, richER, funniER …

The Dark Knight picks up where *Batman Begins* left off. Bruce Wayne's theatrical approach to crime-fighting has drawn forth a new kind of criminal mastermind, an anarchist who wants nothing more than to see the world burn. He calls himself the Joker.

This next instalment again stars a lot of very good actors: Christian Bale returns as Batman, Aaron Eckhart, Michael Caine, Morgan Freeman, Gary Oldman and Maggie Gyllenhaal, to name a few. But it will always remain Heath Ledger's film. *The Dark Knight* may be a major blockbuster but its best scenes are usually the quiet ones with Ledger going one on one with some poor soul. With a nervous tic and mouldy clown make-up, Heath Ledger creates a villain who is as playful as he is wickedly cruel. In all his various dramatic performances, it's easy to forget what great comic timing Heath Ledger had. With his death in early 2008, before the film's release, there was a concern that it might be morbid or sad to watch Ledger in this role, the last film he completed before his death. Personally, I just found it frustrating that we won't get to see him again.

Nolan's new and improved Batman saga is novelistic in tone. He offers a large-scale morality tale that tracks the movable line between hero and vigilante. Gotham City is a philosophical arena where the characters battle over huge ideas of good, evil and justice in a way that you just couldn't do in a more 'realistic' movie. It's the heightened reality of the Superhero Genre that makes it possible.

Oh, and if skin-crawling performances, complex storytelling, and profound ideas don't do it for you, did I mention that the film is completely badass? My only complaint is the protracted action scenes. They're brilliantly staged, but sometimes they go on so long that you can lose focus of precisely what you're supposed to care about. It's a very minor quibble. Seriously, just watch it.

THE SUNDAY MOVIES

Inception (USA/UK) (2010)
Director: Christopher Nolan
Stars: Leonardo DiCaprio, Joseph Gordon-Levitt, Ellen Page

When you go to sleep at night, your mind goes to strange places. It'll wander through your wildest fantasies, dig up darkest fears and inspire your best ideas. What if you could steal those thoughts? Leonardo DiCaprio is a man who specialises in a very unusual kind of corporate espionage: he has found a way to step into a person's dream and steal their ideas. But the real challenge is whether he can do the reverse. Can he *plant* a thought deep within someone's subconscious, and bury it under so many layers that the victim believes the idea was their own? And will he be able to avoid his own nightmares to get there?

Hollywood doesn't produce blockbusters as smart and inventive as this very often. *Inception* is the sort of movie that

demands you have your brain fully plugged in, and preferably well caffeinated. It is essentially a heist movie, with all the fun and pizzazz that comes with the genre, but instead of money or jewels, Nolan has made the goal something psychological — the power of our dreams. This gives him space to explore emotions, regrets, revenge and other meaty terrain while having a bit of 007-style fun as well.

Inception isn't perfect. The fantastic supporting cast of Joseph Gordon Levitt, Ellen Page and Michael Caine are all fairly underdeveloped, and any film like this is bound to have the odd plot hole. Still, the best thing about it is not even the movie itself but rather the conversation you have after the movie. Expect to waste hours on it.

Memento (USA) (2000)
Director: Christopher Nolan
Stars: Guy Pearce, Carrie-Anne Moss, Joe Pantoliano

The one-line pitch of *Memento* sounds like a Charles Bronson flick: our hero's girl is murdered and he sets off on a kickboxing/shooting rampage looking for revenge. The joy of *Memento*, however, is Christopher Nolan's unique approach to the story: reverse in told it's.

Memento opens with tortured soul Leonard Shelby (Guy Pearce) putting a bullet through the head of a man because the words written on a Polaroid have just told Leonard that this man is 'the one'. Leonard suffers from an unusual condition that prevents him from creating new memories. This means that any conversation or event he witnesses will be forgotten minutes after they've passed. Leonard's solution is to use photographs, Post-it Notes and sometimes even tattoos for important information while he sets about his goal. And that goal, in spite of his inconvenient mental state, is trying to track down the man who killed his wife. As it all

unfolds, you're forced to wonder who can really be trusted, and is anybody, including Leonard, really who they appear to be?

Guy Pearce gives a stunning performance as a man who's in a perpetual state of confusion. He feels betrayed by his memory and is constantly worried that he may have done something horribly wrong. Pearce makes this complex trauma seem real, but he also performs the role of Shelby in such a way that he is easy to empathise with.

I can't imagine the complex logistics of crafting a story like this where the narrative flows uphill. Yet Nolan somehow manages it beautifully. He intentionally places you inside the maze with Shelby.

Across all of his films, Nolan loves exploring characters whose internal emotional chaos is reflected in the world around them. The crime-ridden city of Gotham mirrors the traumatised soul of Batman. In *Inception*, DiCaprio literally constructs cities from his emotional anguish. However, for me, *Memento* distils this idea into its purest form. The script also says a great deal about the nature of memory, and how our memories make up a large portion of our identities. If our memory is faulty, what will become of us?

SOME OF MY BEST FRIENDS ARE BLACK

A BEGINNER'S GUIDE TO
INTERRACIAL CLASHES

Generally speaking, I am in favour of interracial couplings of all kinds: blacks/whites, Asians/Greeks, bacon/maple syrup, whatever. It all adds to the great tossed green salad of life.

Except in movies.

Yes, when it comes to interracial coupling, be it platonic or hanky-panky, I am as bigoted as Mel Gibson at a bar mitzvah with an open bar. Not because I dislike ethnicities being thrown together — I am indeed the result of one such union. It's simply because Hollywood makes such a goddamn mess of those relationships. Take one of Hollywood's most common tropes, the interracial buddy crime comedy. It almost always plays out the same: two men of different backgrounds/race are thrown together by sheer happenstance (by which I mean demographically minded marketing executives) and chafe on each other like two dried sticks until the spark of comedy is lit. But then, thanks to the winds of a common threat, they ultimately come to appreciate each other: cue the campfire of mutual understanding. And the audience? We warm our socially progressive hands and hearts in the flames of cross-cultural respect and start to sing 'Why Can't We be Friends?'. Then I think we do something with marshmallows … I'm not sure. I've run out of allegory.

Thankfully, there are a handful of films that either subvert this paradigm, drastically shift the trend or just pull it off well. There're all manner of great movies that have sprung from interracial clashes. So time now to grab someone of a different ethnicity, tape 'em to the couch and prepare to understand each other … and also be arrested for unlawful imprisonment.

FRIDAY NIGHT FILM

Borat (USA) (2006)
Director: Larry Charles
Stars: Sacha Baron Cohen, Ken Davitian, Luenell

Borat Sagdiyev (Sacha Baron Cohen) is a Kazakh TV presenter who has been approved by his government to make a documentary about America — or the 'US and A'. Starting his research and interviews in New York with his buddy/producer Azamat Bagatov (Ken Davitian), Borat watches *Baywatch* on a hotel television and shifts gear. He has a new quest: to meet, marry and maybe kidnap Pamela Anderson.

Except … Borat is a fake character making a mock documentary with real Americans.

Sacha Baron Cohen, who created Borat, Ali G and Brüno, is, in my humble opinion, a diabolical comedic genius. If you've seen any of his work, you'll know what his shtick is: he plays an outrageous character (in this case an anti-Semite, fashionless male) and interviews people without them being completely aware of what's going on, and he has truly refined it into a work of art here. He's not the first person to unleash a character like this on real, unsuspecting masses (Norman Gunston springs to mind), but

he crafts it so beautifully. Cohen is the master of stretching out awkward moments and clearly relishes making you squirm and laugh at the same time.

But what makes this such a truly impressive film is that it's not about Borat at all. This is a film about the madness of the USA, which Cohen draws out by inflicting Borat on innocent, hardworking American racists. Using his character, Cohen exposes bigotry, pillories celebrity culture and more.

SATURDAY FLICKS

Silver Streak (USA) (1976)
Director: Arthur Hiller
Stars: Gene Wilder, Richard Pryor, Jill Clayburgh

George Caldwell (Gene Wilder) is a poncy book publisher who meets a sassy secretary named Hilly (Jill Clayburgh) on a train ride from Los Angeles to Chicago aboard the *Silver Streak*. I mean no disrespect to this poor Hilly girl, but she really is very easy: Wilder somehow manages to seduce her with gardening information he has gleaned from his years of editing?! (Seriously.) If you're getting hot and bothered over secateurs then … actually, y'know what? Never mind. Just when it looks like *Silver Streak* is headed all stations to Light Romantic Comedy Central, a dead body dangles outside George's window.

Turns out the man is Hilly's boss and, while evading his killers, George is thrown off the train and teams up with African American Grover Muldoon (Richard Pryor), a thief who can hopefully help him reboard the *Silver Streak* and save Hilly.

Silver Streak was the first time Gene Wilder and Richard Pryor were ever teamed together on film. The combination gave us three

more pictures: *Stir Crazy*, *See No Evil, Hear No Evil* and *Another You*. The script itself, a charming send-up of Hitchcock movies, might not be side-splitting but it is very entertaining. However, the whole film lights up when Pyror enters, who was not even originally cast in the role.

Yes, this is the archetypal interracial buddy comedy, but it's also a demonstration of how to do it right. Wilder and Pryor have such a distinct chemistry that it still remains watchable more than thirty years after it was released.

Zorba the Greek (USA/UK/Greece) (1964)
Director: Mihalis Kakogiannis
Stars: Anthony Quinn, Alan Bates, Irene Papas

British author Basil (Alan Bates) decides to tackle his writer's block the only way he knows how: spending a wad of cash on travelling to a faraway location. He decides to return to Crete, the site of his late father's now-closed mine. There he meets Zorba (Anthony Quinn), an itinerant Greek labourer. Together they take lodgings with an ageing courtesan (making this just about the ripest ever set-up for a porn remake) and, to cut a long story short, Zorba hooks up with the courtesan and the writer finds himself attracted to a young widow. Meanwhile Zorba shares with the writer his homespun wisdom about the joys and tragedy of life as only a man with an impenetrably thick accent can (see also Yoda and Mr Miyagi).

Though I wouldn't classify *Zorba the Greek* as a comedy, there are big laughs to be had. Similarly, it isn't quite a drama but it does pack a punch in the gut when needed. Adapted from a novel by Greek author Nikos Kazantzakis, *Zorba* is a story about both the flaws and strengths of the human character. Writer, director and producer Michael Cacoyannis (or Mihalis Kakogiannis, if you're feeling authentic) does an admirable job of putting this notion at

the heart of the movie while the fractious, wandering plot helps make the movie feel alive and spontaneous.

And, of course, you can't talk about *Zorba* without mentioning Anthony Quinn's performance. The man of a thousand ethnicities, Quinn played Germans, Arabs and American Indians in his movie career. In the hands of a lesser actor, Zorba could've been completely over-the-top camp. Quinn keeps Zorba rooted in reality and his boisterous charm, joy, sorrow, exuberance and anger emerge from that.

And then, naturally, there's Zorba's iconic dance. Legend has it that the dance almost didn't happen. According to a few Quinn biographies, he had broken his ankle the day he was to perform an elaborate dance comprised of leaping and assorted wild moves, so instead Quinn improvised the now-famous subtle shuffle. Director Cacoyannis asked what kind of dance it was and Quinn replied it was a 'traditional' dance, which I'm pretty sure means he made it up.

THE SUNDAY MOVIES

2 Days in Paris (France/Germany) (2007)
Director: Julie Delpy
Stars: Julie Delpy, Adam Goldberg, Daniel Brühl

Ah, Paris: the city of love, the city of lights … also the city of fascist taxi drivers, fascist vegans and fascist vaginas.

Meet Marion (Julie Delpy) and Jack (Adam Goldberg). He's American, she's French. They've been together two years, live in New York and have just come back from a romantic holiday in Venice and are stopping off in her hometown of Paris for forty-eight hours. But between meeting her psycho ex-hippy family, encountering a raft of fast-food-hating terrorists and Marion's

many, many ex-boyfriends, things get messy. Chaos is unleashed as the couple spiral out of control in a city that is foreign to one and a little too comfortable for the other.

2 Days in Paris (written, directed, starring and even edited by Julie Delpy) does an excellent job of communicating a true, complicated, argumentative romance. Shot on relatively lo-fi digital video, *2 Days in Paris* bubbles with energy. Of course, none of it would work if the central relationship wasn't believable. Luckily, it is. As the couple bitch to each other, the tempo, tenor and wording of the arguments are completely on the money.

Lost in Translation (USA/Japan) (2003)
Director: Sofia Coppola
Stars: Bill Murray, Scarlett Johansson, Giovanni Ribisi

What do you do in a country where you don't speak the language, you don't know anyone and your life has come to a complete and utter standstill?

Lost in Translation, Sofia Coppola's follow-up to *The Virgin Suicides*, follows two lost souls in this same predicament. Scarlett Johansson is the bored young wife of a photographer working in Japan. Bill Murray is an ageing American movie icon who's in Tokyo to shoot a whiskey commercial. While staying at the same hotel they become inadvertent buddies, strangers in a foreign land with more than a few cross-cultural confusions.

This is really the kind of film that just 'exists'. The plot may be languid but it generally works because Coppola delivers great moments of spontaneity and joy, as well as some gentle, deeply human scenes with two people connecting.

Bill Murray employs his patented dry wit but he also offers one of his best dramatic performances to date, with a man worn at the edges. I suspect that Scarlet Johansson was cast in part because

of her resemblance to Sofia Coppola herself. Regardless, it works: she is luminous. And around them is the tapestry of Japanese culture both new (gaudy neon-lit streets) and old (the serenity of a Buddhist temple).

The relaxed pace of this film might frustrate you, but it's all part of the package: a gentle, unforced examination of a transient human connection.

MALE?
FEMALE?
OTHER?
A WEEKEND OF GENDER-BENDING

Genitals. For some they are the defining feature of one's existence. Porn stars Jon Holmes and Ron Jeremy spring to mind. But what if you are stuck in the wrong meat-suit? Gender-bending has long been a staple of cinema and plenty of actors have achieved enormous acclaim by dressing in drag and a sturdy pair of heels. Dustin Hoffman nabbed himself an Oscar for it in *Tootsie* while John Travolta discarded some unnecessary self-respect in the *Hairspray* remake.

However, it's far less common to find a film that genuinely explores what it means to live in between man and woman. One of the earliest attempts to explore the idea was Ed Wood's *Glen or Glenda* (1953). It involves a character called Glen wanting a sex change. This is all well and good but the rest of the film was a strange mixture of BDSM, scientific theories about hats and a dude with the power to control bison. Suffice to say that we've come a long way since then, so get ready to tuck your bits to one side and explore the many permutations of gender.

FRIDAY NIGHT FILM

The Adventures of Priscilla,
Queen of the Desert (Australia) (1994)
Director: Stephan Elliott
Stars: Hugo Weaving, Guy Pearce, Terence Stamp

There's something instantly iconic about that image of a glittering drag queen, sequins in the wind, perched atop a hot-pink bus, roaring across the red dirt of the Australian outback. It has etched its way into history — and by 'history' I mean the endless 'Greatest Aussie Film' montages that they whip out at the AFI awards every year.

Priscilla follows two gay drag queens: Hugo Weaving plays Tick/Mitzi (the one with a secret wife and son) and Guy Pearce plays Adam/Felicia (the obnoxious one whose mother is played by Margaret Pomeranz). Then there's Bernadette (Terence Stamp), a post-op transsexual woman who's recently lost her lover. Together they decide to set out from the relative safety of Sydney and head inland to the red centre of Australia: Alice Springs. The pink Priscilla bus conveniently breaks down a lot, meaning the three characters are afforded plenty of opportunities to hang out with the locals, ranging from a mail-order bride (who shoots ping-pong balls from her nether regions) through to outright homophobic miners.

The mid-nineties was a good time for popular Australian cinema; in quick succession *Strictly Ballroom*, *Muriel's Wedding* and *Priscilla* each made their mark. And although it ticked many of the obligatory boxes for Australian films at the time (stunning shots of the vast outback and the presence of Bill Hunter), there is so much more to *Priscilla*. There's dancing, and awesomely dirty jokes, and enough glitter to kill a man at ten paces.

Priscilla actually does a really wonderful job of exploring all of the variables that go into developing one's gender identity. See, while the biological 'bits' obviously have an impact there are also social, subjective and cultural expectations that come into play. *Priscilla* articulates each of these pressures in a charmingly glitzy fashion.

All that said, a lot of the joy of *Priscilla* comes from watching these two hugely different sides of Australian society (inner-city queer culture and outback Australia) interacting. Sure they clash, often in confronting ways, but then comes the moment when you see a drag queen dressed to the nines in one of the harshest deserts in the world — it's so weird, yet so harmonious.

SATURDAY FLICKS

Hedwig and the Angry Inch (USA) (2001)
Director: John Cameron Mitchell
Stars: John Cameron Mitchell, Miriam Shor, Stephen Trask

Surreal. Beautiful. Heartbreaking. Infectious. Gleefully perverse. Sarcastic. Caustic. Unflinching. Empathetic. Wildly inventive. And very, very, very funny.

These were the things I scrawled down the first time I watched *Hedwig and the Angry Inch*, a cabaret punk-rock opera about an East German trans woman and her desire to find completeness by singing to utter strangers in a chain of crap American seafood restaurants.

As a young teen, Hedwig (who was then known as Hansel) grew up in East Berlin and was obsessed with Western pop music including David Bowie. Hansel meets a black US soldier, Luther Robinson, and is wooed by his rich American delicacies (gummy

bears — or 'goooomy bears', as Hansel calls them). They fall in love and decide to marry. But the law insists that marriage must be between a man and a *woman*. So Hansel adopts his mum's name and has a sex change. Sadly the operation is botched, leaving Hedwig with an 'angry inch'. What follows is her amazing punk-rock life story.

Hedwig originated from a punk/drag show inspired by androgynous rockers like David Bowie. John Cameron Mitchell and Stephen Trask wrote the stage musical together, with the character of Hedwig loosely based on John Cameron Mitchell's own childhood babysitter and a series of people he knew growing up as an army brat in Berlin. The production grew into a cult theatre hit before it was transformed into a film directed by and starring Mitchell. Through elements of cabaret sass and trippy rock-opera visuals you become intimately acquainted with Hedwig's life as neither man nor woman. The film takes a few minutes to hit its groove, but by the time Mitchell dons a Farrah Fawcett bleached-blonde wig and starts belting out the ballad 'The Origin of Love' (about how male and female gender was created by angry lords splitting human beings in two) the film is utterly spellbinding.

Transamerica (USA) (2005)
Director: Duncan Tucker
Stars: Felicity Huffman, Kevin Zegers, Fionnula Flanagan

Felicity Huffman plays Bree, a pre-op transsexual who used to be known as Stanley. Bree is just one week away from getting the surgery that will seal the genital deal, when she discovers that she fathered a son seventeen years ago. Bree's therapist forces her to go visit him on the other side of the country. The problem is that her son, Toby (Kevin Zegers), has become a street prostitute with a taste for cocaine. Bree pretends to be a Christian missionary and agrees

to take Toby back with her but leaves out a few key details, like a) she's not entirely woman, and b) she's his father.

Transamerica actually explores a very complex subject but wraps it up in sweet and simple packaging. It looks and feels like your typical buddy road movie, complete with shots of cars driving off into the setting sun, visits to petrol stations, and so on. In actual fact, it deals with the emotions and logistics of being both transgender (Bree) and gay (Toby) in a surprisingly honest and genuine way. The best parts of this film are where the complex emotions of both characters are laid bare.

That's not to say *Transamerica* isn't funny — in fact, it's very funny, with a wonderfully dry sense of comedy that comes from the awkward situations. And if there's one thing this film has no shortage of it's awkward situations.

THE SUNDAY MOVIES

The Crying Game (UK) (1992)
Director: Neil Jordan
Stars: Stephen Rea, Jaye Davidson, Forest Whitaker

I'm not going to give away the twist of this movie. Though for many, the twist *is* this movie. In truth, there's so much more to *The Crying Game* than most people realise.

A team of Irish Republican Army terrorists kidnaps a British soldier, Jody (Forest Whitaker). If the government doesn't give in to their demands, he will be killed. The prisoner is put under the watch of Fergus, a morally conflicted Irish soldier. The two develop an uneasy bond. Jody asks Fergus to look after his lover, Dil, if something should happen to him. Indeed, something horrific does happen and Fergus is suddenly on the run. While hiding out in

London, Fergus seeks out Dil and, unexpectedly, falls in love with her. But he soon learns that you can't escape your old life, and his new one has some revelations of its own.

The Crying Game is all about misdirection. At every turn the plot confounds expectation and pushes in surprising directions. For starters, it takes two of the most divisive trends of Britain in 1992 — the 'troubles' in Northern Ireland and the emerging gay club culture — and melds them into a love story and a wildly popular one at that. The success of *The Crying Game* had a strong impact on the way movies were later funded. Its box office receipts suggested that the broader viewing public *would* see a film about almost any subject matter — if handled well. While it may be mostly known as the ultimate 'plot twist' film, it also offers a lot of complexity, humanity and drama. *The Crying Game* may defy your expectations, but it never cheats you.

Boys Don't Cry (USA) (1999)
Director: Kimberly Peirce
Stars: Hilary Swank, Chloë Sevigny, Peter Sarsgaard

It was the little independent film that could, and it won Hilary Swank an Oscar for portraying Nebraskan teenager Teena Brandon, the biological female whose life takes a horrific turn when she begins living as a male. Teena wants to be a man but cannot afford the operation. She is uncomfortable living as a woman and equally disatisfied with being regarded as a lesbian. And so Teena Brandon becomes Brandon Teena.

Brandon, irony of ironies, is the perfect guy. Not only does the town love him, he ends up in a relationship with local beauty Lana (Chloë Sevigny). But problems arise in the form of Lana's last boyfriend, the psychopathic John (Peter Sarsgaard).

Boys Don't Cry is a movie that is not so much 'watched' as 'experienced'. Director Kimberly Peirce utilises a visual language that

is quite sparse, cold even. It throws the psychological complexities of her characters into relief. To call Swank's performance anything other than stunning is unfair; she fills Brandon with so much heart, magnetism and vigour.

To be honest, *Boys Don't Cry* is an incredibly tough film to watch. The ending is shocking, but it leaves you with one awful thought: this is real. Inhumanity and brutality on this scale exists in our world.

MOTHER'S DAY
MOVIE MUMS YOU SHOULD
BE GLAD YOU DON'T HAVE

Happy Mother's Day! On this weekend, above all others, please be nice to your mum — if for no other reason than this: at least she's not one of these bitches.

The standard for batshit-crazy movie mothers is still largely measured against the berating Mrs Bates in Alfred Hitchcock's classic *Psycho*. Without giving too much away, let's just say if you can be this menacing and non-corporeal at the same time, you're doing well. Since then we've had a vengeful mother in the original *Friday the 13th* and a maternal nutter in *Carrie* who chose to show her Christian spirit by beating her daughter with a Bible and locking her in a closet. That'll teach her to show off her telekinesis!

Of course, you can't say the words 'insane', 'Hollywood' and 'mum' in the same sentence without mentioning the world-class bitch that was Joan Crawford. An ageing Crawford and her crazy eyebrows starred in 1964's *Strait-Jacket*, about a mother who's locked up in an asylum for two decades. After being released and reunited with her daughter, people mysteriously start turning up headless. Coincidence? Methinks not. Not only did Crawford play a wonderfully heinous mum, she also *was* one or at least that's what her biopic *Mommie Dearest* implies. *Mommie Dearest* is told through the eyes of her

adopted daughter. It's a camp classic, but in the grand annals of atrocious parenting, Crawford was just one of many …

FRIDAY NIGHT FILM

Serial Mom (USA) (1994)
Director: John Waters
Stars: Kathleen Turner, Sam Waterston, Ricki Lake

Beverly Sutphin (Kathleen Turner) appears to be the perfect housewife. Beneath the veneer, however, lies a boiling pot of stabby tendencies. And when she kills, she does so in a way that would make Martha Stewart proud.

Director John Waters was once famously dubbed the dirtiest filmmaker in the world (by himself). He first became known for gag-reflex-testing underground hits like *Pink Flamingos* (which featured a drag queen eating faeces — 'nuff said). Shortly thereafter Waters began experimenting with more mainstream genres and produced minor hits like *Hairspray* and *Cry-Baby*, a trend that culminated with *Serial Mom*. But while these later films *seem* more mainstream, they are in fact as subversive and shit-stirring as ever.

John Waters takes great pleasure in needling the delicate sensibilities of bigoted, uptight and conservative suburbanites, and *Serial Mom* is no exception. Both Waters and Turner appear to savour the opportunity to defile the Martha Stewart version of motherhood by spattering it with blood and gore. But it's more than that. *Serial Mom* is a broadside at American suburbia, the role of women and the way we glorify violence. The film seems to argue that the upscale suburbia depicted in *Serial Mom* places an unhealthy burden of perfection on women, the sort of pressure that could lead them to crack … and kill someone with a leg of ham. Waters also

136

sets his sights on America's obsession with crime. Western societies love to decry violent acts like murders, but we can't wait to hear all the details on the news.

I doubt if *Serial Mom* would've worked without this cast. Kathleen Turner appears as a faded beauty who's let a beige suburban existence drain her of life. She also manages to balance realism with high camp and helps make *Serial Mom* the killer satire that it is.

SATURDAY FLICKS

Postcards from the Edge (USA) (1990)
Director: Mike Nichols
Stars: Meryl Streep, Shirley MacLaine, Dennis Quaid

Meryl Streep plays a young Hollywood actress, Suzanne Vale, who's always lived in the shadow of her mother, an ageing star of stage and screen (rendered with diabolical glee by Shirley MacLaine). Streep's character is fresh out of rehab, so fresh you can almost taste the charcoal inside her mouth when she wakes from a night of having her stomach pumped. She is supposedly midway through filming a new movie and the production insurers insist that she must be kept in the care of her mother — who, coincidentally, is a raging alcoholic. MacLaine then sets about suffocating her daughter by controlling every aspect of her life. Fun times.

Based on a loosely autobiographical story by Carrie Fisher, ex-*Star Wars* leading lady and daughter of musical star Debbie Reynolds, *Postcards* is a look at psycho mums from the perspective of the ones they damage the most — their offspring.

Fisher's knowing and effortlessly bitchy dialogue is a riot (Man: 'I have feelings for you.' Streep: 'How many? More than

two?'). Mike Nichols' pacy direction moves scenes along with nurse-like efficiency. Above all, though, *Postcards* crystallises why a psycho mum is so scary: when you take that enshrined idea of unconditional maternal love and twist it into a dangerous thing, it messes with something elemental within us.

Precious (USA) (2009)
Director: Lee Daniels
Stars: Gabourey Sidibe, Mo'Nique, Paula Patton

Put yourself, if you can, in the shoes of a sixteen-year-old black girl living in Harlem in 1987 for a moment. You are enormously overweight. You're basically illiterate. Your mother is a horrific bitch who sits on her endlessly expanding arse and collects welfare cheques. You happen to be pregnant — for the second time. And here's the kicker: the father is a junkie … who is also your own dad.

What.

The.

Fuck.

No human should have to deal with *any* of this, but this is all part and parcel of being Claireece 'Precious' Jones. *Precious* is actually based on a novel called *Push*, which was written in an unusual stream-of-consciousness prose style that aimed to put the reader inside the head of Precious. The movie interprets that by giving the audience an inside view of Precious's constant hallucinatory panic attacks where she steps out of reality and imagines herself as a booty dancer in a Salt-n-Pepa video clip.

Precious is beautifully directed with camerawork that gets you right into the personal space of the characters. The rich, gaudy colours and pools of light highlight everything from the grime of their home to the sickening grease on the food they eat. However, it's the casting and acting that you will remember about this film.

Newcomer Gabourey Sidibe as Precious has a face that seems to be halfway between that of a pit bull and an emotional brick wall, designed to block out every abusive, hateful thing said to her. That said the movie is absolutely stolen by Precious's mother Mary, played by Mo'Nique. She rips into her part with a monstrous rage that's nothing short of terrifying. She's so hateful, so dangerous, so shifty you want to kill her.

THE SUNDAY MOVIES

Mother (South Korea) (2009)
Director: Joon-ho Bong
Stars: Hye-ja Kim, Bin Won, Ku Jin

Respected Korean TV actress Hye-ja Kim stars as Mother, a woman whose reason for living is her 27-year-old son, Yoon Do-joon (Bin Won). Yoon is very slow, very horny, a part-time drunk and a professional dickhead. One should avoid calling him retard, though, as he does not take well to that. Yoon lives at home and sleeps in the same bed with Mother (which is not at all creepy, right?).

One night Yoon Do-joon follows a young girl through the streets after a bender but he loses her in a dark alley. The next morning, she is dead in a very public fashion. He can't remember the events of the night prior. The police reckon he looks guilty enough and so Yoon is arrested. This sends Mum into overdrive. In spite of a corrupt defence lawyer, heavy bureaucracy and an especially unhelpful confession of guilt by Yoon, Mother takes it upon herself to clear her son's name.

Korean director Joon-ho Bong became quite well known for his eco-thriller/family drama *The Host*. Joon-ho leaves all the clues to this murder mystery out in plain sight for you, so consider every

detail. Just when you are certain you know how *Mother* is going to play out, it twists around on itself and heads off in even stranger directions. Joon-ho is a master of mixing genre cocktails (murder mystery? family drama?) and then exploding your expectations of them. By reconstructing the remaining narrative from the shards of familiar structures he creates something wholly new but accessible at the same time.

Oh, and once everything locks into place and its secrets are finally revealed, the film almost demands an immediate repeat viewing. *Mother* is a great puzzle.

Bad Boy Bubby (Australia) (1993)
Director: Rolf de Heer
Stars: Nicholas Hope, Claire Benito, Ralph Cotterill

Bubby (played by Nicholas Hope, who looks freakishly like Hugo Weaving) has been locked in a squalid apartment for thirty-five years by his mother. She is a pleasantly plump woman (read: obnoxiously obese bucket of lard with legs) who physically, emotionally and sexually abuses Bubby for no conceivable reason. When Bubby is not torturing his pet cat, guzzling down soggy bread for tea or cowering under a wall-mounted crucifix, he is made to satisfy his mother's sexual needs. Bubby has never stepped foot outside the cramped two-room favela he shares with his mum — that is, until his absent father (Ralph Cotterill) makes a surprise return. Bubby is eventually forced out of the apartment and must now fend for himself in a world he does not understand.

Bad Boy Bubby is surely one of the most depraved images of motherhood ever committed to screen. Director Rolf de Heer, known for his generally unkind portrayal of families in films like *Alexandra's Project*, takes archetypal 'motherly' traits like nagging and amplifies them to the point of being violent.

If you're struggling through the claustrophobic first act in Bubby's squalid apartment, fear not. *Bad Boy Bubby* lightens up considerably as he heads out into the big bright world, with his puppy-esque wonder.

It's a difficult film to watch at times, but all of the movie's unfathomable cruelty only serves to make Bubby's journey to liberation so much more potent. Bubby is de Heer's mirror to society, Bubby is the flat surface that spits everything back at the people he meets. *Bad Boy Bubby* is a chilling, enlightening and compelling image of urban Australia, as reflected through one of its victims.

WALKING AND TALKING WITH AARON SORKIN

The year was 1999. The Monica Lewinsky scandal was dominating Bill Clinton's administration, Republican Presidential candidate George W Bush was gaining traction and left-leaning Americans were dreaming of ... something else. Let's face it, at this point they'd settle for anything else. Enter *The West Wing*. With a fictional Democrat president you could believe in and his fast-talking, fast-walking staffers, *The West Wing* was like political porn and audiences lapped it up. For most of us here in Australia this was the first time we took notice of a writer named Aaron Sorkin.

The seven seasons of *The West Wing* earned creator Aaron Sorkin cult status, but there are plenty of other dramas in the Sorkin collection. This weekend is cheating a little as it includes some TV series in their entirety — hence only three entries for the next few days. Take the weekend to try 'em out. Sample a few episodes and see if you like 'em.

FRIDAY

Sports Night (USA) (1998–2000)
Creator: Aaron Sorkin
Stars: Josh Charles, Peter Krause, Felicity Huffman

In 1998, Aaron Sorkin created his first TV series, *Sports Night*, a comedy/drama set in a TV studio where a group of sports nuts

produce a nightly sports news program. The show centres around the two news anchors, Casey McCall (Peter Krause) and Dan Rydell (Josh Charles), and their producer Dana Whitaker, played brilliantly by Felicity Huffman. Aaron Sorkin loves fast-paced dialogue more than sports and this drama focuses on the politics of the office more than the action on the basketball court.

The first season takes a while to hit its groove. You can feel Sorkin trying to find his feet throughout the first few episodes. The American ABC network insisted he use a laugh track for the first season. It's awful but it gradually fades away throughout the season. What's more interesting is that you can see Sorkin experimenting with techniques that he would later be synonymous with, like *The West Wing*'s famed 'walk and talk', with actors delivering rapid-fire dialogue while strutting around endless hallways like mice looking for some mythical cheese.

In the end the show struggled to find an audience and, after two seasons, ABC pulled the plug. A couple of other networks offered to pick up the series but Sorkin had bigger fish to fry … which brings us to the next instalment in the Sorkin Files.

SATURDAY

The West Wing (USA) (1999–2006)
Creator: Aaron Sorkin
Stars: Martin Sheen, Rob Lowe, Allison Janney

So let's say for argument's sake that you've worked your way through the 1152 minutes of drama *Sports Night* had to offer. Next up, *The West Wing*.

Set in the White House, *The West Wing* charts the two terms of the fictional Bartlet administration. Initially Aaron Sorkin planned

to build the show around the White House staffers with President Bartlet in an unseen or at least secondary role. But as the first season progresses, President Bartlet's (Martin Sheen) screen time grows and the show is stronger for it. For Democrat-supporting Americans during George W Bush's administration, *The West Wing* was a portrayal of everything their president could be … but wasn't.

With so many episodes to get through, the full *West Wing* box set is an epic challenge, but well worth it. By season three or four you'll be feeling like the characters are old friends. Despite Sheen's commanding performance, *The West Wing* is an ensemble piece. Any diehard *West Wing* fan has a favourite character, whether it's sassy press secretary CJ Cregg (Allison Janney), charismatic deputy chief of staff Josh Lyman (Bradley Whitford) or Toby Ziegler (Richard Schiff), the moody speech writer.

It's also a relatively educational experience. Aaron Sorkin hired a number of ex-Clinton staffers to consult on the drama. Former White House employees have described it as capturing 'the feel of the White House, shorn of a thousand undramatic details'. The last two seasons focus on the rise of Hispanic presidential candidate Jimmy Smits, which has a more than passing resemblance to Barack Obama's presidential race, despite predating it.

SUNDAY

Studio 60 on the Sunset Strip (USA) (2006–2007)
Creator: Aaron Sorkin
Stars: Matthew Perry, Amanda Peet, Bradley Whitford

At its height *The West Wing* was attracting an audience of about 17 million in the US alone (Australia, I remind you, has a population of around 22 million). So naturally there was plenty of pressure for

Aaron Sorkin's follow-up drama to be a similar success. Unfortunately, *Studio 60 on the Sunset Strip* didn't quite live up to the hype.

For this series, Sorkin returned to the TV studio for a setting. *Studio 60*, a drama about the making of a late-night live sketch comedy show, centres around the duo who write and produce the show, Matt Albie (Matthew Perry) and Danny Tripp (Bradley Whitford, who also played Josh Lyman in *The West Wing*).

The show premiered around the same time as Tina Fey's similarly themed *30 Rock* and, although one program is a drama and the other is a comedy, they cover a lot of the same territory. *Studio 60* is very funny and very smart, but it does suffer a few glaring problems. Firstly, for a show about sketches, none of the sketches seem terribly funny. Also, all the characters are prancing around like they are curing cancer or securing peace in the Middle East. One can't help but feel that if Sorkin set the show in, say, Jon Stewart's *Daily Show* (or something like that) he would've had greater licence to explore the political territory he is so very good at covering.

The drama is more than a little autobiographical: Matt Albie's struggle with drugs mirrors Sorkin's reported love of class A drugs and shrooms, and Matt Albie's on-again off-again relationship with Studio 60's leading lady is loosely based on Sorkin's own relationship with *West Wing* actress Kristin Chenoweth.

The drama did receive some critical acclaim, but it failed to find an audience and was axed after one series. Despite its faults, *Studio 60* is still worth watching. Aaron Sorkin's scripts are tight and funny and a couple of episodes (like the Christmas one) are extremely well written.

IT'S NOT A WEEKEND, IT'S A WRINKLE IN TIME

HOW TO TIME TRAVEL (ACCORDING TO FILMS)

Time travel has been a staple of fiction since … God only knows. And even if He did, He wouldn't tell us lest we irreparably damage the fabric of the space–time continuum. Apparently the notion of time travel dates back to ancient Hindu mythology. The seminal epic *Mahabharata* tells the legend of King Revaita, who travels to a different world to meet the creator Brahma and is surprised to learn that many ages have passed when he returns to Earth. Though to me, that just sounds like jet lag. In any event time travel is a beloved trope of storytelling, from HG Wells to *Doctor Who* to the Governator himself in the *Terminator* movies.

In order to pull off a truly great time-travel movie, with its endless potential paradoxes, you need an incredibly sharp mind for plotting. If you can craft a clever narrative with perfectly timed set-ups and payoffs, you could have a classic on your hands. It doesn't matter what your method is, be it a DeLorean (*Back to the Future*), a nudifying ball of icy lightning (*Terminator*), slingshooting around the sun (*Star Trek IV*), a dwarf-infested wardrobe (*Time Bandits*), falling asleep after getting drunk with your white-trash friends (*Peggy Sue Got Married*) or,

my personal favourite, a *Hot Tub Time Machine*, time travel can make great cinema.

So, dash the Epsom salts into the hot tub as we do all kinds of inappropriate things to a flexible and impressionable space–time continuum …

FRIDAY NIGHT FILM

Back to the Future (USA) (1985)
Director: Robert Zemeckis
Stars: Michael J Fox, Christopher Lloyd, Lea Thompson

Well, how can you not start here? Marty McFly (Michael J Fox) is a preposterously named teenager who is sent back in time from 1985 to 1955. He meets his parents in their high-school days, where his mum accidentally falls in love with him (a plot point that proved a sticking point for movie studios when they tried to shop the original script around). Marty is then forced to fix the changes he makes in the timeline by ensuring that his parents hook up. Then, to make matters worse, he and crazy scientist Dr Emmett 'Doc' Brown must find a way back to 1985.

The idea for *Back to the Future* germinated when writers Robert Zemeckis and Bob Gale wondered what it would be like if they and their dads attended school at the same time: would they have been friends? Enemies? Who would've bullied who?

Director Robert Zemeckis spun their script into a relatable tale with great visual gags and lovable characters. *Back to the Future* is the movie that turned Michael J Fox from a TV actor into a film star, but it nearly didn't. Originally, Eric Stoltz was cast as Marty (Michael J Fox was busy playing Alex Keaton on the TV series

Family Ties). Not long into production, the filmmakers dropped Stoltz (his original footage is all over YouTube and it's hard not to agree with them). Fox was subbed in and the rest is history.

Not only is *Back to the Future* wonderfully funny, visually inventive and iconically eighties, it also has near-flawless plotting. There are set-ups for plot twists in the first movie that aren't paid off until the third film. In fact, every single plot point and line of dialogue becomes important at some time later in the series. You don't often see crafting like this in Hollywood blockbusters.

SATURDAY FLICKS

Twelve Monkeys (USA) (1995)
Director: Terry Gilliam
Stars: Bruce Willis, Madeleine Stowe, Brad Pitt

The world is coming to an end. Mankind has nearly been wiped out by a virus. We've all been driven to live underground. But there *is* a solution: a time machine. If we can go back and stop the virus then we can all be saved. Right? The government, in their infinite and callous wisdom, opt to use a convict named James Cole (Bruce Willis) as their time-travelling guinea pig. Cole is sent on missions to the past to collect information on the Army of the Twelve Monkeys, the terrorist organisation thought to have released the disease. This arduous task is made even more difficult by Cole's recurring childhood nightmares about a shooting in an airport.

Twelve Monkeys was inspired by a groundbreaking twenty-eight-minute short film called *La Jetée* by Chris Marker. Made in 1962 and composed almost entirely out of still images, it told the story of a prisoner in post-apocalyptic Paris where scientists had developed time travel 'to call on past and future to the rescue of the

present', but the process itself seems to have an unfortunate effect on people's mental stability.

Filmmaker Terry Gilliam is crazy. And if he's not, then he is far too good at channelling crazy in his films. Whether it's his work with Monty Python or his abortive attempts to make his Don Quixote film (see the 'How not to make a movie, according to movies' chapter), Gilliam has demonstrated, at the very least, that he is more than capable of communicating insanity on a big screen. *Twelve Monkeys* explores the mental damage done by time travel and shows a world racked by nightmarish technology (I especially like the interrogation set-up made of multiple TV screens with disembodied voices). As Gilliam told *Sight & Sound* magazine, 'To me that's the world we live in, the way we communicate these days, through technical devices that pretend to be about communication but may not be.'

Timecrimes (Spain) (2007)
Director: Nacho Vigalondo
Stars: Karra Elejalde, Candela Fernández, Bárbara Goenaga

Pick any single hour of your life and the chances are you couldn't chart every little decision you made in it. Imagine if you had to go back into a past hour and unpick those decisions, again and again …

Timecrimes is a massively underrated gem. A middle-aged Spanish man has just moved into a beautiful new villa. While he's chilling out on the back porch with his binoculars he spies a beautiful naked woman (as you do). Like any aspiring sex-pest, he goes to investigate. Suddenly he finds himself being stabbed with a pair of scissors. Soon it becomes obvious that he has stumbled into a time loop with multiple versions of himself. His survival now hinges on making sure that the loop goes to plan.

Directed by tastily named filmmaker Nacho Vigalondo, *Timecrimes* is a genuinely intelligent and gripping time-travel flick.

It's based on the scientific notion of self-causality: for every result there is a preceding cause. Nothing can exist without a catalyst, but what if the event from the *past* was caused by a figure from the *future* going back in time putting the events into a sort of loop? *Timecrimes* is cleverly plotted, extremely tense but also dryly humorous at times, with a lot of very human dilemmas that come with potentially tragic outcomes. At first *Timecrimes* is a little infuriating in its complexity, but as soon as the story gets going and the loop tightens on our hero you will be hooked. I recommend watching *Timecrimes* with other people so you can all unpick it together.

THE SUNDAY MOVIES

Primer (USA) (2004)
Director: Shane Carruth
Stars: Shane Carruth, David Sullivan, Casey Gooden

A word of warning: I have watched *Primer* three times and I still can't explain exactly what happens in it. But I still love it.

Made for just US$7000, *Primer* is a movie about two engineers working in Texas who are developing anti-gravity technology in their backyard laboratory. It's there that they stumble across a method to untether oneself from time. Jazzed just by the very thought, the boys start stealing bits of copper tubing out of the back of their own fridge to construct 'the box'. The consequences are not what anyone expects.

Primer was written, directed and produced by Shane Carruth, a mathematician and former engineer, and he does absolutely nothing to pander to the audience. Everything from the clinical cinematography to the inquisitive score builds with a quiet intensity. There're no fancy special effects, no computer-generated time-

travel dooverlackie. Instead you have hardcore speculative fiction at its intense best. *Primer* is a smart movie, and it demands that you are too. Carruth's script throws in shorthand phrases and jargon used by real working scientists. You don't necessarily understand everything that is said, but you follow it enough to understand the *weight* of their actions. These aren't well-funded government scientists. They are smart, normal guys who drink beer and pay rent.

The fact that this drama is based on such ordinary people forces you to wonder how *you* would cope with the power to shift through time and the moral implications of having this kind of control. Even if you don't understand precisely everything in *Primer*, you'll probably end up feeling smarter for just watching it. *Primer* is a confounding, mind-opening piece of work, provided you have your head screwed on tight today.

Donnie Darko (USA) (2001)
Director: Richard Kelly
Stars: Jake Gyllenhaal, Jena Malone, Mary McDonnell

Donnie Darko (Jake Gyllenhaal) is a troubled teenage boy growing up in the 1980s. He sleepwalks at night and has some fairly intense hallucinations about a giant bunny called Frank. Frank advises Donnie that in twenty-eight days, six hours, forty-two minutes and twelve seconds the world will come to an end. Shortly thereafter a jet engine crashes into Donnie's bedroom — it's as though fate wanted to put a big exclamation point on the end of its threat of global destruction. Luckily, Donnie is not in the bedroom at the time, and so begins the countdown to the end of time. To tell you any more about the plot would be giving it away, but let's just say that time travel does figure in all this somewhere.

Donnie Darko is a divisive movie. There are those who think its vague ending and plot turns are the mark of a filmmaker who has

a lot of good small ideas but no grasp of how to actually tell a story. This is a completely reasonable argument, somewhat supported by director Richard Kelly's follow-up films, which have been so bad and illogical that they could kill unicorns. That said, I would argue that *Donnie Darko* is not a vague film but one that is open to interpretation, and that's part of the fun of it. It never fails to make me laugh with its wonderfully crafted scenes of awkward humour, like Donnie's sister's dance recital, or Mrs Farmer, the anally retentive PE teacher. It's also a film where you can allow yourself to get lost in the sheer beauty of the imagery and sound design. And it tugs at the heartstrings — my heart breaks for Donnie's aimless and disturbed soul.

However, the reason I really love this film is that every time I watch it, I gain something new from it, which in turn changes my interpretation of the ending. In that sense it's a film that keeps on giving. Sit back and let it wash over you, then decide just how far down the rabbit hole you want to go.

NICOLAS CAGE
LOSER AT LARGE

Nicolas Cage is a nutter. Actually, to be more accurate, Nic Cage is at his best when he plays a nutter. Nic Cage is the king of portraying characters on the edge of their own self-inflicted insanity. This, my friends, is where Nicolas Cage is at his most 'Cage-iness'. Sure, the man has made his fair share of shit. Recently there's been a rash (and I use the term in a very literal sense) of irritating family-friendly Disney flicks. But when Nicolas Cage is at his volatile best, it's an amazing thing to witness. Whether he's playing a crazed policeman (*The Wicker Man*) or, um, a crazed policeman (*Bad Lieutenant: Port of Call — New Orleans*), there's always a small part of you that knows you're watching Nic Cage *playing* a crazed policeman. And that makes it all the more special. He projects the image of a man crumbling on the inside, but he does it with such style. Please now enjoy the single greatest loser in the pantheon of modern Hollywood: Nicolas Cage, loser at large.

FRIDAY NIGHT FILM

Lord of War (France/USA/Germany) (2005)
Director: Andrew Niccol
Stars: Nicolas Cage, Ethan Hawke, Jared Leto

There are enough guns in the world to provide one for every twelve human beings; *Lord of War* is about the guy who wants to

arm the other eleven people. Cage plays Yuri Orlov, a Ukrainian immigrant who grew up in the ghettos of Brooklyn, where people get shot every day. One day it dawns on him: guns make the world turn. And so, along with his brother, played by Jared Leto, Yuri grows into one of the single most successful gunrunners in the world.

Nicolas Cage was the perfect choice for this role; he has a way of seeming both absolutely calm and deeply distressed at the same time. Yuri is your uber-charming guide to the weapons of mass destruction, ones that are bought and sold like Happy Meals. He's humorous and the movie is actually very peppy, though every now and again it surprises you with a scene depicting the horrific destruction that Yuri's wares cause. As Yuri's lifestyle begins to implode, the film becomes enveloping.

Lord of War comes from Andrew Niccol, who wrote *The Truman Show* and directed *Gattaca*. Here Niccol has generated a visually creative and clever Hollywood drama, laden with killer lines, like: 'After the Cold War, the AK-47 became Russia's biggest export. After that came vodka, caviar and suicidal novelists.' And whilst the film does become a tad preachy on the anti-gun side, it is at its best when satirising the violent, nihilistic side of human nature.

SATURDAY FLICKS

The Weather Man (USA/Germany) (2005)
Director: Gore Verbinski
Stars: Nicolas Cage, Hope Davis, Nicholas Hoult

Nicolas Cage plays — no great surprise here — a weather man for a Chicago TV station, David Spritz. His life is the very definition of mediocrity. He's just been divorced, his daughter is overweight

and, like most weather men, he doesn't really know anything about weather, he's just real good at reading off an autocue.

But there are these two opposing pressures in his life. One is his father, who was a brilliant writer and excellent father, something Spritz doesn't feel he lives up to. The other is that he's up for a job as a national weather man on a morning TV show.

A movie about mediocrity? Wow, that sounds exciting. What makes *The Weather Man* so entertaining is how Spritz chooses to overcome his mediocrity: with the most radical responses he can muster. As the film progresses, it serves you one ordinary situation that Spritz responds to in increasingly bizarre ways. The more unpredictable and left-field these reactions are, the better the movie gets. And yet *The Weather Man* is also tempered by a tremendous sadness. The best moment in the movie sees Spritz and father Robert Spritzel (Michael Caine) doing nothing more than sitting in a car, listening to the bruised lyrics of Bob Seger's 'Like a Rock'. This scene captures what's so special about *The Weather Man*: it's the sad comedy of it all, a kind of beige-coloured beauty.

The Bad Lieutenant: Port of Call — New Orleans (USA) (2009)
Director: Werner Herzog
Stars: Nicolas Cage, Eva Mendes, Val Kilmer

'Whatever I take is prescription. Except for the heroin.'

New Orleans policeman Sergeant Terence McDonagh (Nicolas Cage) has just gotten himself promoted to lieutenant, via an act of bravery just after Hurricane Katrina. He jumped into the muddy, dangerous waters at a flooded jail to save a prisoner. He injured his back in the process and McDonagh is now addicted to painkillers. This would be no big deal except he's already addicted to just about every other drug on and off the market.

Then McDonagh gets a big case. A clan of Senegalese immigrants — parents, grandmother and two young children — is slaughtered. But who cares, right, when you've got to keep up with your high-maintenance, high-class prostitute girlfriend (Eva Mendes) and a dad who's sinking the piss with extreme prejudice?

Technically this movie is a remake of the great nineties film *Bad Lieutenant* that starred Harvey Keitel. Try to forget that movie exists. It's not bad, but this film has almost nothing to do with it. Cage plays his role in all of his over-the-top glory. He's fascinatingly deranged; sometimes even annoyingly so. Apparently he was inspired by Watergate-era Richard Nixon, with his jowly face and stooped posture. *Bad Lieutenant: Port of Call — New Orleans* has a very seventies vibe to it, with its loopy, almost incidental murder mystery and insane anti-hero. It happily jumps between comedy and drama, with the absurd humour emerging the clear winner.

Ahem, keep an eye out for a scene with an iguana. Amazing.

THE SUNDAY MOVIES

Leaving Las Vegas (France/USA/UK) (1995)
Director: Mike Figgis
Stars: Nicolas Cage, Elisabeth Shue, Julian Sands

Based on a semi-autobiographical novel by John O'Brien, Nicolas Cage plays Ben Sanderson, an alcoholic who has decided to commit suicide. Sanderson has wrapped up the loose ends of his personal and professional life, and now he is free to drink himself to death in Las Vegas. The problem is that he's just made friends with a hardened prostitute, played by Elisabeth Shue.

The cover of this movie calls it a comedy/romance …

The cover lies.

Whilst it definitely isn't a comedy, you'd have to say *Leaving Las Vegas* is quite funny. The movie is also beautifully acted, cleverly crafted, and sometimes even joyous. And in the middle of this self-destructive predicament is Cage, with his staggering talent for playing the ultimate loser.

The original novel by John O'Brien was an exercise in deliberate depression, and O'Brien himself committed suicide two weeks after production of the film began. A halt to production was considered, but work continued as a tribute. Director Mike Figgis manages to release some of the madcap maudlin energy of O'Brien's writing and imbues the movie with a sense of — for want of a better word — life.

The movie is mostly sleazy without being sexy, which I gather is a pretty appropriate analogy for Vegas itself. There certainly isn't anything romantic about the way Sanderson drinks (he's basically impotent). As an examination of alcohol addiction, the movie is stunning and horrifying. *Leaving Las Vegas* is a film that pours your heart into a glass and you never get it back.

Adaptation (USA) (2002)
Director: Spike Jonze
Stars: Nicolas Cage, Meryl Streep, Chris Cooper

Charlie Kaufman (Nicolas Cage) hates himself. And I don't blame him. He's a failed screenwriter who has been hired to adapt *The Orchid Thief* by Susan Orlean (Meryl Streep), wandering tale about passion and botany, into a screenplay. His new script, unsurprisingly, is going nowhere. Charlie's frustrated mood is not helped by the arrival of his twin brother, Donald (Nicolas Cage, again), an affable dickhead who also wants to be a screenwriter. Donald's approach is to write to the Hollywood formula and collect the cash. Amidst all this Charlie begins to re-imagine *The Orchid Thief*. His new vision

of the film will bring in the book's author as a character who has an encounter with the clever redneck John Laroche (Chris Cooper). Whilst Orlean's book may not have much by way of story, it does imbue each of the characters with a tangible sense of obsession. Laroche fixates about his flowers, scouring dank swamps for elusive orchids, while Orlean is fixated on Laroche. Somewhere in this meta-story lies the passion that Charlie wants to bring out onto the page, and so Charlie writes himself into their story in the hope that his character can find it.

So, just to clarify: Charlie Kaufman is a real writer, he really wrote a movie named *Being John Malkovich* and he really wrote this film. There is a real Laroche and a real Orlean. Everything else is a figment of (real) Kaufman's imagination. *Adaptation* steers into and around multiple meta-narratives and allegories. Kaufman definitely identifies and captures some of the spirit of the book but he then goes further to explore deep philosophical questions about fiction and adaptations.

If *Adaptation* falls down anywhere, sometimes it feels more like an intellectual exercise rather than a movie you can get lost in. That said, it's an intriguing and stimulating film. Plus, Nic Cage playing two fat men with receding hair and sweaty palms is epic loser-dom.

HOW TO BE ROYAL
(ACCORDING TO THE MOVIES)

Your royal highness, for this weekend you shall be feted with jewels, rich foods and scented dooverlackies. My liege, you shall be entrusted with wisdom to rule a nation, an army to collect other nations ... oh, and a harem of gender-nonspecific beauties that replenishes itself like a packet full of Tim Tams. Downside? I suspect the first time you mistake Camilla Parker Bowles for a corgi will be rather awkward. And you will probably be killed by/married into your own family. But hey, the royal headgear is still good, right?

Royalty is nothing if not naturally cinematic. There's pomp and circumstance, high stakes, embarrassing wealth and a general sense of importance to these movies. Not only are they popular with moviegoers, royalty flicks are often quite Oscar-baity. While many of the movies within this genre are stuffy ye-olde wanks about obnoxiously unlikeable monarchs, some are rather good. So, assume your cushy throne and prepare to learn the art of royalty according to film.

FRIDAY NIGHT FILM

The King's Speech (UK) (2010)
Director: Tom Hooper
Stars: Colin Firth, Geoffrey Rush, Helena Bonham Carter

The role of a monarch is largely a symbolic one. You have to rock up, embody the strength of a nation (wearing medals and a sash

help) and then maybe give a few speeches. Easy.

Unless, you have a speech impediment.

Queen Elizabeth II's dad George VI (Colin Firth) was never meant to be king. Back in the 1920s he was second in line, and just as well because he suffered from a terrible stammer. Thanks to his elder brother's unpopular taste in women, George (or Bertie, as he was known to some) reluctantly ends up with the gig of official realm-ruler in 1937, coinciding with the lead-up to World War II. Sometimes power is a burden thrust upon the unsuspecting. King George and his wife, Elizabeth (Helena Bonham Carter), turn to a slightly bonkers Australian speech therapist (Geoffrey Rush) for help.

The King's Speech is a clever, funny, moving flick. The film also looks beautiful. It would've been very easy to shoot this like a stodgy period piece, but instead director Tom Hooper uses odd camera angles and framing that give the movie an undercurrent of crazy that suits Rush's character to a tee.

However, *The King's Speech* owes the majority of its success to its cast. There's Geoffrey Rush as a failed Shakespearean actor turned pushy speech therapist, Helena Bonham Carter as Queen Elizabeth has a deliciously droll English wit (it's also a rare pleasure to watch Bonham Carter portray someone who's not a sociopath), and then, of course, you have Colin Firth. Look, let's not mince words, when an actor agrees to play both a historical figure *and* a character with a speech impediment, it's because they want to win themselves an Oscar. But in this instance, Firth really did deserve one. Bertie is an uptight, emotionally shattered man. Throughout the movie he begins the slow process of gluing himself back together again. There is something visceral about watching Firth overcome his speech impediment. You find yourself hanging off the chair, willing him to get the words out.

SATURDAY FLICKS

The Queen (UK) (2006)
Director: Stephen Frears
Stars: Helen Mirren, Michael Sheen, James Cromwell

Fast-forward to Bertie's daughter, Her Royal Highness Queen Elizabeth II. In spite of its name, *The Queen* is less a movie about the woman than it is about the institution of the monarchy and the crisis of relevance it suffered in the wake of Princess Diana's death in 1997.

In this version of events, Diana was widely regarded to be an annoyance within the Royal Family. When she is killed, the Queen hides away at Balmoral with her two grieving grandsons. The public cry out for their monarch to validate the worldwide mourning for Diana, but Her Majesty stubbornly refuses to do so. It comes down to the new British Labour Prime Minister Tony Blair to coax her round and persuade her into a new way of thinking about how the Royal Family relate to the British people.

Director Stephen Frears keeps you very close to the players in this film: Blair, the Queen and grumpy Prince Philip. The only taste of the outside world comes from real news footage of the era, the effect of which is twofold: the reports instantly transport you back to the event to recall where you were when you first saw that same news footage, but by blending the real images with this imagined drama it also legitimises Frears' version of events.

However, *The Queen* is at its best when examining the value of the monarchy as a symbol. You see the Queen struggling with what she believes the British people want of her — quiet, restrained mourning — while the film supposes that is quite the opposite of what they wanted. Frears implies that the nation needed its

monarch to represent them and their sadness. This presents a unique challenge for a staid woman who survived World War II with her upper lip unflinchingly stiff. Full credit to Helen Mirren for bringing this psychology to life; she makes stoicism cinematic with the emotion sitting just below the boilerplate.

The Queen is a thoughtful movie and a great exercise in manipulating history and imagination into a very watchable cocktail.

Elizabeth (UK) (1998)

Director: Shekhar Kapur

Stars: Cate Blanchett, Geoffrey Rush, Christopher Eccleston

The next all-important lesson of royalty is this: never forget that you have no job security.

Elizabeth I was the controversial queen who was variably described as a heretic, a whore and 'that chick without eyebrows'. Cate Blanchett portrays Elizabeth over several decades, so we see her transform from a young princess in exile into plaster-faced alabaster monarch. We witness Elizabeth barely escaping execution at the hands of her sister Mary, played by what appears to be a blancmange in a corset. Why such murderous sibling hatred, you ask? Religion. Mary, you see, is Catholic and Elizabeth is Protestant. When Elizabeth is finally installed as queen she takes some early missteps (how else would you describe sending a thousand men to be slaughtered by an angry French woman?). She proves to be even worse at speed-dating as her advisors rush to find her a husband so that she can squeeze out some over-privileged heirs and solidify her hold over the throne. This heady business of marriage and governance is, however, of little interest to Queen Elizabeth. She is far too busy getting her nether regions fiddled by nobleman Lord Dudley (Joseph Fiennes) — or, as I've dubbed him, Sir Puffy Pants.

Cue the soft-focus rumpy-pumpy. Elizabeth is soon betrayed and plotted against, and then she meets a cross-dressing French prince.

Blanchett (in her star-making role) can pack so much emotional detail on her pasty face with just a single look: she plays the girl and the leader, the schemer and the victim, all at once. Plus, I've never seen such a wide variety of facial expressions that all say the same thing: 'Please, sir, rip off my bodice.' Sure, they play it fast and loose with the historic facts, but as opulent royal viewing, *Elizabeth* is brilliant. It's bloody, deeply romantic and at times violently sexual.

THE SUNDAY MOVIES

The Last Emperor (China/Italy) (1987)
Director: Bernardo Bertolucci
Stars: John Lone, Joan Chen, Peter O'Toole

Next lesson: Royalty can be a prison. Or so it seems for Pu Yi, the last emperor of China. He begins his journey as a young prince in China's famed Forbidden City, a lush compound that he is never allowed to leave. When the monarchy is overthrown by revolutionary forces, Pu Yi is captured by the communist military and imprisoned once again. Freedom only truly finds Pu Yi when he is 're-educated' and released as a common farmer.

There's a tremendous sadness about this movie that will sneak up and grab you when you least expect it. *The Last Emperor* is filled with sumptuous visuals of the real Forbidden City (it was actually shot there, which required some considerable negotiation with the ever-cuddly Chinese government). However, the emotional core of the film is Pu Yi himself. The film forces you to see the world from his point of view, a lonely and emotionally vacant existence for all its initial privilege. You sense his isolation, his desire for

human connection. To accentuate this longing the movie has a tactile quality to it, with lingering emphasis on touch — the touch of silk on Pu Yi's skin, the translucent light touching his skin.

The Last Emperor is a wholesale critique of hereditary privilege and communism. You witness a nation in extreme cultural and political upheaval — through the disarming and thoughtful eyes of a child. It's a very unusual perspective on power.

Cleopatra (UK/USA) (1963)
Director: Joseph L Mankiewicz
Stars: Elizabeth Taylor, Richard Burton, Rex Harrison

And the most important lesson of all: beware the danger of indulgence. And *no* film does embarrassing extravagance quite like the 1963 blockbuster *Cleopatra*.

Cleopatra tells the epic story of a beguiling princess who became queen of Egypt, lover of both Roman emperor Caesar and Mark Antony. This is no ordinary opulence. This is four-plus hours of droll, erudite dialogue delivered by larger-than-life actors with larger-than-life mammary glands against a stage so ludicrously huge it may actually be bigger than Egypt's real pyramids and the Vegas ones combined. The cast is uniformly entertaining, particularly Rex Harrison as Julius Caesar, with his charming, arrogant screen presence. Elizabeth Taylor is mesmerising, and I'm not just referring to her, um, top deck, although it *is* hard to miss.

But the truly amazing story is the one that carried on behind the scenes. *Cleopatra* was based on a script originally drafted in 1917 and rewritten more times than anyone can count. Elizabeth Taylor was initially a bit so-so about the production so she demanded $1 million to grace the screen with her presence. At the time, less than five people in Hollywood had ever been offered such a large amount of money (Taylor's asking price at the time was more like

$125,000 per film). The only way Fox could even afford to agree to this deal was if it took the form of a deferred payment into a trust fund for Taylor's children that they could pay over time. Once the film got underway studio executives began employing all manner of creative accounting techniques to hide the real (and staggeringly large) price tag for *Cleopatra*. The production itself could charitably be described as a nightmare. There were hairdresser strikes, kickbacks to catering companies, a pandemic of meningitis, disappearing office supplies and then — some $17 million later — the studio stopped production, hired a new director ... and the whole nightmare began again in another country.

Then of course there was *the* love affair: even though they were both married, Elizabeth Taylor and Welshman Richard Burton embarked on a romance (I suspect built on their mutual love of alcohol). The storm of interest they generated helped a great deal with publicity for the movie. *Cleopatra* was actually a very popular film that garnered quite a few shiny statuettes, but nothing was going to make up for all the self-indulgent spending that went into making this most epic of love stories. It took decades for Fox to make any of their money back. Hollywood Royalty let loose on the Royalty of the Antiquities did a dangerous combination make.

PLAY IT AGAIN, SAM
REMAKES THAT ARE BETTER
THAN THE ORIGINAL

These days, Hollywood is where original ideas go to be ignored — just look at the number of films based on books, plays, TV shows, board games, computer games, themepark rides and, yes, other movies. In the major blockbuster season of 2010 there were only really two noteworthy major releases that *weren't* based on some other material; one was *Inception* and the other was Tom Cruise's *Knight and Day* — which was actually comprised of the plots of about 300 other movies.

All that said, every now and then the remake (the most unoriginal of Hollywood crutches) can yield a flick that equals or even surpasses the original. Sometimes, even, you get a movie that is so universal, so flexible that not only *can* it be remade, it *should* be remade for every generation — *War of the Worlds*, *Invasion of the Body Snatchers* and *White Chicks* all spring to mind.

After narrowing down the definition of a remake to a movie that is clearly based on another feature-length film (and not, say, a classic text like a Shakespearean play or Jack Ryan novel), here is a weekend of remakes that improve on their originals.

FRIDAY NIGHT FILM

Ocean's Eleven (USA) (2001)
Director: Steven Soderbergh
Stars: George Clooney, Brad Pitt, Julia Roberts

Danny Ocean (George Clooney) does what comes naturally: he steals shit from rich people and looks cool doing it. Recently released from prison, Danny sets about proving just how little he learned from incarceration by planning a new heist. He constructs a ragtag crew of eleven utterly charming players and sets the crosshairs on casino owner Terry Benedict (Andy Garcia). He plans to relieve Benedict of $160 million (chickenfeed, really) as well as Benedict's girlfriend, Julia Roberts, who just so happens to be Ocean's ex-wife. It's a dangerous gambit that is going to take hair-trigger timing, but if any team can pull off the ultimate score it's Ocean's Eleven.

The original *Ocean's Eleven* was made in 1960 starring Frank Sinatra. The story goes that Ocean Version 1.0 (or Ocean Classic Edition) was a production that existed solely to provide Sinatra and his Rat Pack mates with an excuse to hang out, shoot craps, smoke cigars and make passes at the showgirls. And it shows: the original *Ocean's Eleven* is mediocre in just about every way possible.

Steven Soderbergh's 2001 remake of the Vegas caper stars a group of actors with far more diverse backgrounds and, accordingly, this ensemble's compound energy is far more entertaining. Also, this movie has a script, something they appeared to misplace in the original.

Clooney moves with an ease and charm too seldom seen in today's cinema. No slouch in the crazy-huge-celebrity department himself, Brad Pitt gets to act as George's right-hand man, always with food in hand. Clooney and Pitt have a great onscreen

chemistry resulting in some classy, well-crafted super-slick, fast-talking fun. *Ocean's Eleven* is a blast. 'Nuff said.

SATURDAY FLICKS

The Man Who Knew Too Much (USA) (1956)
Director: Alfred Hitchcock
Stars: James Stewart, Doris Day, Brenda De Banzie

Dr Ben McKenna (James Stewart) is holidaying in Morocco with his wife, Jo (Doris Day), and their son, Hank (Christopher Olsen). Ben is an American doctor and his wife was once a stage singer of some success. On the bus to Marrakech they meet a suspiciously friendly Frenchman, Louis Bernard (Daniel Gélin). While in Marrakech Louis Bernard reappears — stabbed in the back. As he dies, Louis whispers a few ominous final words into Ben's ear. This unasked for knowledge is going to mean a very, very bad day for Ben. Their son is soon kidnapped. But why?

The Man Who Knew Too Much is the only example in this chapter of a director remaking his *own* film. Alfred Hitchcock kept the basic premise of his early 1934 thriller — a family on vacation stumbles upon top-secret information that leads to their child's kidnapping — but he updated the setting, shot in colour and cast proper Hollywood superstars James Stewart and Doris Day in the new film. The plots of the two versions have marked differences and Hitchcock himself proclaimed this the superior version — so who are we to argue with him?

The Man Who Knew Too Much has all the suspense, twisted storytelling and light humour of Hitchcock's best movies. Hitchcock and screenwriter John Michael Hayes even managed to incorporate Doris Day's singing skills into the plot of the film after Paramount

Pictures insisted that a song be included. In the hands of a more mediocre moviemaker these scenes would've seemed clunky, but they make Day's musical ability a crucial element to the climax. In fact the music is generally one of the best parts of this film, especially the fantastic climactic scene set in the Royal Albert Hall set to Arthur Benjamin's powerful 'Storm Cloud Cantata'. Hitchcock creates a visual tempo to match the swelling music, featuring ever-quicker cuts and tightening close-ups. It's masterful, beautiful moviemaking.

Dirty Rotten Scoundrels (USA) (1988)
Director: Frank Oz
Stars: Steve Martin, Michael Caine, Glenne Headly

Like most Hollywood comedians, Steve Martin has made just as many bad films as he has good ones. This is one of the good ones. In *Dirty Rotten Scoundrels* he plays small-time crook Freddy Benson, who takes on suave and debonair con man Lawrence Jamieson (Michael Caine). What follows is a shameless battle for the fortune of an American soap heiress.

Although *Dirty Rotten Scoundrels* is not officially credited as a remake of *Bedtime Story*, it closely follows the plot of the 1964 film starring David Niven and Marlon Brando.

Steve Martin and Michael Caine don't really sound like the best pairing for a comedy, but it works. The film pits Caine's effortless charm against Martin's ingenious ability to contort his face and body. Both are unashamedly callous and wicked — and that's what gives the film its real bite. For example, you've got Martin playing Caine's supposedly retarded brother, Ruprecht. Watching Martin run all over the room, banging pots and pans and shouting out the word 'Oklahoma!' over and over is hysterical every time.

Once the con gets into gear, you see what these two men are made of. Caine impersonates a famous doctor, Martin pretends

to be a cripple who was wounded by love, and each situation becomes more far-fetched than the last. The interwoven plot is smart while never being overly complex. Director Frank Oz keeps things moving fast with a supporting cast that enhance the team of Martin and Caine. With plenty of wit, fun and humour, *Dirty Rotten Scoundrels* is well worth it.

THE SUNDAY MOVIES

Scarface (USA) (1983)
Director: Brian De Palma
Stars: Al Pacino, Michelle Pfeiffer, Steven Bauer

Tony Montana (Al Pacino) is an ex-Cuban ex-prisoner, and an excellent hit man. He arrives on the sunny beaches of Florida and quickly rises up the ranks of the local Cuban mob. Tragedy beckons for anyone dumb enough to stand in his way.

In the early eighties, cocaine was the most glamorous narcotic in America, infused with a dangerous scent of wealth. Drug kingpins like Pablo Escobar had yet to become household names. The bling and booty of gangsta rap were years away. The movie studios had largely failed to put this world on screen. In the abridged words of Tony Montana, 'Hollywood was like a great big pussy just waiting to get fucked.'

Then came *Scarface*.

Scarface redefined gangster culture and set a new standard for cinematic violence, profanity and sheer bloody-minded gall.

The film came with quite the pedigree: directed by Brian De Palma (*Carrie*, *The Untouchables*), Oliver Stone (*JFK*, *Born on the Fourth of July*) wrote the screenplay, and an incendiary Al Pacino played the lead role, at the height of his over-acting phase (which,

I believe, stretches from 1940 to … last Tuesday?). *Scarface* was a remake of a 1932 film by Howard Hawks which starred Paul Muni as a psychopathic Italian American gangster. The original certainly created no shortage of outrage in its time. Hawks was forced to water down and reshoot scenes in order to make it suitable for general release, but the censored result was still pulled from cinemas and dropped after a brief run. With their remake, De Palma and Stone upped the ante considerably for a new generation, including unforgettably brutal scenes like a chainsaw dismemberment and a finale involving enough firepower to supply a small tin-pot African dictatorship.

Critics of this film decried its extreme violence, over-the-top depiction of cocaine culture, and record-breaking expletive usage (apparently, there are 206 utterances of 'fuck'). But they usually fail to realise that beneath the mounds of cocaine and litres of blood, *Scarface* is the quintessential tale of the American dream, the classic hard-work-equals-success story boiled down to its essence.

3:10 to Yuma (USA) (2007)
Director: James Mangold
Stars: Russell Crowe, Christian Bale, Ben Foster

Dan Evans (Christian Bale) is a respectable farmer with a wife and kids. But he has a cash-flow problem, and there are some very important people who would like to turn his land into a railroad. Then comes the day that changes everything. Dan and his kids witness a robbery committed by the most infamous kleptomaniac in town, Ben Wade (Russell Crowe). Wade is caught and needs to be escorted to the local train station (a few days away). The job of escorting Wade falls to Evans, and it's not going to be simple.

The original *3:10 to Yuma* is actually a pretty damn good film but this updated version is brutal, intense, sharp, blackly humorous,

and loaded with colourful characters and grippingly staged action. Both Bale and Crowe are renowned for being fairly intense actors (read: slightly nutty) and in this film it really pays off. Bale's character is often in danger of becoming the mono-dimensional hero that makes Hollywood flicks so boring, but instead he gives the character depth and quirks. Similarly Crowe seems to savour toying with your expectations of what he might do next.

Director James Mangold paces the film very tightly. He also brings a level of excitement and stylish realism to the action scenes. What sets this film apart from the original is that it has a depth and nuance that the original didn't possess. The subtlety of the performances, in particular, focuses all of your attention, pulling you right into the drama.

HOW TO GET RID
OF A DEAD BODY
(ACCORDING TO MOVIES)

To bury or to cremate? That is the question ... Well, that is the question most of us will deal with when faced with a dead person. For the super-rich/insane, there's also the premium options, like 'to be turned into fireworks' or 'to be shot into space' or 'to have ashes loaded into bullets'. Sadly, no one has yet made a movie featuring these. Cinema has, however, given us plenty of *other* ideas about what to do with a cadaver.

Body disposal scenes are frequently the most memorable of any movie. Ask anyone what they remember about *Red Dragon* and they'll tell you that it wasn't as good as *The Silence of the Lambs*, but I'm ninety-eight per cent confident that on pressing them further they'll recall that scene where Hannibal Lecter fed the dead dude to everybody for dinner. Or there's the infamous end of *Fargo* where a body is fed through a woodchipper. And who could forget the amazing body disposal of 007's *GoldenEye*, where a man was reduced to the size of a stock cube via a trash compactor. It was positively Bauhausian. Whatever that means.

FRIDAY NIGHT FILM

Weekend at Bernie's (USA) (1989)
Director: Ted Kotcheff
Stars: Andrew McCarthy, Jonathan Silverman, Catherine Mary Stewart

This is the fable of two bumbling accountants who are invited to their boss's exotic beach house on a hot summer's weekend only to find that he is dead. As a cavalcade of oblivious drunken rich-people stereotypes party on around him, the two number-crunchers employ ludicrous shenanigans to make his mustachioed millionaire corpse seem alive.

Weekend at Bernie's is a masterpiece of stupidity. Critics of this much-maligned eighties screw-up comedy love to complain that 'you can clearly see the dead guy's arm still moving' or 'wouldn't he begin to smell in all that heat?' What trifling details are these? What pedants these people are! You see, these critics fail to understand that a truly moronic movie requires a lot of skill. To transform a plot this thin into entertaining moviemaking requires actors with effortless charm and masterful skills in physical comedy. And it must be said that eighties teen icons (and nineties twenty-something nobodies) Andrew McCarthy and Jonathan Silverman have these qualities in spades.

Weekend at Bernie's holds the dubious honour of being one of the more parodied movies in popular culture, with references popping up on *The Simpsons*, *Friends* and *How I Met Your Mother*, to name but a few. It's also the punchline to nearly every one of Wil Anderson's jokes. Once you've watched it it's easy to understand why. There's an immediate warmth to the characters and a knowing wink to the whole decomposing affair.

Also recommended is the sequel, *Weekend at Bernie's II*, which features a voodoo princess reviving Bernie into a zombie, another acceptable method of dealing with a dead body. (For more details about reanimation, see the 'Love at first bite: what's the big deal about zombie flicks?' chapter.)

SATURDAY FLICKS

Soylent Green (USA) (1973)
Director: Richard Fleischer
Stars: Charlton Heston, Edward G Robinson, Leigh Taylor-Young

The future just looked better in the seventies. From *Logan's Run* to *THX 1138*, there's so much to love in the aesthetics: minimalist beige apartments with pointless angular furniture and lava lamps. Dear God, how I love the lava lamps. Thanks, baby boomers, you rule.

This gaudy image I've just described is how rich New Yorkers live in the year 2022 according to *Soylent Green*. For everyone else, however, it's a very different story. The world of *Soylent Green* has become so polluted and overpopulated that food is now a rare and expensive commodity. People instead live on reprocessed vegetable tablets made by the Soylent Corporation. When a very well-connected businessman with links to government and Soylent is assassinated, the ragged, sinewy Detective Thorn (Charlton Heston) is brought in to investigate. Thorn's investigation begins with the victim's in-house kept woman, or 'furniture', as they are charmingly called. Thorn follows a tasty trail of discovery and soon uncovers an insidious government conspiracy about what humanity's food source really is.

Soylent Green is probably best known for its endlessly sent-up final line (which I won't quote, although you might be able to

work it out given the title of this chapter). But what's surprising about this movie is just how vivid and evocative it is about our potential future. The movie opens with a montage of American history that begins right back in the old west, where humankind was busy taming nature. By the time the montage is over you can see how nature has had her revenge: the skies have been scorched with pollution, the land is unable to bear food.

Soylent Green is, despite its furniture, far from camp. A sharp, methodical and ultimately cathartic look at a possible world to come.

Rope (USA) (1948)
Director: Alfred Hitchcock
Stars: James Stewart, John Dall, Farley Granger

The curtains are drawn at this New York apartment — and for good reason. Inside, a man is being strangled with a paltry bit of rope. Why? Well, simply because these two assailants can. John Dall and Farley Granger play young, well-educated, charming and completely gay men (although thanks to the wonders of censorship, neither character realises it). Their victim is an old friend and they have killed him as part of an experiment: to see if they can pull it off and get away scot-free. The body is then stored *inside* the apartment, and the film unfolds in real time as the two murderers throw a party — including the victim's dad and girlfriend — over a man's dead body.

Rope was inspired by the real-life murder of fourteen-year-old Bobby Franks in 1924 by University of Chicago students Nathan Leopold and Richard Loeb, who set out to commit a perfect crime. There are so many reasons why this movie is entertaining. Firstly, it's an entire film that plays out in virtual real time (albeit with a slightly-too-fast setting sun outside the window of the apartment).

The whole movie is shot as though it is one take (with swooping close-ups behind people's jackets every ten minutes to cover the actual edits, because you could only fit ten minutes of film in a canister). But as impressive as these structural contrivances may be, within minutes you are instantly pulled into a very tight, fascinating game of brinksmanship. The script is remarkably clever, edging the murderers towards discovery and filled with somewhat nihilistic rhetoric about the nature of life and justice. Both these men operate off the logic that truly gifted and enlightened human beings should have the right to take another life.

Everything is so tightly choreographed, the cameras, the acting and the set (because it was shot in real time, the set walls were built on rollers so they could be pulled silently out to make way for the heavy cameras). If you've ever wondered what the big deal with Hitchcock is, watch this — you won't have to wonder for much longer.

THE SUNDAY MOVIES

Shallow Grave (USA) (1994)
Director: Danny Boyle
Stars: Kerry Fox, Christopher Eccleston, Ewan McGregor

Danny Boyle is a very talented guy. He was the director who brought us films like *28 Days Later*, *Slumdog Millionaire*, *127 Hours* and *Trainspotting* ... and it all started right here. In 1994 Boyle took a bunch of nobodies like Ewan McGregor and future Dr Who Christopher Eccleston and put them up on the big screen. *Shallow Grave* is a story about, for want of a better word, three arseholes. Specifically, three yuppie arseholes. There's a New Zealand-accented doctor, a desperately boring accountant and a loud, obnoxious

Scottish tabloid reporter. Together, in their beautiful apartment, they are interviewing for a new flatmate. They gleefully ridicule one after the other until they finally land on a very charming brooding type played by Keith Allen. He moves in, and two days later he turns up dead. The upside? He's left a bag of cash. Downside? In order to get rid of the body they're gonna need to do some nasty things. Cue hacksaw and none-too-fine dental work.

The pressure of the act and the pleasure of the money have wildly unpredictable results. Eccleston for example retreats to the attic, drills holes in the ceiling and begins spying on everyone. You can say goodbye to that rental bond. It's pretty clear that even though this was Boyle's first movie and he had a pretty small budget, there was a lot of talent both in front of and behind the camera. You can see him experimenting with the visceral imagery, fast editing and detailed sound mixing that he would later win great accolades for. *Shallow Grave* grows steadily darker, with an increasingly gothic palette. Boyle shows you depravity seeping through a charming, sensitive, new-age world. The performers inject every scene, no matter how mundane, with depth and charm, walking that fine line between being charismatic and despicable. But, more than anything, *Shallow Grave* is just a terribly stressful thriller. Dig it.

Alive (USA) (1993)
Director: Frank Marshall
Stars: Ethan Hawke, Vincent Spano, Josh Hamilton

And then of course there's the simplest option of all to get rid of a body — eat it.

Alive is the terribly true, terrifyingly honest tale of a planeload of rich Uruguayan teenage rugby players who crash in the Andes (in one of the most spectacular and horrific plane crash scenes ever shown on film). Some are killed, others are injured. Once they

realise that their rescue has been called off and they have run out of whatever meagre rations they had, an impossible decision remains. If they want to get help and save themselves they need strength, and the only way they can get that is to eat the flesh of the dead.

Once you get past the inevitable weirdness of a whole bunch of Uruguayan boys having American accents (or, even stranger, semi-Latin, semi-cornfed-Idaho accents), *Alive* is a remarkably powerful story. Director Frank Marshall and Piers Paul Reed, who wrote the original literary account, both deserve an enormous amount of praise for bringing this tale to vivid life and illustrating the psychological point that those involved were pushed to. While characters occasionally speak in a strangely formal manner that damages the film's believability, in its best moments *Alive* is so plausible that you are forced to wonder if you would be capable of doing the same to survive. The conversation you have after the movie is almost as powerful as the film itself, and there really aren't enough movies you can say that about.

AN EOFY GUIDE TO CINEMA'S BEST ACCOUNTANTS

Good job, reader!

A sensible person would be setting aside these next two days to pore over receipts (or a very convincing receipt-maker) on this, the first weekend of the new financial year and the earliest chance to claw back a fistful of your hard-earned cash in the form a tax refund. But no, not you. You instead have picked up this book with the intention of slovenly ploughing through five movies of varying quality, each tenuously linked by some questionable prose. I applaud you.

This weekend is dedicated to the real heroes of tax time: accountants. They may not be one of cinemas most celebrated professions — not like thieves, assassins or prostitutes with hearts of gold — but accountants are to the new financial year what Santa Claus is to Christmas. But where the latter feeds on credit-card debt, the other finds inventive and mostly legal ways for you to pay the credit-card debt. *<Elton John's 'Circle of Life' swells>*

Movie accountants come in all shapes and sizes, though always wearing suits. There is the soulless number-cruncher, the well-intentioned nerd and, my favourite, the swindler. Though special mention should go to the much-maligned musical accountant, like the pirates of the Crimson Permanent Assurance from Monty Python's *Meaning of Life*. Adorned with their green

visors they 'row' back and forth with their adding machines, singing a wonderful 'Accountancy Shanty'.

In any event, hopefully this chapter will help guide you through every conceivable loophole to a happy tax return.

FRIDAY NIGHT FILM

Ghostbusters (USA) (1984)
Director: Ivan Reitman
Stars: Bill Murray, Dan Aykroyd, Sigourney Weaver

If you've never seen *Ghostbusters* before, be ashamed of yourself. Now is an excellent time to self-flagellate. When you're done bandaging up the resultant sores, go immediately to your nearest rental outlet and pick up *Ghostbusters*.

Three para-psychology professors (not a real thing) develop a method for catching and holding ghosts (also not a real thing). After losing their jobs, they turn this technology into a small business to make ends meet. As business starts to boom, some douche from the Environmental Protection Agency strides in aiming to foul up their company, their lives and the fragile paranormal balance of New York City. And it all ends in a giant marshmallow. What more could you want in a flick?

The first *Ghostbusters* movie is one of the most watchable and re-watchable comedies to ever emerge from Hollywood. Slime, incoherent technobabble, giant man-eating gargoyles and Bill Murray equals high entertainment. The first film is jammed with unforgettable sequences, from the iconic ghost character of Slimer to the classic Venkman line that is simply impossible to slide into polite conversation: 'It's true. This man has no dick.' Though, lord knows, I keep trying.

The acting is also fantastic. Harold Ramis (who co-wrote the script with Dan Aykroyd) is the perfect straight-man. Bill Murray is also at his laconic best. But the stars of the production are Aykroyd and Rick Moranis. Moranis plays Louis Tully, professional accountant and concentrated ball of social awkwardness. He's the sorta guy who throws a party and then explains how various aspects of his hosting are saving him money on his taxes. Moranis has never been funnier, though that may be because eighty per cent of his other movies are quite unwatchable.

SATURDAY FLICKS

Stranger than Fiction (USA) (2006)
Director: Marc Forster
Stars: Will Ferrell, Emma Thompson, Dustin Hoffman

I dunno about you, but one chapter about accountants just isn't enough. How about a whole *book* on the existential tragedy of being an accountant? Harold Crick (Will Ferrell) is an obsessive-compulsive IRS auditor who lives a painfully boring life with few friends or hobbies. He just *loves* numbers, and sees them everywhere he goes. Then Harold's life takes a sudden and, thankfully, gripping turn when he begins to hear a voice ... Has he gone crazy? He doesn't think so, for the voice, the Narrator, is a well-spoken British woman (Emma Thompson) who details the mundane events of his life as though it's some kind of book. A book about an accountant?! What manner of bullshit is this? Harold is, of course, deeply bothered by the voice, but things become much worse when she narrates the following:

'*Little did he know that this simple seemingly innocuous act would result in his imminent death.*'

Stranger than Fiction is a silly idea that inexplicably works wonders on the big screen. Director Mark Forster sucks you into the lonely world of Harold Crick, and before you know it you've become invested in his life and are willing him to finally locate the Narrator and save his own existence.

I should confess: I've never been a fan of the way this movie ends. I still think it's too neat. Aside from that small complaint *Stranger than Fiction* is a fantastically inventive flick. Zach Helm's script offers a clever stylised world. However, the main reason this movie works is Will Ferrell himself. A divisive comedy figure, often people only remember Ferrell in his loud, boisterous, borderline-insane roles, but he is also a fine actor. In this film his toweringly dopey indignation is endearing.

The Producers (USA) (1968)
Director: Mel Brooks
Stars: Zero Mostel, Gene Wilder, Dick Shawn

Washed-up Broadway producer Max Bialystock (Zero Mostel) is a genius. An evil, fraudulent, artistically barren genius. Enter his anxious accountant, Leo Bloom (Gene Wilder), and together they realise that they would make more money with a flop than a hit. So the two set out to produce a play that is guaranteed to fail. A play about … Hitler. The Hitler you knew, the Hitler you loved. The Hitler with a little song in his heart. It shall be called *Springtime for Hitler* and it shall be the biggest bomb in Broadway history. How could it not? They've picked the worst play, hired the most inept queen of a director (Christopher Hewett) and cast the worst star ill-gotten money can buy (Dick Shawn). But what happens if the play inadvertently becomes a huge hit? Cue blitzkrieg.

The Producers was the directorial debut of now-legendary comedic filmmaker and Broadway musical sell-out Mel Brooks.

Ironically, *The Producers* was itself a risky move that became an unlikely hit. The film spent years in development, waiting for someone with the balls to fund this Jewish writer and his tale of two losers bent on producing the most offensive musical ever conceived. Mel Brooks was a trusted Oscar-winning comedy writer, but he'd never directed a feature film. He originally intended to call the movie *Springtime for Hitler*, after the fictitious production, but had to settle on the more circumspect *The Producers* to make sure theatre owners would put the movie's title on their marquee. He cast an old Broadway pro in Zero Mostel and a relative unknown named Gene Wilder (who at this point had only appeared briefly in *Bonnie and Clyde*).

The Producers has all the trademarks that make a Mel Brooks' production: mad energy, expert sight gags and comedy riffs. And unlike Mel Brooks' other films, *The Producers* actually has a plot (yes, *Spaceballs*, I'm looking at you). Even with its late sixties references, *The Producers* is incredibly easy to watch. It's a fantastically fun romp that's hard to top, and we know this because the 2004 remake was excruciatingly lame — although it did contain a nice little musical number about accountants.

THE SUNDAY MOVIES

Moonstruck (USA) (1987)
Director: Norman Jewison
Stars: Cher, Nicolas Cage, Olympia Dukakis

Cher is bookkeeper extraordinaire (that's *like* an accountant, right?) Loretta Castorini, a 37-year-old widow in Brooklyn Heights who is looking to remarry. To reach her goal, Loretta gives up on love and accepts a proposal from Johnny Cammareri (Danny Aiello), a man

she rationalises as a good provider and a decent friend. Immediately after he pops the question to her, Johnny hops on a plane to Sicily to see his mother one last time before the old lady wheels herself off this mortal coil. Before he goes, Johnny asks Loretta to invite his estranged younger brother Ronny (Nicolas Cage) to the wedding. Ronny is a fiery, one-handed baker who instantly falls in love with Loretta. Now all they have do is figure out what to do about Loretta's impending marriage.

Cher is absolutely delightful as a woman who learns to believe in love — or, rather, 'be-leie-eie-ve' in love — though you may not recognise her with the full control of her facial muscles. Then there's Nicolas Cage and his particular brand of crazy, which as we've already established is a unique and wonderful experience.

Moonstruck's central premise is fairly simple, but that allows the movie to focus on the characters. There's a lot of funniness and heart to be extracted from the cultural tropes of the Italian American, Catholic family, and writer John Patrick Shanley highlights them without being condescending. The Castorinis and the Cammareris scream and swing their arms like any Italian caricature, but they also feel authentic, with dollops of love and sadness too. *Moonstruck* is a vivid portrait of Italian family life.

Midnight Run (USA) (1988)
Director: Martin Brest
Stars: Robert De Niro, Charles Grodin, Yaphet Kotto

Being a professional bounty hunter is a tough gig but if anyone can do it, surely it's Robert De Niro. Jack Walsh has the unpleasant task of catching all manner of disreputable cretins who've run out on his boss, bail bondsman Eddie Moscone (Joe Pantoliano). Eddie is so impressed with Jack's work that he fast-talks (as only Joe Pantoliano can) our bounty-hunting hero into a very important gig: bringing

in the accountant. Jonathan 'The Duke' Mardukas (Charles Grodin) was a mob accountant until he embezzled $15 million from Chicago mob boss Jimmy Serrano (Dennis Farina). The Duke took the money and then ... wait for it ... gave it to charity. Jack is set on the trail of the Robin Hood accountant, but it doesn't take long for him to realise that he's not the only one after this very unusual bookkeeper.

The acting in *Midnight Run* is a cut above your garden variety action/comedy. Robert De Niro and Charles Grodin imbue their characters with complex emotions and conflicting motivations. The story cleverly juggles a number of story threads within the overall narrative as we slide between Jack, The Duke, the FBI and the bail bondsman. There is a lot going on but the story propels forward at a great pace with a perfect balance between humour and action.

THUGLIFE
INTERNATIONAL GANGSTER
DEATH-MATCH

The United States has produced some of the finest gangster movies in the world. You had Irish American gangsters in *Road to Perdition*, Ben Affleck's *The Town* and the Coen brothers' underrated classic *Miller's Crossing*. There were Puerto-Rican American thugs in *Carlito's Way*, Cuban-born mobsters in *Scarface* and numerous pan-Asian hoodlums in any movie starring Jet Li. And of course you have the Italian American goons in *The Godfather*, *Casino*, *The Sopranos*, *The Untouchables* and, at the very top of the list, *Goodfellas*. They're all excellent films that I highly recommend. But the first thing you notice is that all of these gangsters — and I'm talking about the really iconic gangster flicks — is that they're all imported into America from somewhere else in the world. So for our second round of weekend death-match we're asking the question: of all the nations outside of America — which country has the hardest-core wise guys?

Welcome to International Gangster Death-match.

FRIDAY NIGHT FILM

Lock, Stock and Two Smoking Barrels (UK) (1998)
Director: Guy Ritchie
Stars: Jason Flemyng, Dexter Fletcher, Nick Moran

We start in the most dignified country on the planet, the home of Shakespeare and Colin Firth: Great Britain. *Lock, Stock and Two Smoking Barrels* exploded onto the movie scene as part of a new wave of ballsy Brit flicks (think *Trainspotting*) that revitalised the global image of the British film industry. *Lock, Stock* launched director Guy Ritchie into the big league, though it also had the dubious honour of turning Vinnie Jones and Jason Statham into international stars.

So here are the vitals. Eddy (Nick Moran) is a great card player. I mean truly, staggeringly inspired. He and his three mates have each pitched in a few thousand bucks so that Eddy can play at a high-stakes local game run by 'Hatchet' Harry Lonsdale (PH Moriarty). There's one small problem: the game has been rigged against him. When it all goes sour, Eddy, Tom (Jason Flemyng), Soap (Dexter Fletcher) and Bacon (Jason Statham) have to come up with a very, very hefty wad of cash with limited time. So the boys conceive a heist. The plan involves ripping off some psychopathic dealers who are themselves doing over a group of docile weed-growing chemists who — wait for it — are also stealing from a big-time gangster. Then there's a bunch of smaller subplots, a guest appearance from Sting and ... never mind: cue the violence and outrageous sweariness!

Lock, Stock is still, to this day, a Red Bull can's worth of energy. The players are colourful and entertaining, even if they're largely incomprehensible. Guy Ritchie has a flair for comic plotting and the film is tightly assembled in such a way that it pushes characters from

one subplot into another's subplot. It sometimes seems coincidental and needlessly complex, but Ritchie delivers dazzling payoffs all throughout the film — typically featuring some gratuitous blood and dismemberment.

SATURDAY FLICKS

Animal Kingdom (Australia) (2010)
Director: David Michôd
Stars: James Frecheville, Guy Pearce, Joel Edgerton

Welcome home. You didn't think I'd forget to include an Aussie gangster flick, did you? *Animal Kingdom* is the story of Joshua 'J' Cody (James Frecheville). When his mother dies of a heroin overdose, J goes to Melbourne to stay with his grandmother, Janine 'Smurf' Cody (Jacki Weaver). There J discovers that he was born into a family of criminals, led by his uncle Andrew 'Pope' Cody (Ben Mendelsohn). One by one the family is being hunted down by the police (who might as well be criminals), and somewhere in there J has gotta find his place in this wild kingdom — strong, weak or dead.

Animal Kingdom is dark, tragic, blackly funny and pretty much a big petrifying bag of win. The film doesn't leap off the screen; instead it slowly bubbles, offering an unvarnished look at a low-rent family of criminals. Director David Michôd creates an oppressive environment of anxiety and paranoia, a sense that the flimsy threads holding the clan together can, and will, snap at any moment. Expect to grip your couch a lot. The movie will probably seem a bit slow at first, but when things start to unravel, they do so with a gut-wrenching amount of tension. There's treachery, twists and blood-soaked revenge, much of it shocking, but it never feels

sensational. Even the enveloping sound design is noteworthy for how it positions you right inside J's headspace

But the thing you'll remember most about *Animal Kingdom* is Jacki Weaver as J's diabolical grandmother. Trust me on this one.

City of God (Brazil/France) (2002)
Directors: Fernando Meirelles, Kátia Lund
Stars: Alexandre Rodrigues, Matheus Nachtergaele,
Leandro Firmino

A knife appears on screen before you even see the title in *City of God*. At first the blade makes a quick, sharp cut across the screen, then the slashes gradually become sharper. Soon they're intercut with images of blood, then an animal of some kind, and after that kids laughing, dogs barking, the flash of a gun. This is life in a Rio slum, reduced down to a few quick frames. Fast, lively, chaotic and, above all things, bloody.

City of God tells the twisting saga of two generations of sweaty teenage gangsters in a hastily constructed Brazilian housing project. With no paved roads, no electricity, no plumbing and no transportation, they dub their home the City of God. The film explores the fluid allegiances, rivalries and romances of the hoodlums, from the end of the sixties through to the dawning days of the eighties. Most of the local boys aspire to be criminals, but the worst of them is pint-sized sociopath L'il Zé (Leandro Firmino). On the other hand you have Rocket (Alexandre Rodrigues), who can't seem to acquire the meanness required to become a goon so instead he becomes our narrator. The film culminates in a ruthless drug war that threatens to destroy everyone in the City. Rocket and his crappy old camera are there to document it all.

City of God is incredible. Seriously. It's just an amazing flick. Co-directors Fernando Meirelles and Kátia Lund paint a sweeping,

epic drama about an entire city that exists in a state of permanent conflict, detailing gang politics and complex friendships with devastating results.

Perhaps what is most amazing about *City of God* is that the majority of the cast were from real-life shanty towns and the actual City of God favela itself. It all adds up to a production that is as humorous as it is moving, as grand as it is intimate. Just go get it already.

THE SUNDAY MOVIES

Sonatine (Japan) (1993)
Director: Takeshi Kitano
Stars: Takeshi Kitano, Aya Kokumai, Tetsu Watanabe

Of course you can't talk about gangsters without mentioning the Japanese equivalent: the Yakuza. Murakawa (Takeshi Kitano) is Yakuza middle management. He's bored with the daily routines of roughing people up and collecting the odd finger. When another envious Yakuza underboss plots to steal his territory, Murakawa is forced into hiding. This, however, gives him a chance to start anew. But is he capable of it or will he always be a standover man?

There are very few people in any entertainment industry in the world who can claim that they've been a comedian, TV presenter, poet, artist, world-renowned writer, director, editor and actor. But these are just a handful of the achievements of Japanese icon Takeshi Kitano, who both directs and stars in *Sonatine*. He also has a gift for cruelty, and I don't just mean as a character. You see, before Kitano made movies he was hugely famous in his homeland for presenting violent, though admittedly hilarious, TV game shows. When he made the move into films Kitano wanted to avoid his funny-man image, so everything in this film is very deadpan.

Takeshi manages to communicate the boredom of his character without necessarily boring you, the audience. Takeshi puts you inside his gangster's headspace, making you experience the emotional detachment that comes from killing for a living. The camera hardly ever moves to accentuate the often extreme violence, as most movies would do. The violence comes in brief bursts, but it's all so matter-of-fact that it is actually quite funny. Sometimes, it's over before you have time to register that you just witnessed a bullet shoot through a skull. It's a genuinely unique take on the genre.

La Haine (France) (1995)
Director: Mathieu Kassovitz
Stars: Vincent Cassel, Hubert Koundé, Saïd Taghmaoui

La Haine is French for 'the hate', and that is precisely what is gradually brewing in this gangster flick about three disaffected Parisian youths: an Arab, a Jew and a Sudanese. They wander the charred streets of Paris after a night of rioting while one of their best friends is in a coma from a police beating. The police are on edge, middle-class France hates these immigrant kids and there is a missing gun floating around the alleyways. This has not been a good day and it won't be a good night.

Director Mathieu Kassovitz once called France 'a revolutionary country and proud of it', which is putting it lightly. Riots have been a semi-regular event in France for the last few decades, its citizens frequently protesting with anger and frustration over big issues like social inequality, industrial reform and the right to wear stripey shirts and berets. In all seriousness, France has seen a large influx of new cultures and races in recent decades. With this, seems to come a rise in nationalism, xenophobia and urban deprivation. Kassovitz was inspired to make this film after the riots that followed the real-

life death of Makomé Bowole, a young man who was shot in the head while handcuffed to a radiator in a police station.

Mathieu Kassovitz runs the entire gamut of emotions in this ninety-minute flick: everything from rage, hatred, comedy, friendship and loyalty. The camera is almost constantly in motion, with French hip-hop beats blaring out of every window and rapid-fire dialogue giving a sense of the vitality of this unstable community. The whole cast has an effortless chemistry but Vincent Cassel as Vinz presents an especially gripping fusion of testosterone-laden bravado and utter cluelessness.

In spite of the specificities of the French scenario, there's something universal about this film: the frustrations of being on the outskirts of society, forgotten by a corrupt and flawed system. At times *La Haine* is lighthearted and at other times it's horrifically brutal. At all times it's compelling.

SERVING UP A PLATTER OF FOODIE MOVIES

Do not eat. Seriously, stay away from the kitchen. Take whatever snacks you were planning on chewing today, just put them back in the pantry and back away. Because this weekend's movies are so flavoursome, rich, sumptuous, laden with calories, dripping with flavour, and oozing with sweet, tingling, near-orgasmic joy that you will put on weight simply by watching them.

Cinema adores food in a way very few other art forms can. Not only is food innately visual, the eating of food and the preparation of food often acts as a proxy for other aspects of human life. For example, food binds family together like eggs in a batter. Food also has a sexual component, what with all those fluids and all that soft, moist, warm flesh to be consumed ... But above all, it's that close-up, the money shot of the perfect dish, that makes you salivate. Time to dig in ...

FRIDAY NIGHT FILM

Chocolat (USA/UK) (2000)
Director: Lasse Hallström
Stars: Juliette Binoche, Judi Dench, Alfred Molina

Make no mistake: *Chocolat* is *Footloose* for chocolate. We enter this fascinating French town where everyone speaks English with a

different accent. In spite of this strange quirk, they are a conservative, church-going community under the moral authority of a count (played by a moustache with Alfred Molina attached). A north wind sweeps into the town in the form of Juliette Binoche (an actual French person, playing a half-Mayan itinerant chocolatier). Although the moustache takes an instant dislike to her, Binoche's chocolate creations begin to perform miracles with the townsfolk (a further affront to the church, I imagine). There are chocolate buds that invigorate sexless marriages, and truffles that ignite childhood wonder. Binoche's store soon becomes a shelter for battered women and diabetics with a poor understanding of their disease.

There's a wonderful fairytale quality to *Chocolat*. It is simple, unironic and warm-hearted, but that doesn't necessarily make it simplistic. All of the actors instil their characters with little complexities and contradictions — some that might not even be on the page. Binoche's character, Vianne, emanates a sadness and a fateful knowledge that she can never put down roots.

The food looks mouth-watering and is shot with loving intensity. In fact the entire film has these warm, earthen colours that make everything look just a little bit edible. Sure, it's not the most original idea for a movie, but *Chocolat* pulls on both the tastebuds and the heartstrings.

SATURDAY FLICKS

Tampopo (Japan) (1985)
Director: Jûzô Itami
Stars: Ken Watanabe, Tsutomu Yamazaki, Nobuko Miyamoto

They call *Tampopo* a 'noodle western' (a spin on the Italian-made spaghetti westerns like *The Good, the Bad and the Ugly*). Set in a small Japanese town (okay, it's on the outskirts of a big city), two lone

riders (ahem … truck drivers) rolling through the night stop at the only saloon in town (really it's a noodle house, and there're several). The drivers partake of mediocre ramen noodles being made by a sweet single mother named Tampopo. The truck drivers resolve to make like Mr Miyagi and train Tampopo in the fine art of making noodles 'with integrity'. The boys give her philosophical training in cooking, a strict exercise regime, taste tests, culinary espionage and a dash of extreme makeover.

The central plot of *Tampopo* is charming, camp and will make you very hungry. The lovingly detailed shots of a perfectly constructed ramen (noodle soup) are almost architectural in their beauty. But it's the non-sequitur subplots that really make *Tampopo* unique. Like the young businessman who upstages his superiors with his detailed knowledge of French cuisines, or the housewife on her deathbed who makes one last meal for her ungrateful swine of a husband. But the most remarkable subplot is that of a gangster in a pristine white suit. He and his girlfriend literally make love with their food; unleashing a live yabbie to writhe around on her navel, he licks lemon and sugar off her nipples. The pièce de résistance is when they pass an egg yolk from mouth to mouth until it breaks and dribbles down their faces …

Food can be sensual, joyous, comforting, competitive, a lovable mess or an art form to be massaged into perfection. *Tampopo* explores food in all of these glories.

Pieces of April (USA) (2003)
Director: Peter Hedges
Stars: Katie Holmes, Oliver Platt, Patricia Clarkson

Thanksgiving movies are America's national shame. Or at least they should be. Hollywood is already prone to saccharine mythologising most of the time, but when it comes to Thanksgiving they go more syrupy than normal. Thank God that the genre does, occasionally,

give us some winners like this one.

April Burns (Katie Holmes) is a tattooed and pierced outcast living in a scummy apartment in New York. She has never had a great relationship with her mother, Joy (Patricia Clarkson). For that exact reason she's offered to cook this year's Thanksgiving meal in her microscopic New York flat, without a working stove or anyone to help.

While the rest of the Burns family speed down the highway to New York recounting all of April's failures, she races around her building trying to find a working and available oven. As she makes her way through the oddball citizens of her building she collects cooking tips and more than a few lessons about human nature.

Pieces of April is the directorial debut of Peter Hedges, better known as the writer of *What's Eating Gilbert Grape* and for co-writing the script for *About a Boy*. It has a very light hand about it; the hand-held digital video, desaturated colour and some choppy editing helps transcend some of the Thanksgiving-sweetness that we've come to expect with this subject matter.

Katie Holmes brings a great sense of strength and intelligence to a role that I think could've come off as very insipid or annoying. Patricia Clarkson as April's emotionally unstable, unpleasable mother is not just engaging but also heartbreaking. *Pieces of April* is a pleasant surprise in a genre not known for quality.

THE SUNDAY MOVIES

Big Night (USA) (1996)
Directors: Campbell Scott, Stanley Tucci
Stars: Tony Shalhoub, Stanley Tucci, Marc Anthony

Set in a small town on the New Jersey shore in the 1950s, *Big Night* follows two immigrant brothers from Abruzzo, Italy, who own

and operate a restaurant called Paradise. It's a very empty paradise. The chef brother, Primo (Tony Shalhoub with a moustache that makes him look disturbingly like Seinfeld's Soup Nazi), is an artiste who makes only authentic Italian food and, in 1950s America, that means lasagne and risotto. Primo loathes being asked to make spaghetti and meatballs. His brother Secondo is the manager, played by Stanley Tucci (back when he had hair, which makes him look alarmingly similar to Andy Garcia), and it's Secondo who has to make their business survive.

This is a movie almost entirely produced by actors — and you can tell. The visual palette of *Big Night* is quite sparse, decidedly lacking in external shots and any of the bustling atmosphere you might expect from a movie about a restaurant. As a trade-off, you get a wonderful dynamic between the brothers, a tense but mutual understanding. Tucci is the charming out-goer with a lot on his plate and Shalhoub has the social skills of uncooked penne. Ian Holm plays Pascal, their closest rival restaurateur with a big, commercial Italian palace of food. Far from being competitive, he's a loud charmer who loves the boys dearly and wants to hire them.

As much as *Big Night* feels like a glorified stage play at times, it soon morphs. As the brothers prepare for their last make-or-break party, the camera starts gazing longingly at ingredients, the cooking process, and the riches that the brothers aspire to (like the Cadillac that Secondo wants to buy when his restaurant is a success). Food is the beginning of the dream that ends in money.

The film climaxes with a huge, elaborate dinner party, a scene that is virtually without dialogue. Just the mouth-watering, joyous consumption of food.

Fast Food Nation (USA/UK) (2006)

Director: Richard Linklater

Stars: Greg Kinnear, Bruce Willis, Catalina Sandino Moreno

Okay, you're hungry by now, right? Well then let's wrap the weekend up with the cinematic gastric band that is *Fast Food Nation*, a film that explores the terrifying realities behind the multibillion-dollar fast-food industry.

The Big One is the fastest-selling burger at a fictional fast-food company. There's just one problem: they've discovered cowshit in the meat. This discovery becomes the flashpoint for a series of interlocking narratives featuring the vast array of people involved in making the modern hamburger: from the girl who sells it over the counter, to the company executive, to the illegal immigrant who works at the meat-processing facility. In director Richard Linklater's words, it's 'all the stuff you're not supposed to think about'.

Fast Food Nation (based on the groundbreaking non-fiction book by Eric Schlosser) outlines, in scathing detail, a vision of the fast-food industry that is driven by callous exploitation and greed. It takes you from the innocuous fast-food restaurant counter to the lowest of the meat-packing plants. It was a curious decision to turn a non-fiction examination of industrial politics into a fictional narrative film. Linklater has also crafted the absolute worst-case scenario at each stage of food production (shit in the meat, spitting in the burgers *and* sexual harassment at the meat-packing plant? Really?). Upon its release, Linklater argued that fictional film is still the best way to communicate directly to an audience's heart: 'Politics can be so big and it can be abstract. In our fiction we can carve something to make specific sense. It's been said that art is the lie that reveals the truth.' And the truth, in this case, is a wryly funny, occasionally sickening and very effective bit of polemical moviemaking.

NAZIS ARE EVIL
(JUST IN CASE YOU FORGOT)

Let's face it: aside from Kyle Sandilands and Beelzebub himself, is there anyone easier to hate than Nazis? And yet it's for this same reason that Nazis are difficult to portray on screen: they become shorthand for evil, and shorthand doesn't make for compelling characters. The enormity of atrocities like the Holocaust are often too gargantuan to communicate within one narrative, the human tragedy too bottomless to portray in one thread. And so the film industry instead gives us small — often memorable — slices of the Nazi experience. Of course, there's the camp Major Arnold Toht in *Raiders of the Lost Ark*. Adorned in his long leather jacket, he's the bespectacled Gestapo guy who seems to ejaculate at the mere thought of torturing someone. There are even Hero Nazis, like Tom Cruise's depiction of the real-life Colonel Claus von Stauffenburg in *Valkyrie*, one of the masterminds behind a plan to kill Hitler in the dying days of World War II. The role gives Cruise ample opportunity to deploy the patented super-intense staring that he so often loves to substitute for acting. Cruise is, however, obligated to wear an eye patch for the character, and directing the intensity of a two-eye stare through a single iris makes him look like a constipated man willing a laser to shoot from his face.

One-eyed, laser-guided, fibre-deficient colonels notwithstanding, there are many great films that explore not just what it meant to live with a Nazi ideology but also what that meant for the world. Here, now, a weekend getting under the skin of the Third Reich.

FRIDAY NIGHT FILM

The Great Dictator (USA) (1940)
Director: Charlie Chaplin
Stars: Charlie Chaplin, Paulette Goddard, Jack Oakie

In 1940, Charlie Chaplin (who admittedly already had the Hitler moustache) made this viciously funny piss-take on Hitler's rise to power. The film stars Chaplin on double duty as both a Jewish barber and a Hitler-inspired fascist leader (or 'Phooey', a send-up of 'Führer') named Adenoid Hynkel, the dictator of the fictitious state of Tomainia.

Please don't let the age of this movie put you off. *The Great Dictator* features some of the greatest comic set pieces ever committed to celluloid. Not only will you laugh at the movie, you'll be in awe at the sheer complexity of the jokes. Especially the physical gags like the extended sequence with our faux Führer in an upside-down aeroplane, or his serenade to world domination where he dances with a giant globe of the Earth. My mouth still drops a little when I watch Hynkel deliver a rally speech in German-ish gibberish. It's the perfect caricature of Hitler's incendiary speeches, which Chaplin studied carefully in newsreels.

The Great Dictator is also a movie with serious balls. This wasn't made at the height of the war — in fact, Chaplin was way ahead of public opinion. America was technically at peace with Germany when Chaplin started crafting *The Great Dictator*, so launching a stinging satire on Hitler was a politically dangerous move at the time. It's widely believed that Chaplin was galvanised to make the film when he began hearing from Jewish friends in Europe about the escalating violence and repression of Jews back in the 1930s. But there may have been a less noble impetus as well. Chaplin was well loved in Germany at this time and was even mobbed by fans on a

1931 trip to Berlin, which annoyed the ascending Nazi party. They funded a book in 1934 called *The Jews are Looking at You*, which asserted that Chaplin was 'a disgusting Jewish acrobat' (he wasn't Jewish, but he *was* very flexible). A friend of Chaplin's allegedly sent him a copy and it has since been suggested that it was this ego-bruising publication that was the real genesis of *The Great Dictator*.

Either way, it was a contentious production. Chaplin claimed that halfway through production the studio tried to dissuade him from completing the project. Conversely, then President Franklin D Roosevelt is said to have sent his advisor Harry Hopkins to personally meet with Chaplin and encourage him to finish the film. Legend has it that Hitler was sent a copy of the film and viewed it twice.

SATURDAY FLICKS

Downfall (Germany) (2004)
Director: Oliver Hirschbiegel
Stars: Bruno Ganz, Alexandra Maria Lara, Ulrich Matthes

Most people would know one infamous scene from the movie *Downfall*. It takes place deep underground within a German bunker when the Führer Adolf Hitler realises that there is no hope for the Nazis and proceeds to chuck a tantrum the size of Austria. However, the last time you saw this scene there's a reasonable chance that you were actually watching Hitler ferociously realising that he had been banned from XBox Live, that Michael Jackson was dead, that there is no camera on the iPod Touch or, my favourite, that he can't find Wally. Yes, this Oscar-nominated film owes much of its infamy to an internet meme where Hitler's memorable tirade has been re-subtitled to reference any number of news events. As it turns out, the rest of the movie ain't bad either.

Based on two books, live interviews and meticulous research, *Downfall* follows the last twelve days of Hitler's life, hiding underneath Berlin as the Third Reich disintegrates into chaos. Rather than getting caught up in the mythology of the man, director Oliver Hirschbiegel attempts to show Hitler as a human — afraid, insecure, petty, terrifying and terrified.

Sixty-six years after World War II, the Third Reich remains an understandably difficult subject for Germans to explore on film. *Downfall* broke one of the few remaining taboos by portraying Adolf Hitler in a central role with a German-speaking actor, Swiss-born Bruno Ganz. He did four months of research, studying recordings of Hitler's private conversations in order to mimic what Year 1 teachers would call his 'inside voice'. The result is a performance without fear or favour, depicting Hitler as a delusional yet charismatic man, weighed down by the failure of his dream.

Humanising Nazis is a fraught pathway. If you make them too sympathetic you run the risk of trivialising their crimes. Make them too evil and they can become cardboard cut-out villains. There are very few films that manage the balancing act — *Downfall* is one of them. In a way it's much scarier to explore how horrendous events like the Holocaust can emerge from a human being with all the same personality flaws as, say, you or me.

Judgment at Nuremburg (USA) (1961)

Director: Stanley Kramer
Stars: Spencer Tracy, Burt Lancaster, Richard Widmark

Judgment at Nuremburg, one of Hollywood's earliest treatments of the Holocaust, is a fictionalised account of the third Nuremberg trial held after the end of World War II. Specifically, it explores the trial of four German judges and in doing so delves into the murky territory of the moral responsibility of the German people

under Nazi rule. At the same time it very gently examines the 'character' of the German people, primarily through the character of Mrs Bertholt (Marlene Dietrich), widow of an executed Nazi officer. As a German who fled the country years prior to the war, there is a wistfulness to Dietrich's performance and you can't help but feel that she has a very personal investment in the film.

Judgment at Nuremberg may be a long film but it is a commanding story. Stanley Kramer's direction is methodical, adopting a deliberately considered pace as he walks you through every detail of the cases. Once you get wrapped up in the courtroom drama, mind you, you hardly notice it.

The script is as much about ethics and morals as it is about the specific crimes that the Nazis perpetrated. The film is not asking whether the Nazis did right or wrong but rather the movie forces you to consider that morality can be relative, and is often more flexible than an eighteen-year-old pole dancer. Who decides what is right and what is wrong? Who decides when murder is justifiable? Who decides where patriotism ends and atrocities start? In times of conflict the answers to these questions suddenly become harder to grasp.

THE SUNDAY MOVIES

The Reader (USA/Germany) (2008)
Director: Stephen Daldry
Stars: Kate Winslet, Ralph Fiennes, Bruno Ganz

What if you fell madly in love with someone who turned out to be a Nazi?

It's 1958 and Kate Winslet plays an abrupt working-class German woman named Hanna Schmitz. Hanna may lack social skills, but she still has needs. Womanly needs. Oh, who am I kidding?

She wants to get laid. Enter teenager Michael Berg (David Kross). As the two embark upon a whirlwind summer romance, it slowly becomes clear that Hanna has a secret.

The plot of *The Reader* moves back and forth in time, spanning several decades. It traverses an illicit affair, a war-crimes trial and plenty of pregnant pauses with guilt-ridden eyes. All very Oscar-baity stuff, no?

The Reader was a film soaking in strife from the get-go. While the script was being developed, not one but two of the three original producers tragically died, Sydney Pollack and Anthony Minghella. Kate Winslet was in and out of this film thanks to a scheduling clash involving her role in another movie, *Revolutionary Road* (which her husband was directing — can't really say no to that one, can you?). In fact, we very nearly had Nicole Kidman's immobile visage in *The Reader*, but then our Nicole went off and got pregnant — bullet dodged. The production also had to wait for David Kross to turn eighteen before they could shoot any of the sexual scenes. Executive producer Scott Rudin withdrew his name as producer when studio boss Harvey Weinstein released this film at the same time as *Revolutionary Road* and *Doubt* as he did not want *The Reader* to compete with them for awards. Speaking of awards, when the time came for acting gongs Kate Winslet had to be pitched in two different categories (lead actress and supporting actress) because she was up against — wait for it — *herself* in multiple movies, including in her (now divorced) spouse's vastly inferior *Revolutionary Road*.

Production woes aside, *The Reader* is a haunting and visceral watch. It shows the tortured soul of a woman who did things she can never take back. Kate Winslet turns in a sexually and emotionally charged performance as Hanna Schmitz eventually comes to represent a nation's guilt and conflicted remorse.

Ilsa, She Wolf of the SS (USA/West Germany) (1975)
Director: Don Edmonds
Stars: Dyanne Thorne, Gregory Knoph, Tony Mumolo

In the last three days you've experienced Nazis as comic figures, as humans and as avatars for the ephemeral notion of justice — so why not Nazis as kinky sex objects?

We are at the pointy end of World War II. As the engorged bratwurst of the Allied forces plunges deep into the throbbing bosom of Germany they encounter a camp. This is a POW camp run by the most eviiiiilll of all Nazis, a prison where the most degrading medical experiments are carried out by a woman whose lust for pain is second only to her lust for ... well ... cock. If you fail betwixt her nether regions you can expect a merciless demise. Fear the wrath of Ilsa, She Wolf of the SS.

Shot for just $150,000 on — wait for it — the leftover set of sitcom *Hogan's Heroes* over nine days in 1974, *Ilsa, She Wolf of the SS* is a bona fide cult classic. It is very, very, *very* loosely based on a real Nazi named Ilse Koch, 'The Butcher of Buchenwald', who was known to 'use' male inmates for 'personal purposes'. Though it's hard to imagine she managed to pull off quite as much damage as her cinematic counterpart.

With its castrations, medical experiments, wild orgies, electrode nipple clamps and wandering accents, *Ilsa, She Wolf of the SS* is unashamedly exploitative trash. It is, however, exploitative trash of the highest grade. The pace is tight, it packs in a lot of shocks (sexual and electrical) and the special effects are, well, rather special.

And a big part of what makes *Ilsa* memorable is Ilsa herself. Let's just say that if you like your women Amazonian, Teutonic and big-busted, Dyanne Thorne is the lady for you. Thorne, a Vegas showgirl by trade, originally agreed to do the film on a lark. Her performance is wildly over the top but, to her credit, it also has a few emotional levels — each more disturbing than the last.

INSIDE THE MAGICAL WORLD OF HAYAO MIYAZAKI

Master Japanese animator Hayao Miyazaki leads a monastic life: all work, no play, no TV and no internet. And yet, he is far from a dull boy. Japan's most financially successful filmmaker, Miyazaki is the most prolific and beloved Japanese animator this side of the bloke who invented *Astroboy*. John Lasseter, director of *Toy Story*, has even declared him 'the world's greatest living animator'. I am inclined to agree.

It's also quite likely that Miyazaki is also the only feature animator on Earth who embarks on the laborious process of 2-D animation without a script. Instead he starts his films with the locations. His animation studio, the famed Studio Ghibli, has an enormous image bank of landscapes with staff constantly designing new locations and worlds. It's into those that Miyazaki sticks his head and then imagines what kinds of characters might live in that world, and from there the story flows. Perhaps it's because of this unique approach that Miyazaki's movies are so absorbed with a sense of discovery and wonder.

Some inaccurately call Hayao Miyazaki the Disney of the East. Firstly, Disney was more a producer than an animator. But there is a more subtle, conceptual difference between the two. Disney movies provide an escape to wondrous places

that reaffirm the goodness of the world. Miyazaki, however, makes movies that are fantastic, heartfelt, dangerous, tender and sometimes outright grotesque. And yet there is always something of our own world or human nature in these fantastical places. Miyazaki invites you to look through a window to another world only to present your own reflection in the glass. And he hates singing animals.

FRIDAY NIGHT FILM

Howl's Moving Castle (Japan) (2004)
Director: Hayao Miyazaki
English voice cast: Emily Mortimer, Christian Bale, Lauren Bacall

Even though this is one of his more recent movies, it feels like the best place to enter the world of Miyazaki. *Howl's Moving Castle* is based on a book by English fantasy writer Diana Wynne Jones. I say 'based on', but really they're nothing alike. Set in Vague-istan, Europe, on the brink of a devastating war, a young, diligent milliner's assistant, Sofi, has incurred the wrath of the Witch of the Waste (a six-foot tall creature that looks like a cross between Bette Davis, an octopus and a ball of reclaimed fat). The wicked witch (herein referred to as the BetteBallopus) casts a spell on our Sofi that makes her appear to be an old woman. In horror, Sofi runs off into the wilderness only to stumble upon a magical castle/mechanical-tumour-on-legs. Within this giant contraption lives a talking flame with the voice of Billy Crystal, a child with a detachable beard and a devilishly handsome flying sorcerer named Howl. And by 'devilishly handsome' I mean unbelievably effeminate, emotionally childish, obscenely vain, but hey, he's

voiced by Christian Bale so all is forgiven. It turns out that Howl and the BetteBallopus have some history. Will he help Sofi break the spell?

This is a checklist of all of the elements that make a great Miyazaki movie:

- clever characters who quietly undermine your expectations of them
- interactions that are complex and quirky
- a wildly inventive universe filled with technology, magic and mythology
- none too subtle anti-war sentiment
- bizarre flying machines
- a young girl as the main protagonist

Howl's Moving Castle has them all …

SATURDAY FLICKS

Spirited Away (Japan) (2001)
Director: Hayao Miyazaki
English voice cast: Daveigh Chase, Suzanne Pleshette,
David Ogden Stiers

Howl's Moving Castle has a very clear narrative thrust, but not all of Miyazaki's films do. This isn't necessarily a bad thing. In the case of *Spirited Away* there may be less focus on the story, but the sense of wonder is much, much larger.

We've still got a young girl heroine, Chihiro Ogino but, unlike most of Miyazaki's bevy of little girls, this one isn't heroic. In fact, I find her a wee bit irritating. Chihiro is driving with her family to their new home when her dad — who is an unbelievable oaf with a penchant for speeding — stumbles across a door leading to an

abandoned village full of seemingly free food. So they eat, because stealing and gluttony are values that any parent would want to pass on to their kids. What they don't realise is that this is a magical place and the engorged parents are soon turned into pigs leaving young Chihiro a lone human in a bathhouse for the spirits (who look like deformed animals). Aided by a few friendly beings, she finagles herself a job at the bathhouse filled with strange and mysterious ghouls who often aren't quite what they seem. But how exactly does she escape this place … oh, and turn her dipshit parents into humans again?

This was the big film for Miyazaki. It won the 2002 Oscar for best animation, the first Japanese anime to ever do so. A simple plot description can't quite convey the peculiar texture of *Spirited Away*. It's magical and ethereal but the character interactions seem deeply rooted in recognisably human folly. Every scene overflows with a fountain of detail, both visual and thematic. In some ways Chihiro is a pint-sized representation of a modern, cynical Japan itself, and the bathhouse a gentle satire on how Japanese traditions have been commoditised and commercialised. But Miyazaki isn't arguing for us to abandon the modern entirely for the traditional. The only characters that survive *Spirited Away* are the ones who find balance.

Laputa: Castle in the Sky (Japan) (1986)
Director: Hayao Miyazaki
English voice cast: James Van Der Beek, Anna Paquin, Mark Hamill

In many ways, this was the movie that signalled the full birth of the Hayao Miyazaki we know today. In 1984 Miyazaki directed a manga (Japanese comic) adaptation called *Nausicaä of the Valley of the Wind* and it became a surprise hit. It was Miyazaki's first solo film

as a director and by all accounts he was genuinely surprised by its success. Emboldened by this, Miyazaki and his producing partner, Isao Takahata, launched their very own production company, Studio Ghibli, with this movie, *Laputa: Castle in the Sky*.

Set in a mining town that is embedded in a gargantuan ravine, the film opens on a young boy named Pazu (voiced in the English version by James Van Der Beek). He works in the mines until some girl named Sheeta falls out of the sky. That's weird enough, but she also has a magical pendant that must possess some pretty special power because everyone wants it: pirates, the army and a mysterious aristocrat named Muska. The pendant leads the two of them to an ancient floating castle known as Laputa that was thought to be legend.

If you're a keen reader of nineteenth-century fantasy you'll know that Laputa is a reference to Jonathan Swift's *Gulliver's Travels*. And if you're a keen student of the Spanish language you'll know that *la puta* is also Spanish for 'whore'. We're fairly sure that Swift knew that; whether Miyazaki did is less clear. Either way, the movie is only known as *Castle in the Sky* in most Spanish-speaking countries, including the USA.

With his first original film, Miyazaki went for a blockbuster. There are cities that hover in the sky, epic zeppelins and air pirates swooping like buzzards. Generally you don't have a natural sense of the physics in 2-D animation. But Miyazaki brings it all to compelling life. There's also great comedy, madcap adventures and a soundtrack big enough to rival any Hollywood production.

The idea of 'balance' finds its way into this film as well: nature and science, air and earth, culture and technology — they are things that need to be weighted correctly to work in harmony.

THE SUNDAY MOVIES

My Neighbor Totoro (Japan) (1988)
Director: Hayao Miyazaki
English voice cast: Dakota Fanning, Elle Fanning, Tim Daly

If you had to sum up the way this movie is made in one word it would be 'lovingly'. The story, characters, scenes, feel, design — all are crafted with true affection.

It's the tale of two young sisters who travel to a country town in Japan to be near their mother, who is sick at a nearby hospital. However, this is a world where magic and the ordinary coexist without anyone batting an eyelid. As the two girls open the door to their new house, thousands of tiny black fuzzy dot creatures scurry to escape the light of the newly filled apartment. They are soot sprites, which love to take up residence in abandoned houses but flee as soon as someone moves in. The girls eventually encounter a host of magical critters in the area, like a giant cat that is also a bus and most importantly a huge rabbit-like creature known as Totoro.

By rights, this movie shouldn't work. And in fact, depending on your attention span, it may not work for you. There is no villian, no conflict, no goal. And yet this is where you get to see the real genius of Miyazaki: he doesn't require any of those elements in order to construct a watchable film experience. The characters are both mysterious and instantly lovable. The personalities of the girls are so authentic and believable. There's comedy in the interactions between the girls and the creatures and yet every one of their encounters is also tinged with sadness and fear. Combine all of these elements together and it becomes impossible to look away from the film. It's Miyazaki at his purest.

Princess Mononoke (Japan) (1997)

Director: Hayao Miyazaki
English voice cast: Billy Crudup, Claire Danes,
Gillian Anderson

When Hollywood uber-producer Harvey Weinstein was preparing for its US release, he signalled his intent to make a number of re-edits to this, Miyazaki's most complex and epic film. Rumour has it that a package soon arrived on Weinstein's desk. In it was a gleaming samurai sword and a note that read: 'No cuts.'

Since then, all Miyazaki flicks have been released uncut in the USA.

Princess Mononoke is set at the birth of the Iron Age in feudal Japan. It sees mankind at a crossroads: some humans still live in harmony with nature and others who wish to exploit her for gain. A handsome prince has been attacked by a grotesque oily 'boar god' leaving him cursed. He travels west to where the beast originated in the hopes of finding a cure, but instead he finds the industrial Iron Town, ruled by the formidable Lady Eboshi. There he encounters the wildcard, a mysterious girl raised by wolves named Princess Mononoke.

Princess Mononoke is long, colourful and layered. It mixes fantasy, environmental politics, feminism, mysticism, samurai fisticuffs and a healthy dose of decapitation. No one in this story is a clear villian or hero; everyone has justifiable motivations. This is partly why *Mononoke* is so engaging: the allegiances are never concrete. *Princess Mononoke* is an epic examination of humankind's difficult relationship with nature.

WHY YOUR COMFORTABLE LIFE IN THE SUBURBS SUCKS AND YOU SHOULD BE ASHAMED OF IT

Every year, millions of Australians embark upon buying their first home, thus slipping into the great Australian dream — indentured financial servitude to a bank. But hey, most don't care. Why would they? You, dear home owner, now have a quarter acre of flat surfaces on which to have sex with your other half. Sure your neighbour has initiated some kind of suburban arms race over who has the most technologically advanced pressure hose to irrigate her expertly manicured grass. She probably has a dead handyman buried there, beaten to death with an Ikea catalogue. Of course, this neighbour will become all too easy to ignore when you start squeezing out the baby bonuses. From thereon it's simply a case of managing your steady decline into alcohol dependency until you can swap this suburban dream for Alzheimer's.

Well, at least that's the popular movie version of it, anyway. Cinema does not appear to be all that fond of suburbia. Tom Hanks' nineties comedy *The 'burbs* sees Nazis move into the house down the street, while the gloomy Kate Winslet and Leo DiCaprio film *Revolutionary Road* follows a couple suffering through hyper-conservative 1950s American suburbia — a condition which

seems to bring on lots of sobbing, yelling, drinking and Golden Globes. Even in Australia we've had our suburban hang-ups. For every parochial celebration like *The Castle* there's been a *Lantana* (the sprawling tale of dysfunctional couples) or a *Suburban Mayhem* (portraying a teenage mum who creates a tornado of petty crime and voluminous bogan hair). As much as filmmakers appear to resent these repressed cookie-cutter lives, they also cannot stop making films about them. So this weekend we knock on the front door of suburbia to find out why filmmakers seem to hate it so very much …

FRIDAY NIGHT FILM

The Joneses (USA) (2009)
Director: Derrick Borte
Stars: Demi Moore, David Duchovny, Amber Heard

What a good-looking family the Joneses are. Mum (Demi Moore) and Dad (David Duchovny) look like the ultimate milf/dilf couple along with their two attractive, smart teenage offspring. How chic they are, always dressed in the latest clothes and brands. And so ahead of the curve on gadgets! They even have the best hors d'oeuvres. Most of their products haven't even been in TV ads yet …

Well, I guess that depends on your definition of an ad.

You see, the Joneses aren't a real family. They're 'stealth marketers': a team of walking, talking advertisements. The 'family' are paid to wear and use the latest gadgets in the hopes that the entire community will aspire to be just like them. This demographically perfect American family unit moves into upscale suburbs, where they make friends and influence people … to buy things. The adults have been assigned a son,

Mick (Ben Hollingsworth), and a daughter, Jenn (Amber Heard). The two 'teens' are tasked with the job of becoming trendsetters at their local high school. In truth, 'daughter' Jenn is a sex-crazed nymph with a taste for older married gentlemen. Dad and son aren't a hundred per cent comfortable living lies and slowly begin to witness the damage they're doing. Only Demi Moore, ambitious, cold and perfect as a sub-zero fridge (yours for only $6000), is completely dedicated to their cause. To the outside world, this is one great family, and keeping up with these Joneses is going to be a bitch.

The Joneses opened in US cinemas smack bang in the middle of their financial recession. With millions of people out of work, the idea of a comedy about out-of-control luxury spending was considered unsavoury and the movie was a tremendous flop, which was a shame because there's a lot to like about *The Joneses*. It's a cracking concept that's been hit on a few times in other films but never truly fleshed out to this level. Whilst the last third of the movie is a bit lazy, the filmmakers generally do a decent job of detailing the questionable and fuzzy moral quandaries of this kind of lifestyle. Perhaps most impressive is Demi Moore. Sure she has the head of a forty-year-old on the body of an eighteen-year-old, but her performance plays out on a number of levels as a manager, a morally conflicted leader and professional hustler.

SATURDAY FLICKS

American Beauty (USA) (1999)
Director: Sam Mendes
Stars: Kevin Spacey, Annette Bening, Thora Birch

Lester Burnham (Kevin Spacey) is a man devoid of worth, or so he seems to think. After too many years of marriage to his OCD

wife Carolyn (Annette Bening), Lester has decided to make some changes that involve reverting to teenager behaviour (cue the self-pleasuring, weed-smoking and recklessness). Meanwhile, Lester's daughter, Jane (Thora Birch), has concluded that her parents are embarrassing morons (with considerable evidence to support her in this conclusion). She falls in with the mysterious new boy next door, Ricky Fitts. Ricky, as it happens, is a drug dealer. He keeps his brutal retired marine colonel father off the scent by behaving like a lobotomised Mormon. It's a very effective act. Another of Jane's school friends, Angela, has recently become the object of Lester's masturbatory fantasies. As all their lives become intertwined you get the clear sense that it isn't going to end well — also we are told from the outset that Lester will die within a year. The question is, which one of these despicable people will kill him?

The world of *American Beauty* is wistful, tongue-in-cheek and sometimes outright cruel. The characters are often actively unlikeable. And yet director Sam Mendes makes them all sympathetic in some way. It's the Great American Dream that British-born Mendes is most critical of. By all measures, the Burnhams have hit the apex of middle-class achievement: they have a big house in the suburbs, immaculate furniture, a stunning garden, a comfortable income and a very sensible minivan. Yet no one is happy; all of the passion has been leached from their souls. *American Beauty* is a wholesale attack on virtually every slice of suburban American society, along with middle-aged sexual frustration, materialism, rigid patriotism and, of course, the corporate culture that funds all of the above.

Blue Velvet (USA) (1986)

Director: David Lynch

Stars: Isabella Rossellini, Kyle MacLachlan, Dennis Hopper

Welcome to David Lynch's image of the strange, beautiful and sometimes violently grotesque side of small-town America. A very young Kyle MacLachlan plays a clean-cut college kid, Jeffrey Beaumont, who discovers a detached human ear near his house (as you do). Being a naturally inquisitive kind of lad, he launches his own unofficial investigation. Before long he's seduced into the town's dangerous, dreamlike underbelly. He enlists the help of Sandy Williams, a local high-school girl played by Laura Dern. Their investigation leads them to lounge singer Dorothy Vallens (Isabella Rossellini) and a certifiably crazy local named Frank Booth (Dennis Hopper).

Let me flag this now: David Lynch films can be a pain in the arse. Sometimes Lynch seems more concerned with his own transcendental artistic process than creating a watchable experience. At their worst, Lynch's films tend to be so bogged down in the inner workings of his mind that they become meaningless to anyone who isn't David Lynch. On the other hand, you then get films like *Blue Velvet* where he actually manages to hook the audience with his unique vision of the world. In this case that world is folksy, American suburbia. Lynch once called *Blue Velvet* 'The Hardy Boys go to Hell' and that's not a bad description — the plot moves much like any straight-up detective story. Jeffrey Beaumont is our gumshoe; we learn the facts of the case as he does. But it's in those clues that we get plugged into Lynch's subconscious: the severed human ear, the suburban field that belies a violent swarm of insects, a ghostly lounge lizard caked in white make-up lip-synching love songs into a desk lamp. Come on — don't tell me Freud wouldn't be having a field day with this

218

stuff. Each one of these images evoke a nightmarish quality, but the compound result is also seductive.

THE SUNDAY MOVIES

The Virgin Suicides (USA) (1999)
Director: Sofia Coppola
Stars: Kirsten Dunst, Josh Hartnett, James Woods

The Virgin Suicides chronicles the year 1974 in Grosse Point, Michigan. The voice of Giovanni Ribisi tells the sad, magical tale of the five Lisbon sisters. A year apart in age, from thirteen to seventeen, the girls have been shut away from society by their overprotective and religious parents. And yet the locals are somewhat surprised when thirteen-year-old Cecilia (Hanna Hall) jumps to her death during a party. Her death is ruled an accident — after all, who could be so sad so young? The tragic, bewitching fate of the remaining sisters unfolds before you, all through the eyes of the smitten local boys.

Until *The Virgin Suicides*, director Sofia Coppola's highest point in the film industry was an acting gig in *The Godfather: Part III*, directed by her father, Francis, that is probably best forgotten (let's just say she looked like a dyslexic trying to read her lines off a bunch of cue cards). And so Sofia Coppola reinvented herself as a director with *The Virgin Suicides*. Good move. Coppola pulls you into a lethargic, nostalgic place filled with longing. If you're in the right mood, this movie is completely transfixing. On top of the perfect soundtrack and entrancing performances, you have Coppola herself creating a nostalgic wistful gaze on the film. The film looks and feels like a series of memories that have degraded over time.

Paranoid Park (France/USA) (2007)

Director: Gus Van Sant

Stars: Gabe Nevins, Daniel Liu, Taylor Momsen

You're sitting in a class. It's deathly boring and gradually you drift into your own detached daydream … This hazy malaise is what it's like to step into *Paranoid Park*, named for an infamous Portland skate park. When teenager Alex (Gabe Nevins) visits the hallowed grounds of Paranoid Park, it sparks a series of tragic events. The police start to bear down on our hero but the problem is that he can't actually remember anything about the events in question. Director Gus Van Sant puts you right inside Gabe's head, so you're never quite sure what has transpired. The film flows out of order, starting with the events far prior to and long after the culminating 'event'. As the movie pushes on, the flashbacks and flashforwards move closer inwards to the event.

This isn't a movie about skating but about getting inside the head of an average suburban teenage boy as we work with him back to that moment of trauma. Gus Van Sant has been documenting American teenagers for the better part of twenty years; some of his films are good, others mind-blowingly shithouse. This is one of his better ones. He clearly understands that the best way to understand a character is to show us what they're passionate about. This film is nothing less than majestic as it showcases the elastic moves of the skaters, all set against gentle electronic music.

Complaints? After the climax of the film, the movie hangs around too long.

ALL CRITICS ARE WANKERS

It's true. Let's not deny it. Any person who spends their days ripping apart some poor artisan's finely honed creation is, quite simply, a tool.

To the best of my knowledge the old adage remains true: no one has ever built a monument to a critic. That said, they have proved to be monumentally fun movie characters. Critics frequently make for witty and caustic figures, be they in the realm of food, theatre, music or — heaven forbid — film. Some critics are written with such naked hatred you just have to laugh at them. M Night Shyamalan's *Lady in the Water* features a blowhard movie reviewer (Bob Balaban) who moves into an apartment block besieged by werewolfs, water nypmhs and chronically bad scriptwriting. He is arrogant, self-important and, surely, not at *all* inspired by the countless film critics that ravaged Shyamalan's previous films.

Or why not make the fight more personal, like George Lucas and Ron Howard? The two took on polarising *New Yorker* film critic Pauline Kael in their film *Willow* by creating the character General Kael, a baby-killing army leader. Kael's review of *Willow* was priceless: 'too embarrassed for the filmmakers to feel any suspense'.

So fill up your poison pen and wait for your weekend to reach critical mass …

FRIDAY NIGHT FILM

Ratatouille (USA) (2007)
Directors: Brad Bird, Jan Pinkava
Stars: Brad Garrett, Lou Romano, Patton Oswalt

Hateful food critic Anton Ego (voiced by Peter O'Toole) is an accurate example of a critic who has spent too long doing what they do. After decades of consuming culinary mediocrity, every meal Anton lifts to his mouth tastes passé. It takes the cooking of a rat named Remy (voiced by Patton Oswalt) to help him reconnect with his childhood love of food.

Ratatouille is one of Pixar's more conventional movies. It's not as groundbreaking as *Toy Story*, as heartbreaking as *Up* or *Toy Story 3* or as innovative as *WALL-E*, but a conventional Pixar film is still vastly better than ninety per cent of everything that has ever existed anywhere in space, time and the universe.

Specifically there are two things *Ratatouille* does very well.

Firstly, food. The Pixar team pioneered a new development to replicate the translucency of real food and flesh on screen, the way light scatters just under the surface of the skin. Pixar carted a team of professional chefs into their offices to help make their digital food look truly tasty.

Secondly, a sense of scale. *Ratatouille* always keeps the audience at Remy the Rat's point of view. From that angle, the human kitchen suddenly becomes both a playground and a perilous obstacle course.

The script is witty with an inherently subversive concept (aren't we supposed to keep rats *out* of the kitchen?). At the end of the day though, this is a romantic film. It's all about the adventure and discovery of beautiful, rich food, and of Paris. It's exuberant to watch the characters fall in love with their meals.

SATURDAY FLICKS

Almost Famous (USA) (2000)
Director: Cameron Crowe
Stars: Billy Crudup, Kate Hudson, Philip Seymour Hoffman

For a long time, Philip Seymour Hoffman was just one of those 'that guys'. You know, those actors with a face you recognised from a thousand bit parts, but whose name always seemed to escape you. But generally Hoffman was always the best thing in a film. It didn't matter how lame the script or direction, Hoffman always seemed to shine.

Same goes here.

Welcome to California. It's the dying days of rock (ahem … 1973) and William Miller (Patrick Fugit) is a teenage prodigy. He's too young for his grade, but too smart for it also. And, despite the lectures of his domineering professor mother (Frances McDormand), his heart belongs to rock music. While writing pieces for street magazines around the city, William meets famed journo and critic Lester Bangs (Hoffman), who both inspires and terrifies him. Soon William gets his big break as a writer and is sent on the road to cover Stillwater, an emerging band coming to terms with their new fame and unfulfilled talents. On the road with them is a cavalcade of willing groupies, including the glowing, mysterious Penny Lane (Kate Hudson). Along the way, William learns Valuable Lessons™ about integrity, sex and Quaaludes. And through this heady mix Lester Bangs is always there on the other end of the phone line because, as he puts it, 'The only true currency in this bankrupt world is what we share with someone else when we're uncool.'

Almost Famous is a loose autobiography of the early years of its own writer and director, Cameron Crowe, who was the youngest

ever writer for *Rolling Stone* back in the 1970s. Lester Bangs was actually a real rock critic and writer. Crowe gives us a slightly romanticised view of him and the rest of the music world, but who cares — *Almost Famous* is a movie brimming with charismatic acting, great music and so many scenes that you want to relive.

Inglourious Basterds (USA/Germany) (2009)
Director: Quentin Tarantino
Stars: Brad Pitt, Diane Kruger, Eli Roth

Once upon a time in Nazi-occupied France, infamous 'Jew Hunter' SS Colonel Hans Landa (Christoph Waltz) found a family of Jews hiding under a dairy farmer's house. The daughter of the family, Shosanna (Mélanie Laurent) escapes, but the rest of her family is slaughtered. Three years later she is living under an alias, managing a French cinema. Meanwhile, a crack team of Jewish American soldiers known as the 'Basterds', under the command of Lieutenant Aldo Raine (Brad Pitt), storm their way through the countryside, bringing guerilla warfare to the Nazi army. When Hitler decides to attend a movie premiere at Shosanna's cinema, the lives of the Basterds and Shosanna will converge, with explosive consequences. The key to their survival may just be the keen cinematic understanding of a military tactician (Michael Fassbender) ... who also happens to be a film critic.

The marketing for *Inglourious Basterds* would have you believe that this is some kind of live-action version of Wolfenstein with a poster designed by a dyslexic. Whilst that film would be awesome, this is not it. But *Basterds* is still fairly awesome, and Tarantino has crafted some of the most memorable dialogue you'll ever hear. Brad Pitt as Lieutenant Raine is a hardened redneck, the sort of guy who has learned to shrug off civilisation and get down to the messy business of winning, while also being totally charming and

224

terrifyingly ruthless. Also, pretty much everything that comes out of his mouth could be put on a T-shirt and sold online. On the other side of the coin is Jew-hunting SS Colonel Hans Landa who is just as ruthless, charming and volatile as Raine.

Tarantino goes out of his way to put movie culture itself at the centre of the film. The whole film is a meta-conversation about how we use film as a cultural tool in history to rewrite events. And with this film Tarantino doesn't just rewrite history, he enacts an elaborate revenge fantasy on history and then carves a bloody swastika on history's face.

THE SUNDAY MOVIES

All About Eve (USA) (1950)
Director: Joseph L. Mankiewicz
Stars: Bette Davis, Anne Baxter, George Sanders

Actress Margo Channing (Bette Davis) is a Broadway celebrity. Her star in the thespian scene is so large and luminous that only one thing could block it out: her ego. Or perhaps, just perhaps, also the ever-so-polite fan she's just met: Eve Harrington (Anne Baxter). Eve, you see, is the girl who goes from adoring fan to personal assistant, fill-in performer, award-winning star and ultimately usurper of Eve's life and loves. All the while Eve is propelled by her puppetmaster, Addison Dewitt, theatre critic.

All About Eve was nominated for fourteen Oscars, which might lead you to suspect that it's rather good. In fact, it's great, a masterclass in ego, show business and celebrity culture. The script is smart and sassy but filled with little nuances that let you read between the lines about each character's intentions (thus making you feel smart, which is always a plus). The performances are all

razor sharp; Bette Davis is at her diabolical best. This was her first film following a disastrous working relationship with Warner Bros. As soon as she exited her contract with the studio this script landed in her lap and would prove to be one of her most memorable roles. All that said, it's George Sanders as the Machiavellian theatre critic who strikes you every time, a philosophising, erudite master of the theatre scene who wields his power decisively and ruthlessly. It's a joy to watch.

Hamlet 2 (USA) (2008)
Director: Andrew Fleming
Stars: Steve Coogan, Elisabeth Shue, Catherine Keener

Okay, go with me on this one. I don't think I've ever seen a film as wildly uneven as *Hamlet 2*. It is both one of the worst and funniest comedies I've seen.

Steve Coogan plays Dana Marschz, a failed actor. Not as in 'a guy who was once huge but failed spectacularly' but rather 'a guy who once made a very compelling series of haemorrhoid commercials and then ended up teaching drama at a high school in Nowheresville, USA'. His school plays are almost always based on popular Hollywood films and they never fail to receive scathing reviews from the school newspaper critic, twelve-year-old Noah Sapperstein (Shea Pepe). It's Noah who convinces Dana that he must create an original production next, and so he begins writing *Hamlet 2*.

There are so many gleefully stupid moments in this movie. For example, the all-singing, all-dancing rendition of 'Rock Me Sexy Jesus'. At this point you might be wondering why Jesus makes an appearance. You might also be thinking, 'Wait — doesn't everyone die at the end of the first *Hamlet*?' Answer: yes. But fear not, Coogan's character has a narrative device that will blow your mind — a time

machine. And yet this is only a fraction as moronic as the technique the film uses to bring Elizabeth Shue — as herself — into the story.

Coogan's performance holds this movie together — he's a blowhard, but an increasingly lovable one. The movie is littered with excellent, if non-sequitur, jokes. Unfortunately there are also large, gelatinous chunks in the middle of the film with some atrocious plotting, dialogue and ill-considered twists. If you can withstand that, the gags are quite bizarrely funny.

GETTING INTO A CLUSTERCUSS WITH WES ANDERSON

There are a few sure-fire ways of knowing that you're in a Wes Anderson movie. For starters, every shot will be perfectly symmetrical and art-directed within an inch of its life. Chances are you'll be watching a highly dysfunctional family on the brink of an emotional calamity. The film will be funny, but if the comedy were any drier it would be a pretzel. In the background is most likely a soundtrack of sixties and seventies pop rock, the sort of tracks you might not know the names of but inherently recognise the melody, perhaps through the subliminal power of classic-hits radio.

Oh, and Bill Murray is being serious.

Congratulations, you are truly in a Wes Anderson movie, the man once declared to be the next Martin Scorsese (by Scorsese himself, no less). He may have only made but a handful of movies to date but Anderson has etched himself one of the most distinctive styles out there. A director who has somehow managed to absorb influences as disparate as the Peanuts comics and the French new wave, Anderson's look has been replicated throughout movieland in flicks like *Garden State* and *Son of Rambow*.

Anderson's films are deeply intimate, often referencing very personal objects or events in Anderson's own life. (He once even

228

asked Anjelica Huston to wear his mother's glasses as a prop.) When Anderson's films are good they are accessible, funny and at times heartbreaking, with characters saying the sorts of things that no one will usually say but everyone has thought.

FRIDAY NIGHT FILM

Fantastic Mr Fox (USA) (2009)
Director: Wes Anderson
Stars: George Clooney, Meryl Streep, Bill Murray

This might seem like an unusual place to start with Wes Anderson. It's not his first movie; in fact, it's his sixth. And unlike all of his other films, *Fantastic Mr Fox* is animated and it's an adaptation of a book, and a kids' book at that. But I would argue that this is the most 'Wes Anderson' of Wes Anderson's movies. Using wonderful handmade animation, it expands Roald Dahl's children's classic into a film that both grown-ups and kids can find something in. That old silver fox himself George Clooney voices Mr Fox, once a champion killer of farm chickens. He and sexy wife Mrs Fox (Meryl Streep) were fast, clever and suave. But then they had kids and Mr Fox needed to get a less dangerous career. Now with a teenage son and entering middle age, the urge to kill chickens has returned so Mr Fox takes on the three meanest farmers in town: Boggis, Bunce and Bean.

Who would've thought that foxes and existential drama were a perfect match? *Fantastic Mr Fox* is a film about what you want to be versus what you should be versus what you really are. We're always aspiring to be something else, but should we just be content with what life has already presented us with?

Stop motion is the perfect medium for Wes Anderson to work in. He's always made stylistic films with every element of the screen

perfectly crafted — animation seems like the logical next step. Stop motion offers something unique from other forms of animation: texture. You can see the creases in the characters' fur, the wood grain in the sets and even the dust in the air as the figures are animated. It is the most human form of animation.

Of course, I'm making this all seem very, very serious and important. But *Fantastic Mr Fox* is also very silly and fun. The best bits in the movie are the moments that have nothing to do with the plot, like a grumpy old farmer critiquing a campfire song or Mr Fox's elaborate little mental tics.

SATURDAY FLICKS

The Life Aquatic with Steve Zissou (USA) (2004)
Director: Wes Anderson
Stars: Bill Murray, Owen Wilson, Anjelica Huston

Meet Steve Zissou, a world-famous oceanographer who roams the oceans in his dilapidated vessel, the *Belafonte*, with his addled crew of misfits. That is until the dramatic appearance of the Jaguar Shark, a beast once thought to be mythical. We now know it's not mythical because it just ate Steve's first mate and best friend. Awkward.

Bill Murray stars as Steve Zissou, a thinly veiled tribute to infamous seafarer Jacques Cousteau. Faced with the loss of his best friend and the sudden appearance of his long-lost son (Owen Wilson), Zissou embarks on a mission to kill the shark that killed his friend, thus fulfilling the age-old Chinese proverb: two wrongs make a tasty shark fin soup.

This is one of those strange films where I initially wasn't quite sure if I liked it or not. By the end, however, it had completely and inexplicably won me over. *The Life Aquatic* opened in cinemas

with very high expectations: the trailer looked hilarious and so did the supporting cast, which included Owen Wilson, Willem Dafoe, Anjelica Huston and, of course, (our) Cate Blanchett. The humour in this film is (true to Anderson's form) very dry, possibly a little bit too much so resulting in a mid-section plot lull. However, if you're open-minded about it, *The Life Aquatic* is also a genuinely sweet character piece about an arrogant, emotionally retarded old man.

Similarly to *Fantastic Mr Fox*, most of the special effects in the film are created out of stop motion, giving the film a handmade feel that reflects the decrepit state of the *Belafonte* and indeed Zissou's life. And just quietly, the soundtrack is full of David Bowie songs sung in Portuguese which, frankly, is just too damn cool …

The Royal Tenenbaums (USA) (2001)
Director: Wes Anderson
Stars: Gene Hackman, Gwyneth Paltrow, Anjelica Huston

The Tenenbaums are a family of geniuses presided over by two powerful forces, Royal (Gene Hackman) and Etheline (Anjelica Huston) Tenenbaum. He was the wild rascal. She was a woman of polished class. Their marriage did not last. They did, however, produce a gaggle of brilliant, idiosyncratic children who each proved to be utterly self-destructive — for genius is a heavy burden to bear. Chas (Ben Stiller) is a talented businessman who has become rigid to the world thanks to the death of his wife in a plane crash. Margot (Gwyneth Paltrow) is a successful playwright. She puffs on her cigarettes, cheats on her husband and refuses to communicate with any language outside of her theatre performances. Then there's Richie (Luke Wilson), the once-famous tennis player who is crippled with guilt because of a secret: he loves his adopted sister, Margot. All in all, the Tenenbaums are a colossal emotional

clusterfuck. Enter their long-estranged dad, Royal, to bring a little childlike chaos (and a daub of tactless racism) back into their lives.

How do you make a movie full of selfish people watchable, and even likeable? That's the challenge with this movie, and Wes Anderson comes up with a novel solution: embrace it. By putting their neuroses front and centre, Anderson is saying to his characters: you're a bit odd, but be proud of it. The result is playful, erudite, funny, introspective and not a little bit sad. In fact, those are the best parts of this film: the little slithers of melancholy where a character admits something that completely reveals their soul.

Gene Hackman is wonderfully droll, upbeat and cruel all in the same breath — which you have to admit is a challenge. Everyone in this sprawling troupe is perfectly cast, though it's the tightly wound Ben Stiller who creates its best moment at the film's climax.

THE SUNDAY MOVIES

Rushmore (USA) (1998)
Director: Wes Anderson
Stars: Jason Schwartzman, Bill Murray, Olivia Williams

Meet Max Fischer (Jason Schwartzman). Max is a student of Rushmore Academy, one of the nation's best schools. His dad is but a lowly barber and so Max has been admitted to Rushmore on a scholarship for penning a stage play. One of Max's most notable talents is writing and directing theatrical productions, but he is also the president and founder of many societies at Rushmore (like the excellently named 'Bombardment Society', a glorified dodgeball team). Max's endless extracurricular activities see his grades slip and he is in danger of being expelled. This is a problem because Max has just fallen in love with a first-grade teacher at Rushmore, Ms Cross (Olivia Williams).

Co-written by Anderson and Owen Wilson, *Rushmore* is a film that most people either love or hate. Part tongue-in-cheek satire, part coming-of-age drama, part mid-life-crisis flick, whatever genre you think it fits into, *Rushmore* is a gentle tale about deeply flawed people.

With the obvious exception of Bill Murray, most of the actors in this were largely unknown when it came out, but Wes Anderson has drawn out brilliant performances from everyone. Jason Schwartzman, nephew to Francis Ford Coppola and son of Talia Shire (Adrian from *Rocky*!), is totally convincing as the big-talking prep student who retains our sympathy even when he's being a world-class dickhead ... which is often. It's hard to believe that the role was originally conceived as a skinny, miniature Mick Jagger. Eighteen thousand teenagers from all over the USA, Canada and Britain tried out for the role before Schwartzman wandered into the casting with a prep-school blazer and a handmade Rushmore patch that he'd crafted himself.

The Darjeeling Limited (USA) (2007)
Director: Wes Anderson
Stars: Owen Wilson, Adrien Brody, Jason Schwartzman

Picture your family in front of you right now. If you weren't related to these people, would you be friends with them?

If you're one of the many who didn't shout a resounding 'yes' then it's time to hop aboard *The Darjeeling Limited*. This time round Anderson is putting us on a train in the middle of India with three estranged American brothers. The trip has been devised by Francis (Owen Wilson), self-appointed leader of the trio. The brothers have, at best, a strained relationship. Peter (Adrien Brody), in particular, would rather gouge out his droopy sad eyes than be here, especially given that his first baby is due to be born in a few weeks. The

youngest brother, Jack (Jason Schwartzman, sporting a glorious moustache), is nursing a broken heart and trying to work his way back to some form of emotional health. His habit of routinely checking the messages on his ex-girlfriend's answering machine is not helping. As the brothers trek across India on a dilapidated and beautiful train, secrets are unveiled, wounds are ripped open and a limited degree of hilarity ensues.

This movie has everything you'd expect to find in an Anderson flick: odd characters, smart writing, vibrant colours and a beautiful, authentic soundtrack. While Anderson is not exactly reinventing his style, he's certainly refining it. The whole film has a wonderfully warm 'lived-in' quality and you can simply sit back and let it wash over you.

The Darjeeling Limited perhaps doesn't quite pack the emotional or comic punch it should have, but even an ordinary Anderson movie is better than most.

INTERFACING WITH CYBORGS

It is a truth universally acknowledged that everything becomes cooler with robots. Except for reality. Robots in the real world are pretty much only useful for building cars or entertaining the Japanese. Recent studies indicate that, to date, approximately zero number of real androids have come to life and attacked people. For shame, robotics industry, for shame.

Instead it has been left to movies to show us the wide horizons that cybernetics could achieve, be they androids, cyborgs, robo-suits or even sexy ladybots. In fact, there should probably be an entire chapter dedicated to the ladybots of pop culture, from the Terminatrix of *Terminator 3* to eighties sex icon Kelly LeBrock in *Weird Science*, a movie famed for postulating the theory that a modem and a thunderstorm could result in a masturbation fantasy.

In all seriousness, robotics has a very important role in movie history. Often it's through looking at our opposites that we discover who — and what — we are, and the same applies with human and machine. Humans have used film to enact our fear of technologies like nuclear power, genetic manipulation and food processors. One notion, however, seems to terrify above the rest: what happens when humankind and mechanics merge. Whether it's machines impersonating humans or people absorbing robotic elements, this represents an affront to the sanctity of flesh. The

collision of the two has resulted in some terrifying, smart and occasionally wonderfully moronic moviemaking.

FRIDAY NIGHT FILM

A.I. Artificial Intelligence (USA) (2001)
Director: Steven Spielberg
Stars: Haley Joel Osment, Jude Law, Frances O'Connor

A.I. Artificial Intelligence is a movie that often gets a bad rap in the canon of Spielberg flicks. I understand why — its ending is retarded. Mind you, the last fifteen minutes of most Spielberg movies should be lopped off. (Seriously, give the theory a run and you'll be amazed at how many films it works on.)

A.I. takes you to a future where rampant global warming has seen oceans rise and resources pushed to the limit. Humans (well, the wealthy ones, anyway) are now using robots known as mechas for everything, from taking out the garbage to sex work. Thankfully not the same models and not at the same time. Within this world a question has emerged: what if we created a robot that could love? A child, perhaps, that might give love to childless parents? Where once the rich and wealthy would adopt a small child from some exotic-slash-poverty-stricken locale, now they would simply order one. Enter William Hurt (or, as I call him, Professor Soliloquy), who creates David (Haley Joel Osment). A boy. A robot. A toy. Or something far more unknowable.

David is first given to a family whose child is in a coma. After a rocky start, Mother (Frances O'Connor) and minibot David eventually bond. When her real son miraculously arrives home, however, the parents don't quite know what to do with the plastic boy. What ensues is an odd, magical and sometimes baffling journey

seen through the eyes of a child — albeit a digital one — to earn back his mother's love.

A.I. is halfway between a childhood nightmare and a fairytale. Spielberg fills the film with a sense of longing and confusion. It's the performances, however, that really make this movie what it is. Clearly a film like this doesn't work without a child actor of significant talent, and Haley Joel Osment (coming off the back of mega-hit *The Sixth Sense*) was an obvious choice. Osment has a face devoid of natural character — porcelain, pure and blank. The young actor takes his blank slate and gradually fills it with pain and yearning as David's humanity leaks out.

Overall, *A.I.* is a bit of a patchwork quilt, taking you from a slightly creepy domestic drama to a horror adventure to an existential fairytale. This unevenness in some way helps to prepare you for the absurd final chapter of *A.I.*, which is too odd for words. And yet in spite of it, this story breaks my heart. Every single time.

SATURDAY FLICKS

The Stepford Wives (USA) (1975)
Director: Bryan Forbes
Stars: Katharine Ross, Paula Prentiss, Peter Masterson

Joanna Eberhart (Katharine Ross) and her husband, Walter (Peter Masterson), have just moved from the hectic streets of New York City to the hamlet of Stepford, Connecticut. Pretty quickly Joanna begins to notice some peculiar behaviour from the women of Stepford: obsessed with domesticity, it's like the entire town has somehow internalised the Lifestyle Channel. With the help of her new friend Bobbie (Paula Prentiss), Joanna uncovers the dark secret of Stepford.

Since its release in 1975, *The Stepford Wives* has become a pop-culture touchstone (the term 'Stepford wife' is still used decades later to describe a woman who is strangely devoted to cooking, cleaning, and loving her man). The film is based on a novel by Ira Levin, who was also responsible for what eventually became 1968's *Rosemary's Baby*, and both films have a lot in common (think betrayal-prone husbands and secret societies). But while *Rosemary's Baby* has all of the demented fun of Satan worship and whatnot, *The Stepford Wives* was really shooting for social commentary. Its aim was to unpick both the contentious sexual politics of the era and the women's liberation movement. At the core of *The Stepford Wives* sits one terror: the fear that men would rather be married to brainless automatons than independent, equal women. Basically, select every achievement of women's lib and hit control-Z.

Aspects of *The Stepford Wives* ring more true today than they did three decades ago. As an example, we've seen advances in cosmetic surgery allow husbands and boyfriends to have their women sculpted in the vision of porn stars and supermodels. *The Stepford Wives* is an iconic and smart social satire that is still as relevant as it ever was.

Blade Runner (USA) (1982)
Director: Ridley Scott
Stars: Harrison Ford, Rutger Hauer, Sean Young

Blade Runner is a beautiful, complex movie, but be warned: there are some glaciers that could outpace it. The key to enjoying this movie is to allow yourself to get lost in its wonderfully detailed world.

Los Angles in 2019 is a sprawling metropolis of skyscrapers in decay. Against dark charcoal skies sits a society drenched in rain and lit only by sickly neon lights and animated billboards. Alone within this artificial mayhem is Deckard (Harrison Ford, under instruction

to display no more than four emotions during the entire film). He is a blade runner, a cop with one purpose: to capture Replicants, artificial humans built to do whatever us fleshy types deem unsavoury, like mining distant planets, fighting for us, or pleasuring us. The Replicants were crafted to exist without emotions but tend to develop them anyway, which is why each Replicant comes with inbuilt obsolescence: a four-year life span. They're sexy, they're intuitive, they die every four years — they might as well be an Apple product.

Looking at a human facsimile that is so close to our own flesh and blood forces us to re-evaluate what it really means to be human. *Blade Runner* leaves you with a nihilistic sense that we have potentially wasted the gift of humanity. This thought is of course rendered in the style of a futuristic version of those classic detective novels: a lone ranger armed with a dry wit, a trusty anorak and a steel nerve against an impersonal city of strangers.

There're more cuts of *Blade Runner* than there are on an emo teenager. The original US release was massacred by the film's financiers. The original international version happily included more gratuitous sex and violence, but remains nonetheless something of a mess. A highly inaccurately named 'Director's Cut', which came out in 1992, improved the film by removing the atrocious voice-over (I honestly believe Harrison did an intentionally slapdash job on the narration hoping that it wouldn't be used, though he denies this). The truth is that version would be better titled the 'Director's Consultant Cut' because Ridley Scott didn't really have time to look over it. (*Thelma and Louise* wasn't gonna direct itself now, was it?) The only version that truly counts is Ridley Scott's 2007 release, *Blade Runner: The Final Cut*. It adds in large chunks of scenes that mercifully return some continuity to the plot. All in all, it's the smoothest version of the film.

THE SUNDAY MOVIES

RoboGeisha (Japan) (2009)
Director: Noboru Iguchi
Stars: Yoshihiro Nishimura, Naoto Takenaka, Asami

A gentle word of warning: this is not for the faint of heart. In fact, *RoboGeisha* is really only for those who are vaguely curious about what you'd get if you locked a crazy person in a padded cell with Microsoft Word, a lot of drugs and DVDs of *Memoirs of a Geisha*, *RoboCop* and *Godzilla*.

RoboGeisha is the story of two warring geisha sisters and the evil megalomaniac businessman/dreamboat with greasy hair who they work for. He alters his girl recruits into assassin machines and plans to destroy all of Japan by turning his castle into a walking robot that climbs Mount Fuji and ... oh, forget it. Words simply won't do this film justice. It has to be seen to be believed.

The film is a bizarre combination of martial arts, slapstick gore, soft-core fetish wear, soap opera, revenge flick and outright comedy (intentional or otherwise ... I haven't decided). And yet through all the insanity there is this fascinating social commentary about the role of femininity in Japanese mythology — at least, it feels that way. The geisha, with her pristine white face and subservient demeanour, is usually assigned the fragile personality of a china doll in films and books. This movie inverts that and transforms an archetypal geisha into a weapon of mass destruction. Her self-imposed emotional restraint is transformed into a psychosexual goddess of war, adorned in gratuitous fetish gear and automatic weapons in place of mammory glands.

Director Noboru Iguchi is famed for delivering a cocktail of young girls and wanton destruction. He wrings sizeable laughs from these extremes, whether it's the camp horror (like acid-milk-

squirting breasts, or a character killing someone with the ol' fried-prawn-in-the-eye trick) or playing up the childlike innocence. Just wait for the line 'I can't believe I'm a Transformer!' and you'll know what I mean.

Battlestar Galactica (USA) (2004–2009)
Creator: Ron D Moore
Stars: Edward James Olmos, Mary McDonnell, Jamie Bamber

It's so rare to encounter a film that holds you in sway from the moment it begins to the moment it ends. It's even rarer for a television series. Those of you who are not sci-fi inclined, please, I beseech you, do not let the ludicrous name of this series put you off, because *Battlestar Galactica* is nothing short of brilliant. Originally a remake of a spectacularly camp seventies TV show, writer Ron D Moore resurrected this tale in the aftermath of 9/11. The result is a show about society at the very edge of its existence.

In the *Battlestar Galactica* universe, humans exist on twelve planetary colonies. The Cylons, a race of clunky shiny metal men that humans once built as slaves, have long since done what robots are wont to do and rebelled. A long and bloody war ensued. Peace was eventually established and no one has heard of the Cylons in forty years.

Until now. In one fell swoop the twelve colonies are obliterated in a nuclear apocalypse leaving barely a few hundred survivors wandering space in a dozen battered spaceships — think Old Testament Hebrews exodusing their way out of Egypt … except in space. Pretty soon this small human convoy is being hunted by the Cylons, but the freaky part is that these once rusty rebels now possess the ability to look like humans. Some even believe that they *are* human. Cylon agents may have been implanted within the human ranks but the question is, to what end? If Cylons simply

wanted to destroy all of humanity, why didn't they finish the job? It seems the fates of humanity and the Cylons are linked.

This television series is a masterpiece. Sure, you're probably not gonna get through the whole four seasons today. If nothing else, watch the initial 2003 miniseries that launched it. On its premiere, the series echoed the traumatic images of 9/11, a people under siege. Rather than just a superficial analogy in space (this ain't no *Star Trek*), *Battlestar Galactica* depicted in stark reality how troubled times can draw out both the best and worst of humanity. As the episodes unfurl you'll see how desperation can make the worst acts seem reasonable.

Tight, pithy, insightful scripting and towering performances from the likes of Edward James Olmos and Mary McDonnell bring emotional depth to every scene. The look and feel of the series was defiantly non-sci-fi, thanks to the hand-held cinematography. Expect to be challenged, amazed and surprised by some of the most passionate, subversive and entertaining fiction ever committed to screen.

FATHER'S DAY FLICKS

Happy Father's Day! My initial idea for this weekend was to show you the best dads in movies ... but seriously, who wants that? I mean, how cruel would it be to compare your dad to those really noble, heartwarming dads in film? No father wants to be held up to *The Lion King*'s Mufasa, a dad who died for his child. No father wants to be held to the lofty moral virtues of *To Kill a Mockingbird*'s Atticus Finch. And how inadequate is your old man gonna feel when he doesn't have $250,000 in disposable income to hurl at your wedding like *Father*(s) *of the Bride* Spencer Tracy and Steve Martin?

A far better gift is to watch these movies and (hopefully) remind yourself that you are lucky not to have a cheap, abusive, mentally deranged, militant, religious zealot arsehole as a progenitor. Sure, your dad may have been a horrific embarrassment in front of your friends, but at least he didn't try to kill you (I hope).

FRIDAY NIGHT FILM

The Star Wars trilogy (USA) (1977–1983)
Directors: George Lucas, Irvin Kershner, Richard Marquand
Stars: Mark Hamill, Carrie Fisher, Harrison Ford

Ha-ha! You knew I'd find a way to work the *Star Wars* trilogy into this book somehow. Make sure you and Dad settle in, because I'm

assigning all three films tonight (don't worry, we'll only schedule one on Sunday). Not only is the full original *Star Wars* trilogy a fine father–offspring bonding mechanism, it also features one of the all-time worst dads ever. Without giving away too many generation-defining plot twists, this particular dad tortures his daughter, cuts off his son's hand, orders the execution of his son's adoptive parents and freezes his son's best mate in carbonite.

What a dick.

If you've never seen it before, *Star Wars* is a classic, well-constructed bit of popcorn entertainment. In creating it, George Lucas begged, borrowed and stole some of the oldest storytelling tropes in history. He drew upon universal themes, characters, and images from legends and fairytales the world over, cherrypicking ideas from King Arthur, Gilgamesh, Theseus and Beowulf to give his interstellar epic a mythic resonance. After sampling from the greatest hits of ancient lore, Lucas then borrowed, sometimes almost scene-for-scene, from the movies of his hero, Japanese director Akira Kurosawa. A portion of the plot of *Episode IV — A New Hope* (the original *Star Wars*) is essentially *The Hidden Fortress*, one of Kurosawa's most crowd-pleasing samurai epics. There's also a sequence in Kurosawa's *Yojimbo* that features outlaws bragging about how awesome they are and ends with a flash of a sword and an arm on the ground. Sound familiar?

Lucas took the midair plane fights from World War II films for the space battles, borrowed from westerns to create the desert planet of Tatooine, and lightsaber duels were inspired by the great swashbucklers like Errol Flynn. In essence, *Star Wars* is a complete inventory of popular mythology and culture and — to Lucas's credit — he seamlessly combined them into an epic with humour, heart and innovation. The result is timeless, and bloody good fun.

SATURDAY FLICKS

Natural Born Killers (USA) (1994)
Director: Oliver Stone
Stars: Woody Harrelson, Juliette Lewis, Tom Sizemore

You should probably also be grateful that your dad didn't raise you to be a mass murderer. Ed (Rodney Dangerfield) is an abusive slob who beats his wife and sexually abuses his daughter, Mallory (Juliette Lewis). In doing so he performs the not inconsiderable feat of making our main character, serial killer Mickey Knox (Woody Harrelson), look like a hero.

Oliver Stone's *Natural Born Killers* is not an easy film to sell. It follows two mass-murdering lovers named Mickey and Mallory while making a statement about the celebrity they engender. The film is fast-paced, surreal, and genuinely goes out of its way to resemble a bad acid trip.

Stone continuously mixes and matches the kinds of film stock he shoots on, from clean 35-millimetre, to grainy black-and-white 8-millimetre, even video. Similarly he employs all manner of lighting and colouring techniques. It's designed to keep you on the edge at all times. The violence is graphic, but largely unrealistic — it's an exaggeration, a fabrication designed to make you focus on the construction of the film as much as the drama within it. Oliver Stone is condemning America's obsession with tragedy, crime and violence as entertainment. Take, for example, his use of a fictional sitcom called *I Love Mallory* to explain Mallory's abusive past; the sitcom theme music and laugh track fit the stereotype, but the dialogue is stomach-turning.

Stone isn't a terribly subtle filmmaker. He criticises the recklessness of the media in glorifying violence. The film seems

to argue that when violent acts are sensationalised, the result is a society that becomes desensitised to violence.

Natural Born Killers is a powerful, delirious and gut-wrenching indictment against the media. It's not for the faint of heart but, if you're willing to see the world through Oliver Stone's demented lens, it's pretty incendiary stuff.

The Shining (USA/UK) (1980)
Director: Stanley Kubrick
Stars: Jack Nicholson, Shelley Duvall, Danny Lloyd

Sweet Jesus, if you're a recovering alcoholic with a history of violence do you *really* think that locking yourself in a creepy, isolated hotel with your family for a long, dark, cold winter is a good idea?

And yet that is precisely what struggling author Jack Torrance (Jack Nicholson) does. He packs his wife, Wendy (Shelley Duvall), and their somewhat touched young son, Danny, off to the Overlook Hotel, a vast country resort in the Colorado mountains. The plan is that they'll be spending the winter as caretakers while Jack finishes his book. Look, maybe I'm being a bit harsh on Jack — I suppose he wasn't to know that the hotel is haunted and his son has previously unnoticed telepathic powers — but still, just because you've got a bad case of writer's block and a few demonic hallucinations doesn't mean you get to prance around an empty hotel attacking your wife and child with an axe.

Stanley Kubrick is one of those directors who is labelled 'genius' a lot. When you watch this movie, it gets a little easier to see why. He may have been a world-class fuckwit to work with, but the resultant film in this case was well worth it. Kubrick could create more tension with silence than most directors can with the finest dialogue. When *The Shining* starts, the pace is deliberate

and contemplative. It's almost as though Kubrick is intentionally slowing your heart rate so he has ample room to ratchet up your stress levels later.

While *The Shining* gives you plenty of jump-several-centimetres-off-the-couch scares it's also a lot more than that. Kubrick creates an all-pervasive sense of insanity, as though he really wants you to experience Jack's madness. Particularly effective is the music by Wendy Carlos and Rachel Elkind; you will not easily forget the screeching strings and angular crashes. Kubrick also fashions some of the most unnerving imagery ever shown on film. Take the scene with the naked girl that turns into a decaying, crusty old lady — you won't be able to look at naked women for at least a day.

THE SUNDAY MOVIE

Frailty (USA/Germany) (2001)
Director: Bill Paxton
Stars: Bill Paxton, Matthew McConaughey, Powers Boothe

The 'God's Hand' serial killer has been hacking his way through Texas for some years, and then something odd happens: a man named Fenton Meiks (Matthew McConaughey) walks into the office of FBI investigator Wesley Doyle (Powers Booth) claiming that he knows who the killer is — his brother, Adam. To convince Agent Doyle, Fenton flashes back in time to explain the family history. Their father (Bill Paxton), who raised the boys alone after their mum died in childbirth, received a vision from an angel who gave them a quest: their family would be tasked with killing human demons.

The horror genre falls into two camps, generally: there's horror that attacks the body (the slasher/killer/monster movie) and then

there are the films that terrorise the mind (the demon/supernatural/insanity movie). *Frailty* falls pretty clearly into the latter. Sure you see plenty of murders in the film, but the real fear isn't that Meiks is going to hurt you. The fear is that he might be right: what if demons truly do live amongst us?

Bill Paxton both directs and stars in this and he treats the film like a serious drama. There's a fascinating subtext within the film about emotional dependency be it in religion, substances or something altogether darker. This movie could have become a camp gore-fest, but instead there are occasional sparks of violence punctuating a pervasive sense of unease. *Frailty* will linger long after you've watched it.

THE SILENT PUNCHLINE

Comedy is an art form, but it's one that most of us judge simply by what makes us laugh. To be fair, that is still comedy's best measure, however behind every laugh there is usually an elaborate, complex architecture. If you deconstruct a gag there are countless questions that need to be asked: who is the target of the joke? Is it hitting them? What is the structure of the joke? Is the punchline in the right spot? Some people are just born with an ability to make people laugh, but those talented few usually still invest an enormous amount of time in honing their art to get the maximum guffaw with minimal waste. Honing a verbal joke is a lifetime necessity for most comics — but honing a non-verbal laugh can be much harder.

Meet the silent comedy stars. Long before sound came to movies there were comedians who could move people to fits of laughter using nothing more than their body. It may sound outdated, but all it takes is a few seconds of watching these performers with their expertly choreographed moves to realise that comedy can indeed be universal. Not all these films are completely silent, but they are fine examples of flicks that make you laugh without the verbal punchline.

FRIDAY NIGHT FILM

Play Time (France/Italy) (1967)
Director: Jacques Tati
Stars: Jacques Tati, Barbara Dennek, Rita Maiden

Behold, my friend, Paris, circa 1967. This gleaming metropolis showcases all that is modern (read: chrome-plated) about French society. Please enjoy the clean, contemporary amenities of Orly airport. Tourists are always welcome here, in fact more so than bona fide residents. We're particularly proud of our precise cubicles, tamed nature, roomy apartments and snooty restaurants. This Paris is civilised.

And then in stumbles Monsieur Hulot (writer, star and director Jacques Tati). A crumpled buffoon of a man, he is an insect carrying the disease of chaos, ready to infect the precision machine of modern Paris.

Within minutes *of Play Time*'s opening scenes it appears more an elaborate work of art than a film. Though not strictly speaking a 'silent' film, it certainly communicates through actions rather than words. Think of *Play Time* as a dance — a colossal, masterfully choreographed, hilarious dance. The film avoids any close-ups, in an attempt to make the focus about the group and the crowd. Humanity itself is the hero; its antagonist is the city. Tati said that his goal for the film was to 'defend the people' in the face of imposing architecture. The first half of the film sees people divided by cubicles and apartments, the implication being that the mechanics of modern times is keeping us apart. By the second half Paris's architecture begins to crumble thanks to the accident-prone M. Hulot.

Play Time is akin to watching fish in an aquarium, or a lava lamp. I know that sounds like an insult but the sheer complexity of movement on the screen is enough to keep it entertaining. It's a wonderful example of satire that uses a silly vehicle to explore the

sobering question of whether human beings can survive against the machine.

SATURDAY FLICKS

The Gold Rush (USA) (1925)
Director: Charlie Chaplin
Stars: Charlie Chaplin, Mack Swain, Tom Murray

He is perhaps the most iconic of all physical comedians, so what's the big deal with Charlie Chaplin?

Well, the dude is fairly funny … and he wasn't shy about it. 'I don't need interesting camera angles,' Charlie Chaplin once said. 'I am interesting.' Whilst it's a kinda douchey thing to say, he wasn't wrong. Chaplin's 'Little Tramp' character, with his twirling cane, Hitler-esque moustache, a slightly-too-tight coat and hat and too-loose pants was always an outsider trying to pull himself upwards. Almost every appearance he made on film was about trying to find the most basic sustenance: a decent meal, a nice bed to sleep in and someone to love him. *The Gold Rush* was one of his purest comedy-fantasies, a mega production (for the time) with some genius set pieces, including Charlie transforming into a chicken and the 'dance of the dinner rolls'.

Here's the pitch: the Little Tramp has made his way to Alaska for the Klondike Gold Rush and he's out to make his fortune. He partners with a starving gold digger (played by Mack Swain, one of Chaplin's regulars) looking for some lost claim, falls in love with a lonely saloon girl (Georgia Hale) and manages to tick off a powerful outlaw, plus there's an odd twist involving amnesia.

Well before Chaplin began shooting *The Gold Rush* he was pretty much the most famous man on Earth. After living his

childhood in brutal poverty, his career began in English music halls and twenty years later he was a star. In 1918, age twenty-nine, Chaplin became Hollywood's first million-dollar-a-year movie star. His personal and professional reputation allowed him to build his very own studio with creative control of his work. (Which is now occupied by Jim Henson Studios, with the entrance guarded by Kermit the Frog sporting the Tramp's bowler, outfit and cane.)

Much of *The Gold Rush*'s comedy comes from the clash between humour and the deadly serious circumstances that face the Tramp. Without words, Chaplin derives side-splitting comedy from deeply scary things, like cannibalism. He moves from ROFL-worthy laughs, to poignant, and back to funny again. Pure genius.

Modern Times (USA) (1936)
Director: Charlie Chaplin
Stars: Charles Chaplin, Paulette Goddard, Henry Bergman

Welcome to your second Chaplin flick of the day. *Modern Times* opens with the archetypal representation of the rat-race: everybody off to work at the beginning of the day. When we catch up with the Tramp, he's a factory worker on an assembly line. In a very conscious decision, the only voices you hear tend to be from those in power. The plant barks Big Brother-like orders via video monitors throughout the complex, even in the bathroom.

The comedy comes out of the monotonous work. The Tramp must repeatedly tighten bolts so fast that his arms enact the actions even when he's not in at work. The last straw is a mechanical feeding machine that will eliminate lunch breaks. The Tramp is tied down to the device. Predictably the apparatus malfunctions and hilarity ensues.

Chaplin had a long history of subtly tweaking his comedy with social and political concerns of the era. *Modern Times* is, you could say, Chaplin's rage against the machine. His villains are the towering

mechanical gizmos, gears and conveyor belts that render humans almost inhuman.

The origins of *Modern Times* are fascinating. The inspiration came during an eighteen-month tour of Europe where Chaplin met with world-renowned thinky types like HG Wells, Albert Einstein and Mahatma Gandhi. With Gandhi he apparently chatted about Chaplin's belief that machines, if used wisely, could truly help mankind. He resolved however that if they were used purely for profit then machines would only give us misery. Chaplin later watched the Great Depression ravage the Western world and witnessed the rise of fascism; when he returned to his adopted home of America he could see the same trends in place replacing the 'can-do' optimism of America's early days. Chaplin used this movie as a platform, applying the most recognisable movie character in the world to give the working classes some empathy, if not a voice.

THE SUNDAY MOVIES

The General (USA) (1926)
Directors: Clyde Bruckman, Buster Keaton
Stars: Buster Keaton, Marion Mack, Glen Cavender

While most people would recognise the face of Charlie Chaplin, for my money it's Buster Keaton who remains the greatest of all the silent clowns. With a completely stony-faced constitution, Keaton was an elegant comedian whose flair for epic, stunt-laden action sequences also made him the Jackie Chan of the 1920s … though I like to think that Keaton would've knocked back the script for *The Tuxedo* (2002).

Buster Keaton's career began when he was six months old and tumbled down a flight of stairs unharmed. Suddenly he had a stage

name: Buster (apparently given by Harry Houdini). Keaton grew up in a vaudeville family, being thrown around on stage as part of their act. It was essentially child abuse, but it's hard to overstate the physical skills Keaton obviously gained. Instead of using stunt doubles in his films, Keaton himself doubled for some of his other actors, doing their stunts as well as his own. And this movie will show you why.

Buster Keaton's character Johnny loves both his train, *The General*, and, of course, his sweetheart, Annabelle Lee (Marion Mack). The Civil War breaks out and Keaton is turned down for service because he's more useful as a train engineer, but Annabelle thinks he didn't join up because he's a coward. When Union spies capture *The General* with Annabelle on board, Johnny must rescue them and prove himself to both his heart's desires.

The film has him crawling all around giant moving trains, where every hanging hook and stray piece of wood is a potential source of danger. Keaton turns them all into objects of comedy. These physical stunts need to be seen to be believed: it's the real Keaton on a real train that's really moving. The cameraman was under instruction to keep shooting until Keaton yelled 'cut' or was killed. It's a complete marvel to behold.

Steamboat Bill, Jr (USA) (1928)
Directors: Charles Reisner, Buster Keaton
Stars: Buster Keaton, Tom McGuire, Ernest Torrence

This time round Keaton stars as the simple-minded, accident-prone Bill Canfield Jr, who comes home to help his burly redneck dad work on his Mississippi River steamboat and immediately demonstrates why he is woefully underqualified for such an occupation. To make matters worse, Bill falls in love with the daughter of his dad's worst enemy.

Steamboat Bill, Jr features one of the most hair-raising and infamous stunts of the silent era. During a high-wind storm, the side of a house falls down and nearly flattens Buster … except it doesn't because Keaton is in the precise position to go through an open window. Keaton did the stunt himself with a real building wall and no trickery; if he had stood just centimetres off the correct spot he would have been flattened. Keaton refused to rehearse the stunt saying that if something went wrong, 'Why waste a wall?' It was a gag that could've easily killed Buster had it gone wrong. Luckily it didn't, and instead of a stoic-looking corpse we have one of the great moments in film.

Keaton's third wife, Eleanor, once argued that he took professional risks due to his crappy personal life, including a failed first marriage, financial problems and the threat of losing his independence as a filmmaker. Whatever the reasons for his risky business, the filmic results are incredibly entertaining.

MOVIE KIDS WHO WILL PUT YOU OFF PROCREATING

Ah, children. What endearing bulbs of joy and wonderment. What fonts of innocence and delight.

What little shits.

If movie history has taught us anything it's that children are vile, not-to-scale devils that must be culled for the betterment of mankind. There were those playful twin ghosts that haunt the hotel of *The Shining*. What about a bloodsucking Kirsten Dunst in *Interview with a Vampire*? And who could forget *Deliverance*, with that banjo-picking hillbilly kid who was undoubtedly the product of six generations of inbreeding. Though if you want to see something truly bizarre, try to track down seventies horror flick *Demon Seed*. Without giving away too much, let me simply say that watching Julie Christie breed with a computer is precisely as disturbing as you might imagine.

The notion of an evil kid cuts right to the core of our humanity. Children are supposed to be symbols of purity. We attach so much emotional importance to them — which only makes them harder to kill. But not impossible …

FRIDAY NIGHT FILM

The Exorcist (USA) (1973)

Director: William Friedkin
Stars: Ellen Burstyn, Max von Sydow, Linda Blair

The Exorcist wasn't so much a movie as it was a phenomenon. This story of a girl, Regan MacNeil (Linda Blair), being possessed by Satan is one of the most profitable horror movies of all time, in spite of being banned in a number of countries. *The Exorcist* is also one of the highest-earning movies in general, grossing more than $401 million worldwide (and a further $112 million for the director's cut re-release in 2000). The film also proved to have a huge effect on popular culture, earning ten Academy Award nominations and winning two for best sound and best adapted screenplay.

The Exorcist is well known for its oft-parodied shock scenes. We all know the image of a possessed girl and her spinning head, levitating body and proclivity for shoving religious symbols in her lady parts. And yet, in spite of its reputation, *The Exorcist* is mostly quite demur; it's a slow burner that builds to some of its more horrific scenes. Even the movie's iconic scares have been rendered a little camp by the passing of time. Seriously, if you were a demon endowed with the power of telekinesis, would you really only use it to move furniture around a room? Is Satan *that* concerned with feng shui? As for Regan MacNeil, though, there can be no questioning how creepy she is, even if she sometimes feels less like a demon-infested child and more like the world's worst attention-seeker: 'Look at me, Mum, I can turn my head all the way around! See, this is what I think of your pea soup, and look where I can fit a whole crucifix …'

That said, the film is a thrilling watch that will surely have you reaching for the closest prophylactic. And what more could you ask from a Friday night?

SATURDAY FLICKS

Ringu (Japan) (1998)
Director: Hideo Nakata
Stars: Nanako Matsushima, Miki Nakatani, Yūko Takeuchi

So you put in an unnamed video tape and press 'play', only to find some weird short film that smacks of wanky high-school video art. Then you get a phone call that tells you that in seven days you will die.

None of this would've happened if you'd just got the damn DVD.

Welcome to *Ringu*, one of the most successful and influential Japanese horror movies of all time. It follows a reporter who encounters such a tape then must unravel its secrets before she and her son are killed. The legend speaks of an undead girl with wet black hair who will reach out of the television to do all manner of unsavoury things to their faces before dispatching them off this mortal coil.

It's really a testament to director Hideo Nakata that this movie is as scary as it is. Although based on a book, Nakata borrowed more from an actual urban legend that was circulating in Japan at the time about a similar video. Hideo Nakata, one of the best known directors of the J-Horror genre, has a sparse, unnerving style inspired by an age-old tradition of ghost stories that are performed without dialogue in kabuki theatre. Accordingly, this film relies on very few words and instead on meticulously placed symbolic images and

sounds. Most potent is the image of the wet-haired girl; essentially faceless; all you can make out is one malevolent eye peeping out between her matted tendrils. And she's coming at you fast.

Ringu also demonstrates the core differences between Western horror and Eastern horror. Western horror is usually built around 'good versus evil', a notion that originated from the idea of 'god versus devil'. In traditional Japanese culture there are no such entities, so in J-Horror ghosts aren't monsters but often spirits who have been wronged. Not being intrinsically evil (and in fact sometimes quite sympathetic) gives the horror an emotional resonance that's sometimes missing from Western horror.

The Brood (Canada) (1979)
Director: David Cronenberg
Stars: Oliver Reed, Samantha Eggar, Art Hindle

The Brood stars Samantha Eggar as a mental patient whose inner anger begins to take the form of murderous deformed children. It's all part of a plan by an unconventional psychotherapist (ahem … nutter) played by Oliver Reed. He's masterminded a therapy technique known as 'psychoplasmics' that allows his patients to turn their negative emotions into a physical change of some kind. For example, a man who was verbally abused by his father develops welts on his body as a way of expressing his pain. Another patient develops lymphatic cancer, supposedly a manifestation of his self-hatred.

In the medical community, this phenomenon is known as 'complete and utter horseshit' [citation needed]. But hey, it's great material for a movie, and it also makes leeches, lobotomy and trepanation all seem quite reasonable.

The Brood is a massively underrated horror flick that has aged surprisingly well. It's one of the earlier works by Canadian director

David Cronenberg, who would eventually become known as one of the leading lights (darks?) of a subgenre known as 'body horror'.

The Brood was partially inspired by a painful custody battle with his ex-wife for their daughter Cassandra — he thought it would be interesting to see pain materialised. It's a visceral horror flick, but not without emotional resonance. By turning 'emotional rage' into biological matter in the form of mutated children, he makes the film that much more tactile and horrific. You can't help but feel a little violated because he's messing with something that's very personal to us: our bodies.

THE SUNDAY MOVIES

Village of the Damned (UK) (1960)
Director: Wolf Rilla
Stars: George Sanders, Barbara Shelley, Martin Stephens

'So young. So innocent. So deadly.' These are the words that adorn the poster for this cult 1960 movie. Based on the eerie John Wyndham novel *The Midwich Cuckoos*, the film goes like so: one day all of the inhabitants (including pets) of the British village of Midwich suddenly fall unconscious. About two months later, the women of child-bearing age discover that they're all pregnant, no doubt resulting in a number of awkward conversations with husbands and boyfriends. Something wicked this way gestates. All the knocked-up ladies give birth on the same day, and these ill-begotten tots grow up with matching blond hair, a hive mind, glowing eyes and poorly dubbed voices.

The interplay between the children and their teacher is what makes *Village of the Damned* shine. The kids look and behave like what you'd get if you crossbred the Hitler Youth with the latest

intake at Eton, resulting in a fantastically smart battle of cool and unfeeling intellects. The only thing more annoying than a kid who thinks they're smarter than you is a kid who actually is smarter than you … and the only thing scarier than that is a kid with the power of telekinesis and perfectly rounded vowels.

The Bad Seed (USA) (1956)
Director: Mervyn LeRoy
Stars: Nancy Kelly, Patty McCormack, Henry Jones

And here we have, potentially, the mother of all evil movie kids. The year was 1956, the actress was Patty McCormack and the character was a right bitch. McCormack plays a blonde, bubbly eight-year-old sociopath named Rhoda Penmark who would kill a classmate without batting an eyelid, often over the most trivial things, like penmanship awards. So in other words, she's a standard selective-school student.

William March's novel *The Bad Seed* proved to be incredibly popular when it was first published in 1954. Swiftly adapted for the stage where it picked up multiple Tony Awards, Warner Brothers decided to bring the play to the big screen and cleverly brought most of the Broadway cast with them. Director Mervyn LeRoy, God bless him, pretty much just lets them do their well-rehearsed thing. As a result, the film version of *The Bad Seed* is extremely well acted, if a little stagey.

The story feeds on the external question of nature versus nurture: is evil born or created? Patty McCormack gives a masterful performance as Rhoda that is petulant, terrifying and cute — often at the same time. Her acting was so impressive that it actually became a problem for the studio. The original ending that sees Rhoda getting away with three different kinds of murder created censorship issues. These were the days when studios had to follow

the Hays Code of Decency which stated that no villain in a film could 'get away with crime' (yes, they were that specific). So the studio set about reshooting the ending, but this created difficulties of its own because they couldn't kill off a child, even if she was sociopathic. Warner's solution is as moronic as it is amusing. As the film draws to a close, Rhoda receives a certain 'comeuppance' at its climax. Afterwards all the actors are shown doing a theatrical-style curtain call and Rhoda — a character who has just killed several people — is suddenly seen bent over her mother's lap for a spanking while *winking* at the camera! It's a totally bewildering conclusion to an otherwise terrific film.

CURLING UP ON THE COUCH TO FEEL GUILTY ABOUT THE HOMELESS

Comfy? Got the slippers on? Tea warm? Now is the time to snuggle in on the couch and feel guilty about homeless people through film. *<insert awkward middle-class silence here>*

This may sound like a boring and oh-so-worthy chapter, but there's a surprising mix of movies out there that explore life without a fixed home address. As you've already read, one of the greatest pioneers in comic history was Charlie Chaplin as the Tramp, the iconic bum of silent cinema. The image is memorable: baggy pants, derby hat, a proto-Hitler moustache and what appeared to be a crippling speech impediment. The Tramp, however, was a vehicle for Chaplin to reflect on the poverty of the Depression while making audiences laugh. He used the bumbling antics of the Tramp to expose the meanness, wastefulness and sometimes beauty of society. The Tramp, as with many of these films, proved that we can indeed learn most about a culture by how well they treat their disadvantaged. It's a principle we've seen time and time again, sometimes resulting in some really excellent films.

FRIDAY NIGHT FILM

The Pursuit of Happyness (USA) (2006)
Director: Gabriele Muccino
Stars: Will Smith, Thandie Newton, Jaden Smith

It's 1981. Chris Gardner (Will Smith) is a San Francisco salesman who isn't doing great. His latest investment, bone density scanners, are too expensive for hospitals and no one is taking the bait. His wife (Thandie Newton) is done being supportive and leaves. Out of the blue, Gardner is offered an internship as a stockbroker. The problem is that it doesn't pay anything for six months while he learns the ropes. He struggles through as life deals him blow after blow until he ends up living on the streets of San Francisco.

The American dream states that America is the land of opportunity, and you can be anything you want to be with enough hard work. But we all know life isn't that simple, and this movie holds that ideology up to the light. It's a surprisingly unflashy watch. One of the best things about *Pursuit* is that it addresses the really mundane details of being homeless, like how one handles bills, tax, and so on.

For a movie so steeped in the idea of America, the producers opted to go with an Italian director named Gabriele Muccino (*The Last Kiss*); allegedly Will Smith handpicked him on the basis of his Italian movies. Muccino keeps the film simple and warm, allowing everything to be played small with a big heart on the sleeve. It's a full-scale Hollywood production made with something of an indie filmmaker's spirit. This light touch keeps everything in check to feel authentic and not as cloying as it could be. Will Smith has always had a natural easy charm and it serves him better sometimes, I think, in smaller dramas. His performance is reserved and intelligent. Smith's real son Jaden plays his fictional son and it pays off. The chemistry

between Smith and his son is unquestionable and they make it easy to care about the pair.

SATURDAY FLICKS

Tokyo Godfathers (Japan) (2003)
Directors: Satoshi Kon, Shôgo Furuya
Stars: Toru Emori, Yoshiaki Umegaki, Aya Okamoto

Tokyo Godfathers is a stunning animation about three homeless folk in Tokyo: a runaway teenage girl, an old alcoholic and a transvestite with a habit of breaking into haiku. Together they adopt an abandoned baby found in a garbage bin then set about searching for the baby's parents. As they split up to cover the city we follow each of their unique perspectives and take a journey through the underbelly of Tokyo. Along the way we encounter a whole new side of Japanese society, a world of darkness, pain, magic and wit.

This is the third film from Japanese anime director Satoshi Kon and he's packed more detail, heart and beauty into this film's running time than most directors could achieve in a decade. All three of the 'godfathers' are raw but endearing. The banter between them is fast, funny and has a biting sharpness to it, not dissimilar to the hurtful insults that define most sibling relationships — for that is precisely what they are: a family. No one knows what will hurt you quite like a member of your own clan, and so the insults thrust between the three are as brutal as they are funny. In spite of *Tokyo Godfathers'* heavy subject, it's also a playful piece with ethereal magic permeating the plot.

The animation is topnotch, the characters are all rendered in vivid detail, with some of the most entertaining facial expressions I have ever seen. The story may come together a little too

conveniently in the end but if you're looking for a heartfelt film to take home and curl up with, *Tokyo Godfathers* will do the trick.

Dark Days (USA) (2000)

Director: Marc Singer
Stars: Marc Singer

Under the streets of New York sits a maze of abandoned subway tracks, and therein lies a community of squatters who carry out their lives in total darkness. *Dark Days* is their story — and an amazingly beautiful one at that. Captured on grainy black and white film with a haunting soundtrack by American hip-hop producer DJ Shadow, *Dark Days* is a doco that doesn't need to pull heartstrings to make you feel something.

Director Marc Singer had never made a film before this. In fact, the reason the movie is shot in black and white is because he was told it was far harder to mess up than colour film. British-born Singer actually lived in the subway for two years to capture the true experience of life underground. The result is stunning.

He explores their world in detail and with a generous spirit. Many of the citizens of these underground tracks are addicts. Most seem to be deeply traumatised (two are brought to tears retelling the deaths of their children). Some have called the tunnels home for more than a decade, and there is a certain logic to living there: 'Wintertime I don't freeze, summertime I don't burn up,' one resident explains. 'The only thing we don't got is running water.' You have to marvel at their ingenuity, too. The citizens of this trash-filled tunnel village hook into the city's electricity using an almost comical number of extension cords. They somehow manage to power lights, portable stoves, small refrigerators, space heaters and even TVs. Some have even painted the walls inside their shanties.

266

The best observational documentaries are often the ones where the audience feels utterly submerged in a world. *Dark Days* does precisely that.

THE SUNDAY MOVIES

The Fisher King (USA) (1991)
Director: Terry Gilliam
Stars: Jeff Bridges, Robin Williams, Adam Bryant

Jack Lucas (Jeff Bridges) is an arsehole radio shock jock known for saying outrageous things and passing them off as common sense. After one of his listeners takes this common sense and uses it to open fire on a bar full of people, Jack has a meltdown. He retreats to a quiet, angry, drunken life working in a record store. One day, a gang attacks Jack but a homeless man named Parry (Robin Williams) comes to his aid. Somehow Jack is drawn into Parry's quest — yes, that's right, a quest. You see, Parry believes he is one of King Arthur's knights on a mission to retrieve the Holy Grail. Awkward.

Director Terry Gilliam loves to make visually flamboyant films with an absurdist bent, like *Twelve Monkeys*, *Brazil* and *Monty Python and the Holy Grail*. Even though *The Fisher King* was the first project where he had nothing to do with the scripting, it's no different. Gilliam traces the fine, fuzzy and movable line between fantasy and reality as he gets inside the heads of this unlikely duo.

Our two main characters have both developed wildly unhealthy ways of dealing with their demons, be they real or imagined, Williams with his delusions of Arthurian legend and Bridges with his industrial-strength narcissism. It's a testament to both actors that they are able to play such characters whilst still imbuing them with

the sort of charisma you need to keep an audience interested in their plight.

It would be fair to call the film a little eccentric, but it would be unfair to dismiss it as only that. Gilliam crafts vivid sequences that will etch their way onto your retina. In particular, his oddly angled medieval fantasy sequences look like they were directed by someone with a virulent inner ear infection. Amidst the astounding imagery there is genuine humanity shining through *The Fisher King*. Certain moments of comedy, fantasy and drama don't come off, but this is still an original, touching movie.

Tekkon Kinkreet (Japan) (2006)
Director: Michael Arias
Stars: Kazunari Ninomiya, Yû Aoi, Yûsuke Iseya

If you had a serious, gritty film about street kids in one hand and a trippy stoner flick in the other and you let them breed like rabid animals in the kasbah of animation, then *Tekkon Kinkreet* would be the ungodly offspring.

Tekkon Kinkreet began life as a manga (Japanese comic) called *Black and White* and it took a Japanese-speaking American, filmmaker Michael Arias, to convince a Japanese animation studio to take it to the big screen. The film is set in a decaying city called Treasure Town and we zoom in on two itinerant street kids. Black, the elder, is violently protective of White, which is just as well, because White has a few screws loose. When a crooked new developer rolls into Treasure Town to redevelop the city into a family-friendly fun park, Black makes the mistake of pissing them off. Pretty soon the mafia, the police and giant blue warriors are bearing down on the brothers.

Tekkon is a ripper film. Arias uses a combination of richly detailed 2-D animation with smooth 3-D computer animation to

create a sprawling, decaying metropolis that looks like Macau after a strong earthquake. It's filled with low-hanging electrical wires, crooked towers, poky alleys, trashy neon signs and buildings with questionable structural integrity. The colours are warm and human, and every inch of the movie pulsates with a kind of organic energy that you just don't get from most animation movies.

The whole is anchored by the very authentic and heartfelt brotherly relationship sprinkled with unquestionably human inflections. Be warned, though: there are large parts of this film that simply don't adhere to any internal logic (um, the boys can fly but can't find food? What, this city's restaurants don't have windows?) and yet that is part of its appeal. It's a heightened reality that these kids live in and the world that they experience isn't necessarily a logical one.

IS YOUR REALITY REAL?

Hope you had a nice week at work, school, university, watching daytime TV … but did you at any point consider the possibility that everything around you is a lie? What if you are in fact some kind of meat-battery producing kilowatts of energy for an evil race of robots? <insert dramatic music here>

Cinema is an art form that often seeks to envelop you, drawing you in so that you might escape reality and get lost in another universe. So far it has failed to reach the immersive quality that was promised by virtual reality. Actually, it's kind of disappointing that virtual reality turned out to be bullshit. I feel for those poor *Beyond 2000* presenters from the eighties and nineties who confidently informed us that bulky headsets and electrode-encrusted fingers were the future of human connection. Still, I suppose that was better than knowing that the future was all Facebook pokes and FarmVille. But in spite of the fact that real-life technology has opted to disappoint us, fictional technology is still very, very interested in deconstructing our reality.

Welcome to a weekend of virtual realities and really trippy movies.

FRIDAY NIGHT FILM

TRON (USA) (1982)
Director: Steven Lisberger
Stars: Jeff Bridges, Bruce Boxleitner, David Warner

'80s Movie Executive 1: 'Hey, whaddya got there?'

'80s Movie Executive 2: 'You mean this? It's a Commodore 64, a compu ... compubox?'

'80s Movie Executive 1: 'You mean computer? You're an idiot. And why are you wearing your wife's shoulder pads?'

'80s Movie Executive 2: 'I like the extra height ... Yeah, so this computer thing is really cool. It's got something called MS DOS. It can make words ... and dots ... and lines ... and ... I'm thinking we could make a good movie out of it.'

'80s Movie Executive 1: 'Really?'

'80s Movie Executive 2: 'Yeah, I think I'll call it *TRON*. Wanna go do some coke and watch the greed-is-good speech from *Wall Street*?'

'80s Movie Executive 1: 'Fuck yeah!'

This is how I imagine *TRON* came into being. Or maybe not. The important point here is that whilst you're watching this flick, it's hard to escape the sense that this movie is the answer to the eternal question: How do we make MS DOS sexy?

TRON came about after a hard-fought seven-year battle through technological, financial and political barriers, and the result was one of the more groundbreaking films of the eighties.

The plot goes like this: Within the concrete walls of the Big Evil Computer Company™ ENCOM sits a large mainframe. The Master Control program runs the elaborate system — and it is

surely evil (we know this because it speaks with an English accent and this is an American movie from the eighties). Meanwhile, a recently fired yet gifted programmer in the form of Jeff Bridges is trying to hack his way back into ENCOM. His sting works a little too well because he is inadvertently transported inside the world of the mainframe. <insert bullshit scientific explanation here> He has now entered the sprawling computer world known as 'The Grid'. The code looks like a vast wireframe landscape. Programs now take on the form of people who talk like they have mild autism and wear neon spandex suits (modesty has no place in the digital realm). Over them all, the ruthless, faceless and slightly douchey Master Control program presides with an iron fist.

This is a kitschy movie, no question. The day-glo bodysuits and dated graphics are all glorious in an eighties retro chic kinda way. And yet *TRON* is also full of really inventive action set pieces and there's an effortless charm to Bridges' Kevin Flynn character. This was one of the earliest films to incorporate computer-generated effects into a film. Funnily enough, the Academy of Motion Picture Arts and Sciences would not allow *TRON* to be in the running for best special effects because using computers was cheating, apparently — my how times have changed.

SATURDAY FLICKS

The Matrix (USA) (1999)
Director: Andy Wachowski, Larry Wachowski
Stars: Keanu Reeves, Laurence Fishburne, Carrie-Anne Moss

Keanu Reeves plays Tom Anderson, a slightly-too-cool-to-be-real hacker by night and monosyllabic software engineer by day. However, throughout his life, Mr Anderson has always felt like he

was meant for something greater. What a wanker. Luckily Reeves is unable to string together a sentence long enough to communicate this sense of entitlement, so we'll let it pass. Then he has a phone conversation that will change his life. It comes from a man named Morpheus who has the sort of rich baritone voice box that's usually reserved for portraying God or narrating nature documentaries. Morpheus (Laurence Fishburne) explains that our 'world' is in fact an elaborate digital veil of perception that has been constructed to keep humans entertained while we are farmed for our body heat. The 'Matrix' is a communal reality beamed into our brains while we lie in a coma producing warmth. However, there is a legend within the Matrix that tells of the one who can 'break the code' — and by that they mean 'can move really, really, really fast and has a strong aptitude for kung-fu'. Could our Tom (with new alias Neo) be … the one?

What would all the derivative Hollywood action directors of the noughties have done without *The Matrix* and its groundbreaking visual stylings? This film borrowed imagery and plot points from the best of Japanese anime, Chinese kung-fu movies and the emerging world of cyberpunk fiction to create a cinematic universe that was elegant in its simplicity. But it was the visual treatment that Larry and Andy Wachowski gave this story that really kicks it up a notch: bullet-time cinematography, elaborate martial arts and brilliant use of slow motion have all contributed to *The Matrix*'s iconic status. Perhaps what makes it so interesting is that the visuals are actually an innovative means of communicating a very cerebral concept: if you can perceive a world bigger than your reality then you can break and bend that reality.

Whilst the *Matrix* sequels disappeared up their own metaphysical arseholes, the first still stands up as a clever and original action movie.

Dark City (Australia/USA) (1998)

Director: Alex Proyas

Stars: Rufus Sewell, Kiefer Sutherland, Jennifer Connelly

In a city of perpetual night we meet a man named John Murdoch (Rufus Sewell) who is on the run. We don't know why. Actually, it's not entirely clear if *he* knows why he's on the run. Pretty soon a girl, a cop and a bow-legged German scientist all become players in an unfurling saga.

We slowly discover that this is a very unusual city. Each night, all life in the city rams to a halt and then — whether by magic or science — buildings sprout, streets disappear and entire city blocks are rearranged. All of this occurs at the collective will of a cabal of elongated, pasty and trench-coated ghouls. This dark city is their experiment and they are tweaking it until they get what they need out of their lab rats: us.

If you were to watch the trailer to *Dark City* you'd probably think, 'Wow — that looks freakishly similar to *The Matrix*.' Unfortunately, a lot of people made that same assessment when *Dark City* was released within months of the Wachowski epic. For this reason, *Dark City* never got the accolades it probably deserved.

Directed by Aussie filmmaker and photographer Alex Proyas, *Dark City* moves with a thumping and hypnotising rhythm. The editing, the music and the strained look of fear on Rufus Sewell's face all combine to give the film a relentless mounting tension. It's also a movie that borrows elements from all over cinema history. You'll notice the harsh angular lighting and jagged editing, a visual language that first emerged out of early German horror movies following World War I. And naturally *Dark City* folds in elements from classic Hollywood detective tales and flecks of Greek mythology for good measure. To his credit, Proyas blends these elements in such a way that it creates an entirely unique form.

Dark City is an entrancing, underrated nightmare about a city that is not what it seems.

THE SUNDAY MOVIES

eXistenZ (Canada) (1999)
Director: David Cronenberg
Stars: Jude Law, Jennifer Jason Leigh, Ian Holm

Allegra Geller (Jennifer Jason Leigh) is what you might call a 'video game designer'. She, however, regards herself as a craftswoman of immersive digital environments. I say, why bicker over semantics? The important point is that Allegra's game creations are so controversial that she has now become the target of anti-game terrorists, vigilantes who believe in the divine superiority of flesh. Allegra, however, knows that technology is at its most potent when it's intertwined with the body, and so when she is under attack she escapes into her own game. There she is hunted down by a band of terrorists armed with fleshy weapons made of cartilage. Her only protection is trainee Ted Pikul (Jude Law), and he appears to be fairly stupid.

Director David Cronenberg is one of cinema's great innovators. Time and time again he's injected thrillers, horror movies and science fiction with a subtextual edge that makes them so much more interesting than most other genre directors' films. This movie had an unusual genesis. Cronenberg's inspiration for this tale of an artist on the run was the infamous fatwa declared on Salman Rushdie back in 1989 for his controversial book *The Satanic Verses*. And in the mid nineties, what kind of artist could be considered more groundbreaking than a game designer?

Despite these serious underpinnings, *eXistenZ* is an unexpectedly sensual film, with Cronenberg finding both horror and eroticism in

the interplay between technology and the flesh. The reality of *eXistenZ* is grotesque in some ways and borderline pornographic in others, an uncommon combination that Cronenberg milks wonderfully. It's not the most flashy or visually stunning film you'll see this weekend but it is one of the most complex. If you're anything like me, *eXistenZ* will mess with your head. If you find yourself making sexy-eyes at a Wii controller, I recommend a cold shower.

The Thirteenth Floor (Germany/USA) (1999)
Director: Josef Rusnak
Stars: Craig Bierko, Gretchen Mol, Armin Mueller-Stahl

Transport yourself back to 1930s Los Angeles. You spy a rich old man decked out in his top hat and tails. He is also balls-deep in a seemingly endless procession of young, attractive wenches. Then he suddenly wakes up ... in the nineties. You see, this 1930s world is a simulacrum of reality stored within an elaborate computer system up on the thirteenth floor of an LA apartment. And the old man? He's its creator. The girls? Don't ask. The old man has found a secret within his virtual world. Whatever it is, it is so destructive that he has just been stabbed to death in the early hours of the morning. Now the young executive who runs the virtual reality company (Douglas Hall, played by Craig Bierko) is the prime suspect, and even he isn't sure he didn't do it.

I'm gonna say this right up-front: the biggest weakness of this movie is the leading man. Craig Bierko has roughly as much charisma as an Asperger's-afflicted igneous rock. He seems completely disconnected with the clever and moody plot, constantly staring off into the middle distance, almost as though he can vaguely make out his future career of musical theatre and primetime TV guest appearances. Mind you, he really does rock the designer stubble.

The plot of this movie is a clever layering of reality upon reality. I'm sure you've noticed by now that movies about simulated realities always appear to borrow from film noir (dark angular shadows, evasive dialogue, men who can't be trusted with the truth and women who, well, just can't be trusted). The best explanation I can proffer is that this subject matter lends itself to virulent paranoia. In order for a virtual reality film to work, you as an audience member must feel mistrustful — not simply of the players but of the very nature of reality. A truly great movie about unstable reality should give you the sensation that the cosmos itself is playing some trick on you. And in spite of the weak performance that anchors it, *The Thirteenth Floor* does this very well.

DOCUMENTARIES ABOUT OBSESSIVES
(THAT MAKE YOU FEEL BETTER ABOUT BEING NORMAL)

What's the one thing that you love more than anything? Don't say 'family' — even your family will roll their eyes when you do. If there is something that you are obsessed with — garden gnomes, blow-up dolls, Fabergé eggs, kidnapping *Junior MasterChef* contestants to be your pantry gimps — then my advice to you is this: get yourself a camera crew. If the last fifty years of documentaries have taught us anything it's that obsessions are innately cinematic.

Obsessives make for great documentary talent. Why? Well, let's not beat around the bush: crazy people make us feel better about being normal. More importantly (and less pejoratively), there is always going to be something infectious about seeing anyone passionate about something they love. And when that love is threatened or put to the test, the stakes are higher and the drama is richer. As the Ku Klux Klansman once said to the jihadist, everything is better in extremes.

FRIDAY NIGHT FILM

The King of Kong (USA) (2007)
Director: Seth Gordon
Stars: Steve Wiebe, Billy Mitchell, Mark Alpiger

Buried deep within Middle America, an epic duel is brewing. It is the ultimate battle for glory. The grand struggle for … the world's highest Donkey Kong score. <*cue 'Eye of the Tiger'*>

Our first contestant is hot-sauce magnate Billy Mitchell, a man with a face that says 'I am the love child of Chuck Norris and a woodland elf', a mouth that speaks only in Yoda-esque soundbites and an ego so big it can be viewed from high orbit.

Contestant number two is Steve Wiebe. He is a loser. Well, that's how the movie is framing him, anyway. He's actually a soft-spoken family man who always seems to come up short: a high-school athlete who missed out on the big leagues; a musician whose band never cracked the scene; and an aeroplane engineer who got laid off the day he and his wife signed the mortgage papers on their house. All Steve has ever wanted was to be the best at something. Why not Donkey Kong?

Mitchell and Wiebe battle it out for Doney Kong supremacy in garages and decaying suburban video game arcades (filled with middle-aged men who all seem to think it's Dress-Like-A-Pedophile Day). The result is an epic of Lucasfilm proportions. There are accusations of corruption, eighties power ballads and no second chances … unless you have a spare quarter.

The King of Kong is a love letter to classic arcade games but you don't have to love these games to dig the movie. Culled from over 350 hours of footage, director Seth Gordon has constructed a classic Hollywood underdog story, set in the real world — well, real-ish, anyway. Wiebe v. Mitchell stands amongst the greatest film

rivalries: 'Luke v. Vader'; 'Rocky v. Apollo Creed'; 'Rob Schneider v. Laughter' and 'John Candy v. Cake'. *The King of Kong* has all the elements of a blockbuster screenplay: deception, malice, injustice, astonishing twists, victory and heartbreak. This is one of those odd movies where you constantly find yourself asking: 'Who *are* these people and how did *this* get to the centre of their world?' And yet their obsession gives birth to enormous charm.

SATURDAY FLICKS

Trekkies (USA) (1997)
Director: Roger Nygard
Stars: Denise Crosby, Frank D'Amico, Barbara Adams

The original *Star Trek* premiered on television back in 1966. It was a not particularly well-reviewed show about a surprisingly multicultural bunch of astronauts travelling the universe to seek out new life and new civilisations, and to ponder weighty moral allegories and hopefully hook up with green alien chicks. *Star Trek* lasted barely three years on TV. (To put that in context, there are more episodes of *Cougar Town* than there are of the original *Star Trek*.) But the spandexed adventures of Captain Kirk, Spock et al. were later revived on the big screen, and then multiple spin-off TV shows, more spin-off movies and so on. *Star Trek* is now seen in more than a hundred countries and has been translated into dozens of languages. Over thirty million fans watch *Star Trek* programming around the world each week, and 'Trekkies' are the only fans listed by name in the *Oxford English Dictionary*.

So how did this one low-rating show manage to pull such a loyal and inventive audience? Good question, and it's just one that this fascinating doco tries to answer. To be a fan of *Star Trek* is one

thing, but to be a Trekkie puts you in a whole different universe. This doco investigates the value and meaning that *Star Trek* has had on people's lives.

This documentary works perfectly fine whether you're a fan of all things *Trek* or not. If you have any sympathy for the adventures of captains Kirk, Picard, Sisko or Janeway, as I sadly do, then you will recognise this movie as a celebration of *Star Trek* and a showcase of how people love it. It relishes in showcasing this love, like the dentist who has decked out his entire surgery as a starship or the juror who sat on the impeachment trial of US President Bill Clinton in a Starfleet uniform complete with phaser (think ray gun).

Of course if you're not a Trekkie and have never witnessed a single frame of the franchise, well, prepare to watch a bunch of lovable nut cases. Either way, the movie is priceless.

Spellbound (USA) (2002)
Director: Jeffrey Blitz
Stars: Harry Altman, Neil Kadakia, Nupur Lala

We live in a spelling hell.

Between spell-checking software and txt spk, I'm surprised when I see a fully grown adult assemble a four-syllable word unassisted, let alone … gasp … young people.

As it turns out, there are indeed youth who furiously study dictionaries and thesauri. They do so every year for the Scripps Howard National Spelling Bee championship in Washington DC.

This beautifully constructed 2002 doco by Jeff Blitz follows eight teenagers in their obsessive fight for spelling superiority. He makes the spelling bee as compelling and suspenseful as a sporting final, but also presents a fascinating portrait of smart kids and their parents. There certainly isn't any obvious criticism of anyone in the film, but you do get some telling glimpses of some serious stage

parenting going on behind the scenes. My favourite example is the parent who hires people in a thirld world nation to pray for his son in the competition. Creepy.

In amongst all the insanity, Blitz crafts a poignant and surprising portrait of a multicultural USA. *Spellbound*'s team of young contenders is drawn from all walks of life and ethnic backgrounds, from the mollycoddled Connecticut princess to the second-generation Indian immigrant who is ironically stumped by the word 'Darjeeling'. *Spellbound* is also a fine statement on the English language itself. Anyone who has ever tried to learn will tell you that it's a bizarre, frequently illogical bowl of cultural influences. English often includes words that are literally Greek or French words absorbed into our own tongue. *Spellbound* is enthralling entertainment, compelling drama and a smart examination of the cultural melting pot of modern America.

THE SUNDAY MOVIES

Big Dreamers (Australia) (2007)
Director: Camile Hardman
Stars: Ron Hunt, Bryan Newell, Roger Chandler

Tully used to be a prosperous township in tropical north Queensland — until Brazil dumped its sugar surplus on the global market. How will the sugar-cane-dependent town survive? At a meeting called to save the town from financial disaster, Ron Hunt stands up and proposes to build the world's biggest gumboot in honour of Tully's 1950 rainfall record of 7.98 metres. Ron insists that the Big Golden Gumboot will put Tully on the map, so he and the local Rotary Club hire out-of-towner Bryan Newell to build the edifice. Tully's local artist and fellow Rotarian Roger Chandler is not happy. The

cost of the boot blows out to $90,000, and construction is endlessly delayed by rain. As personalities clash and Ron navigates the maze of financial hurdles, engineering woes, kilometres of red tape and the rocky outcroppings of small-town diplomacy, Ron soon wonders whether he has made the right decision.

Australia is well known for its love of 'big' things, from the Big Pineapple to the Big Tassie Devil. *Big Dreamers* is a funny and cleverly edited documentary, and a lot of time has clearly been invested in piecing this narrative into a compelling and laconically amusing tale. Expect to see appearances from the local identities, farmers and — naturally — the resident UFO nut. Though the best part is all the little inset-segments in the film that profile the guardians of other 'big' Australian eyesores. Very funny stuff.

Gates of Heaven (USA) (1978)
Director: Errol Morris
Stars: Lucille Billingsley, Zella Graham, Cal Harberts

Pets. God bless those furry, feathered and sometimes scaly substitutes for true human connection. Who doesn't love a pet? (Aside from people with allergies.) But no matter how much you may adore your pet, the people documented in this film put you to shame.

These days, director Errol Morris is regarded as one of America's most prolific documentary makers with powerful and politically charged films under his belt, like his shocking doco about Abu Ghraib prison, *Standard Operating Procedure*. There's also his film *The Thin Blue Line*, which pioneered the use of stylistic re-creations and also may have gotten a wrongly accused man pulled out of jail. This amazing career of groundbreaking works all began with this movie … in a pet cemetery.

You might think that documenting the owners of dead pets about the impact those pets had on their life is an improbable

concept for a movie, and you wouldn't be alone there. Famed German filmmaker (and world-renowned nut bar) Werner Herzog was so unconvinced that this would get screened, he vowed to eat his shoe if the film appeared in a cinema.

It was. And yes, Herzog did eat his shoe. In fact, they even made a short film about the event, *Werner Herzog Eats His Shoe*. Snappy, no?

Gates of Heaven itself is a very slow but moving film. It hooks into the elegiac pace of its subjects (mildly senile Americans). It's worth it, though. Morris uses pets and our collective love of them to paint a bigger picture of mortality and belonging. He's taken a small story and given it universal resonance.

THEY WILL COME FROM ABOVE!
WHEN MOVIE ALIENS ATTACK

Anal probes. When the aliens finally decide to make their strike, they are free to unleash a nuclear winter, biological plague, Godzilla, walls of fire or even a sequel to *Battlefield Earth*, whatever. I don't care so long as we're not subjected to anal probes. Thank you, alien overlords, the floor is yours.

Frankly, it's not a question of *if* but *when* the green men will come and Pine O Cleen our planet of every last life source. Hollywood says it is so, thus it shall come to pass. The fear of an intergalactic invasion from the heavens via small green men who regard us with cool envy is hardly new. One might argue that it speaks to a latent xenophobia that all humans are largely hardwired with, and perhaps that's why many of these films play like some kind of paranoid nightmare. Don't let that put you off, though, if for no better reason than because you need to prepare yourself. The next few days' viewing will provide some all-important tips on how to survive when aliens attack.

FRIDAY NIGHT FILM

Invasion of the Body Snatchers (USA) (1978)
Director: Philip Kaufman
Stars: Donald Sutherland, Brooke Adams, Jeff Goldblum

In this 1978 remake of *Invasion of the Body Snatchers*, the aliens don't even need bodies to take out humanity (at least those in the San Francisco Bay area). Instead they just borrow the ones that are already here and duplicate them.

There have been four movie versions of this story but, for my tastes, this one is the best, starring Donald Sutherland as Matthew Bennell, a San Francisco health inspector who uncovers the invasion. His mate, self-help guru Dr David Kibner (Leonard Nimoy), has seen a trend of patients' whingeing that their loved ones are acting weird and are no longer themselves. There's the standard response of 'No, that's crazy talk, he's just disinterested in you and your whiny ways', but that position becomes untenable when the friends discover a partially formed duplicate of Jack Bellicec (Jeff Goldblum). Whilst the potential for awesomeness that goes with any multiples of Goldblum is high, things soon turn nasty. The 'pod people' take over the city. Meanwhile, our Scooby gang must avoid sleep, for it is in our sleep that the alien infection consumes and replaces its victims with doppelgangers grown in pods.

There are some movies that really *should* be remade every generation. This is one of them. The original 1956 *Invasion of the Body Snatchers*, directed by Don Siegel, was an apt study of paranoia in the era of the Cold War and Joe McCarthy's communist witch-hunts. In this version, director Philip Kaufman uses the alien invasion to highlight the increasing anonymity of modern city life. It teases your own sense of mistrust, ultimately suggesting that the greatest threat may not come from out there but from within. Kaufman even

286

made good on Don Siegel's original intention to give the tale a dark, twisted ending, which Siegel couldn't get past the studio back in the fifties. *Invasion of the Body Snatchers* is smartly written, well shot, has impressive performances and, most importantly, is freaky as hell.

SATURDAY FLICKS

District 9 (USA) (2009)
Director: Neill Blomkamp
Stars: Sharlto Copley, David James, Jason Cope

When Earth finally makes first contact with aliens in this movie, it's anything but majestic. According to *District 9*, around two decades ago an alien spaceship, filled with underfed, rudderless, prawn-like creatures essentially broke down in the skies above the South African city of Johannesburg. For the past twenty years these aliens have been holed up in a slum called District 9, run by weapons-manufacturing corporation MNU. These guys have spent millions trying to tap into the aliens' technology to see if they can adapt it and scrape together something profitable from the whole wretched exercise. Meanwhile, the district itself is a humanitarian clusterfuck, with native South Africans rioting in protest and Nigerian gangs using D9 as a playground. Racism, prejudice and segregation are taking over (unheard of in South Africa) so the plan is to move the aliens to a new settlement, out of sight and out of mind. Heading up the taskforce is MNU middle-manager Wikus Van De Merwe (Sharlto Copley), who has completely bitten off more than he can chew.

South African director Neill Blomkamp cleverly riffs on the audience's memory of South African apartheid as he depicts aliens being segregated and suffocated by bureaucracy. The film itself takes its name and inspiration from the real-life District Six, an inner-

city residential area in Cape Town that was declared a 'whites only' area by the apartheid regime, forcibly removing 60,000 people and relocating them twenty-five kilometres away. Curiously, the filming location for *District 9* was itself a genuine slum from which the government was forcibly relocating the residents to government-subsidised housing.

District 9 is a thoroughly unique sci-fi film that works on a variety of levels. If you're after well-handled socio-political commentary and satire and a genuinely entertaining popcorn flick, *District 9* has all that in spades.

Starship Troopers (USA) (1997)
Director: Paul Verhoeven
Stars: Casper Van Dien, Denise Richards, Dina Meyer

Starship Troopers is a misunderstood movie. On first glance it's a hyper-earnest, fascist-glorifying blockbuster about a bunch of Ken- and Barbie-doll soldiers who go off to be eviscerated by oversized arachnids controlled by a giant brain with a vagina for a face. In truth it's a deeply clever black satire on totalitarianism, military propaganda and war.

In a future Earth where one can only become a voting citizen through national service, Johnny Rico (Casper Van Dien, the world's leading actor who also looks like a gay-for-pay porn star) is a fresh-faced, kinda stupid kid who follows his schoolmates into the army. His girlfriend becomes a pilot, his best mate works in military intelligence and he becomes cannon fodder ... sorry, I mean infantry. Their paths crisscross through boot camp to their eventual assault on an alien lair, intercut with hilarious 'news' footage that's heavily influenced by World War II propaganda, whilst everything about their uniforms is reminiscent of Nazi Germany.

288

Often mistaken for just another sci-fi shoot-'em-up, *Starship Troopers* is actually one of Hollywood's most unconventional anti-war films. The massive, grotesque insect-aliens plough through the world's most implausibly attractive soldiers, and in doing so they rip apart that sanitised Star Wars-image of battle, exposing war as a vicious and horrendous bloodbath.

The genius of this movie is that director Paul Verhoeven cast actors too stupid to know that they were acting in a satire. The tragedy of this movie is the initial audience was too stupid to notice as well. Verhoeven contrasts the bright, bubbly patriotism represented in the soldiers with the increasing brutality of that actual fight, and he doesn't hold back. There are dismembered bodies, holes being blown in people heads … it's pretty intense.

Keep an eye out for a co-ed nude shower scene where the entire cast are (mostly) naked. The only way Verhoeven could get them to agree to do it was if he directed the scene in the buff. So he did.

THE SUNDAY MOVIES

War of the Worlds (USA) (2005)
Director: Steven Spielberg
Stars: Tom Cruise, Dakota Fanning, Tim Robbins

War of the Worlds is a flawed but occasionally brilliant retelling of the classic invasion-of-the-world story. Ray Ferrier (Tom Cruise), a divorced father of two, is home with his kids when a lightning storm hits. Suddenly giant three-legged killing machines rise from the ground, with lasers to vaporise anyone stupid enough to watch. Cue escape. Cue explosion. Rinse and repeat.

Like *Invasion of the Body Snatchers*, *War of the Worlds* is one of those films prime for a remake as it always provides filmmakers

with an empty allegorical vessel to fill. For starters, step back a century or so to 1898 when the original book was published. Europe was at the top of its game; they had steam power and they'd easily colonised the rest of the world. And then along comes this story about angry Martians who are systematically wiping out all humanity — starting with famous European landmarks — making the once-mighty Europeans refugees. Profoundly disturbing stuff if you believe that you're God's gift to the globe. Fast-forward to 1938: America is on the brink of World War II, fear is already palpable, and suddenly the radio broadcast of *War of the Worlds* goes to air and people — already tensed for an invasion — go crazy. In the 1950s at the height of the Cold War, the first film version of *War of the Worlds* rolls out, spruiking our fear of an invasion that would descend from the heavens like a Soviet warhead (and it ain't no surprise that it came from the Red Planet). And then you have this film from 2005, when every newscast was warning about a new foreigner to be afraid of. This version of *War of the Worlds* is filled with scenes of America transformed into a war zone — images that have a startling resemblance to the sorts of pictures we saw from September 11.

Aside from referencing imagery of 9/11, Spielberg also borrows from the Holocaust to bring humanity's dying days to cinematic life. Even the casting of Tom Cruise is perfect. He's such a beige, characterless performer that he becomes an audience proxy, of sorts. You imprint yourself on him and think 'What would I do if I were that guy' — which is precisely what you should be thinking in a disaster movie. Where this movie does fall down — and criminally so — is the ending. The climax of *War of the Worlds* is as iconic as it is underwhelming, and this movie seems to make it even worse by adding an inexplicable fairytale conclusion for our heroes. I've said it before and I'll say it again: the last fifteen minutes of a Spielberg movie are usually best left on the cutting-room floor.

The Thing (USA) (1982)

Director: John Carpenter

Stars: Kurt Russell, Wilford Brimley, Keith David

In the Antarctic tundra, a lone husky is running for its life. For some unfathomable reason two Norwegian scientists are trying to shoot it dead. But they miss, and the husky arrives at a remote American research facility. There it becomes clear that this is no ordinary husky and the Norwegians aren't the dog-hating arseholes we initially assumed. They are, in fact, a courageous team trying to stop the most hideous of alien infestations.

The Thing explores the idea of shape-shifting alien life form that absorbs other beings and then perfectly mimics them. Any one of the men in this remote outpost may have been taken over by the creature. Any of them could be one of those *things* in disguise. Kurt Russell is forced to take a leadership role in the American team as distrust starts spreading amongst the men. Who is the alien masquerading as? In the midst of winter, the men are alone, totally disconnected from the outside world. They're tired and all they can do is wait to see when the creature rears its fake, blood-drenched, insectoid head.

The Thing has a perfectly balanced ensemble who've been given great dialogue. Their interplay with one another, intertwining and clashing, adds up to a fascinating portrayal of paranoia. Oh, and there's plenty of jump-out-of-your-chair scares coming at you as well.

Carpenter brilliantly doles out both red herrings and bona fide clues as to who may have been absorbed by the Thing. You never quite know what will happen next, yet all of the scares feel motivated and not contrived.

The Thing is a vicious take on the dangers of paranoia and the more base elements of the human survival instinct, and a great thriller to boot.

IN CASE OF EMERGENCY
THE FILMIC FEAR OF FLYING

They say that flying is one of the safest modes of transport. Whilst my brain is sure that this is a fact, my *gut* is equally sure this assertion is also bullshit. If cinema has achieved anything at all, surely it's been to make most of the movie-going population shit-scared of flying.

It certainly makes sense for us to fear flying — after all, if we were meant to fly we would've been given wings. And for most of us, the physics of flying remain a mystery. Automobiles we generally understand: they have wheels, they roll. But the relationship between driving and flying can be seen as analogous to the relationship between smoking pot and doing crystal meth: one you could conceivably argue is 'natural', the other is an unnatural blight against all that is good and holy and won't someone please think of the children?

Or something like that.

Whatever the source of our deep collective fear of planes, they've resulted in some terrifying, funny and fascinatingly stupid films.

FRIDAY NIGHT FILM

Flying High (USA) (1980)

Directors: Jim Abrahams, David Zucker, Jerry Zucker
Stars: Robert Hays, Julie Hagerty, Leslie Nielsen

You wanna know the amazing thing about *Flying High*? (Apart from the fact that Paramount Pictures changed the original title *Airplane* to *Flying High* for Australia because they're of the abiding belief that we are a nation of bong-toting hippies.) The really stunning thing about *Flying High* is that it manages to pack in almost every different genre of comedy, style of joke and mode of gag into one damn film.

Flying High features ludicrously over-the-top slapstick, like having an inflatable pilot. It uses wordplay, satire, hell, even bizarrely obscure subliminal gags. For example, throughout the Boeing jet flight, the background noise is always of a propeller plane. Indeed the background propeller audio was lifted from a 1957 movie called *Zero Hour* — the same movie that *Flying High* is actually based on. Yes, it's a little-publicised fact that this film is in fact a very unusual remake. Legend has it that the comedic trio of David Zucker, Jim Abrahams and Jerry Zucker were working on their live sketch comedy act Kentucky Fried Theatre. They used to set the VCR to tape late-night TV so they could get the real cream of shithouse advertisements to parody. Instead they accidentally taped *Zero Hour*, an overblown, trashy aeroplane disaster movie. Utterly enthralled at its potential for comedy, the trio purchased the remake rights. Large chucks of *Flying High* are, in fact, verbatim chunks of *Zero Hour* (just with a comedic delivery). Genius!

They even managed to turn the casting into a joke of sorts by hiring actors like Robert Stack, Leslie Nielsen, Peter Graves and Lloyd Bridges. These were serious don't-mess-with-me-or-

my–Brylcreemed–hair leading men — not exactly known for their comedy chops. The goal was to have these guys play their roles as straight as possible while stupid things happen around them. The end result is a film that thrives on sidestepping your expectations. *Flying High* is a thoroughly stupid and wonderful film.

SATURDAY FLICKS

United 93 (France/UK/USA) (2006)
Director: Paul Greengrass
Stars: David Alan Basche, Olivia Thirlby, Liza Colón-Zayas

Of the four planes hijacked on September 11 2001, Flight 93 was the only one not to hit its intended target, crash-landing in rural Pennsylvania rather than into the White House. The reason? Because the passengers and crew launched an assault against the hijackers, sacrificing their own lives in the process. *United 93* tells the story of the eponymous flight in almost real time. It also shows the utterly bewildered response to the hijackings by the various air traffic control and military command centres throughout the USA.

When *United 93* was first announced it was the subject of much controversy, and people debated whether it was too soon for America to relive this horror. Perhaps it was, but that doesn't mean the film itself isn't stunning. British writer/director Paul Greengrass takes on America's national horror with a great deal of realism, blending fictional and documentary techniques to reach some kind of truth about the events on board United Airlines Flight 93. He smartly avoids a lot of Hollywood–style emotional manipulation. *United 93* is stripped back and it cuts straight to your gut, constantly putting you in the reality of the situation and reminding you at every turn that 'this did happen'. Greengrass cast an incredible

group of unknown actors; you feel every terrified sob, every muffled profanity, and every bead of sweat from their foreheads. Greengrass, the man who took over the excellent Bourne movies, uses every tool at his disposal to enhance the authenticity of the experience, because he knows that's where the true power of the film lies. It even comes down to the subtle, small techniques that you don't notice till the end. For example, you never see an external shot of the aircraft. There are no big, dramatic, cinematic pans of the plane swooping through the sky.

Instead, you are in with the passengers right to the very end.

Red Eye (USA) (2005)
Director: Wes Craven
Stars: Rachel McAdams, Cillian Murphy, Brian Cox

You know those really tense and stressful movies, when you take a deep breath at the end and realise that you've just been on a hell of a ride and survived?

Red Eye is one of those movies.

Aboard the last flight outta Texas, an attractive young woman (Rachel McAdams) is being chatted up by a charming young businessman (Cillian Murphy). Then the plane takes off and he comes clean. He's got her father hostage and he's going to have him killed if she doesn't do exactly what he tells her.

Red Eye takes the thriller genre back to basics. There are no fancy action set pieces, not much by way of expensive computer graphics, no profound deeper meaning — it's just a tense cat versus mouse battle of wits.

The reason it works so well is the strength of the two lead actors. At this point McAdams was best known for her roles in teen flicks like *Mean Girls*, so it's great to see her glossy Hollywood good looks gradually stripped back as she fights with everything she's got.

Cillain Murphy begins the film with a cool, heartless face, but as the movie progresses he becomes more and more desperate. They're an equal match and that's why their fight is so engaging — neither of them are geniuses and both of them end up fighting for their lives. *Red Eye* has strains of *The Silence of the Lambs* too, with its effective dynamic of a strong, independent but emotionally damaged woman up against a cool, well-spoken, manipulative man.

I still have no idea how *Red Eye* ends, though: I spent the last ten minutes in a foetal position, covering my eyes and clenching my bowels.

THE SUNDAY MOVIES

The Flight of the Phoenix (USA) (1965)
Director: Robert Aldrich
Stars: James Stewart, Richard Attenborough, Peter Finch

Frank Towns (James Stewart) is an oil company pilot whose plane crashes 130 miles off course, smack-bang in the middle of the Sahara Desert. After several days of wishing, waiting and hoping for a rescue, it becomes clear that it ain't happening. The team decide to do something strange: Stewart reluctantly agrees to help fellow crashee aviation designer Heinrich Dorfmann (Hardy Kruger) with his insane plan to build a *new* plane from parts of the old one. What's going to kill these guys first — the heat, each other, or their slapdash new aircraft?

Jimmy Stewart had long been one of Hollywood's most beloved and reliable leading men but by this point you can really tell he was slowing down. It wasn't his last performance, but age is definitely starting to weary him: he plays a bitter man just a little too well. Though, as always, Stewart keeps everything just below the surface.

It's one of the reasons he's so interesting to watch — you're looking not just for what he's saying, but what he's not saying too.

The Flight of the Phoenix is not a melodramatic or terribly emotional film; there's a terse stiff-upper-lip personality to it. The plane crash is a cleverly edited scene that somehow weaves in the opening credits while building a palpable sense of panic. And there's no shortage of black humour, as cast members are swiftly introduced and then killed off.

It's also worth pointing out that no character, except maybe Peter Finch's soldier, is all that likeable. In fact, the general mood of the group only ever seems to slide between whingeing and outright hostility. Contrary to basic logic, this proves to be one of the film's best attributes: as the audience is unable to root for any one cast member, the focus of the movie then becomes whether or not the group can survive.

The Flight of the Phoenix is a lean, mean and suspenseful take on human frailty.

Snakes on a Plane (Germany/USA/Canada) (2006)
Director: David R Ellis
Stars: Samuel L Jackson, Julianna Margulies, Nathan Phillips

After witnessing a fatal mob hit in Hawaii, a young surfer Sean Jones (Nathan Phillips) is ushered into protective custody by FBI agent Neville Flynn (Samuel L Jackson). Badass Flynn intends to take Jones back to LA to testify. How will the mob boss try to stop Nathan Phillips testifying? That's right, by putting snakes on the plane. Hundreds of them.

I repeat: Samuel L Jackson is stuck on a plane with hundreds of snakes.

Let me make this abundantly clear: under no circumstances are you to watch this movie sober. As you witness the passengers

of Pacific Air 121 (including a hypochondriac gangsta rapper and a thinly veiled Paris Hilton parody) fend off hordes of poisonous snakes, may I suggest a shot is required for each bite?

Perhaps the most interesting part of *Snakes on a Plane* (apart from, obviously, the snakes, and their presence on the plane) is the cottage industry of internet humour that this movie engendered upon its announcement. Rumour has it that Jackson agreed to appear in the movie on the strength of its name only. The moment the existence of the film became public, people created their own made-up trailers, their own audition tapes, their own behind-the-scenes extras and even their own music videos. The net response was so huge that the filmmakers apparently decided to add in scenes and lines suggested by the fans …

As for the film itself … well, it's stupid. Which is fine, because you will be far too plastered to notice. At a certain point the film devolves into a greatest-hits album for every disaster movie ever made. Every character is a one-dimensional stock archetype, though Samuel L Jackson smears his own patented brand of radness into every scene.

HOW NOT TO MAKE A MOVIE, ACCORDING TO MOVIES

So much of this book is about recommending the great and wonderful movies throughout history. It's designed to be a celebration of the films that make you laugh, cry, recoil in fear and other sensations. But sometimes the greatest achievement is simply to get a damn flick made. Producing a movie is a tremendous undertaking and one that should not be taken lightly, especially if you are a moron. And many morons like to think they can make a movie. Go figure. Should you ever wish to make a film, please take this weekend as both a tutorial and a warning buoy. The perils are many: difficult stars, lack of ideas, inadequate planning, societal constraints or just good old-fashioned bad luck. This is your guide to great movies that show you how not to make a movie.

FRIDAY NIGHT FILM

Lost in La Mancha (UK/USA) (2002)
Directors: Keith Fulton, Louis Pepe
Stars: Terry Gilliam, Jeff Bridges, Tony Grisoni

In the summer of 2000, director Terry Gilliam set out with grand plans to finally complete the film he'd been planning for over

twelve years, *The Man Who Killed Don Quixote*. He invited this documentary crew along to witness his process.

Gilliam had tried in 1999 to get *Don Quixote* made, but it ended in tatters. This time, though, it was all going to be different. He had some lucrative European financial backers and was now blessed with a cast featuring Jean Rochefort and Johnny Depp. As the cameras get set to start rolling on location in Spain, it finally seems as though Gilliam's dream is coming true …

Or, y'know, not.

You see, Gilliam didn't count on the endless contract disputes. Nor could he predict that his lead horseman would get haemorrhoids. Gilliam definitely didn't anticipate that his production team would all speak different languages. Oh, and then there's the film's key location, which is blitzed by a storm and located uncomfortably close to a NATO bombing range …

As much as you feel sorry for Gilliam, this film (narrated by Jeff Bridges) relishes in documenting every tragic twist in his cursed production. It feels a lot like the filmmakers were trying to bolster what little dignity the cast and crew had left. Gilliam gives some very funny and insightful if painfully honest interviews. Meanwhile a monosyllabic Johnny Depp does his best impression of a guy who's just woken up.

Directors Keith Fulton and Louis Pepe had previously documented the making of Gilliam's *Twelve Monkeys* (entitled *The Hamster Factor and Other Tales of Twelve Monkeys*). Contrary to what you might expect, both filmmakers are adamant that Gilliam supported them as they mercilessly recorded every single nightmarish turn of events in this film. Apparently Gilliam is a fan of people documenting the making of his films so that if … sorry … *when* proceedings turn sour he has a record of the events. Something tells me this man has seen a few lawsuits.

SATURDAY FLICKS

Making Venus (Australia) (2002)
Director: Gary Doust
Stars: Glenn Fraser, Denis Whitburn, Jason Gooden, Julian Saggers

In 1997, twenty-something cousins Jason and Julian are bored to tears. Armed with $100,000 and a film idea, they decide it's time to change their lives. *Making Venus* is an Aussie doco that follows the five-year journey of Jason and Julian as they attempt to produce a film about the porn industry. To be called *The Venus Factory*, the idea is to make a film about a porn star who tries to break into acting. Except the script makes no sense, the unions are bearing down on them, they've burnt through two directors and the money is running out. Oh, and the extras are drunk.

Making Venus was originally supposed to be a rudimentary 'making of' documentary, but it grew into something much more. Director Gary Doust had no way of knowing how it would all unravel over the years and give him enough material for a feature film, but the result is incredibly engaging. And excruciating. Jason and Julian have boundless fervour for their film. They're particularly proud of their business skills and ability to get out there and raise more money by 'knocking on doors', even if those doors mostly belong to family and friends. You squirm as you watch these people pour their lives and income into this black hole of a film. Even though many of the doco's subjects are unlikeable twats, you can't help but feel sorry for them, the same way you feel sorry for an ant as you obliterate it with a magnifying glass.

It only gets worse with two failed test screenings, re-shoots, firings, irritated investors, dwindling cash and no film distributor.

This is a wonderful film about two boys with plenty of money and balls but not much in the way of skill.

Baadasssss! (USA) (2003)
Director: Mario Van Peebles
Stars: Mario Van Peebles, Nia Long, Joy Bryant

New York, 1970: moviemaker Melvin Van Peebles (played by his son, Mario Van Peebles) is a hot new filmmaking commodity. Along with Gordon Parks and Ossie Davis, Van Peebles is one of only three black directors working in Hollywood. His latest film, *Watermelon Man*, is about to be released and the buzz is good. The big studios are eager to discuss his next project; all he needs to do is play by the rules, and fame, money and security will be his for the taking.

But there's something bothering Melvin. He is surrounded by racial strife. There are protests in the streets, civil rights leaders being assassinated and the last Kennedy is gone. Government reform is now a distant prospect. Van Peebles decides that he must do something. He vows to fight 'the Man' on the only battlefield he knows: the cinema screen. He crafts a pitch for a movie that is so controversial he can't even convince his agent to get on board, let alone the studios.

How is he going to make it? Van Peebles ropes in hippy comrade Bill Harris (Rainn Wilson) to be executive producer. Van Peebles will produce, write, finance, direct and star in his magnum opus. The process is complicated, fraught and definitely not the best way to make a movie.

This is a drama about the true-life making of one of the most influential films in American history. Van Peebles' 'controversial' film, called *Sweet Sweetback's Baadasssss Song*, is the story of a well-hung black man on the run from racist white authority. Part action flick and part art film, there was a tangible sense of indignant rage in

its background that struck a major chord with African Americans. *Sweetback* inspired a string of movies known as blaxploitation that reshaped African American culture and introduced some of the first bona fide black heroes and heroines. Not all the films were good, but when they were they provided a very complete statement of black culture and identity, exploring language, music and life in the ghetto.

Melvin's son, Mario Van Peebles, has taken his father's tale and crafted it into a beautiful, if slightly chaotic, docudrama. The opening montage gets bogged down in Daddy Van Peebles' own revolutionary self-importance, but once the production is underway *Baadasssss!* is a great watch.

THE SUNDAY MOVIES

Tristram Shandy: A Cock and Bull Story (UK) (2005)
Director: Michael Winterbottom
Stars: Steve Coogan, Jeremy Northam, Rob Brydon

Laurence Sterne's famously loopy eighteenth-century novel *The Life and Opinions of Tristram Shandy* was long regarded to be one of those rare 'unfilmable' novels. A chaotic comedy about how impossible it is to reduce the complexities of life into a coherent narrative. In it Tristram Shandy *plans to* tell his life story but instead gets so caught up in digressions that, 700 pages on, he hasn't even been born yet. The novel is stubbornly self-aware, self-parodying and obsessed with the idea of storytelling itself. The narrative even steps off the page to talk about the physical book itself (for example, instead of describing a woman's beauty, Sterne gives you a blank page to inscribe your own visions of loveliness — which, you have to admit, is ingenious).

As you can see, *Tristram Shandy* was considered unfilmable with good reason. Which is why director Michael Winterbottom doesn't even try. What he does instead is make a movie that replicates the perspective, intent and personality of Sterne's novel, and the outcome is, similarly, ingenious.

Tristram Shandy: A Cock and Bull Story is a truly bizarre, funny and digressive backstage drama that stars Steve Coogan (best known from Winterbottom's *24 Hour Party People*) as a fictionalised version of himself. In this film, we have Steve Coogan playing 'Steve Coogan' playing Tristram Shandy and his father, Walter Shandy, in a film version of the book *Tristram Shandy* as part of a film which is also an adaptation of the book *Tristram Shandy* and ... y'know what? Never mind.

If you're looking for a clear plot and narrative, don't bother with this. *Tristram Shandy* works best if you surrender to the episodic rhythm. 'Coogan' chides his co-stars, flirts with a production assistant (Naomie Harris) and fumbles through a visit from his girlfriend (Kelly Macdonald) and baby son. The movie also embarks on a metacommentary on itself. If I were to attempt to describe how that works I suspect a hole would open up in the space–time continuum to swallow me, so let's leave it at this: *Tristram Shandy* is a strange, wondrous and unique take on filmmaking, storytelling and self-obsessed arseholes.

8½ (Italy) (1963)
Director: Federico Fellini
Stars: Marcello Mastroianni, Anouk Aimée, Claudia Cardinale

Guido Anselmi (Marcello Mastroianni) is a famous Italian director. Anselmi is working on a science-fiction film ... or so he thinks. Actually he has no idea what film he's making. Somewhat understandably this is making the cast, financiers and crew all rather

antsy. Then you add in Guido's personal problems (ahem, he's a slut) and you have a recipe for disaster. Guido's proactive solution is to retreat into his mind. He meanders through his own memories and fantasies, attempting to ascertain just what the hell he's supposed to be doing with his life. This is all very meta, of course, because what we're *really* doing is peeking into *8½*'s director Federico Fellini's own twisted psyche. Through the avatar of Anselmi, Fellini lays bare his attitudes to truth, filmmaking and women.

To understand this movie, it helps to understand a little about Federico Fellini. He first emerged in the early 1950s as part of a school of filmmakers determined to reflect the harsh reality of life after the war (a movement referred to as 'neo-realism'). The reason Fellini himself is considered such an important filmmaker is because he pushed that style of moviemaking in a whole new direction. He gradually made Italian cinema more luscious, emotional, expressive and deeply personal with films like *La Dolce Vita* and *La Strada*. But none more so than *8½*.

While Federico Fellini was working on *8½* he was at a loss for ideas and plagued by the fear that his creative juices had run dry. So, in a stunning act of narcissism, he decided to make a film about the challenges of trying to make a film. It's a credit to Fellini's latent skill that *8½* ended up being one of his most surreal, impassioned and unsettling films.

Late note: under no circumstances watch the God-awful musical adaptation of this film, *9*, which is so fucking atrocious it could kill kittens.

JUST THE HEADLINES
JOURNALISTS ON FILM

When you spread a newspaper across the kitchen table this morning, did you ever wonder about the person behind those columns of expertly rewritten press releases? Did you imagine the journalist, with their dramatic life filled with vexing ethical quandaries and unresolved sexual tension fuelled by litres of alcohol? Did you visualise that person's never-ending search for truth in the face of mountainous government evil or corporate greed?

Of course you did. Because you live in la-la land.

The truth about journalism is that for every groundbreaking, Zeitgeisty story (in our era most likely involving a footballer's penchant for group sex) there are hundreds of thousands of writers, producers, subeditors and presenters who are simply there to feed the machine. Yes, a newspaper, website or bulletin must be filled with content, good or otherwise.

Movies love journalism because it's an active profession. It gives our heroes an excuse to go anywhere, day or night, and talk to anyone. The result is a wide array of iconic characters, from Bridget Jones to Tintin to Clark Kent to Truman Capote to *Anchorman*'s Ron Burgundy (and, of course, who could forget Tara Reid in *Van Wilder: Party Liaison*).

But movie directors can't quite decide whether they really believe in the profession of journalism. Yes, the entire history of

cinema is quietly weighing up the pros and cons of that innocent-looking newspaper you opened this morning. So put it aside: let's watch some movies.

FRIDAY NIGHT FILM

Broadcast News (USA) (1987)
Director: James L Brooks
Stars: William Hurt, Albert Brooks, Holly Hunter

There are three journos: Jane (Holly Hunter) is a producer with excellent news sense, a healthy amount of moral indignation and zero love life; Aaron (Albert Brooks) is an excellent reporter with a knack for getting dramatic stories out of war zones; and Tom (William Hurt) is a moron news presenter who looks good on TV, presenting with authority and calm, unfettered by actual thoughts. These three are heading in very different directions and yet their fates are inextricably linked.

Broadcast News delivers characters that initially appear to be one-dimensional, and the movie invites you to judge them as small-minded in their own ways. However, director James L Brooks wisely pulls the rug out from under you, revealing that they're all far smarter and more complex than they look. In doing so he makes the inevitable love triangle that much more compelling.

This is arguably Brooks' best film: it's tender, sharp-edged, bluntly honest and many other positive tactile adjectives. In most of his other roles William Hurt effortlessly projects a lofty intelligence, and yet he is totally convincing here as a well-intentioned, easily corruptible news presenter. Albert Brooks is at his best playing lovable misers and this is a particularly well-written one. But Holly

Hunter is the soul of the film. Passionate and energetic, we feel her rage about the state of her profession but — amazingly — the movie never succumbs to being a polemic about journalism.

The way news is delivered has changed so much in the past couple of decades. Prime-time US news programs like the ones depicted in *Broadcast News* have been overtaken by 24-hour round-the-clock bluster. To watch the film today is to realise just how much the world of broadcast reportage has changed. In spite of its age, *Broadcast News* is a cogent examination of TV news and how it operates. It details the constant pull between stories that are genuinely newsworthy, if somewhat boring, and the stories that are compelling, but not quite news.

SATURDAY FLICKS

Network (USA) (1976)
Director: Sidney Lumet
Stars: Peter Finch, Faye Dunaway, William Holden

Howard Beale (Peter Finch) is a news anchor; it's all he has in life. Well, that is until he gets fired for low ratings. So Howard does what any news presenter should do in such a position: he promises to commit suicide live on air. This produces an incredible spike in viewing figures, and his diabolical ratings-obsessed network president Faye Dunaway decides to keep Beale on air while he spouts his insane crackpot ramblings. He quickly evolves from news man to TV prophet to pure corporate profit.

Network isn't one of the best movies made about news: it's one of the best movies *ever*. You will not find a better exploration of broadcasting and its effect on the human psyche, both as viewers, makers and owners of the medium. The script by Paddy Chayefsky

was prophetic of the rise of news-as-entertainment and reality TV. (Though personally, I wish Chayefsky could have lived long enough to see *Dance Your Ass Off* — one can only imagine what blistering work of genius he would've wrung from that.) So powerful was *Network*'s insight into news that right-wing TV juggernaut Glenn Beck used it as a model for building his career; Beck went from news presenter to charismatic TV prophet of the insane within a matter of months. Just like Beale he introduced props, costumes and perfectly timed on-air breakdowns.

Australia's Peter Finch delivers a career-defining performance as Howard Beale. On the surface Beale seems to be off his freaking rocker, but you can sense that he is connected to some deeper truth. He comes across as a person who has untethered himself from our plane of existence and is looking down at us, calling life for the twisted game it is.

However, the performance that truly steals the movie is Faye Dunaway. With her wide, piercing eyes, she too is the victim of a religious fervour: the cult of ratings.

His Girl Friday (USA) (1940)
Director: Howard Hawks
Stars: Cary Grant, Rosalind Russell, Ralph Bellamy

Hildy Johnson (Rosalind Russell) is the best damn reporter that fast-talking newspaper editor Walter Burns (Cary Grant) has ever had. She was also the best wife he ever had. And now she's divorced him and is about to run off with a nice, normal man who'll treat her like a lady. So she goes to say goodbye to Grant, only to be reeled into one big story about a man on death row that could change the course of an election. Much skulduggery ensues.

His Girl Friday started life in the 1930s as a play about two men. Legendary film director/egomaniac Howard Hawks was

doing a reading of the script in the office after he first signed on to make the picture, and the story goes that when his secretary was reading some of the parts he decided he preferred the central duo with a woman. The casting of the now-female role was a shit fight. Rosalind Russell certainly wasn't the first choice, in fact I think she was number 203 after the likes of Katharine Hepburn, Claudette Colbert, Margaret Sullavan, Ginger Rogers, Joan Crawford and Irene Dunne. Russell found her lack of priority rather insulting. If you read her autobiography, she's also got some pretty choice words for her director. Mind you, Russell was a piece of work too. During the production she realised that she didn't have as many great lines as Grant so she hired a writer to knock up all of her 'adlibbed' lines. She ended up with one of the strongest female roles of the era.

If you're a fan of repartee-rich viewing like *The West Wing* or *Sports Night*, this is your movie.

THE SUNDAY MOVIES

The Insider (USA) (1999)
Director: Michael Mann
Stars: Russell Crowe, Al Pacino, Christopher Plummer

Smoking kills. We all know it. However, if you work for tobacco company Brown & Williamson then you are not allowed to say it. Especially not if you have the sort of proof that high-ranking tobacco chemist Jeffrey Wigand (Russell Crowe) does. Dr Wigand has recently been fired because he would not be implicit in what he thought were serious health concerns, and he is initially unwilling to repeat these concerns to *60 Minutes* producer Lowell Bergman (Al Pacino). When he eventually does, an avalanche of death threats, lawsuits and public smears is set off.

The Insider is based on the life of Jeffrey Wigand, a corporate whistleblower for the tobacco industry. Director Michael Mann has crafted a very methodical film. *The Insider* spends a lot of time focussing on the details and processes of being a journalist: getting a source onside, dealing with legal ramifications, making the story work for television, getting the vision right. Mann stops this from being eye-gougingly boring by taking all these details and pouring them into the structure of a thriller, applying the intensity and psychology of an action movie. He also uses the camera to get up close and personal — you can feel the pressure on these people and it's terrifying.

Al Pacino excels at his patented brand of gruff, shouty overacting. It's not to everyone's taste, but it's been especially well applied here. But it's Rusty Crowe who puts well over thirty-odd foot of grunt into making this role work. Sure, Russell gained weight, made himself look older and all that please-gimme-my-Oscar-'cos-I'm-hideous bullshit. But what's really impressive about his performance is how he created a feeling of vulnerability. Wigand is a man used to being respected and he knows he has a moral responsibility but is ill-prepared for what lies ahead. It's a crying shame they didn't give Crowe an Oscar for this.

Good Night, and Good Luck (USA) (2005)
Director: George Clooney
Stars: David Strathairn, George Clooney, Patricia Clarkson

Eloquence, clarity and grace: can you remember the last time you heard these words used to describe news broadcasting? If you said 'Yes, in 1954 when Edward R Murrow broadcast his considered, nuanced deconstruction of Senator Joe McCarthy's witch-hunts into American citizens whom he accused of being communists' then you are lying. Because you would be too old. Go die now, please.

Indeed eloquence, clarity and grace are precisely what George Clooney's monochrome ode to classic broadcast journalism captures. In the 1940s, Edward R Murrow became famous for reporting on the London Blitz back to America during World War II. Generations of journalists still look up to him as the patron saint of American broadcasting. From 1951 to 1955, Murrow hosted a nightly TV current affairs program called *See It Now*. It was the most influential news program on television according to the Museum of Broadcast Communications, and a forerunner of *60 Minutes*. Edward R Murrow decides to take on Joseph McCarthy, a junior senator from Illinois intent on destroying the lives of countless Americans who he accused of being communists. The face-off will bring pressure down on the network, the show and Murrow himself.

The son of a former TV news man, director George Clooney clearly shares Murrow's wish that TV could become a public service. Shot in noir-ish black and white, and gilded with smooth-like-your-liquor jazz, *Good Night, and Good Luck* is effortlessly cool. It features an astonishingly good cast — Robert Downey Jr, George Clooney, Jeff Daniels, Frank Langella — but anchoring it all, pun unintended, is English actor David Strathairn as Murrow. When he looks down the barrel of a camera and delivers expertly crafted, lyrical words that are in fact verbal scalpels designed to dismember and carve McCarthy and all that he represents, it is breathtaking.

ALL-NIGHT BENDERS

If you happen to spend a lot of time awake while everyone else is asleep, you'll know that the world can seem a bit alien at night. Cities and towns take on a wholly different personality depending on whether it's 2 am or 2 pm. It's not just the lighting that's different on this stage — the cast and soundtrack are also entirely different. And sometimes, on just the right night, with the right players and the right music, these nights can become something special.

Moviemakers have long known this, which is why the 'all-night bender' movie is one of the more vibrant of these sub-sub-subgenres. There was *The Allnighter*, an eighties turkey starring the Bangles' lead singer Susanna Hoffs (written and directed by her mum), and then the 1978 'classic' *Thank God It's Friday*, which followed the staff and patrons of an LA disco called The Zoo on a Friday night. It's pretty bad, but it is worth seeing just for the early appearances by Jeff Goldblum as a sleaze and Debra Winger as an innocent wench. So fetch the Red Bull and percolate the coffee: strange and wondrous things happen in the middle of the night.

FRIDAY NIGHT FILM

Harold and Kumar Go to White Castle (USA) (2004)
Director: Danny Leiner
Stars: John Cho, Kal Penn, Neil Patrick Harris

After a night of smoking marijuana, two roommates (Harold, a low-ranking Korean investment banker, and Kumar, an Indian med student) head out on the town with the munchies. Their goal is to find two things: more drugs and a fast-food joint. Instead they stagger aimlessly across New Jersey, are attacked by raccoons, subjected to eighties romantic-pop and have their car stolen by Doogie Howser.

If you're not a fan of puerile teen comedies then don't expect to like *Harold and Kumar*. It is every bit as stupid as you imagine it to be, but it's also infinitely funnier than it deserves to be, especially for a film made by the guy responsible for *Dude, Where's My Car?* The filmmakers seem to have disregarded all the boundaries of good taste with wild abandon (the only way to do so). It's unpredictable, charming and frankly a bag full of fun. Kal Penn and John Cho have phenomenal chemistry. The film acknowledges cultural stereotypes like the studious, weak Asian and the gifted Indian doctor and then proceeds to, quite rightly, completely ignore their race and just play them as characters.

Though the main reason to watch this is Neil Patrick Harris. Harold and Kumar pick up a hitchhiking fictionalised version of Harris, who is drifting alongside the road tripping balls. He tries to talk Harold and Kumar into picking up some prostitutes (Harris is in real life openly gay). He ends up stealing their car, outpacing a cheetah (long story) and then snorting a line of coke off a supermodel's arse cheek. It's fun.

314

SATURDAY FLICKS

Go (USA) (1999)
Director: Doug Liman
Stars: Katie Holmes, Sarah Polley, Jay Mohr

Your all-night party could also be a really bad trip. Welcome to
Go. Take a dodgy drug deal, two soap stars, an angry check-out
chick and some militant bouncers and you're in for a really bumpy
night. *Go* might be a bit over the top but it has some brilliant black
comedy that makes it a totally worthwhile bender.

Director Doug Liman, with his first decent-sized Hollywood
budget, created a night of chaos and questionable decisions. The
relatively young cast get to have a lot of fun. Check-out chick
Ronna (Sarah Polley) has an angry strength about her. Timothy
Olyphant stars as Todd, a drug dealer, and experiments with the
steely intensity and unpredictability that would later prove popular
in TV series *Deadwood*. And Taye Diggs does a very good impression
of the coolest person on Earth.

When *Go* was first released it was frequently described as a
'young *Pulp Fiction*' but that incorrectly sells it. Whilst I love
Tarantino, he didn't invent the circular story structure nor was he
the first to write snappy pop-culture-laden dialogue. I think *Go*
is far more interested in capturing a sense of a certain time in a
certain city.

There are certain plot twists that stretch the bounds of
plausibility, and by all accounts it's a pretty poor facsimile of true
rave culture (hard to come by at the best of times), but as a fun
night of LA-style bedlam, it's damn entertaining.

Superbad (USA) (2007)
Director: Greg Mottola
Stars: Michael Cera, Jonah Hill, Christopher Mintz-Plasse

Superbad follows two horny high-school buddies and one disastrous night of aborted partying. A lot of people are gonna say that *Superbad* is just another crass and puerile teen flick. And they're right. It's also wading in just about every bodily fluid this side of the pancreas. But it's a film about teenage boys — to *not* be crass and puerile would be a gross misrepresentation. In fact, the reason this comedy works so well is because it's so honest about everything. The jokes ring completely true (even if they are about creative ways of hiding an erection), while the warm, grainy, almost seventies tones and funky soundtrack make everything feel so familiar. But when you dig down into it, *Superbad* has a real heart.

Which I suppose isn't surprising given that Seth Rogen and Evan Goldberg started writing this when they were thirteen. Michael Cera and Jonah Hill are perfectly cast as the central characters. Sure Michael Cera can only really do one character — nervous, naïve nerd — but he does it so well. As the highly strung yin to Cera's dopey yang, Jonah Hill brings a foul-mouthed fury to the film as Seth, a guy who says everything that pops into his horny teenage mind. That said, the leads get a run for their money from veteran players Seth Rogen and Bill Hader as two police officers trapped in their own arrested development, and Chris Mintz-Plasse's character 'McLovin' is the breakout star.

Superbad lags a bit in the midsection, and I think there are a lot more elements of adolescence that they could've mined in addition to dick jokes, but the honesty of *Superbad* provides its biggest laughs — and its heart.

THE SUNDAY MOVIES

Dazed and Confused (USA) (1993)
Director: Richard Linklater
Stars: Jason London, Wiley Wiggins, Matthew McConaughey

It's May 1976 and school's out … forever. It's the last day of term. That doesn't just mean freedom for those graduating from this Texan high school but also initiation for the next year's incoming freshmen. This entails a vicious paddling for the boys (Catholic school?) and a public tomato sauce and mustard shower for the girls (definitely a Catholic school). Of course for the seniors, it's party time.

Dazed and Confused follows twenty-four students, ranging from incoming high schoolers to a creepy toolie hanger-on in the form of Matthew McConaughey. There's hooking up, drinking, bullying, more drinking and then there's some more hazing scenes that are difficult to contextualise in polite company.

I think the principal achievement of *Dazed and Confused* is how oddly timeless it feels. It's set in the mid-seventies but the emotions and little vignettes that director Richard Linklater puts together still have an evocative potency. The movie immediately transports you to high school via the superjet of nostalgia. It's obviously a very autobiographical film for Linklater (he grew up in Texas) but he also invited the young cast to give him feedback, and a number of the most memorable scenes were the result of the stars' own input. Of course, this openness was just one of the many reasons the film was a nightmare to work on for Linklater, who was using studio money to make a film for the first time. It all went awry, with producers and executive producers even going so far as to start directing actors behind Linklater's back.

Of course in retrospect none of it matters: the film is a beautiful, funny, wistful and critical look at the cruelties of high school.

After Hours (USA) (1985)
Director: Martin Scorsese
Stars: Griffin Dunne, Rosanna Arquette, Verna Bloom

But my top all-nighter is a little known Martin Scorsese flick from 1985 called *After Hours*. Office worker Paul (Griffin Dunne) meets a girl. They arrange to catch up. But he loses her number and, whilst trying to track her down, his whole night goes to shit. Above anything else, this is a movie about the personality of New York City, and all of its crazies who come out at night. Soon Paul finds himself the suspect in a string of burglaries in the area and he becomes the object of a witch-hunt by a posse of SoHo locals, sadomasochists, angry cabbies and ice-cream-truck drivers.

You can thank Jesus for this one. Martin Scorsese, the famed New York director behind movies like *Goodfellas* and *Raging Bull*, had originally set his heart upon making a movie called *The Last Temptation of Christ*, in which Jesus was to be depicted with a wife and kids and played by Willem Dafoe. Much to Scorsese's surprise (though no one else's), this proved to be a difficult film to get funded. *After Hours* was the backup plan.

There are a couple of stories about how this film came into being. The first is that it was based on a screenplay by one Joseph Minion, who wrote it as part of a university film assignment. The much better story is that a decent chunk of the first thirty minutes appears to be lifted from 'Lies', a 1982 public radio monologue by Joe Frank, the great LA-based radio artist. He was apparently never officially credited at the time but was later 'paid handsomely' to forget about it.

Regardless, the end result has a palpable sense of chaos that runs perilously close to the absurd. Apparently Scorsese told cameraman Michael Ballhaus to light up the imagery one notch brighter than reality, one notch darker than fantasy. It's not a bad description for the whole piece.

WHY ALL TOURISTS MUST DIE

There's nothing quite like that look of a dazed and disoriented tourist. Anybody who lives near any landmark that attracts such a people will instantly recognise them: a brand-new novelty T-shirt, some form of ill-fitting visor to gently shade that furrowed, befuddled brow that says, 'I can work out where the Harbour Bridge is, but more importantly I *shouldn't have* to work it out … why doesn't this godforsaken city on the arse-end of the globe simply unfurl itself in a manner that makes my point of destination clear and — you know what, fuck your random city for not catering to my every whim. *I'm going to go to Starbucks!*'

I think we can all agree: tourists like these must die.

If one ventures to a foreign locality then one simply must allow that one may be hacked to death by the locals. Such is the lesson of modern cinema. In fact, tourist-killing movies are a genre unto themselves, dating back at least as far as the sixties and Herschell Gordon Lewis's hilarious *2000 Maniacs* (which had to be downgraded from *200,000 Maniacs* because of the unsustainable extras' salaries). These movies partly feed on the distrust between rural and urban dwellers, or, more specifically in the case of American films of the North and the South, between the soft and hackable liberals and batshit-crazy rural polygamist axe-wielding, zealous conservatives. Ironically the movies largely find their origins in a form of hippy culture. In

the post World War II boom and with the rise of youth and car culture, the road trip, and the road movie, became the ultimate expression of freedom. But then came the Vietnam War, conscription and televised images of combat, and suddenly American life didn't look so peachy. A sense of nihilistic brutality set into the American consciousness and before you knew it 1974's *The Texas Chainsaw Massacre* had five friends whose trip to visit two of the group's grandfather's grave gets cut short by the power-tool-wielding Leatherface and his ravenous family, and from that point onwards, the road movie became things like these …

FRIDAY NIGHT FILM

Deliverance (USA) (1972)
Director: John Boorman
Stars: Jon Voight, Burt Reynolds, Ned Beatty

Four suburban blokes have decided to take a camping/canoeing trip on the Cahulawassee River in rural Georgia. It's an escape from their flat suburban lives: Lewis (Burt Reynolds), Ed (Jon Voight), Drew (Ronny Cox) and Bobby (Ned Beatty) have come here for a chilled vacation with plenty of male bonding and dead animals cooked on a poorly constructed fire. But this weekend will be anything but relaxing. Our four 'heroes' don't exactly treat the locals with that much respect, which turns out to be a huge tactical error because these hillbillies are a vicious bunch. Before you know it the men are being chased by a bunch of yokels who really want to give 'em a thorough proctology exam. And quicker than you can say 'uninvited sodomy', they're on the run.

What a weird little move *Deliverance* is. If you're after an hour and a half of banjo playing and men squealing like pigs, you'll be disappointed. Also, you have something very, very wrong with you. Director John Boorman loves to go in every direction but the way you think it will. Burt Reynolds gives a particularly good performance as a man obsessed with being 'at one' with nature — think Crocodile Hunter with added dickhead factor. Jon Voight as Ed is also solid as the only vaguely likeable character. No one ends up looking great here: it's about the division within the United States, and the difference, disrespect and sheer distrust between urban and rural America. In its day it proved so popular that it led to a renewed interest in whitewater rafting, which in turn led to a sharp increase in the number of rafting fatalities in the early to mid 1970s. Any film that can inspire an actual death toll is powerful indeed.

SATURDAY FLICKS

Cabin Fever (USA) (2002)
Director: Eli Roth
Stars: Jordan Ladd, Rider Strong, James DeBello

Who said tourists had to be killed by people? Nature itself can punish you for travelling.

Cabin Fever is the story of five disturbingly attractive college students who holiday at a remote lake in North Carolina. One by one they contract a virus that begins to eat them alive.

This little movie, with its minuscule budget (a touch over $1 million) and its liberal lashings of fake blood, certainly struck a chord with horror fans. With its mix of terror and comedy, it was a breath of fresh/decomposing air and spurted horribly infected new blood into the genre.

The movie starts out as a fairly stock-standard horror film. The teenagers party hard: sex is had, woodland creatures are shot at, alcohol is guzzled, and so on. But the kids are about to have their inebriated existences cut short. A diseased crazy man, who is literally vomiting cups of blood, begs for help. The kids come to the not unreasonable conclusion that the man is infectious. They then make the less defensible decision to light him on fire, and watch him run, screaming into the woods — right into the cabin's water supply. Nice work, Scooby gang.

Cabin Fever develops itself enough to be both a very scary and very funny morality play, with some none-too-subtle comments on the dark side of small-town America. *Cabin Fever* taps into an audience's inherent germophobia and then just picks at it for all it's worth. Panicked (and monumentally stupid), the five friends begin to stumble their way through a rudimentary quarantine process before skipping 'Go' and not collecting their two hundred dollars on their way to Every-Man-for-Himself-ville. Then you throw in a retarded dog, some irritable gun-toting rednecks and a Shaolin mullet-child with a taste for pancakes and this shit gets real.

Director Eli Roth tells an effective film which just gets stranger as the film progresses, though at times it seems slightly unsure of its own identity, in particular whether it's a cookie-cutter teen-horror flick or a dark, surreal David Lynch-style moral drama.

The Cars that Ate Paris (Australia) (1974)
Director: Peter Weir
Stars: Terry Camilleri, John Meillon, Kevin Miles

George and Arthur Waldo are steering their caravan across Australia. A horrific accident kills one of the brothers and when the other awakes he is concerned to discover that the entire population of the

small country town of Paris seems intent on keeping him captive in the city bounds. Any attempt to leave is met with roadblocks and alarmingly aggressive junk cars. Surprise, surprise, it turns out that Paris is in the business of *causing* car accidents. They then make false insurance claims and salvage auto parts, all in an attempt to keep their impoverished town from going under.

A title like this may bring to mind images of murderous Mustangs and sadistic Saabs roaring across the outback hunting for errant Parisians (who, naturally, signal their surrender via mime, Marcel Marceau style).

The reality is — amazingly — actually far stranger. This is really a dark comedy about culture: Paris is a town with its own culture of vehicular conquest and it's on the verge of destruction. Directed by Peter Weir, *The Cars that Ate Paris* does a scarily good job of setting up a surreal and dark atmosphere.

Weir went on to make a name as an artistic, subtle mainstream director making films like *Witness* and *The Truman Show*. Here you can see him meshing the melancholic, the mysterious and the downright murderous.

THE SUNDAY MOVIES

Dead End (France/USA) (2003)
Directors: Jean-Baptiste Andrea, Fabrice Canepa
Stars: Ray Wise, Lin Shaye, Mick Cain

For twenty years, Frank Harrington (Ray Wise) has been taking his family to Grandma's place for Christmas via the same route, but this year he's decided to take a shortcut. Big mistake. The family find themselves stuck on a road that never seems to end — no towns, no shops, no signs and no turn-offs.

It all starts when the family picks up a strange woman in white on the side of the road, allegedly lost. She sits in the backseat, cradling her mute and very dead-looking 'child'. When Frank pulls over at a cabin to call for help it all begins.

Dead End is a solid little horror flick. It's tense, suspenseful and well photographed. It also has a wonderfully creepy atmosphere and the scares arise as much from your own imagination as they do from anything actually on the screen in front of you. Opting against too much gore or sharp frights, writers/directors Jean-Baptiste Andrea and Fabrice Canepa have a fun li'l ride, despite some contrivances and a twist ending you can see from the horizon.

The weight of the film rests on the interactions between the family members, and each character brings some interesting personality quirks to the flick. The thrust of the flick is the mystery that has engulfed the Harrington family. Why does the road they're on never end? Who in holy hell is the white lady? And what's the go with the black car leaving behind a wake of mutilated bodies? The uncertainty of who might be next to take the ride creates a palpable, sustained uneasiness. *Dead End* is my favourite kind of thriller: a film that can balance terror with a little bit of comic relief to let you recover before it frightens the bejesus outta you again.

ET: The Extra-Terrestrial (USA) (1982)
Director: Steven Spielberg
Stars: Henry Thomas, Drew Barrymore, Peter Coyote

Yes, I've decided that this is indeed the most subversive and disturbing tourist-killing flick you will watch this weekend. Because the villain is us humans, and we should be ashamed of ourselves.

Elliott (Henry Thomas) finds ET, a visitor from another planet, hiding in his backyard and, like any kid who finds a stray animal/alien/backpacker, decides to keep him. Hiding the alien from

his mother (Dee Wallace), Thomas and the neighbourhood kids befriend the creature. A variety of cute and cuddly things happen until the government decide to set up a small biohazard-themed fun park … oh, and kill our charming, generous intergalactic tourists.

Humanity, you suck.

It's not every year that the director of another movie gets up at the Oscars to accept a best picture statuette and says, 'I was certain that not only would *ET* win, but that it should win. It was inventive, powerful, [and] wonderful. I make more mundane movies.' That was Richard Attenborough accepting an Academy Award for his film *Gandhi*, and he wasn't wrong. *ET* is a remarkable film, so let's cap off a heavy weekend with something light. Inspired by his own upbringing with divorced parents and bored with shooting *Raiders of the Lost Ark* in the oh-so-exciting dunes of Tunisia, Spielberg wrote the script remarkably fast. He spent US$1.5 million designing and building the creature and realised it was something that only a mother could love. Chocolate company Mars agreed with him: they found ET so ugly that the company refused to allow M&M's in the film, so Hershey got their Reese's Pieces in instead.

In the end, the film is undeniably the result of a director — a boy, really — working through his Peter Pan complex, an abandoned boy lost in flights of fantasy. It's full of superb performances and some of the most indelible images ever committed to film.

LOVE AT FIRST BITE
WHAT'S THE BIG DEAL
ABOUT ZOMBIE FLICKS?

There are a *lot* of zombie movies. It's a genre that is fervently loved by its fans and viewed with jaundiced confusion by those on the outer. So this weekend, we go back to the basics.

What is a zombie, anyways? Classically speaking, a zombie is a dead human (or occasionally pet) that has been brought back to life through some unholy means. A zombie will typically retain most of its primal instincts, such as the desire to eat, visit shopping centres and pull sweet choreographed dance moves (see Michael Jackson's 'Thriller' for details). The most common cause of zombitis is a virus typically transferred through physical contact — à la biting — though in rare cases vigorous oral sex has proved effective as well. The average diet of a zombie is live human flesh — brains are considered to be a sought-after delicacy. If a zombie bites you, do not inform your closest friends, because you'll shortly want them as a snack. Zombies, however, make for poor conversationalists with a disappointing vocabulary, largely restricted to 'Grrrr', 'Arrrgh', 'Blergble', or variations of the above.

And yet cinema loves zombies, and not just because they give characters an excuse for guilt-free violence and sanctioned looting. No, the zombocalpyse is often used as a potent vehicle to comment on all manner of topical social ills. This weekend

walks you through a far from definitive list — there's an endless supply of fine movies and TV shows worth looking at, from classics like *Dawn of the Dead*, to innovative variations like *Quarantine*, to newer TV series such as *The Walking Dead* or *Dead Set*. Think of this as a tasting plate of undead flesh, one that demonstrates not just seminal movies but also the various flavours of Zombie Cinema.

FRIDAY NIGHT FILM

Shaun of the Dead (UK) (2004)
Director: Edgar Wright
Stars: Simon Pegg, Nick Frost, Kate Ashfield

Shaun (Simon Pegg) is one of life's great disappointments. He is an English slacker in his twenties who is content to simply plonk himself in the corner of the local pub, get plastered with his mates and master every video game he can lay his pasty fingers on. Somehow he's managed to maintain a relationship with Liz (Kate Ashfield). She, however, has recently cracked it with his lazy attitude and dumps him. Shaun falls into a depression that even his roommate Ed (Nick Frost) can't pull him out of. Not that Ed should feel bad about that because a raging nationwide zombie-attack seems to barely distract Shaun. At first he doesn't even notice the undead staggering around the streets of London. Eventually it becomes clear that the rising zombocalypse poses an unacceptable threat to Simon and Ed's way of life (drinking and video games). And Shaun certainly isn't going to let a little thing like hordes of flesh-eating Londoners prevent him from getting both his girl and life back.

The first thing that strikes you about *Shaun of the Dead* is how incredibly well constructed it is; director Edgar Wright makes smart use of the camera and tight editing. But the real reason *Shaun of the Dead* works so brilliantly is because never once do the zombies become a joke or less than a true threat to our heroes. Wright expertly balances the two genres — the comedy is sharp and clever when it needs to be, and the horror is gruesome and heartbreaking.

Performance-wise, Pegg as Shaun is likeable, but it's Nick Frost as his best mate who is the most fun to watch, typifying that friend who always manages to screw everything up. *Shaun of the Dead* is witty, charming, horrific and — best of all — different.

SATURDAY FLICKS

Zombieland (USA) (2009)
Director: Ruben Fleischer
Stars: Jesse Eisenberg, Emma Stone, Woody Harrelson

In this flick, the zombie invasion has come and gone and only a few true humans survive in the wasteland that we once called Earth. A few of these humans include obsessive-compulsive Columbus (Jesse Eisenberg), rough-and-tumble redneck Tallahassee (Woody Harrelson), the smart and sneaky Wichita (Emma Stone) and her sister, Little Rock (Abigail Breslin). This unlikely foursome join forces to fight zombies and work out their inner demons to very amusing and poignant effect.

Zombieland opens with a spectacularly brutal and hilarious opening-credit montage about how to survive a zombie attack and then gradually works its way into being a warm-hearted, sweet film. Expect high doses of both laughs and gore, but somewhere along the line — almost without you noticing — the film makes you care

about the characters involved. Too many horror films (even comically inclined ones) pull the audience into a cynical guessing game of which of the dickhead characters will die first, and by which wildly innovative method. Don't get me wrong, sometimes that's fun (see the 'We're gonna need a bigger sequel: a beginner's guide to shark movies' chapter), but *Zombieland* knows that a powerful, visceral response can come by making the audience genuinely care about the characters first. Chuck in a gratuitous cameo by Bill Murray, a quotable script and a narrative climax that is as madcap as it is brilliantly choreographed and you're in for some fun. *Zombieland* is a quirky, heartfelt and vicious flick that, like *Shaun*, is cleverly produced and directed.

28 Days Later (UK) (2002)

Director: Danny Boyle
Stars: Cillian Murphy, Naomie Harris, Christopher Eccleston

A group of radical animal rights activists break into a laboratory seeking to liberate its monkey population and discover they have been 'contaminated' with a man-made virus, charmingly called Rage, that unleashes the animals' inner anger and violence. I'm not sure why you'd want to develop such a thing but hey, scientists are dicks (see the 'For the love of God, why are we doing this?!: why messing with DNA is a bad idea' chapter), though even more stupidly the animal activists release the chimps anyway.

Twenty-eight days later, Jim (Irish actor Cillian Murphy), a bicycle courier, wakes from a coma to discover that London is empty. He soon ascertains that a virus has been released and killed off most of the UK's population. Those who weren't killed or evacuated have — surprise, surprise — turned into a particularly rabid breed of zombies.

28 Days Later is a very different take on your traditional zombie movie (some have argued that the zombies aren't even zombies at

all). British director Danny Boyle is known for vivid, fast-paced and genre-blending films like *Trainspotting* and later *Slumdog Millionaire* and *127 Hours*. Filmed in clinical digital video, *28 Days Later* has an eerie underground quality to it but also wisely employs a dry English wit to relieve the tension.

Boyle makes it clear from the very opening scenes that death and destruction can come at any time, from anywhere, to anyone. There are no safe spaces in this world (take, for example, the church filled with infected freaks that Jim stumbles into). It's always the moment when you've come to trust a situation or person that horror will come crashing through a window. Ultimately *28 Days Later* is about human nature and showcases the very worst that humans are capable of, be they zombies or not.

THE SUNDAY MOVIES

Night of the Living Dead (USA) (1968)
Director: George A. Romero
Stars: Duane Jones, Judith O'Dea, Karl Hardman

And this is where it really started. In 1968 George Romero created one of cinema's most horrific and iconic films. *Night of the Living Dead* isn't that controversial by today's standards, but forty-odd years ago this vision of zombies munching on intestines was considered groundbreaking and seditious.

The film opens with siblings Barbra (Judith O'Dea) and Johnny (Russell Streiner) on their way to visit their father's grave. Upon arrival they're accosted by a very pale, belligerent man … but he is no man. Well, not a living one, anyway. The single surviving sibling (I won't give away which) seeks refuge in an abandoned farmhouse where he or she meets an African American named Ben (Duane

Jones). He too is in hiding, and together they hole up for the night as the living dead close in.

Any other movie in this era would've been shot in colour; however, thanks to their microscopic budget, the filmmakers ended up using the cheapest film stock they could find and the end result has an uncanny, almost documentary feel. There are scenes that are slightly out of focus and continuity errors left, right and centre, but this accidental documentary realism actually enhances the sensation of dread and peril.

Romero's movie would later be regarded as controversial and groundbreaking for its use of gore and its nihilistic vision of a disenchanted youth. Plus there's some nudity. However Romero's biggest 'political' statement was an unintentional one in the casting of a resolute and resourceful black man (Duane Jones) as the film's hero, Ben. These were rare qualities in the black characters presented by most Hollywood productions. In truth, the role was never written with an ethnicity in mind — Romero cast Jones because he was the best actor anyone in the cast knew.

Pre-emptively progressive casting or not, *Night of the Living Dead* came at a time of tumultuous cultural change within America. At the height of the Cold War, Romero's film explored the dangers of neighbour-suspicion, displayed corruption and laziness in law enforcement, and portrayed a government run by complete arseholes. It just goes to show, some shit never gets old.

Tokyo Zombie (Japan) (2005)
Director: Sakichi Satô
Stars: Tadanobu Asano, Shô Aikawa, Erika Okuda

When you see a DVD called *Tokyo Zombie*, how can you *not* rent it, just to see what it's like? The tagline on the cover reads 'the Japanese *Shaun of the Dead*', which is right up there as far as inaccurate movie

mottos go. And yet, a comparison to the British RomZomCom is a perfectly acceptable description if you can imagine *Shaun's* two London louts being replaced by two certifiable morons with matching oversized Afros, a single brain cell between them, and at least one missing chromosome in their DNA. Each night they sleep next to each other covered in matching shower curtains. By day they avoid work by practising jujitsu, which appears to be a cross between karate and the Kama Sutra.

When one of the boys kills their boss with an exhaust pipe (what?) and the other kills a pedophile with a shovel, they do a runner and travel to Fuji Mountain. That's not the actual Mount Fuji, mind you. Oh no, in this version of Japan, Fuji is a garbage pile the size of Mordor and the shape of a skyscraping phallus. It's so repugnant that the smell turns people into, yes, zombies. From here the plot devolves into zombie/human death-matches, killer Russians and more jujitsu.

This film is so bizarre and shocking that I can only liken the experience of watching it to someone slapping you in the face with a 4 kilogram trout. Almost everything about this flick is so wonderfully cheap and nasty, from the sets, to the acting, to the plot. There's clearly been *some* money chucked at it because there is a fair bit of rudimentary computer graphics, but it's generally a badly made film — and that is its charm. Japan has an amazing history of what is called J-Horror — original and bizarre horror movies sent straight to video. This is cut directly from that same cloth (cut with a chainsaw, mind you). The sheer mind-boggling inanity of the film is fun, but it really comes into its own when you're watching a socially inept man try to kill a zombie by wrapping his legs around their head and cracking it open. The real achievement of *Tokyo Zombies* is the fact that, by this point, you no longer feel guilty for watching.

PUPPETS ARE EVIL, SEDITIOUS, AMORAL AND CREEPY. SO THERE.

What is small, fuzzy and only really comes to life when you stick your hand up its rear end? Truth be told there's about three answers to that question; two are downright libellous and the third one is puppets. Whether your puppets come in the form of Muppet or supermarionation, they all have one thing in common: they're really, really creepy. Take, for example, groundbreaking British sixties TV puppet phenomenon *The Thunderbirds*. A long-time favourite of kids' breakfast television, it followed the travails of a pint-sized marionette rescue organisation created to save those in grave danger by using technically advanced (and frequently not-to-scale) equipment. It's a noble goal, but one that was executed by disturbing six-inch figurines with dead eyes and an unsettling wobbly-walk.

This isn't just my own prejudice — cinema has a historically deep-seated fear of puppets that stretches right back to the early days of the medium. In 1929 *The Great Gabbo* told the tale of a brilliant ventriloquist (Erich Von Stroheim) who gradually spins into insanity as his dummy, 'Otto', becomes his only form of self-expression.

Even the art of creating a puppet can be creepy. Take that monstrous *Star Wars* slug Jabba the Hutt. How many innocent

puppeteers squeezed into his innards to make that creature work? There should be clauses in the Universal Declaration of Human Rights to address this. Even here in Australia, why has no one ever questioned the abusive domestic relationship between Mr Squiggle and Blackboard? It is my goal this weekend to convince you beyond reasonable doubt that all puppets are evil, whether they be amoral, inadvertently disturbing or simply garden variety homicidal. Enjoy. And beware.

FRIDAY NIGHT FILM

Team America: World Police (USA) (2004)
Director: Trey Parker
Stars: Trey Parker, Matt Stone, Kristen Miller

Trey Parker and Matt Stone, creators of *South Park*, took to the big screen (and now return to your smaller DVD-sized screen) with *Team America* — who represent every evil of American imperialism in marionette form. It follows a crack unit of puppets defending American interests all over the world with all the subtlety of a bald eagle fornicating with Michael Bay draped over an American flag serenaded by the theme from *Top Gun*. Whenever un-Americanism rears its ugly, tumorous head somewhere on the globe, this gang of unilateral law enforcers shall be there to unleash their righteous fury.

Team America consists of Chris, Joe, Lisa and Sarah. They work to put the 'f' into freedom under the close tutelage of Spottswoode, their classy leader, and I.N.T.E.L.L.I.G.E.N.C.E., their computer. When one member is killed during a culturally offensive offensive in Paris, Team America seeks out a replacement. They find one in Gary, a rising Broadway musical theatre star. It is soon revealed that North Korean leader Kim Jong-il is planning to destroy the world by

brainwashing Hollywood's moronic elite. Team America must now face their greatest challenge: battling their own countrymen.

Scatological gags, glorious helpings of foul language and an oddly stirring sense of grandiose adventure are just a few of the things you can expect to find in this film, along with some truly brilliant musical sequences. Keep an eye out for the rocking theme 'America, Fuck Yeah' and the spoof of nineties musical *Rent*, 'Everyone has AIDS'.

Team America features some of the most biting satire that Hollywood money has ever bought. There is no better way of dismantling the overblown blockbuster world of Jerry Bruckheimer (*Armageddon*, *Top Gun*) and Michael Bay (*Transformers*, *Bad Boys*) than by reinventing it with toys. Parker and Stone keep the puppet-based pyrotechnics as overblown and outlandish as if ripped straight from the overactive imagination of a child. It's a comic stroke of genius to use the trappings of childhood to make something weird, wilfully offensive and brilliantly funny. You have been warned.

SATURDAY FLICKS

Child's Play (USA) (1988)
Director: Tom Holland
Stars: Catherine Hicks, Chris Sarandon, Alex Vincent

Today is Andy's birthday and he really wants a Good Guy, a life-size talking doll that comes complete with its own name and the ability to respond to specific commands. Unfortunately, Andy's mother, Karen (Catherine Hicks, aka the mum from *7th Heaven*), can't afford a proper Good Guy, so she picks up an el cheapo version, which may or may not contain the undead soul of murdering psycho Charles Lee Ray (Brad Dourif). Now Andy is the proud owner of 'Chucky,'

a Good Guy who can play all the time … if by 'play all the time' you mean 'kill innocent people'.

Writer Don Mancini initially set out to create a mystery-slash-commentary on consumerism. While he doesn't quite nail those lofty hyphenated heights, *Child's Play* is a very decent horror movie, with elements of mystery and satire that push it beyond expectations. There are some genuinely unnerving performances and a very memorable three-foot-tall malevolent villain.

Director Tom Holland has a bit of fun toying with your expectations too. We don't actually see the doll do anything nasty until well into the movie. If you didn't know better (and hadn't seen the trailer, the poster or the title of this chapter) you could almost think that the first couple of killings could have been committed by young Andy. Alex Vincent is very good as six-year-old Andy, largely avoiding that cloying 'child actor' quality.

But the real star, of course, is the doll. From the first moment Chucky speaks — 'You stupid bitch! You filthy slut!' — he etches his way into your subconscious. Brad Dourif is a talented character actor and the perfect voice for the foul-mouthed plaything. But full credit also needs to go to effects designer Kevin Yagher. With those big blue eyes and toothy overbite, Chucky looks like a kind of genetically faulty inbred hillbilly.

The Dark Crystal (USA/UK) (1982)
Directors: Jim Henson, Frank Oz
Stars: Jim Henson, Kathryn Mullen, Frank Oz

In this fantasy world, the mystical Dark Crystal is a powerful gem that possesses forces beyond the imagination (whatever that means). A thousand years ago, a shard broke off from the crystal and two new races magically appeared: the large, ponderous Mystics and the angry, irritable Skeksis. These two races have battled for eons

over control of the crystal. However an ancient prophecy says that a miniature rat-like creature known as a Gelfling shall become an unlikely hero (aren't they always?). Legend has it that this magical rodent will find the missing shard, heal the Dark Crystal and end the strife — unless the Skeksis can stop him.

It can't be stressed enough what an amazing job Jim 'Sesame Street' Henson and his team pulled off in the making of *The Dark Crystal*. They managed to achieve such a rich, detailed universe with miniatures, painted backgrounds and some blue-screen work.

It also can't be stressed how disturbing all the creatures are. Most of *The Dark Crystal*'s characters resemble Earth animals in various states of trauma. The Gelflings look like rats who've just paid a visit to Joan Rivers' plastic surgeon. Scientist Aughra resembles a cat that's been through a violent spin cycle. The Skeksis appear to be birds that have been flayed alive while the Mystics have clearly been modelled on some horrific drug-fucked hippy-alligator thing. Whatever unethical Eastern Bloc animal-testing lab Jim Henson visited for inspiration needs to be located by the authorities and burnt to the ground.

And yet this horrific Muppet ecosystem is also why *The Dark Crystal* is so memorable. Their organic, tactile nature and — yes — their resemblance to abused pets all give the film an evocative quality.

THE SUNDAY MOVIES

Strings (Denmark/Sweden) (2004)
Director: Anders Rønnow Klarlund
Stars: James McAvoy, Catherine McCormack, Julian Glover

Picture *Lord of the Rings* with puppets instead of hobbits. *Strings* is the epic tale of a heroic young prince who's betrayed by an evil uncle

(cough … *Hamlet*) who has covered up the king's death (cough … *Lion King*) and made it look like an assassination (cough … have these people even *seen* another movie?). This inspires Sir Princealot to take revenge against a rebel nation that he believes to be responsible for this latest bout of regicide. Unsurprisingly, the rebels don't react too well to this assault and then things get messy … or sawdusty, I suppose.

Yes, the plot has as much originality as a *Glee* cast album. That said, this fascinating movie, co-written and directed by Danish filmmaker Anders Rønnow Klarlund, really does have to be seen to be believed. The heavily stylised marionettes look like the ancient toy set of an emotionally tormented child in a gothic bygone dynasty. They're all orchestrated by lead puppeteer Bernd Ogrodnik, who imbues each of his characters with so many recognisable human inflections that it's quite surreal.

One of the film's great distinctions is that the puppeteering is embraced within the mythology of the movie. Each of the characters is actually aware that they are marionettes and believes they are linked to a higher power via their strings. Cut the marionette's head string, for example, and they die. The prison that holds the prince is conceived around the idea that the puppet strings reach up endlessly into the sky so, instead of jail cells, prisoners are confined below massive flat grids, their mobility limited to the small square openings in the grid that their strings fit through. And new life doesn't come through birth. Instead a couple will whittle a new child from wood and then a set of magical new strings descend from on high to be attached to the inanimate woodlet by Mum and Dad.

Strings is a distinct, unnerving and unusual film.

Meet the Feebles (New Zealand) (1989)
Director: Peter Jackson
Stars: Donna Akersten, Stuart Devenie, Mark Hadlow

If all of these distressing puppets are Freudian reflections of ghastly childhood memories, someone should have arrested Peter Jackson's parents a long time ago. Before he was lording over the rings he was meeting the Feebles, New Zealand's mangiest, most diseased urban family. Trust me, you don't want to stick your hand up these guys — at least not without protection. This black comedy focuses on a motley theatre troupe, including Samantha the slut cat, Trevor the drug-addict rat and Heidi the murderous hippo. What follows is a disquieting series of intertwining plots that feature drug-running, puppet threesomes, the making of a porn film and puppet-based STIs.

Meet the Feebles has a complex production history. Allegedly it was originally developed for Japanese television and only became a feature quite late in the game. Rumour also has it that the script had to be rewritten multiple times to fit the new running length. The dialogue was recorded before shooting began. Money ran out during production, so one scene featuring a flashback to Vietnam was filmed separately (with a different budget) under the title *The Frogs of War*. The great part of all of this behind-the-scenes chaos is that it seems to have infused the action in front of the screen. Peter Jackson has created a sense of utter abandon in the universe of the Feebles, and wild insanity abounds through the characters, the plot twists and the climax. If nothing else, I can promise you that by the end of *Meet the Feebles* you'll never think of animal husbandry in quite the same way.

RECUT
MOVIES THAT HAVE HAD
THEIR ENDINGS CHANGED

You know, it still shocks me to this day that Darth Vader was not only Luke's father but that he was also a completely unaware ghost who secretly had a penis, and that that *penis* had a split personality — one of which is played by Brad Pitt who was destined to kill Dumbledore and all he needed to do was click his heels five times to go back home which, in spite of all the apes, was actually Earth. But the real twist was when Vader actually turned out to be Keyser Söze and the penis was his childhood sled all along.

See, once upon a time the job of ruining movie endings was the domain of dickhead film critics like me. However at some point Hollywood decided that they were even better equipped to ruin movie endings. Movie studios change or reshoot endings all the time to keep audiences happy. And by 'audience' I mean a group of demographically selected people with very little to do during business hours. They are the dreaded 'Test Audience'. The studio will test how this group will respond to an early cut of the film. Any element of the movie that makes them less likely to tweet 'omg transformers wuz hektik!!!' is sliced, reshot or digitally erased. The problem with this is that if, say, *Bambi* were to be made today, the shooting of the mother would've been replaced with a bevy of magical woodland creatures belting out a peppy musical sequence about the value of togetherness and merchandising.

These test audiences have a lot to answer for. Rom-com *The Break-up* was meant to end with Jennifer Aniston miserable and alone. However, in real life, Brad Pitt had just dumped Jennifer Aniston. The fact that she couldn't hold down a man in a fictional world as well was just a little too much for the test audience to bear. There's a similar case for *Die Hard 4.0* (or *Live Free or Die Hard*, as it is hilariously known in its homeland). In order to avoid a US classification of NC-17 (which many cinema chains won't show) the film's ending was cut down. Blood was digitally removed and Willis's iconic, thunderous catchphrase 'Yippee-ki-yay, motherfuckers' was obscured by gunfire, because watching hot globules of lead perforating innocent bystanders is less offensive than the F-bomb.

Live free, indeed.

And so this weekend we embark on good movies that have, for better or worse, had their endings changed.

FRIDAY NIGHT FILM

Pretty Woman (USA) (1990)
Director: Garry Marshall
Stars: Richard Gere, Julia Roberts, Jason Alexander

Pretty Woman is, by all measurable standards, a classic romantic comedy. Boy meets girl, boy discovers girl is a hooker, boy buys girl nice clothes and they both live happily ever after … *Pretty Woman* has a kind of perennial charm about it; Roberts, with her little southern drawl, lights up the screen, and Richard Gere will never make as much sense as he did when he wore shoulder pads. It's a glistening fairytale of a simpler time.

But *Pretty Woman* wasn't supposed to look like this. The original script was called *Three Thousand* (a reference to the fee that Julia Roberts' character, Vivian, charges for her services) and it was much grittier than the film that eventually made its way onto the big screen. Vivian was a prostitute with a drug problem and, in the end, Edward Lewis (Richard Gere) dumps her and she returns to the streets in a crack-fuelled rage.

That could be, perhaps, why Meg Ryan, Michelle Pfeiffer and Daryl Hannah all turned down the role that eventually went to a 21-year-old Julia Roberts. By all accounts both the screenwriter, JF Lawton, and Disney insisted that they were happy with what ended up in cinemas. But let's be honest: we were cheated, plain and simple, out of watching Julia Roberts in a tailspin of ill-begotten class-A drugs. Instead we ended up with a decade of beige romantic-comedy star vehicles.

SATURDAY FLICKS

Australia (Australia) (2008)
Director: Baz Luhrmann
Stars: Nicole Kidman, Hugh Jackman, Bryan Brown

Baz Luhrmann's *Australia* was so over-hyped before its cinema release that it was never going to be able to live up to expectations. It was the film that was supposed to save the Australian film industry, heal the Stolen Generation, cure cancer, slice bread and eradicate premature ejaculation.

Australia was epic in every sense of the word. Part love story, part paid-for outback tourism advertisement, the story unfolds over four years. Beginning in 1938, it tells the tale of Lady Sarah Ashley (Nicole Kidman), a British aristocrat, her drover (Hugh Jackman),

her Indigenous adopted child and a shitload of computer-generated cows struggling to survive on an Australian cattle station called Faraway Downs.

In the original climax, Hugh Jackman was meant to meet his sticky end in the bombing of Darwin but this tragedy was a little too harrowing for the Hollywood studio execs. (What? Had they not seen *Romeo + Juliet* or *Moulin Rouge?*) The tragic ending was filmed and shown to test audiences and they didn't like it either. So after 'intense' discussions with Twentieth Century Fox, Luhrmann agreed to rewrite the ending. *<insert mental image of Baz pouting in his jodhpurs>*

The resulting film is what I like to call a hot mess. *Australia* smacks of a film that was half-written, shot, edited, rewritten, re-shot and re-edited before they sat down, watched once more and decided to spend $20 million on blowing up Darwin and herding some CGI cattle off a cliff. Parts of it are exhilarating, eerie and gut-wrenching, but the plot's big turning points have either too much or not enough emphasis, and are usually in the wrong spot. The entire last half of the movie could easily have been shifted earlier for a punchier ending. It's not that Baz has bitten off more than he can chew, it's that he's bitten off more than he *should've* chewed and then pig-headedly insisted on munching through it all, even if it does take two hours and forty-five minutes.

Yes, *Australia* is beautiful; yes, I cried a bit in parts. But let's face it, the outback looks awesome and I'm a pansy. The biggest surprise is still Nicole Kidman — her comic timing as the stuck-up English bitch is flawless. It's that or they had someone going through frame by frame adding expression to her face. Either way, it works for me.

Clerks (USA) (1994)
Director: Kevin Smith
Stars: Brian O'Halloran, Jeff Andreson, Marilyn Ghigliotti

The career of Kevin Smith is American indie-film legend. He first emerged with this film, *Clerks*, a semi-autobiographical story of a convenience-store clerk who's called in to work on what is set to be the worst day of his life. Smith begged, borrowed and sold his comic-book collection to make the film for next to no money. And in spite of some occasionally wooden acting and rudimentary camera work, Kevin Smith's gift for amazingly profane but brilliantly wrought dialogue shone through. He litters the film with hilarious tirades and verbal sparring matches about sex, hockey, *Star Wars* and life in the suburbs. The interplay crackles along but somehow always feels completely authentic. *Clerks* captured the plight of a generation of suburban slackers and earned Smith both cult status and enough money to buy back his comic collection. And more than ten years later he got to make a sequel where a sex act is performed on a donkey. Win.

Except this happy tale was not always so. Originally *Clerks* ended with the main character being shot dead. Kevin Smith has since said that it was an ending he'd felt obligated to do, that someone pulling a piece and popping a cap in a nearby arse was simply the 'done thing' in indie films. Of course, several bigwigs in the movie business talked him out of it. And so we land ourselves with a far more consistent, open-ended finale.

Call me crazy (and it would be medically accurate to do so) but I tend to think that the original ending was poignant and tragic. It was a film about the pointless menial lives of two New Jersey dudes who work pointless menial jobs that could quite possibly kill them. After developing such an emotional connection with them it makes for a legitimate punch-in-the-gut ending. I reckon he should've stuck with the original, but feel free to debate this amongst yourselves …

THE SUNDAY MOVIES

Little Shop of Horrors (USA) (1986)
Director: Frank Oz
Stars: Rick Moranis, Ellen Greene, Vincent Gardenia

It's a surprise to me that *Little Shop of Horrors* isn't mentioned in the same hallowed breaths as other musicals like *Grease* and *The Sound of Music*. I suppose the presence of a giant flesh-eating, baritone-belting alien with a close likeness to a circumcised penis head might have something to do with it. Whatever the reason, *Little Shop of Horrors* is a thing of camp, disturbing wonder.

Seymour Krelborn (Rick Moranis) is a fumbling, woefully inadequate assistant working at a rundown florist on Skid Row. His life changes when a total eclipse of the sun heralds the arrival of a new plant. Although quaint at first, it soon becomes clear that this plant is a very dangerous thing (I'd say somewhere around the time it decided to eat Steve Martin, who plays a nitrous oxide–addicted rebel dentist with a penchant for violent sex).

The doo-wop, early Motown inspired soundtrack is fantastically catchy, complete with Supremes-style backing singers narrating the whole film. The production is brilliantly staged, particularly the giant alien plant, which was operated by several puppeteers directed by master puppeteer Frank Oz, the hands and mouth behind Yoda, Miss Piggy and Kermit the Frog.

Originally the movie ended with a US$5 million, 23-minute sequence where the alien plant scales the Empire State Building and the main characters are killed off. Test audiences responded very badly to the notion of the leads being killed. (Frank Oz explained that this was a by-product of its adaptation from the original stage musical version to screen. At the end of a musical the cast come out and take a bow, so there's an element of artifice and pantomime that

the audience accept in theatre that they don't in cinema.) And so a happier, more open-ended conclusion was filmed. The original ending was briefly attached to the DVD as an extra feature before it was recalled. Nowadays, you can still see it in its entirety on YouTube.

Fatal Attraction (USA) (1987)
Director: Adrian Lyne
Stars: Michael Douglas, Glenn Close, Anne Archer

Don't fuck with Glenn Close. Anyone with that angular a jawline should not be trifled with. And don't let the bouncy ringlets fool you: one way or another, she's gonna get you like a Blondie song.

Such is the lesson of *Fatal Attraction*, the story of Dan Gallagher (Michael Douglas, the go-to guy for high-class eighties sleaze), a 'happily' married man who has a weekend fling with book editor Alex Forrest (Glenn Close). That is, *he* thinks it's a fling; *she* is deranged. Alex starts rocking up at his work and home, meets his family pets, claims to be knocked up and … Let's just say someone ends up dead. It's compelling, tense stuff. *Fatal Attraction* even inspired countless psychiatric PhDs on erotomania (not a made-up term, I swear) and, whilst I have a few reservations about the coded message behind portraying the only independently careered female in the movie as a sociopath, *Fatal Attraction* is still a great thriller.

But in the original version, Alex met quite a different end where she commits suicide and makes it look like Dan did it. This ending remained for several months in post-production and was released in Japan. But test audiences in the US felt that Dan and his wife, in particular, deserved revenge. So director Adrian Lyne shot the iconic and drama-filled sequence in the bathroom … the result? Ah well, you'll see. Curiously though, there are websites that will edit the original ending onto your DVD, if you so wish.

THE MANY
DISTURBING FACES
OF SANTA CLAUS

It's Christmas! Oh, who am I kidding, you know that. Westfield has probably had a plastic tree up since October in the vain hope of coaxing you into buying turkey breasts, neon Christmas lights and that thing that your mother likes. Christmas is a time of stress, followed by stress-based overeating, with a chaser of overeating.

And at the centre of this is the real hero of Christmas. Some call him Saint Nick, others call him Father Christmas. Yet others call him Jesus. But they're wrong. His real name is Santa Claus. In this day and age, I really wonder how Santa has managed to keep his following so strong. Honestly, how does one convince a child of any reasonable intelligence that there's a morbidly obese man keeping track of how naughty or nice you are? (Presumably he follows you on Twitter and has bookmarked all of your drunken Facebook photos.) Let's not even attempt to garner some scientific explanation supporting his 'gifts all over the world in one night' claims. If FedEx can't do it then I have my doubts. And don't even get me started on the legality of him breaking and entering one's home to deliver the presents.

There's no fixed origin for Santa Claus. The image of a jolly red man with a trans-fat problem dates back as far as the turn of the century but it was solidified by an advertising illustrator named

Haddon Sundblom, who illustrated a grandfatherly character in order to help Coca-Cola sell soft drink during the slow winter months. Santa's been used to sell just about everything from Lucky Strike cigarettes to Japanese KFC to razors — that's right, a dude with a beard schlepping razors.

As the official corporate-sanctioned face of Christmas, what can we learn about the holiday from this man? What lessons can we glean from his many movie adventures that will help us to fully appreciate the two-day festival of brandy custard guzzling? Put down the ham and let's find out.

FRIDAY NIGHT FILM

Miracle on 34th Street (USA) (1994)
Director: Les Mayfield
Stars: Richard Attenborough, Elizabeth Perkins, Mara Wilson

Santa: a lovable rogue with a questionable grasp on sanity?

There are two versions of *Miracle on 34th Street*, the 1947 original and this remake from 1994 featuring Richard Attenborough as Kris Kringle, a department store Santa who firmly believes he is the real thing.

In the true spirit of Christmas commercialism, the 1994 version is set in Macy's rather than the fictional department store 'Coles'. Macy's director of special events Dorey Walker (Elizabeth Perkins) hires Kris Kringle to work as the store's Santa Claus. Her own daughter, six-year-old Susan (Mara Wilson), doesn't believe in Santa. But when Kris Kringle finds himself in court defending himself as the real Santa Claus, Dorey and Susan rush to his defence. As the judge is about to deliver his verdict (which presumably was,

'You're a nut bar — would you like your cell padded or plain?'),
little Susan hands the judge a one-dollar note (ahem, bribery!). On
the money she's circled the words 'In God we trust'. And that's the
clincher. The judge decides that if Americans can believe in God,
then they can believe in Santa Claus too. He does this while blithely
overlooking that some kid with a lisp just attempted to pervert the
course of justice with her sweet moneycash.

Predictably, at that point everyone lives happily ever after, but
'tis the season for feel-good movies and this one ticks all the boxes.
Any film that can make bribery and delusions seem warm and
fuzzy is a quality watch.

SATURDAY FLICKS

The Nightmare Before Christmas (USA) (1993)
Director: Henry Selick
Stars: Danny Elfman, Chris Sarandon, Catherine O'Hara

How about santa as both a victim and the mascot of a patently
inferior holiday?

Like *Miracle on 34th Street*, Tim Burton's *The Nightmare Before
Christmas* is a kids' film, however it has a very different flavour.
Jack Skellington is a glorified stick figure from Halloween Town
who's just stumbled into Christmas Town. Bit by bit the Halloween
Town denizens take over Christmas with their own slightly-too-
dark spin. All the while, Jack himself begins taking over from Santa.
Jack certainly means well, but he is … well, naturally evil. And that
creates problems. Santa, meanwhile, is a pushover, rightly being
overtaken by a far more interesting holiday.

At a time when Disney was making films like *Aladdin*, *The
Nightmare Before Christmas* was a surprisingly sinister movie for

them to back. In fact, Disney chose to release the film under the banner of Touchstone Pictures because of concerns that the film would be too scary for kids.

It's a stop-motion flick in Tim Burton's characteristic gothic style and while making stop motion is always a slow process, *this* film was slower than most. It started as a poem written by Burton in the early eighties and took more than a decade to get it onto the big screen.

The detail in *The Nightmare Before Christmas* is phenomenal. The filmmakers constructed 227 puppets for the film and the main character, Jack Skellington, had around 400 heads to represent every possible expression. The most amazing part is the lyrical and musical quality the movie retains from its rhyming origins. It truly does feel like a fairytale — a properly dark one that could've been around for centuries. It's a classic.

Bad Santa (USA) (2003)
Director: Terry Zwigoff
Stars: Billy Bob Thornton, Bernie Mac, Lauren Graham

Santa as a role model for future foul-mouthed drunks and STD-carriers?

Woman: I've always had a thing for Santa Claus … It's like some deep-seated childhood thing.
Santa: So is my thing for tits.

This quote tells you almost everything you need to know about this screwball comedy (the screwing being quite literal). It stars Billy Bob Thornton as the type of Santa you really don't want coming down your chimney. This drunken, lecherous, foul-mouthed Santa impersonator and his elfin accomplice take a job at a new shopping mall every year. Then, on Christmas Eve, they rob the place. The

duo spend the rest of the year in Florida drinking mai tais and fucking anything that's not nailed down. In other words, this Santa is more naughty than nice.

Produced by the Coen brothers and directed by Terry Zwigoff, best known for indie flicks like *Ghost World* and *Crumb*, *Bad Santa* remains one of the most underrated of seasonal holiday comedies. It achieved a cult status amongst some but it didn't win too many friends amidst conservative commentators who likened the movie to 'an evil twin' of *Miracle on 34th Street*. Personally I think it's more of an abusive uncle, but to each their own.

Bad Santa is also notable for being cursed. It was the last big-screen performance for Thornton's good mate John Ritter (as the uptight shopping-mall manager). Also Bernie Mac (who played the suspicious security chief) died just a few years later at the tender age of fifty. Christmas: it's hazardous to your health.

THE SUNDAY MOVIES

Silent Night, Deadly Night (USA) (1984)
Director: Charles E Sellier Jr
Stars: Lilyan Chauvin, Gilmer McCormick, Toni Nero

And now, meet Santa, product of your pschyo-sexual childhood trauma.

This slasher flick focuses on young Billy Chapman, who witnesses his parents' brutal murder at the hands of a man in a Santa suit. Fast-forward through time (and a string of super-enthusiastic child actors, each less talented than the last) and we eventually meet Billy as a teenage boy. His nightmarish fear of Santa Claus starts interrupting his masturbatory fantasies which brings on Billy's complete break with reality. Cue the Christmassy killing spree!

As you would expect, a film with a Santa suit-clad killer had its critics. Released in mid-November, during the lead-up to the silly season, the axe-wielding Santa ads didn't win the film many friends. Parent groups picketed cinemas throughout its limited release and US film critics Gene Siskel and Roger Ebert infamously read the names of the cast on air, repeating 'shame, shame, shame' after every one.

But they all missed the point. Not only is *Silent Night, Deadly Night* utterly hilarious in its gobshite-ness, it's also one of cinema's most insightful portraits of mental illness and how *not* to treat it: the tough love that Billy's orphanage nuns dole out is met with a meat hook of disapproval. Also, the portrayal of Billy's mentally unstable grandfather is nothing short of masterful. Grandpa overacts like a motherbitch, his volume and pitch rolling up and down like Laurence Olivier on a slippery dip. The actor doesn't just chew the scenery, he chews it, regurgitates it back out like a pelican, fashions the dialogue into a word s'more, freezes it, reheats, masticates it once more and then — and *only* then — he swallows it. His performance is only a fraction less self-indulgent than that last sentence.

Santa Claus Conquers the Martians (USA) (1964)
Director: Nicholas Webster
Stars: John Call, Pia Zadora, Leonard Hicks

And finally, of course, there's Santa as the Alzheimer's-prone intergalactic warrior for peace … well, kind of. This film is widely regarded as one of the worst-made productions in cinema history. It is therefore also comedy gold. Mentally transport yourself, if you will, to a vision of Mars rendered in corrugated cardboard and glitter. It's like someone has taken to a garage with an industrial-grade vajazzler. Next meet the Martians. You will recognise them by their distinctive green colouring and by the vacuum cleaners

hanging out of their heads. Which still isn't as creepy as their 'tickle ray' toys. Mom Martian or 'Momar' and King Martian are worried about their children Girmar (Girl Martian) and Bomar (Boy Martian). After consulting with an 800-year-old alien sage they realise that the kids are distracted by Mars' rigid social structure, which doesn't allow any freedom of expression. So the martian parents hatch a plan: kidnap Santa Claus from Earth!

As you do.

What follows is a truly mind-boggling mix of elves, fat-suits, a polar bear attack, the odd non-sequitur appearance by a robot and a narrative that massacres good sense with extreme prejudice.

Shot on a shoestring budget, *Santa Claus Conquers the Martians* has developed a rabid cult following over the years. The film first gained notoriety when it was ridiculed on the cult TV comedy series *Mystery Science Theatre 3000*. The film has since fallen into 'public domain', meaning pretty much any company can sell a copy without permission. Hence why you'll find that the movie is available in just about every format available form VHS to BitTorrent.

And trust me: it has to be seen to be believed. This film has some truly unforgettable moments. For example, there's the astonishing discovery that a grown adult armed with a disintegration ray could be defeated by four children, some soap suds and a few ping pong balls. I particularly love when the filmmakers start making up their own novelty months of the year, for example, 'Septober'. Then there's the budget effects like the Radar Array CLEARLY made out of toilet paper tubes. Oh and just so you have been warned: there are far worse Christmas songs than 'Jingle Bells' and this film has several of them. And as for Santa himself? Well, you'll never look at the jolly old man in quite the same way.

GOING OUT WITH A BANG, A WHIMPER AND A FIGHT
YOUR GUIDE TO THE APOCALYPSE

If the apocalypse comes tomorrow — or indeed tonight — how will it end? Well, cinema has offered us a bunch of possibilities. There are so many wildly inventive theories and ideas about how our pansy-arse blue planet will be destroyed.

Will it be Terminators? The plague? A zombocalypse? Nuclear war? Rabid genetically enhanced beavers? Or some horrifying combination thereof? Perhaps Armageddon will come in the form of the Gochihr comet predicted by ancient Persians to make humanity act 'like a sheep being attacked by a wolf'.

My money is on the rabid nuclear beaver combo.

Cinema is filled with important lessons on how to cope with the end of time. For starters, you should probably get a dog just like Will Smith has in *I Am Legend*, a film about the last man left on a zombocalyptic Earth. Sure, a dog is handy for hunting and protection. But more importantly there is literally nothing more effective at pulling the audience's heartstrings than a dead dog. Sorry ... spoilers. This next and final chapter is packed with tips just like this. Only better.

FRIDAY NIGHT FILM

Armageddon (USA) (1998)
Director: Michael Bay
Stars: Bruce Willis, Billy Bob Thornton, Ben Affleck

An asteroid the size of Texas is heading for Earth. What is America gonna do about it? Send in Texan rednecks, of course, with the plan to drill a hole in the rock and blow it to kingdom come.

Part of the appeal of apocalyptic movies is that they're huge in every way: big explosions, big melodramatic speeches and, my favourite, big landmarks being obliterated. But *Armageddon* is notable because it follows through on that notion and turns the human quotient up too — the characters, the humour and the romance are all larger than life itself. None of it remotely plausible, most of it broadly insulting to basic science, but all of it is damn entertaining.

I think there's an enormous amount of charm in a movie that is vastly stupid but wholeheartedly so. *Armageddon* is a ludicrous, heartstring-tugging film, with over-the-top end-of-the-world montages of coloured folk crying in temples while good all-American dickheads try to save the world. It's offensive in so many ways, but because it's so hyperbolic it becomes hilarious (to me, anyway).

You can't really question the moviemaking craft that has gone into creating the sheer spectacle of *Armageddon*. The action sequences are thrilling. The charisma of the cast (many of whom would go on to do much bigger things) is unquestionable. And the script, whilst deeply schmaltzy, has some wonderful one-liners. In other words, if you have a healthy sense of irony then this is a lot of fun.

SATURDAY FLICKS

On the Beach (USA) (1959)
Director: Stanley Kramer
Stars: Gregory Peck, Ava Gardner, Fred Astaire

Meanwhile, other films have used the-end-of-life-as-we-know-it as a conduit for much deeper ideas. *On the Beach* shows us the world coming to terms with the end of humanity in the aftermath of a nuclear holocaust. Nuclear submarine USS *Sawfish*, captained by Dwight Towers (Gregory Peck), escapes the lethal radioactive cloud by travelling south to the edge of civilisation. We call it Melbourne.

Based on Nevil Shute's 1957 novel, *On the Beach* was directed by Stanley Kramer, who won the 1960 BAFTA for direction. The US Department of Defense as well as the Navy weren't all that keen on being involved in the making of the film and refused access to their nuclear-powered submarines, so Stanley and his team were forced to use non-nuclear, diesel-electric British Royal Navy submarines. Melbourne itself became quite the star during the making of the film. In addition to using well-known parts of Melbourne, rumour has it that a scene was shot in Melbourne's then nightclub hotspot Ciro's; apparently one-time king of Australian television Graham Kennedy can be seen in it. So grateful was the city that they even ended up naming certain streets in the Berwick area after the production, like Shute Avenue (named after the original novelist, Nevil Shute) and, of course, Kramer Drive (after director Stanley Kramer).

It doesn't match *Armageddon* for melodrama but *On the Beach* offers an intimate and sensitive study of how people deal with their own impending mortality and are forced to examine their values in life, be they love or a decent cup of coffee. Although above all

things, *On the Beach* demonstrates that even at the end of the world, Americans still will not be able to do Australian accents.

Children of Men (USA/UK) (2006)
Director: Alfonso Cuarón
Stars: Julianne Moore, Clive Owen, Michael Caine

The year is 2027. Eighteen years ago, the last baby was born. The world became infertile in 2009 and suddenly there was no future for the human race. In a delicate spark of hope, a revolutionary group called the Fishes has come into contact with a young pregnant woman. For the sake of humanity, the group want to get the girl to a sea-based organisation called the Human Project, dedicated to solving our global sprogging problem. One of the leaders of the Fishes (Julianne Moore) recruits her ex-lover and a former revolutionary, Theo (Clive Owen). He reluctantly chooses to risk his own life for the sake of the next generation.

Children of Men is a masterpiece, and I'm not just talking about the incredibly vivid and believable vision of mankind's slow decline. I'm also not just talking about the breathtaking cinematic set pieces. No, I'm not even talking about the acting — which is uniformly brilliant right down to Clive Owen's eyes (where you can witness his soul slowly going gangrenous). No, this is a masterpiece about the value of children — indeed, the very nature of youth and procreation. Owen finds his resolve cemented when he sees the embryonic gamble at stake.

As you watch and rewatch this magnificent flick, perhaps what is most impressive about it is how it reflects elements of our own time and culture back at us. And that is the great power of science fiction: to take those elements of our society (cult of celebrity, obsession with youth) that we don't always notice and show them through a different prism.

THE SUNDAY MOVIES

The Road (USA) (2009)

Director: John Hillcoat
Stars: Viggo Mortensen, Charlize Theron, Kodi Smit-McPhee

Some disaster has befallen our world. The impression is that of a nuclear catastrophe, but things are never spelled out for you. The forests turn to fire by night and there are only a few survivors left, including the 'Man' (Viggo Mortensen) and his son (Kodi Smit-McPhee). They are travelling down a long road to find others. The weather is dank, the hopes are dim and the company they meet on the road is not pleasant.

The Road is not a science-fiction film; it is a harrowing journey through a terrorised future. Viggo Mortensen and Kodi Smit-McPhee portray a pair of weary nomads who struggle to travel across the bleak wasteland that was America, in the hopes of making it to the coast. You really can't question Mortensen's commitment to the role. When you see his haggard, wizened appearance, please note that he starved himself to help him inhabit the character, both mentally and physically. The effect is a raw, unnerving performance.

Kodi, who was eleven during the production, has equal potency; his breakdowns are gut-wrenching. He possesses such humanity that it becomes a counterpoint to the Man's paranoia. He is the heart of the film.

At its core, *The Road* is a movie about compassion. In a world where men have turned into cannibals, rapists and thieves, can compassion between a father and son survive? Director John Hillcoat gives you that warm and loving relationship to hook into early on in the film. He allows you to invest in them. But then Hillcoat forces you to ask difficult questions, like, is it really compassionate for them to continue living in this world? Would they be better off dead?

Dr Strangelove or: How I Learned to Stop Worrying and Love the Bomb (UK) (1964)

Director: Stanley Kubrick

Stars: Peter Sellers, George C Scott, Sterling Hayden

But the be-all and end-all, as it were, has to be Stanley Kubrick's *Dr Strangelove*. An impotent general sends bombers to nuke the Soviet Union, thus triggering a countdown to a doomsday device and a cascade of increasingly bizarre and desperate actions to stop it.

Very loosely based on thriller novel *Red Alert* by Peter George, *Dr Strangelove* was instigated when Kubrick started exploring the idea of mutually assured destruction. In other words, the unstable 'balance of terror' between nuclear powers the USA and the USSR that maintained world peace by threatening world destruction. Originally intended to be a drama, it soon became clear to Kubrick that the principals of 'mutually assured destruction' were laughable, and accordingly the movie became so too.

For reasons that still blow my mind to this day, Columbia Pictures only agreed to finance this film on condition that Peter Sellers play at least four major roles (including British exchange officer Lionel Mandrake, US President Merkin Muffley and, of course, Dr Strangelove, the wheelchair-bound nuclear-war strategist and recovering Nazi, whose twitchy hand has a Nazi mind entirely of its own). Reportedly, this bizarre situation originated from the studio's opinion that Kubrick's previous film, *Lolita* (1962), was successful in part due to Sellers' performance as a single character who takes on a variety of identities. It is just one of the many strokes of genius of this film as Kubrick captures the absolute madness and utter lack of logic that was the Cold War. The film likens the politicians and generals to schoolboys, and the arms race to a kind of global penis measuring competition leading to the annihilation of humankind. If ever there were a time for boys not to play with their toys, this would be it.

FIN.

And so it ends. No doubt you hated some films I suggested. Sorry about that. Hopefully though you enjoyed a few too. Better yet, perhaps you came up with your own ideas for weekends. Feel free to hunt me down and post them on the various social media outlets I frequent at all hours of the day. Or you could accost me on the street. Yes, I just gave you permission to stalk me. Movies, like cheese, are best shared. Besides, I could use the extra material for when I inevitably write a sequel to this. For now though, let me just say thanks for reading. In case I don't see you, good afternoon, good evening and goodnight.

<credits roll>

THANKS

Most importantly, to my wife, Maddy: I love you more than movies. Ha — take that, movies.

To Mum, for taking me to each and every Disney movie during school holidays. They are some of my best memories.

To Dad, for staying up and taping every movie and TV show I asked for. Both you and the trusty VCR rule.

To my teachers who inspired a love of movies and didn't bother discouraging my love of talking about them.

To Dan Buhagiar and Meagan Loader, for thinking my film reviewing was good enough to put on radio in the first place.

To Simon Marnie, Megan Spencer, Rosie Beaton, Chris Scaddan and Nat Foxon, for getting me on ABC Radio and triple j.

To editor extraordinaire Jo Mackay, for being so patient and laughing at all my terrible jokes — I can only imagine how much pain they must've caused. Also to Susan Morris-Yates for getting the ball rolling.

To Craig Schuftan, for giving me the confidence to try out the idea ... and for a tiny book on grammar basics. Subtle, mate.

To Andrew Denton, executive producer of *Hungry Beast*, who actually had nothing to do with the writing of this book, but 'Blame Andrew Denton' is a killer excuse to give to a publisher when you've missed your deadline by a whole year.

To Maddy once more, because her nose is awesome.

To Bombay Sapphire, Schweppes and the many lime growers of Australia: without your produce this book would be a far better read.

To the enormous number of triple j fans, ABC Radio listeners, FBi cool kids, SBS *Movie Show* viewers, daytime devotees of *The Circle* and my followers on Twitter and Facebook: you make movies fun. Cinema is at its best when it's an orgy. Films aren't fun without people to share them with and you have all given me eight years of the most robust, engaging and passionate discussions I've ever had. I simply can't describe the warm, fuzzy and occasionally itchy sensation I get whenever I talk to you.

And finally … wait for it … to Maddy. Chocolate ducklings forever :)

<end Oscar acceptance speech>

INDEX
OF REVIEWS

A

Adaptation ... 157
The Adventures of
 Priscilla, Queen of
 the Desert ... 129
After Hours ... 318
A.I. Artificial Intelligence ... 236
Aladdin ... 34
Alien ... 27
Alive ... 178
All About Eve ... 225
Almost Famous ... 223
Amélie ... 80
American Beauty ... 216
Animal Kingdom ... 189
Armageddon ... 355
Australia ... 342

B

Baadasssss! ... 302
Back to the Future ... 147
Bad Boy Bubby ... 140
The Bad Lieutenant:
 Port of Call —
 New Orleans ... 155
Bad Santa ... 350

The Bad Seed ... 261
Batman Begins ... 116
Battle Royale ... 56
Battlestar Galactica ... 241
A Beautiful Mind ... 18
Big Dreamers ... 282
Big Night ... 197
Big Trouble in
 Little China ... 98
Black Sheep ... 76
Blade Runner ... 238
Blue Velvet ... 218
Bonnie and Clyde ... 89
Borat ... 122
The Bourne Identity ... 4
Boys Don't Cry ... 133
Brick ... 57
Broadcast News ... 307
The Brood ... 259
Buried ... 101

C

Cabin Fever ... 321
Carrie ... 58
The Cars that Ate Paris ... 322
Children of Men ... 357

Child's Play 335
Chocolat 194
City of God 190
The City of Lost Children 84
Cleopatra 164
Clerks 344
The Crying Game 132
Cube 104

D

The Darjeeling Limited 233
Dark City 274
The Dark Crystal 336
Dark Days 266
The Dark Knight 117
Dazed and Confused 317
Dead End 323
Deep Blue Sea 13
Delicatessen 83
Deliverance 320
Devil 102
Dirty Rotten Scoundrels 169
The Disappearance of
 Alice Creed 105
District 9 287
Dog Day Afternoon 91
Donnie Darko 151
Don't Tell Mom the
 Babysitter's Dead 108
Downfall 202

Dr Strangelove or: How
 I Learned to Stop
 Worrying and Love
 the Bomb 359
Dumbo 36

E

8½ 304
Election 61
Elizabeth 162
ET: The Extra-Terrestrial 324
Eternal Sunshine of the
 Spotless Mind 7
Excalibur 96
eXistenZ 275
The Exorcist 257
The Extraordinary
 Adventures of
 Adèle Blanc-Sec 42

F

Fantastic Mr Fox 229
Fargo 20
Fast Food Nation 199
Fatal Attraction 346
The Fifth Element 41
The Fisher King 267
The Flight of
 the Phoenix 296
The Fly 77

Flying High 293

Frailty 247

G

Gates of Heaven 283

Gattaca 75

The General 253

Ghostbusters 181

Go 315

The Gold Rush 251

Good Morning,
 Vietnam 23

Good Night, and
 Good Luck 311

The Great Dictator 201

H

Halloween 110

Hamlet 2 226

The Hand that Rocks
 the Cradle 111

Harold and Kumar Go
 to White Castle 314

Harry Potter 95

Heat 88

Heathers 55

Hedwig and the
 Angry Inch 130

His Girl Friday 309

Howl's Moving Castle 208

I

If … 59

Ilsa, She Wolf
 of the SS 206

In the Loop 66

Inception 118

Inglourious Basterds 224

The Insider 310

Invasion of the Body
 Snatchers 286

J

Jaws 11

The Joneses 215

Judgment at Nuremburg 203

Jurassic Park 72

K

The Karate Kid 67

Kill Bill (volumes 1
 and 2) 70

The King of Kong 279

The King's Speech 159

L

La Haine 192

Laputa: Castle in the Sky 210

The Last Emperor 163

The Last King of Scotland 19

Leaving Las Vegas 156

Léon: The Professional 43
The Life Aquatic with
 Steve Zissou 230
Little Shop of Horrors 345
Lock, Stock and Two
 Smoking Barrels 188
Lord of the Rings 97
Lord of War 153
Lost in La Mancha 299
Lost in Translation 126

M

The Machinist 8
Making Venus 301
The Man Who Knew
 Too Much 168
The Matrix 272
Meet the Feebles 339
Mega Shark Versus
 Crocosaurus 16
Mega Shark Versus
 Giant Octopus 15
Memento 119
Micmacs 81
Midnight Run 185
Miracle on 34th Street 348
Modern Times 252
Monsoon Wedding 51
Monty Python and the
 Holy Grail 94

Moonstruck 184
Mother 139
Muriel's Wedding 48
My Neighbor Totoro 212

N

Natural Born Killers 245
Network 308
The Night of the Hunter 112
Night of the Living
 Dead 330
The Nightmare Before
 Christmas 349
Nikita 44

O

Ocean's Eleven 167
Office Space 26
On the Beach 356
Open Water 14
Out of Sight 87

P

Paranoid Park 220
Peter Pan 35
Pieces of April 196
Play Time 250
Postcards from the
 Edge 137
Power 65

Precious 138
The Prestige 115
Pretty Woman 341
Primary Colors 63
Primer 150
The Princess Bride 49
Princess Mononoke 213
The Producers 183
The Pursuit of Happyness 264

Q
The Queen 161

R
Rachel Getting Married 52
Raising Arizona 109
Ratatouille 222
The Reader 204
Rear Window 103
Red Eye 295
The Rescuers Down
 Under 37
Rififi 90
Ringu 258
The Road 358
RoboCop 30
RoboGeisha 240
Rope 176
The Royal Tenenbaums 231
Rushmore 232

S
Santa Claus Conquers
 the Martians 352
A Scanner Darkly 5
Scarface 170
Serial Mom 136
Shallow Grave 177
Shaun of the Dead 327
The Shining 246
Silent Night, Deadly
 Night 351
Silver Streak 123
Snakes on a Plane 297
Sonatine 191
Song of the South 38
Soylent Green 175
Spellbound 281
Spirited Away 209
Splice 74
Sports Night 142
The Star Wars
 trilogy 243
Starship Troopers 288
Steamboat Bill, Jr 254
The Stepford Wives 237
Stranger than Fiction 182
Strings 337
Studio 60 on the
 Sunset Strip 144
Subway 45

Superbad 316

Syriana 31

T

Tampopo 195

Team America:
World Police 334

Tekkon Kinkreet 268

The Texas Chainsaw
Massacre 22

The Thing 291

The Thirteenth Floor 276

3:10 to Yuma 171

Timecrimes 149

Tokyo Godfathers 265

Tokyo Zombie 331

Total Recall 6

Transamerica 131

Trekkies 280

Tristram Shandy: A Cock
and Bull Story 303

TRON 271

Twelve Monkeys 148

28 Days Later 329

2 Days in Paris 125

U

United 93 294

The Untouchables 69

V

A Very Long Engagement 82

Village of the Damned 260

The Virgin Suicides 219

W

Wag the Dog 62

WALL-E 28

War of the Worlds 289

The Weather Man 154

The Wedding Banquet 50

Weekend at Bernie's 174

The West Wing 143

X

X-Men 68

Z

Zombieland 328

Zorba the Greek 124